El Greco ✠ of Toledo

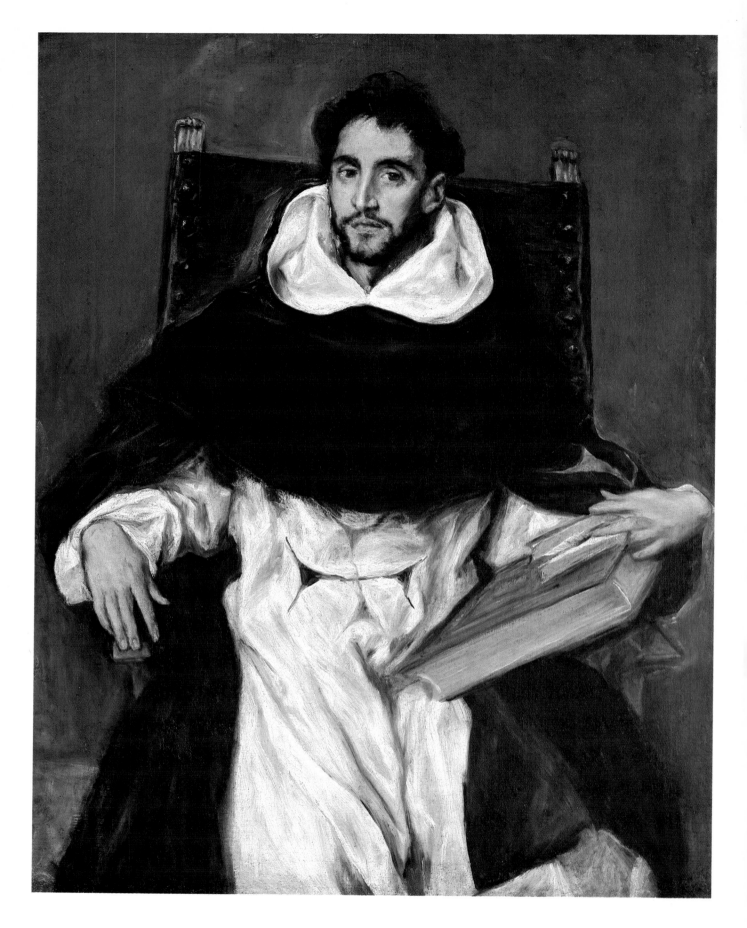

Fray Hortensio Félix Paravicino (cat. no. 63),
44½ x 33⅞ inches, circa 1609 (Boston,
Museum of Fine Arts. Isaac Sweetser
Fund 1904)

El Greco of Toledo

The exhibition El Greco of Toledo *has been organized by*

The Toledo Museum of Art

with

Museo del Prado

National Gallery of Art

Dallas Museum of Fine Arts

Contributions by JONATHAN BROWN, WILLIAM B. JORDAN,
RICHARD L. KAGAN, ALFONSO E. PÉREZ SÁNCHEZ

A New York Graphic Society Book

Little, Brown and Company · Boston

The exhibition *El Greco of Toledo* has been made possible by a generous grant from the American Express Foundation. Additional support for the exhibition has been received from the National Endowment for the Humanities and the National Endowment for the Arts, Federal Agencies, and through a partial federal indemnity from the Federal Council on the Arts and the Humanities.

Exhibition dates:

MUSEO DEL PRADO, Madrid, April 1–June 6, 1982
NATIONAL GALLERY OF ART, Washington, D.C., July 2–September 6, 1982
THE TOLEDO MUSEUM OF ART, Toledo, Ohio, September 26–November 21, 1982
DALLAS MUSEUM OF FINE ARTS, Dallas, Texas, December 12, 1982–February 6, 1983

Chapter 3 (essay by Alfonso E. Pérez Sánchez)
translated from the Spanish by Edward J. Sullivan

Library of Congress Cataloging in Publication Data appears on page 276

Jacket and cover illustration: *Saint Martin and the Beggar* (cat. no. 30; pl. 17), Washington, National Gallery of Art. Widener Collection 1942

New York Graphic Society books are published by Little, Brown and Company. Published simultaneously in Canada by Little, Brown and Company (Canada) Limited.

Printed in the Federal Republic of Germany

Under the High Patronage of

HIS MAJESTY JUAN CARLOS I, KING OF SPAIN

and

PRESIDENT RONALD REAGAN

OF THE UNITED STATES OF AMERICA

Lenders to the Exhibition

Barcelona, *Torelló Collection:* cat. no. 21
Barnard Castle (County Durham, England), *The Bowes Museum:* cat. no. 15
Boston, *Museum of Fine Arts:* cat. no. 63
Cleveland, *The Cleveland Museum of Art:* cat. nos. 27, 45
El Escorial, *Patrimonio Nacional:* cat. nos. 12, 53
Fort Worth, *Kimbell Art Museum:* cat. no. 66
Illescas, *Hospital of Charity:* cat. no. 42
Kansas City (Missouri), *Nelson Gallery – Atkins Museum:* cat. no. 14
London, *Stavros S. Niarchos Collection:* cat. no. 17
Lugano, *Thyssen-Bornemisza Collection:* cat. no. 6
Madrid, *Instituto de Valencia de Don Juan:* cat. no. 28
Madrid, *Museo del Prado:* cat. nos. 1, 7, 24, 32, 33, 34, 59, 64
Madrid, *Plácido Arango Collection:* cat. no. 18
Madrid, *Várez-Fisa Collection:* cat. nos. 41, 50
Minneapolis, *The Minneapolis Institute of Arts:* cat. no. 3
Montforte de Lemos (Lugo), *Colegio del Cardinal – Padres Escolapios:*
 cat. no. 11
Montreal, *Montreal Museum of Fine Arts:* cat. no. 58
Naples, *Museo e Gallerie Nazionale di Capodimonte:* cat. no. 57
New York, *Charles S. Payson Collection:* cat. no. 4
New York, *The Metropolitan Museum of Art:* cat. nos. 35, 40
New York, *Oscar B. Cintas Foundation:* cat. no. 23
New York, *Stanley Moss Collection:* cat. nos. 5, 13
Oslo, *Nasjonalgalleriet:* cat. no. 51
Ottawa, *National Gallery of Canada/Galerie Nationale du Canada:* cat. no. 38
Palencia, *Cathedral Sacristy:* cat. no. 10
Paris, *Musée du Louvre:* cat. nos. 19, 61
Private collections: cat. nos. 8, 36, 60
San Francisco, *The Fine Arts Museums of San Francisco:* cat. no. 37
Sitges, *Museo del Cau Ferrat:* cat. no. 20
Stockholm, *Nationalmuseum:* cat. no. 44
Toledo (Ohio), *The Toledo Museum of Art:* cat. no. 22
Toledo, *Cathedral:* cat. nos. 29, 46, 47
Toledo, *Church of Saint Leocadia:* cat. no. 16
Toledo, *Hospital of Saint John the Baptist (Hospital de Afuera):*
 cat. nos. 25, 65
Toledo, *Museo del Greco:* cat. nos. 39, 48, 49, 55, 62
Toledo, *Museo de Santa Cruz:* see cat. nos. 16, 29
Villanueva y Geltrú, *Museo Balaguer:* see cat. no. 32
Washington, *Dumbarton Oaks Collection:* cat. no. 52
Washington, *National Gallery of Art:* cat. nos. 2, 26, 30, 31, 43, 54, 56
Worcester (Massachusetts), *Worcester Art Museum:* cat. no. 9

Foreword

The great Mannerist artist Domenikos Theotokopoulos, called El Greco, created paintings that electrified the artistic, political, and religious climate of his adopted city of Toledo. While the artistic formation of El Greco took place first in Crete, then in Venice, and later in Rome, it was upon his settling in Toledo that his singular genius flowered in the particular climate of learning and patronage that prevailed there. An impetus for this exhibition was our realization that recent scholarship on El Greco and his work in Toledo, and on the city itself, places him in a more reasoned historical context than did the mystical, romantic, and even physiological interpretations of his art that have been widely promulgated during this century.

In creating the exhibition *El Greco of Toledo* our intention has been to bring together for the first time a substantial percentage of El Greco's finest works from Spain and elsewhere in Europe, as well as from North America. Many of these paintings, a number of them very large, have never before been readily accessible. The project has been a truly international effort, made possible by the remarkable cooperation of lenders, governments, and scholars.

Essays by Jonathan Brown and Richard L. Kagan in this catalogue present a new view of El Greco and of the Spain in which he worked. They reassess the artist's relationship with the men and institutions of the city in which he lived for almost forty years, on the basis of recent research conducted in the various archives of Spain. The essay by Alfonso E. Pérez Sánchez discusses the development and original contexts of El Greco's altarpiece ensembles, which have been dispersed. William B. Jordan's catalogue entries focus on the specific works in the exhibition, fully documenting the pertinent sources of scholarly knowledge.

We are particularly grateful to these scholars for developing these new humanistic interpretations here. We are especially indebted to William Jordan for his key role as chairman of this scholars' committee. The responsibility for selecting the paintings in the exhibition, as well as for writing the essays and catalogue, rests primarily with these scholars. They received valuable advice in this task and in requesting loans in Spain from, José M. Pita Andrade, Comisario of the exhibition in Spain and Honorary Director of the Museo del Prado. The scholars' committee was assisted in their bibliographic research by Sam Heath, Irene Martin, Susanna Meade, and Sarah Schroth, and we are obliged to them for their fine work.

To Harold E. Wethey and Fernando Marías go our thanks for offering valuable advice to the scholars as they constructed their essays and entries for the catalogue.

We are grateful to His Majesty Juan Carlos I, King of Spain, and to Ronald Reagan, President of the United States, for their honorary high patronage of the exhibition. His Excellency José Lladó, Spanish Ambassador to the United States, and His Excellency Terence A. Todman, United States Ambassador to Spain, have offered their advice and full support throughout this project. At the Spanish Embassy in Washington, Alonso Alvarez de Toledo, Minister Counselor; Roberto Bermúdez, Minister of Cultural Affairs; and Javier Malagón, Cultural Attaché, have been helpful in all respects. At the United States Embassy in Madrid, Eli Flam, Cultural Counselor, has also been very helpful. In addition, we would like to thank

Soledad Becerril de Atienza, Spanish Minister of Culture; Iñigo Cavero
Lataillade and Ricardo de la Cierva y Hoces, former Spanish Ministers of
Culture; Javier Tusell Gómez, Director General de Bellas Artes, Archivos y
Bibliotecas; and José María Losada Aranguren, former Comisario General
de Exposiciones, for their enthusiastic support of the exhibition. We are
grateful to the Real Patronato of the Museo del Prado for their confidence
in this endeavor. Without the extensive cooperation of the Spanish and
American governments, this exhibition would not have been possible.

Indispensable assistance on all fronts was given by two remarkable and
gracious women whose tireless professional and diplomatic support kept
the project alive. To Isabel de Alzaga and Marta Medina of Madrid we owe
our deepest gratitude for their coordination of so many aspects of the
exhibition.

It is only through the extraordinary generosity of museums, churches,
and private collections in North America, Spain, and elsewhere in Europe
that it has been possible to assemble an exhibition of this scope and merit.
The lenders are listed on page 6. We are deeply grateful to the many help-
ful individuals associated with these institutions and collections, and in
particular to those who follow.

In North America: Jan Fontein, Director, and John Walsh, Jr., Baker Cura-
tor of Paintings, Museum of Fine Arts, Boston; Sherman E. Lee, Director,
The Cleveland Museum of Art; Edmund P. Pillsbury, Director, and William
B. Jordan, Deputy Director, Kimbell Art Museum, Fort Worth; Ralph T. Coe,
Director, Nelson Gallery–Atkins Museum, Kansas City; Samuel Sachs II,
Director, The Minneapolis Institute of Arts; Jean Trudel, Director, Montreal
Museum of Fine Arts; Harry A. Brooks, President, Wildenstein & Com-
pany, Incorporated, New York; Ethan D. Alyea, President, Oscar B. Cintas
Foundation, Incorporated, New York; Stanley Moss, New York; Philippe de
Montebello, Director, and Sir John Pope-Hennessy, Consultative Chair-
man, Department of European Paintings, The Metropolitan Museum of
Art, New York; George Szabo, Curator, Robert Lehman Collection, The
Metropolitan Museum of Art; Charles S. Payson, New York; Joseph Martin,
Acting Director, National Gallery of Canada/Galerie Nationale du Canada,
Ottawa; Ian M. White, Director, and Thomas P. Lee, Curator in Charge,
Department of Paintings, M. H. de Young Memorial Museum, The Fine
Arts Museums of San Francisco; Giles Constable, Director, Dumbarton
Oaks Collection, Washington; Richard Teitz, Director, and James A. Welu,
Curator, Worcester Art Museum; and those private collectors who wish
to remain anonymous.

In Spain: Señor Don Alberto Torelló, Barcelona; Señor Don Luis Gamboa
Conde, Hospital of Charity, Illescas; Señor Don Fernando Fuertes Villa-
vicencio, Monastery of El Escorial; Señor Don Plácido Arango, Madrid;
Señor Don Diego Angulo Iñiguez, Instituto de Valencia de Don Juan,
Madrid; Señor Don José Luis Várez-Fisa, Madrid; His Excellency the Duke
of Alba; Colegio del Cardinal–Padres Escolapios, Monforte de Lemos;
Señor Presidente del Cabildo, Cathedral of Palencia; Museo del Cau Ferrat,
Sitges; Señor Don Pedro Guerrero Ventas, Cathedral of Toledo; His Excel-
lency the Duke of Medinaceli, Hospital of Saint John the Baptist (Hospital

de Afuera), Toledo; Reverendo Padre, Párroco de Santa Leocadia–Museo de Santa Cruz, Toledo; Doña María Elena Gómez Moreno, Museo del Greco, Toledo; Museo Balaguer, Villanueva y Geltrú.

Elsewhere in Europe: Elizabeth Conran, Curator, Bowes Museum, Barnard Castle, England; Baron Thyssen-Bornemisza, Lugano, and Simon de Pury, Curator, Thyssen-Bornemisza Collection; Stavros S. Niarchos, London; Dr. Raffaello Causa, Soprintendènte, Museo e Gallerie Nazionale di Capodimonte, Naples; Dr. Knut Berg, Director, Nasjonalgalleriet, Oslo; Michel Laclotte, Inspecteur Général des Musées, and Pierre Rosenberg, Conservateur, Département des Peintures, Musée du Louvre, Paris; Dr. Pontus Grate, Acting Director, Nationalmuseum, Stockholm.

Inspiration for this exhibition grew out of the cooperative spirit of the sister cities Toledo, Spain, and Toledo, Ohio, which recently celebrated the fiftieth anniversary of their friendly association. Ohio's Toledo Museum became the focal point for the anniversary celebration as it sought a more concrete cultural expression of this sister-city relationship. El Greco, who was the greatest artist of Toledo, Spain, is represented in Toledo, Ohio, by two splendid paintings in that city's collection. The museum in Ohio conceived, organized, and implemented the exhibition with the cooperation of its partners, which include not only the three other participating museums, but also the Spanish city of Toledo.

The Honorable Juan Ignacio de Mesa Ruiz, Mayor of Toledo, Spain, and his staff have added inspiration and encouragement at every point. Felipe Rodríguez Bolonio y González, Press Secretary for that city, was an early enthusiast for the idea of the exhibition. The Honorable Doug DeGood, Mayor of Toledo, Ohio, has also been interested in the development of this cooperative venture, as have the members of the sister-city committees in Spain and the United States. Many others in both cities have aided in the complex negotiations for the exhibition, notably Edwin D. Dodd, Chairman and Chief Executive Officer, and William Niehous, Vice-President, Plastic Products Division, Owens-Illinois; and Dee Hillberry, General Manager, Giralt Laporta SA, who helped speed communications.

The exhibition has been made possible by a generous grant from the American Express Foundation. This funding stems from the American Express Company's commitment to broaden cultural perspectives worldwide. In addition to its grant, American Express has given full staff support to aid the exhibition whenever asked. Our sincere thanks to James D. Robinson III, Chairman and Chief Executive Officer; Stephen S. Halsey, Foundation President; Susan S. Bloom, Director of Cultural Affairs; and Dallas M. Kersey, former Vice-President of Public Affairs and Communication. Also of great assistance were Nina Kaiden Wright, Karen Hughes, and David Resnicow of Ruder & Finn Fine Arts.

Additional support for the exhibition has been provided by the National Endowment for the Humanities, the National Endowment for the Arts, and the Federal Council on the Arts and the Humanities.

Major funding of the Spanish edition of the catalogue and logistical support for the exhibition in Spain has been provided by the Fundación Banco Urquijo.

The catalogue has been produced with the editorial and publishing skills of Betty Childs and Floyd Yearout of New York Graphic Society; we are grateful for their untiring efforts and those of their colleagues, especially copyeditor Michael Brandon. Carl Zahn brought his distinguished talents to the catalogue's design. Frances Smyth, Managing Editor of the National Gallery of Art, has advised on graphics for the exhibition.

At the Toledo Museum, William Hutton, Senior Curator; Patricia Whitesides, Registrar; and Gregory Allgire Smith, Assistant to the Director, must be particularly thanked. We would like also to thank the staff members at the Museo del Prado, the National Gallery of Art, and the Dallas Museum of Fine Arts, who helped to complete countless details.

Finally, we are grateful to the citizens of Toledo, Spain, for sharing the fruits of El Greco's unique genius. We hope this exhibition will deepen public understanding of his singular achievement and of the enlightened city that nurtured it.

FEDERICO SOPEÑA, S. J., *Director*
Museo del Prado

J. CARTER BROWN, *Director*
National Gallery of Art

ROGER MANDLE, *Director*
The Toledo Museum of Art

HARRY S. PARKER III, *Director*
Dallas Museum of Fine Arts

Contents

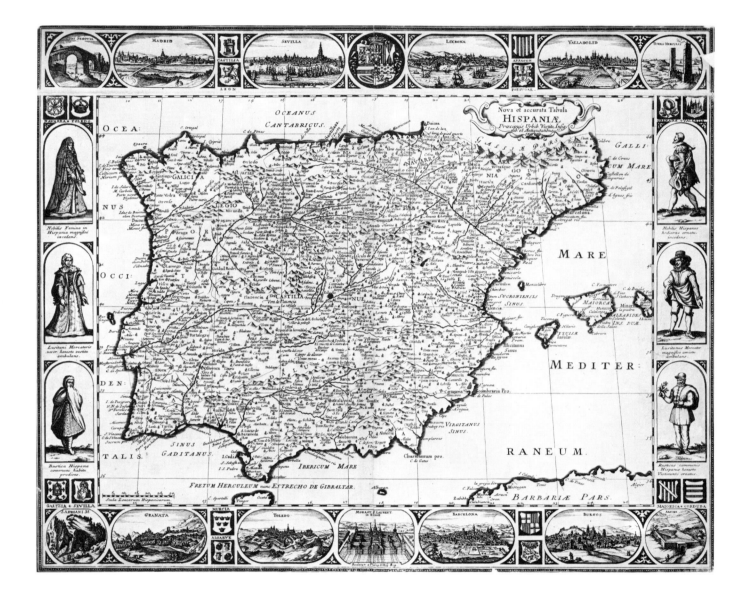

Figure 1. Spain in the early seventeenth century. Toledo is situated in the region known as New Castile (*Castilla la Nueva*). Its central location helped give the city much of its importance.

Chronology: El Greco and His Time

	1541 *El Greco born in Candia, Crete*
Philip II proclaimed king of Spain 1556	
Spanish court moves from Toledo 1561 to Madrid	
Birth of Lope de Vega 1562	
Last session, Council of Trent 1563	
	1564 Death of Michelangelo
	1568 *El Greco in Venice*
	1570 *El Greco arrives in Rome*
Victory of Holy League at Lepanto 1571	
	1576 Death of Titian
Gaspar de Quiroga appointed 1577 archbishop of Toledo	1577 *El Greco arrives in Spain, settles in Toledo*
	1578 *Birth of Jorge Manuel, El Greco's son*
	1579 *Completes the* Disrobing of Christ *and altarpieces for Santo Domingo el Antiguo*
Completion of the Escorial 1582	1582 *Executes* Martyrdom of Saint Maurice
	1586 *Contract for* Burial of the Count of Orgaz
Defeat of the Spanish Armada 1588	
	1589 *El Greco formally becomes citizen of Toledo*
Death of Quiroga 1594	1594 Death of Tintoretto
	1596 *Contract for College of Doña María de Aragón*
	1597 *Contract for Chapel of Saint Joseph*
Death of Philip II; 1598 Philip III proclaimed king of Spain	1598 Birth of Bernini
Bernardo de Sandoval y Rojas 1599 appointed archbishop of Toledo	1599 Birth of Velázquez
	1603 *Contract for Hospital of Charity, Illescas* Peter Paul Rubens visits Spanish court
Publication of *Don Quixote* 1605 (part one)	
	1607 *Contract for Oballe Chapel*
	1608 *Contract for Hospital of Saint John the Baptist*
	1609 Death of Annibale Carracci
	1610 Death of Caravaggio
	1614 *Death of El Greco in Toledo*

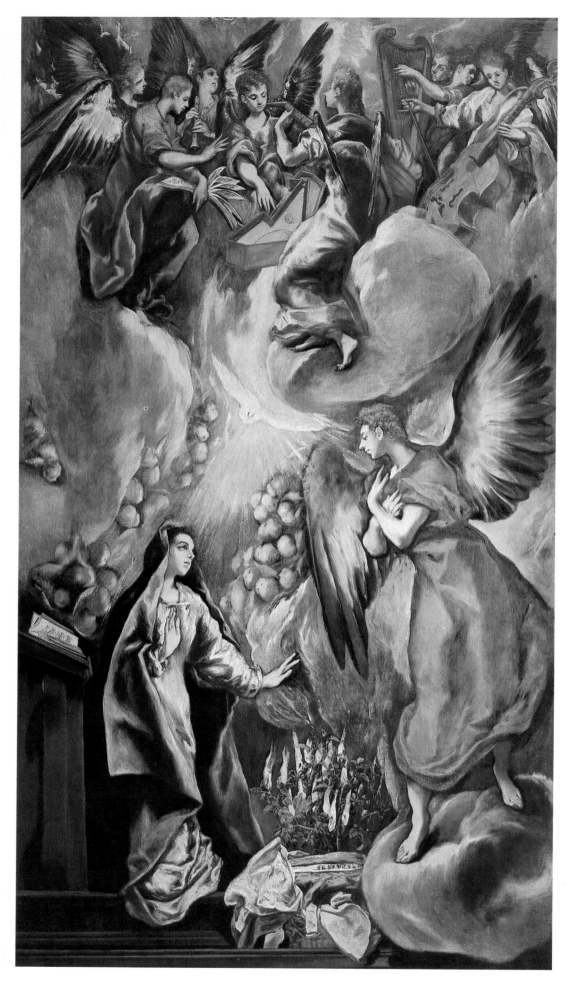

Introduction El Greco, the Man and the Myths

JONATHAN BROWN

Mystic, Mannerist, proto-Modernist. Lunatic, astigmatic. Hispanic, Hellenic. Strange as it seems, this incongruous assortment of labels has been applied to one of the greatest artists of Western civilization, the man we know as El Greco. How is it possible that the image of a painter who died over 350 years ago could be so confused and contradictory?

In large part the answer to this question lies in the history of the changing taste for El Greco's art. During the two and a half centuries following his death, El Greco came to be regarded as a misguided eccentric who merited only a marginal place in the history of art. Then, beginning in the mid-nineteenth century, critics and artists started to rediscover and reinterpret his paintings. The fact that El Greco had been neglected for so many years proved to be an advantage, because it freed him from the weight of established opinion. In a way, he could be recreated in the image of his new admirers, who promptly claimed him as a precursor of ideas that reflected their own concerns, if not those of El Greco. Within the space of a few decades, the transformation of El Greco's reputation was complete, and he had become accepted not only as a great artist but also as a prophet of the ideals and aspirations of the modern era. Our understanding inevitably has been molded by the El Greco revival that began a hundred years ago. Thus, it seems imperative to preface a new interpretation of the artist by carefully considering how the prevailing conceptions of his achievement and reputation came into being.

Perhaps it is best to begin with the historical El Greco, the man who was born, lived, practiced his art, and died in the years between 1541 and 1614. Domenikos Theotokopoulos, as he was named at birth, was born in Candia, the capital of the island of Crete. Since 1204, Crete had been a Venetian possession and a key to the republic's flourishing trade in the eastern Mediterranean. The mercantile, political, and cultural ties between Venice and Crete were therefore close; a sizable colony of Venetians resided in Candia, a sizable colony of Greeks from Crete resided in Venice. But Crete still remained fixed in the orbit of Byzantium and, after the fall of Constantinople to the Turks in 1453, the island became the center of Hellenic culture.

Nothing certain is known of the first twenty-five years of El Greco's life, except that he lived on Crete and became a painter. It can also be surmised from later events in his life that El Greco received a sound education in letters, and that therefore he came from a family of the middle or upper classes, the only ones that could afford to send their children to school.

El Greco's documented existence dates from June 6, 1566, when he signed a document before a Cretan notary public as "*Maistro Menegos Theotokopoulos, sgourafos*," or Master Domenikos Theotokopoulos, painter.[1] Later, in December of that year, the fact of his vocation as painter is confirmed by the offer of one of his works for sale in a lottery, a common form of selling pictures at the time.[2] This transaction is the last record we have of El Greco in his native land. When next sighted, on August 18, 1568, he was in Venice, arranging to send some drawings to a Cretan cartographer in Candia.[3] This rather unrevealing document represents all that is known for certain of El Greco's activities in Venice, although the evidence

<PLATE 1 (cat. no. 32). *Annunciation*, 124 x 68½ inches, 1596–1600 (Madrid, Museo del Prado. On loan to Museo Balaguer, Villanueva y Geltrú)

Note: Medium and support of paintings by El Greco are oil and canvas unless otherwise specified. Works by El Greco reproduced without reference to catalogue number are not in the exhibition.

of his earliest known paintings makes it clear that he had come to Venice to develop his talent as a painter.

Just over two years later, El Greco had moved to Rome and made contact with a Croatian miniature painter, Giulio Clovio, who was employed by Cardinal Alessandro Farnese, a powerful member of a powerful family, one of whose members had been Pope Paul III. On November 16, 1570, Clovio wrote a letter to his patron on El Greco's behalf, requesting that the cardinal permit him to occupy a room in his Roman palace until the young artist could find a place to live in the city.[4] Cardinal Farnese appears to have granted the request, but it is not certain how long El Greco continued to reside in the palace.

Only one more unequivocal reference to El Greco's Italian career has been found. On September 18, 1572, he was admitted to the Roman painters' guild, the Academy of Saint Luke.[5] El Greco paid the entrance fee of two scudi and registered as a painter of miniatures. The other traces of his activity are artistic and stylistic and will be interpreted at a later point. But one fact seems to be clear—that El Greco's career in Italy was at best only a mild success. He attracted the patronage of a few, admittedly select, private persons, but failed to earn a major ecclesiastical commission, without which he could not become famous or prosperous. This mild success, which could also be called a partial failure, may have been among the factors that caused him to go to Spain, where he was first recorded on July 2, 1577.[6]

The precise reasons for this now middle-aged artist to abandon Italy for Spain are elusive, but all the theories that explain his departure agree on one point—that he expected to find the significant commissions that had been denied him in Rome. His principal goal may have been to win the patronage of the king, Philip II, who was beginning to enlist painters for one of the largest artistic projects of the sixteenth century, the decoration of the palace and monastery known as the Escorial, then nearing completion some thirty miles north of Madrid. As it turned out, this goal of El Greco's was frustrated, but it appears that he had prepared a secondary position, from which he was able at last to launch a successful career.

During his seven-year stay in Rome, El Greco had made the acquaintance of a Spanish ecclesiastic, a man named Luis de Castilla, whose father Diego was dean of the cathedral chapter at Toledo.[7] By a fortunate coincidence, Diego de Castilla was supervising the construction and decoration of the convent church of Santo Domingo el Antiguo in Toledo just when El Greco arrived in Spain. At the suggestion of Luis, Diego de Castilla decided to commission the artist to paint three altarpieces for the project (fig. 74).[8] Diego may also have intervened to help El Greco obtain another important commission, a painting for the vestiary of the sacristy of the Cathedral of Toledo. The latter work, the *Disrobing of Christ* (pl. 16), was completed in June 1579, and was followed by the completion of the Santo Domingo commission in September. With these brilliant works to his credit, El Greco established the local reputation that would sustain him to the end of his days. After he was definitively rebuffed at court in 1583, as the result of his failure to please the king with his painting of the *Martyrdom of Saint Maurice* (pl. 2), El Greco settled for good in Toledo.[9]

PLATE 2. *Martyrdom of Saint Maurice*, 176 3/8 x 118 1/2 inches, 1580–1582 (El Escorial) >

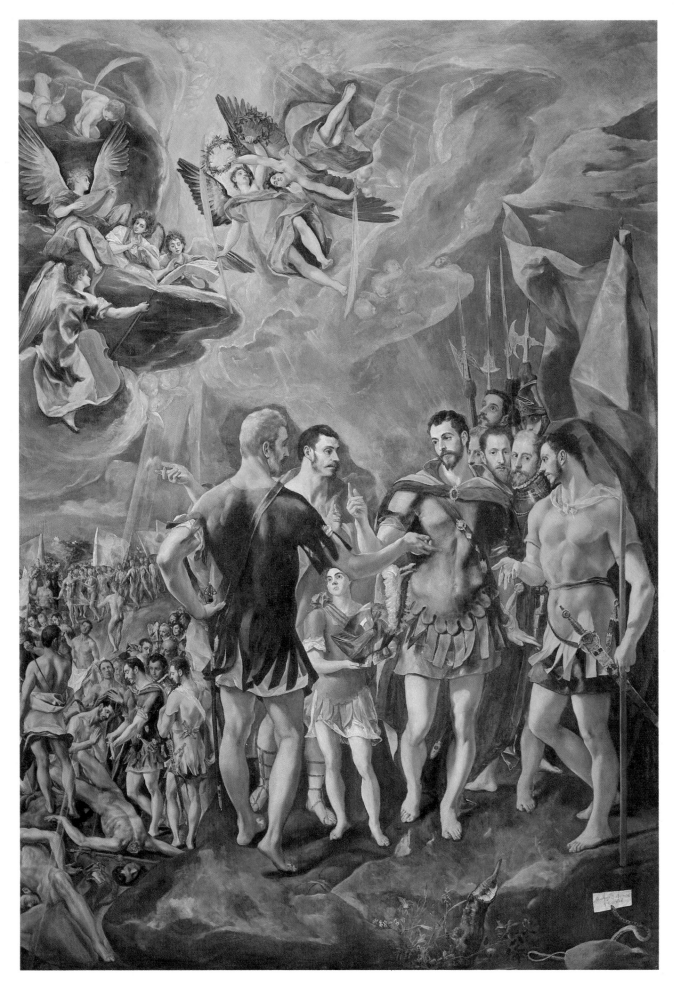

The story of his remaining years can be quickly told. Shortly after his arrival in Toledo, he formed a relationship with a woman named Jerónima de las Cuevas, with whom he lived thereafter.[10] For an unknown reason, they never married, but they did produce a son in 1578, whom El Greco named Jorge Manuel after his father and older brother, respectively.[11] Jorge Manuel was trained as a painter and architect and became his father's partner beginning around 1600.

Information about El Greco's personal life is scanty, and much of it must be extracted from reading between the lines of the abundant documents concerning his commissions and other business affairs. There are also one or two contemporary accounts that provide some insights into his character. And, finally, there have recently been discovered some fragmentary writings by El Greco himself that give invaluable information about his ideas on art, although they are also reticent about his personal life.[12] The documentary sources indicate that El Greco made a good income as a painter, but that he was a poor manager of his finances and therefore was frequently in debt, especially after 1607. Despite this fact, he lived in comfort as a tenant of a large palace in Toledo owned by the marquis of Villena.

El Greco's leisure time was spent more in the company of scholars, poets, and priests than with his fellow artists. He possessed a small library of books in Greek, Italian, and Spanish and worked intermittently on treatises concerning the arts of architecture and painting.[13] He was known for his quick wit and intelligence, and also for his pride and arrogance, which sometimes led to disagreements with his clients about the price of his works. Thus he lived until his death in Toledo in 1614, at the age of seventy-three[14]— except, of course, that all the while he was creating stupendous masterpieces of painting in a style that truly deserves to be called original. It was precisely this quality of genuine, almost unprecedented artistic originality that first plagued and then obsessed viewers of his art over the next three centuries.

To the few of his contemporaries who wrote about his art, El Greco was something of a contradiction and an enigma. His technical mastery could not be doubted, but his style was puzzling because it appeared to be singular, if not unique. Comments therefore usually took the form of grudging admiration, as seen in the remarks of Fray José de Sigüenza, who wrote about the *Martyrdom of Saint Maurice* in his history of the Hieronymite order.[15] Sigüenza's taste in art ran to the naturalistic, and he was also concerned with the clear expression of religious content. On both counts, El Greco failed to measure up to his standards. But nevertheless he had to admit that El Greco had admirers who thought the painting to be artful, who considered its author very knowledgeable, and who found many of his works to be excellent.

The painter-theorist Francisco Pacheco, who visited El Greco at his home in 1611, deftly straddled the fence between censoriousness and approbation.[16] While he could not forgive El Greco's professed disdain for drawing and for its greatest practitioner, Michelangelo, neither could Pacheco bring himself to exclude him from the ranks of the great painters.

By the late seventeenth century, this ambiguous estimation of El Greco began to take a somewhat sharper form, as seen in the brief appraisal of the Aragonese painter Jusepe Martínez.[17] Over fifty years had transpired between El Greco's death and the date when Martínez took up his pen, fifty years during which the writer had seen paintings by some of the greatest Baroque painters in Italy and Spain. In comparison to these works, those of El Greco were starting to look strange indeed—a fact reflected by Martínez's frequent recourse to the words *caprichosa* and *extravagante* to characterize his style. While these words might still have retained a shade of positive meaning for Martínez, they became loaded with disdain when used by critics of the eighteenth century to describe El Greco's work.

The standard text of scorn was composed by Antonio Palomino, a painter better known as a theorist, whose treatise on painting, published in three parts between 1715 and 1724, became the most important source of information on the lives of Spanish painters until it was superseded in 1800. According to Palomino, El Greco's career could be divided into two parts: an early style when he imitated Titian and was a good painter, and a later style when, frustrated because his works were mistaken for those of the Venetian master, he "tried to change his manner, but with such extravagance, that his paintings came to be contemptible and ridiculous, as much for the disjointed drawing as for the unpleasant color."[18] To make the point clear, he coined a phrase that echoed down through the succeeding decades of the eighteenth century and even well into the nineteenth: "What he did well, none did better. And what he did poorly, none did worse."[19]

Needless to say, Neoclassical painters and writers found Palomino's statement much to their taste—a taste that had been formed on the boundless admiration for the cool, normative art of classical antiquity and the High Renaissance. Even so astute a critic as Juan A. Ceán Bermúdez, the founder of modern art history in Spain, was content to retail Palomino's opinion, describing the *Martyrdom of Saint Maurice* with a paraphrase of the earlier source.[20]

Outside of Spain, judgments on El Greco were neither favorable nor unfavorable: they were mostly nonexistent. Virtually all of El Greco's paintings were still in Spain, many in the sometimes inaccessible places for which they were originally intended. The few foreign travelers who took note of Spanish art had little to say of El Greco, unless to translate Palomino into their native tongues.

It was not until the second third of the nineteenth century that a critical revaluation of El Greco began to occur—a reassessment that resulted in a pitched battle between conservatives, who continued to follow Palomino's line, and revisionists, for whom El Greco's unconventional style established him as a great master. The scene for the new appraisal was set by an event as well as a phenomenon. The event was the Napoleonic occupation of Spain (1808–1812), which, among its lesser consequences, brought quantities of Spanish paintings to France as spoils of war. The phenomenon was the Romantic movement, which elevated the exotic and the subjective to the status of important artistic criteria.[21] Selectively searching the past for evidence to buttress their belief in the primacy of emotion over

reason, Romantic writers and artists discovered Spanish religious painting of the sixteenth and seventeenth centuries, first in France among the collections of Napoleon's generals and then in Spain itself. The key figure in promoting the reappraisal of El Greco's art was the poet-critic Théophile Gautier.

Paintings by El Greco had been slow to leave Spain, which meant that a trip to the south was necessary to see them. Gautier made his famous *voyage en Espagne* in 1840, and in his book of this title he formulated his important revision of the value of El Greco's art.[22] Gautier was quite content to accept the prevailing view of El Greco as "extravagant, bizarre," even a little mad. His positive reaction, therefore, did not involve a new perception of the paintings as much as a simple but total reversal of the pejorative connotations of these words. This, however, was a good deal further than most of Gautier's contemporaries were willing to go.

For Sir William Stirling-Maxwell, the Scottish author of the first comprehensive history of Spanish art written in English (1848), El Greco had been "justly described as an artist who alternated between reason and delirium, and displayed his great genius only at lucid intervals."[23] Louis Viardot, an important French art critic, wrote in his influential guide to Spanish museums, published in 1855, that "El Greco was not a great painter," and explained that he was including him in his book because "the talent that goes off course is perhaps no less useful to study than a genius who marches straight to his goal."[24]

Clearly the fight to establish El Greco's place in the pantheon of great artists would not be won overnight. But in the middle years of the nineteenth century, the small band of El Greco's admirers enlisted some important new recruits. Among them was the painter Edouard Manet. In his admiration for El Greco, Manet was in fact following the examples of Delacroix and J. F. Millet, both of whom had owned authentic paintings by the Spanish master.[25] But by the time Manet discovered El Greco, there was a growing body of critical opinion that, for the first time, was seeing El Greco without the prejudices of the past.

The new critics had their own reasons for admiring El Greco, however. In the 1860s advanced artists and writers were seeking ways to renovate and rejuvenate the art of painting, which, they believed, had been reduced to a trivial, hollow mockery of the classical tradition by the teachings and practices of the French Academy of Fine Arts. As part of this new program, they began to scour the past for great artists who had worked outside the classical or academic tradition. El Greco was obviously as good a candidate for this distinction as any to be found. Therefore, as early in his career as 1864, Manet used a work by El Greco as a model for his picture *Dead Christ with Angels* (now in the Metropolitan Museum of Art).[26]

Manet's attention had been directed to El Greco by his friend Zacharie Astruc, the critic and artist, who had visited Toledo early in 1864.[27] Thus, when Manet went to Spain in the summer of the following year, he made it a point to travel to Toledo to study paintings by El Greco, more of which were, still, to be seen there than anywhere else. As is well known, Manet was most impressed by the work of Velázquez, but he also singled out El Greco for praise. More important, by dint of the audacious, original

paintings he executed after his return, Manet played a major role in accustoming the artistic public to accept an alternative, nonacademic style of painting, which helped to make it easier to admire and understand El Greco in different terms.

By 1869, then, it had become possible to defend El Greco against the traditional critics. In that very year, an important French authority on Spanish art, Paul Lefort, praised El Greco in an influential book on the history of painting.

> El Greco was not the madman nor the excessive original that people have thought him to be. He was an audacious, enthusiastic colorist, perhaps too fond of strange juxtapositions and unusual tones, who, piling boldness on top of boldness, finally managed first to subordinate, then to sacrifice everything in his search for effects. Despite his mistakes, El Greco can only be considered as a great painter.[28]

Lefort's emphasis on the effects rather than the techniques of painting, his willingness to subordinate artistic rules to artistic impact, mark him as a man of his time. More important, he represented a point of view that opened the way to seeing El Greco's unusual style as the work of a genius, not of a lunatic who had experienced only occasional lucid intervals.

The battle for the rehabilitation of El Greco's reputation was now close to being won. True, the rear guard fought on, but in a losing cause. As great a scholar as the German Carl Justi, otherwise so profound in his understanding of Spanish art, found it hard to come to terms with the eccentricities of El Greco. His critical remarks, made in the preface to the 1908 reprint edition of his pioneering scholarly study of El Greco first published in 1897–1898, indicate that El Greco's works had engaged Justi's mind but not his heart. "Launched on his career by a pathological problem, pushed by fortune to follow an ever rockier road, [El Greco] represents the most monumental example of artistic degeneration, an unequaled case in the history of art. This undoubtedly accounts for the astonishing admiration and even the reverence that he has inspired in our time."[29] Justi's statement is revealing because it shows how the taste for modern art, which he obviously disliked, and for El Greco were part of the same aesthetic. His statement also suggests that by the beginning of the twentieth century El Greco's admirers had carried the day.

During the last thirty years of the nineteenth century, then, avant-garde artists and critics had succeeded in arousing an ever-growing admiration and enthusiasm for El Greco. Having accomplished the difficult task of moving El Greco from the periphery to the center of artistic interest, they stepped aside momentarily to make way for the scholars who, cautious as always, now felt it safe to begin to study the artist in a scientific manner. At this point, the scene of activity shifts from France to El Greco's adopted home of Spain.

Spanish writers and cognoscenti of the earlier nineteenth century by no means had been entirely hostile or indifferent to El Greco.[30] But the turning point for the admiration of El Greco in Spain appears to postdate the revival of his fortunes in France. It is generally agreed that this can be dated to 1886, when Manuel B. Cossío, soon to be a major figure in the

history of El Greco studies, published an enthusiastic, informed appraisal of the artist in a popular encyclopedia.[31] A few years later, a group of young Spanish artists living in Paris were caught up in the growing French enthusiasm for El Greco and adopted him as their "patron saint." Around 1894, the painter Santiago Rúsiñol acquired two authentic paintings by El Greco in Paris and, on November 14, brought them to his house in Sitges, outside Barcelona, in a noisy, triumphant procession.[32] As part of the festivities, a statue of El Greco was erected in a public park in the town, where it still stands. Finally, in 1902, a monographic exhibition was installed at the Prado,[33] a fitting tribute to the acceptance of the artist as a major figure in the history of Spanish art.

One more important monument to El Greco was also created in Spain—the great pioneering study of his life and work by Manuel B. Cossío. Cossío's fame largely rests on his study of El Greco, published in Madrid in 1908.[34] Through patient archival research and judicious connoisseurship, Cossío gave to the world the first serious, reliable, and informative historical account of the artist. His book, now over seventy years old, is still fundamental to the scholarly study of the artist. But Cossío was by no means a dispassionate writer on El Greco. On the contrary, he offered not only new information on the artist, but also a new interpretation, which turned the painter's work into the quintessential expression of the Spanish spirit.

Cossío arrived at this interpretation on the basis of evidence that, superficially, seems unassailable. He began by asking a question of utmost importance: What was the cause of El Greco's original and eccentric style? As he studied the question, Cossío found the clue to an answer by noting the almost miraculous change in El Greco's style that occurred as soon as he arrived in Spain. In his Italian period, El Greco had been a good if rather unexceptional painter, but after his arrival in Spain, he became a great painter. The answer to the question, therefore, obviously lay in Spain and nowhere else.

This hypothesis was reasonable in principle, but the causal factors Cossío identified were emotional rather than rational ones. With great eloquence, he made his point.

"Castile, an austere and harsh place, was for [El Greco] benign because it made him free. Isolated in Castile, he forgets rules and abandons his teachers, he gathers his forces unto himself and becomes intimate with the spirit and nature of the region, he immerses himself deeply in them yet also allows them to penetrate his soul. Finally, he takes possession of the character of the land and of the Spanish soul; he borrows from them the elements that vibrate in harmony with his singular temperament—the violence, the dignity, the exaltation, the sorrow, the mysticism, the intimate reality, the ash-gray, reddish monotony [of the landscape]—and after a rapid, inevitable assimilation, he comes to form an original, eternal style, and finds a path he can call his own.... El Greco is the most authentic [castizo] of the Spanish painters, infusing his heroes with a [Spanish] sadness at exactly the same time when Cervantes was forging his eternally authentic "Knight of the Woeful Countenance [Don Quixote]."[35]

Cossío's interpretation of the sources and nature of El Greco's genius eventually became accepted as true, and it is therefore important to discover how he came to formulate his theory. First, it should be said that the theory was truly novel. No one before Cossío had paid much attention to the question of nationality in the development of El Greco's art. But Cossío was living and working at a time when enlightened Spaniards had become conscious of the intellectual and moral stagnation of their country and were seeking ways to revitalize their nation.

During the 1860s, Professor Julián Sanz del Río introduced into Spain the philosophy of K. C. F. Krause, a minor German disciple of Kant. Krausism was a form of liberal Catholicism that among other aims sought to intensify the intellectual connections between Spain and the rest of Europe as a means of regenerating Spanish education and culture. Although its aims were not political, Krausism aroused the hostility of conservative segments of society, who perceived that its ideals of intellectual tolerance did not favor their interests. Thus, in 1875, following the restoration of the Bourbon monarchy, the government dismissed professors of Krausist persuasion from their university posts.

In reaction to this, an alternative private institution of learning was founded in Madrid under the leadership of Francisco Giner de los Ríos, a follower of Julián Sanz; it was called the Institución Libre de Enseñanza.[36] In the inaugural address of the Institución, given in 1880, Giner specifically stressed the "need to redeem our [national] spirit," a need that became a cornerstone of the curriculum. As interpreted by Giner, the call to redemption was intended to give Spaniards the confidence to assimilate foreign ideas by applying them to the needs of Spain without sacrificing traditional qualities that had helped to shape the national character in a positive way.

During the closing decades of the century, the Institución Libre de Enseñanza exercised a profound and beneficial influence on Spanish intellectual life — an influence felt by an important group of writers and philosophers later known as the Generation of 1898.[37] Although these men were diverse in their talents and interests, they all acknowledged a great debt to the enlightened example of the Institución. A key piece of writing by a leading member of the group, the philosopher Miguel de Unamuno — entitled "En torno al casticismo" ("On Authentic Tradition") and published in 1895 — set out to define the nature and importance of *lo castizo*, the undeniably authentic elements of the Spanish tradition, as a basis upon which European ideas and methods could be built.[38] One of the points Unamuno raised in this long, complex essay was that art is an excellent gauge of the national spirit. The point was reiterated by another member of the Generation of 1898, Pío Baroja, who drew a distinction between art and science as indicators of national character. Science, he said, was in essence universal, but art was always national, even though it could on occasion attain universality.[39]

Against this background, however quickly sketched, it becomes possible to see how Cossío came to forge the link between El Greco and the Spanish national character. Imbued with the ideals of the Institución Libre, of which he was an original member and later director, it was almost inevitable that Cossío would come to associate El Greco's artistic transformation

with the eternal values of Spanish culture and history that he was teaching to his students.[40]

There was one more crucial element in Cossío's interpretation of El Greco, also inspired by the search for *casticismo*; this was the connection between El Greco and the Spanish mystics of his time. Here again, Cossío was an innovator, for no one had previously thought to connect the painter with the religious visionaries and writers who were his contemporaries, notably Saint Theresa of Avila and Saint John of the Cross. Yet, given the circumstances of Cossío's world, there was an inevitable logic to the idea, because the mystics were regarded as among the most important manifestations of the unique Spanish spirit. Thus, when Cossío came to discuss El Greco's great painting the *Burial of the Count of Orgaz* (pl. 3; figs. 61, 68), this is how he explained its transcendental meaning:

> The subject is not in itself mystical, but merely religious.... But what is mystical is the interpretation, in the most real and direct sense of mysticism, because every element in the painting, notwithstanding the transparent realism, is treated mysteriously, ecstatically, and devoutly. And not only is there mysticism, but Castilian mysticism, because, starting with the funereal story of purely local interest... and ending with the murky, hidden background, all is inward, intimate, serious, sad. All is inward-looking, all is essentially commonplace, and the corpse, the saints, the monks, the priests, and the gentlemen all appear as if enclosed in their "inner dwelling" and rejoicing in it.[41]

The eloquence of Cossío's language was perfectly suited to express a poetical idea that gave the impression of being historically valid. But this idea, born of a profound spiritual crisis in Spain, was expressive only of that crisis and therefore fundamentally irrelevant to understanding El Greco.

Whatever the merits of Cossío's interpretation of El Greco's genius, it soon acquired the status of doctrine, especially in Spain, where an important event unexpectedly played a part in promoting the idea. This event was dramatic indeed: the Spanish-American War of 1898, which cost Spain the last vestiges of her overseas empire. The realization that the days of glory were truly at an end, that the country was now little more than a poor, scientifically backward, powerless European state, made a profound and depressing impression on the intellectual leaders of Spain—the very men who were soon, as a sign of their identification with this national crisis, to be known as the Generation of 1898. The effect of this final defeat on them was overwhelming, forever deflating their optimism and turning their hopes for national regeneration to ashes. One student of the period has described the change of attitude in this way:

> One by one, Ganivet, Unamuno, Azorín and Maeztú either renounced the Europeanizing ideal and practical reforms in favor of a *Volksgeist* mystique in which regeneration was to come from within, from the *alma española* operating at a spiritual level, or else subordinated the former to the latter.... It must be categorically stated that this reinterpretation was decidedly reactionary. It diverted attention from concrete national needs. Secondly, it led, through a scrutiny of the nation's sup-

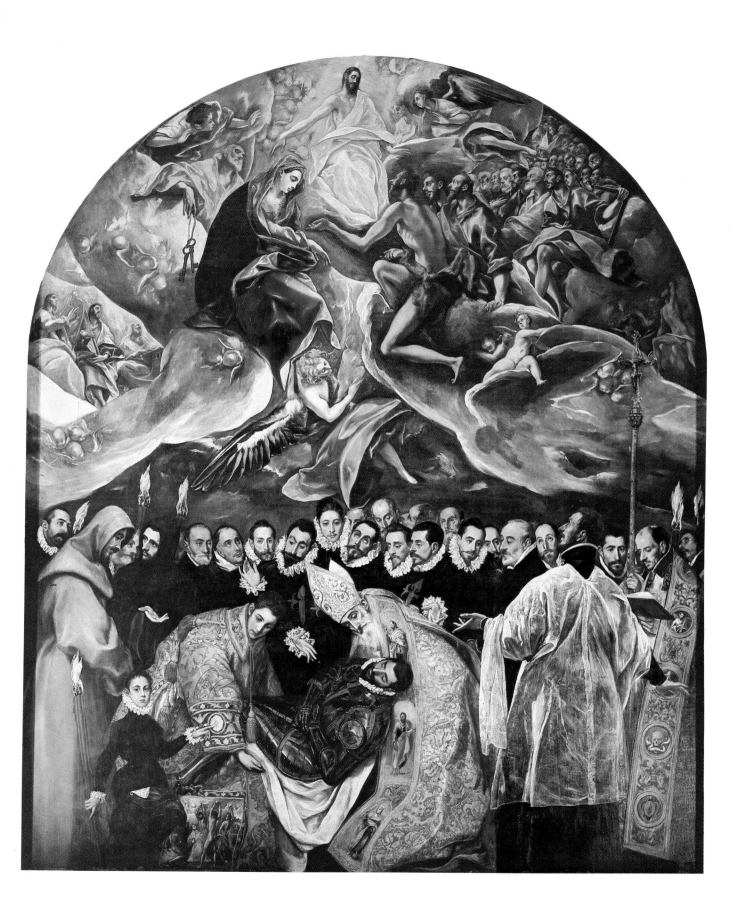

PLATE 3. *Burial of the Count of Orgaz*,
189 x 141³/₄ inches, 1586–1588 (Toledo,
Santo Tomé)

posed cultural tradition, to theories of racial and historical determinism founded on myths and emotionally-charged assumptions.[42]

The impact of this attitude unavoidably left its mark on subsequent Spanish versions of Cossío's myth of El Greco, which soon became pervaded by an unattractive and defensive nationalism. The repeated, at times truculent, insistence on the importance of an abstract ideal of Spanish culture to El Greco's development seriously distorted the understanding of the nature of his art, which was in fact profoundly indebted to Italian sources in ways that are only now being discerned. Finally, the nationalistic claims on El Greco led to an absurd chapter in the history of writing on the artist: the debate over whether his art should be considered as Hispanic or Hellenic. Around 1930 this was a burning issue, enflamed by the claims of an English critic, Robert Byron, that El Greco's style and genius were the result of his Greek heritage.[43] This debate was joined by German, Greek, and Spanish scholars until it mercifully collapsed under the weight of its own pointlessness.[44]

In fairness, it must be said that Cossío, in construing El Greco's art to fit the need of his own circumstances, was hardly unique. During the first third of the twentieth century, El Greco appears to have become all things to all men. Rarely in the history of taste has an artist undergone such a stunning reversal of fortune. After centuries of neglect, he became almost overnight a universally appealing figure. Into the existing vacuum of appreciation rushed all manner of theory to account for what appeared to be an artist without forerunner or follower. The result was a bewildering variety of interpretations, which took years to consolidate.

The most misguided interpretations belong to what might be called the functional school of thought, invented by men of science. Unable or unwilling to grapple with the complexities of El Greco's art, they sought refuge in simplistic theories that attributed his unusual style to what might be called mechanical defects. The most outlandish of these theories, of course, is the one proposed in 1913 by a Spanish ophthalmologist, Dr. Germán Beritens, who apparently believed El Greco to be the one and only painter ever to practice a nonrealistic style and therefore proposed that the distortions of El Greco's art were caused by an optical ailment, astigmatism.[45] Equally untenable was the idea popularized many years later by Dr. Gregorio Marañón that the gaunt and haggard figure types sometimes employed by El Greco in his later years had their origin in the totally imaginary practice of using inmates of Toledo's insane asylum as models.[46] Needless to say, these theories immediately found a place in the folklore of El Greco, where fanciful, colorful, and, above all, simplistic inventions have always been welcomed.

More serious and enlightening were the attempts to hold El Greco up to the mirror of modern art. This was the approach followed in the circle of Manet and his friends in the 1860s, which became more systematic and subtle in the early 1900s. Twentieth-century critics who studied El Greco saw him both as a "proto-Cubist" and a "proto-Expressionist." These contradictory, and to us antithetical, interpretations have their origins in the pioneering theories of abstract art that were beginning to investigate the

possibilities of altering the classical relationship between art and nature. Thus, to the English critic Roger Fry, the great proponent of Cézanne, El Greco was a "singularly pure artist. He expressed his idea with perfect sincerity, with complete indifference to what effect the right expression might have on the public. At no point is there the slightest compromise with the world; the only issue for him is between him and his idea."[47] Fry then went on to explain how El Greco had come to be revered, together with Poussin, as an inspiration for modern artists. "In part this is due to Cézanne's influence.... For Cézanne consciously studied both, taking from Poussin his discretion and the subtlety of his rhythm, and from El Greco his great discovery of the permeation of every part of the design with a uniform and continuous plastic theme."[48]

Fry's interpretation was not destined for a long life, although it contained some profound insights for understanding El Greco's style. Perhaps the theory's subtlety, and, above all, the fact that it defied simple logic (El Greco and Poussin or, for that matter, El Greco and Cézanne, seem unlikely points of comparison) sent it to an early demise. The proto-Expressionist interpretation of El Greco, however, was not burdened with this fatal flaw, because the distortions of reality seen in Expressionist paintings seemed inherently compatible with the distortions of El Greco's style.

One of the earliest examples of writing that interpreted El Greco as a proto-Expressionist came from the pen of Paul Lafond, a prolific French writer on Spanish art. In an article of 1906, he went right to the point.

His work is all passion.... El Greco is a sublime thinker, who by means of imagery has expressed being and states of soul—beings, too, as complicated as we; states of soul as troubled as ours. His work is among the most emotional and captivating that art has produced.... Before these [works] one cannot choose but be caught and troubled by their depth, their nobility, their vivacity of expression, their grandeur. His figures ... shock us like apparitions. His unhealthy tones, running from crude white to absolute black; his harmonies, almost too acute and capricious and jumbled, give a fever, as it were. The master has an indefinable sense of the Invisible Life and what lies beyond; he mingles his figures in a bizarre fashion, which leaves a disquieting obsession.[49]

Lafond's highly charged reaction left its mark on other French writers, notably Maurice Barrès, author of a popular book on El Greco that owes a debt to the essay just cited.[50] But the full conception of El Greco as a proto-Expressionist was to be developed in Germany. Around the years 1910–1912, various German writers, drawing on common sources and, to some extent, on each other, developed an image of El Greco that responded to the needs of the moment.

El Greco was first brought to the attention of the German-speaking world by Julius Meier-Graefe, a leading critic and champion of Post-Impressionism. In 1908 Meier-Graefe had traveled to Spain on a pilgrimage in homage to Velázquez. But, as he informed the readers of his journal of the trip, first published in 1910, the paintings of Velázquez paled beside those of El Greco; Meier-Graefe called his encounter with El Greco's work "probably the greatest experience which could occur to any of us."[51]

By elevating El Greco above Velázquez, then the most revered painter of all, Meier-Graefe promoted a controversy that ensured a wide readership for his book.

Although Meier-Graefe met Cossío in Madrid and talked at length with him about El Greco, he was not convinced that the proposed connection with Spanish mysticism was of much help in understanding the artist. "This Greek," he wrote, "who came from Italy and painted in Spain, without becoming a Spaniard, is wholly European in effect."[52] For Meier-Graefe, El Greco was a precursor of modern art, especially its expressionist strain (although he also detected intimations of Cézanne in El Greco's paintings).

> Personality and tradition signify something different in his case than in that of his contemporaries. They signify rather what they signify for us today. He seems, like Delacroix, not to have inherited, but to have assumed tradition for reasons which are to be found in the psychological conditions of his personality. It is only our age which preserves the possibility of such a genesis for the artist, but it lacks the realization of an El Greco.[53]

In 1911 and 1912 the proto-Expressionist interpretation of El Greco became crystallized in Germany, abetted in no small measure by another crisis of the spirit. Like the spiritual crisis in Spain that had given rise to the mystical interpretation of El Greco, the one in Germany was most deeply experienced by the intelligentsia, notably by a few painters living in Munich. The art of El Greco, it seems, was made for times of turmoil. But the similarity stops there, because the artists of Munich were concerned by what they perceived as the failure of nineteenth-century empiricism, which had succeeded only in producing the moral bankruptcy of capitalistic materialism. The time was at hand, they believed, to renew European society by initiating a spiritual epoch, of which art would be the leading force.[54]

In 1911 these artists, headed by Wassily Kandinsky and Franz Marc, had the chance to see eight paintings by or attributed to El Greco at an exhibition of a private collection in Munich organized by a distinguished art historian sympathetic to their cause, Hugo von Tschudi. Following the lead of von Tschudi and Meier-Graefe, they adopted El Greco as one of their heroes and exalted him in a book they wrote and published in 1912, the famous *Blue Rider Almanac*. In the introduction to this landmark publication, entitled "Spiritual Treasures," Marc made clear his admiration of El Greco.

> We like to emphasize the El Greco case, because the glorification of this great master is very closely connected with the flourishing of our new ideas in art. Cézanne and El Greco are spiritual brothers despite the centuries that separate them. Meier-Graefe and Tschudi triumphantly brought the old mystic El Greco to "Father Cézanne." Today the works of both mark the beginning of a new epoch of painting. In their views of life both felt the *mystical inner construction* [his italics], which is the great problem of our generation.[55]

This passage merits a detailed analysis, but that regrettably must be forgone here. The most important point, however, is Marc's fusion of expressionism with mysticism — a combination he might have gleaned either from Cossío or Meier-Graefe, who made the idea current even while rejecting it. By merging these two potent concepts, Marc predicted, and may even have precipitated, one of the predominant twentieth-century views of El Greco.

The impact of this interpretation was experienced above all in the German-speaking world, which produced the most detailed studies of the supposed relationship between Spanish mysticism and El Greco.[56] Marc's brief but pregnant passage also appears to have been read by Max Dvořák, an influential Czech art historian who taught in Vienna. Dvořák had been developing a theory of art history that interpreted artistic style as a manifestation of the "spirit of the times." One of his major concerns had been the definition of a misunderstood period of sixteenth-century art known as Mannerism. For Dvořák and other art historians in the Germanic world who were studying the period, Mannerism was an art of crisis, the artistic manifestation of a time when the ideals of the Renaissance had crumbled under the impact of the Reformation and when man, once secure in his religious beliefs, had come to doubt his faith. The resulting spiritual anxiety took form in the antirational, anticlassical art of the period from about 1520 to the end of the century.

The concept of Mannerism was developed in the dark days following the end of World War I. Thus when Max Dvořák lectured on El Greco in 1920, the shadow of his own troubled age fell across his words. In terms that clearly echo those of Franz Marc, Dvořák saw El Greco as a mystical, Mannerist painter who would help to show the way to a better world — a world ruled by the spirit and not by matter.

> Today, as in the middle ages and in the period of Mannerism, literature and art have turned once more to the absolutes of the spirit that do not depend on faithfulness to sense perception. In that interrelationship of all experiences which is the secret law of man's fate, everything seems to point toward a new spiritual and anti-materialistic epoch. In the eternal struggle between matter and spirit, the balance inclines toward the victory of the spirit. Thanks to this turn in affairs, we can recognize El Greco as a great artist and a prophetic soul. His fame will shine brightly forth even into the future.[57]

Dvořák, alas, was a greater prophet of artistic taste than of human affairs. But with the posthumous publication of his lecture on El Greco in 1928, as part of a book entitled (in translation) *The History of Art as the History of the Spirit*, the twentieth-century interpretation of the artist became complete. El Greco was now equipped with a set of labels that explained his art to the satisfaction of all interested parties. To Spaniards, he was a cultural hero, the embodiment of their distinctive national religious spirit. To art historians, he was a Mannerist whose subjective art represented a culmination of the anguished temper of his times. To art critics and painters, he was an old master who spoke in a modern idiom.

Fifty years later, the wisdom of these perceptions had filtered into the minds of all art lovers and settled there with the permanence of an established truth—as demonstrated by this evaluation of the artist offered in 1980 by the thirty-ninth President of the United States:

> I think he is the most extraordinary painter that ever came along back then. His paintings now have an atmosphere of mysticism and modernism in that he distorted the tones of the painting, the configuration of the human body, the interrelationship between the landscape and humans in a way to emphasize the points he wanted to make about the character of a person or the character of a scene he was painting. I just think he was maybe three or four centuries ahead of his time, and his paintings have still a remarkable beauty to me.[58]

This spontaneous opinion by an informed if exceptional member of the art-loving public is a faithful echo of the accepted understanding of El Greco as expressed in the relevant section in a standard reference book in English on the subject of Spanish art:

> His realism is of the spirit, not of the flesh. Color, abstraction and dynamic motion are put in the service of a yearning for union with God. This ardent craving was shared by the Spanish mystics of the sixteenth century . . . and explains why Spain suited El Greco and why his art was readily adapted into the mainstream of Spanish art.[59]

These words, written by an acknowledged authority on Spanish art, raise a point of crucial importance—namely, the relationship between the criticism and the scholarship of El Greco's life and art. The quest for historical knowledge about the artist began after the rehabilitation of his reputation had largely been accomplished and, in certain significant respects, was determined by that phenomenon. Subjective ideas influence historical research in many and subtle ways. Perhaps most important is the influence critical appreciation has in defining the goals of scholarly investigation. For instance, if it is believed that El Greco's art was shaped by his contact with the mystics, then it becomes logical to comb their writings in search of texts that will prove the point. The thought that apparent similarities may be only a superficial and misleading coincidence is never seriously entertained. Also, scholars who are looking for one type of evidence may overlook valuable information that does not corroborate their hypotheses. It is possible, of course, for scholarship to take the lead in the interpretative process, but in the case of El Greco it did not happen that way.

The scholarly study of El Greco (like all historical scholarship) has pursued two aims—first, the discovery and classification of data (in this instance, documents and pictures), and second, the interpretation of the collected information. A review of the past seventy-five years of El Greco studies is both rewarding and disappointing. The rewards are found in the formidable amount of information that has been discovered; the disappointment occurs because the interpretations of that information have frequently been colored by preconceptions based on critical appreciation.

Basic research on El Greco first of all has concentrated on defining the

corpus of authentic pictures. Cossío's monograph (1908) was the first of several attempts to establish the canon of El Greco's autograph works. By 1950 two more major catalogues had appeared, each of them accepting more paintings as authentic than had its predecessor.[60] In the last of these, the overly generous catalogue of José Camón Aznar, the number of supposedly authentic paintings had increased by nearly 75 percent over the total listed by Cossío (about 850 versus 498). It was not until 1962 that Harold E. Wethey, in an exemplary monograph, defined a convincing corpus of works that numbered only 285 paintings.[61] The value of Wethey's catalogue is confirmed by the fact that only a handful of pictures has been added to or subtracted from his list during the past twenty years.

Parallel to the classification of paintings has been the equally important labor of archival research, which was conducted principally by three Spanish scholars—Manuel R. Zarco del Valle, Francisco de Borja de San Román, and Verardo García Rey.[62] San Román's contribution in particular was extraordinary; between 1910 and 1941 he published a wealth of documents on El Greco's life in Toledo without which our knowledge would be fragmentary and incomplete.

As a result of all the basic and archival research, the quantity of facts concerning El Greco is now considerable. But the interpreters of the data have tended to accept the myths about El Greco as truths. An important example: nowhere in the copious documentation is there any evidence to suggest that El Greco was in contact with the Spanish mystics, as is commonly asserted. If anything, the documents, when carefully read, disprove the theory by providing ample information about El Greco's true clientele. Nevertheless, only a few scholars have seen fit to question the validity of this putative connection. Paul Guinard, author of one of the best biographies of the artist, voiced his skepticism in no uncertain terms:

> All the parallels so far drawn between passages in the writings of Santa Teresa and El Greco's *Resurrection* and *Pentecost* are not only unconvincing, they are extremely far-fetched. The same is true of the poetic imagery of Saint John of the Cross.... The language of painters is not that of mystics, and the problems conditioning the painter's language lie too far afield, anyhow in this instance, to justify the parallel. Besides, the problems that haunted El Greco fall into a distinctly liberal order of meditation—that of a man of the Renaissance—embracing poetry, science and the purely technical side of the painter's art.[63]

The truth of this observation now seems inescapable. Even before Guinard's book on El Greco appeared in 1956, a small number of important studies of the artist's individual commissions had begun to demonstrate that El Greco operated, with great originality to be sure, within the typical professional framework of the late-sixteenth-century artistic world.[64] These studies, and others that have since appeared,[65] also indicate that El Greco was immersed in the artistic thought and traditions of his time. Recently, the conception of El Greco as an intellectual artist has been confirmed by the sensational discovery of extended comments on art from the pen of El Greco himself. The discoverers of this priceless document,

Fernando Marías and Agustín Bustamante, have convincingly shown that it proves El Greco's belief in the prevailing ideas of Italian sixteenth-century art practice and theory.[66]

The next step in the reinterpretation is the one that we propose to take in this catalogue—a study of El Greco in his world, the world of Toledo, where he lived from 1577 to his death in 1614. The subject of El Greco and Toledo has been studied before, but we believe that our approach is novel in some respects. Most important is its interdisciplinary character. In the first essay, a historian examines the economic, cultural, and social conditions of the city in the waning years of the sixteenth century. The analysis of the economy and institutions of the city, which is based on the author's research in the Toledan archives, makes it possible to understand more thoroughly than before the character of the organizations and personalities that shaped the world of El Greco. The other two essays, written by art historians, are dedicated to studying El Greco's career in Toledo, with the intention of showing how the special conditions of that time and place made it possible for him to develop his rare artistic genius. Chapter 2 is a discussion of the artist's development within the context of his intellectual and professional connections that seeks to demonstrate how they influenced the development of his art and determined the success of his career. The succeeding essay deals with El Greco's commissioned altarpieces, in which the interaction between artist and patron can be closely observed. Last in order, but not in importance, is the catalogue of works in the exhibition. Through generous sponsorship and extraordinary international cooperation, about a quarter of El Greco's extant oeuvre—and a high percentage of his major works—has been assembled in one place for the first time.

In advancing a new interpretation of El Greco, the authors are acutely aware of the risks of the endeavor. The dismantling of myths may seem like an exciting sport, but it is really a dangerous business, for it imposes a responsibility to replace the outmoded myths with new ideas of greater validity. In the case of El Greco, this is an awesome task. The myths about El Greco rescued his art from neglect and gave it life and meaning; this was undoubtedly a great achievement. Furthermore, the myths were built with a passion and sincerity that have continued to stimulate interest in the artist. Regrettably, however, they can no longer sustain the weight of historical evidence. The moment has arrived to try to understand El Greco as a man of his time, not of ours. In carrying out this task, we have tried to eliminate the misconceptions without diminishing the stature of this remarkable painter or the power and subtlety of his art.

NOTES

1. Mertzios (1961), p. 218.
2. Constantoudaki (1975), pp. 296–300.
3. Ibid., pp. 305–307.
4. Ronchini (1865).
5. Martínez de la Peña (1967).
6. Zarco del Valle (1870), p. 591.
7. Vegüe y Goldoni (1926–1927). On the relationship between Luis and Diego de Castilla, see chapter 1, n. 90.
8. García Rey (1932), pp. 23–24; San Román (1910), pp. 129–140; idem (1934).
9. Llaguno y Amirola (1829), vol. 2, p. 349; Zarco Cuevas (1931), pp. 139–142.
10. Gómez Menor (1963–1966).
11. San Román (1927), pp. 143–144; Mertzios (1961), p. 218.
12. Salas (1966), pp. 52–53; idem (1967a); idem (1967b); Marías and Bustamante (1981).
13. San Román (1910), pp. 195–197; idem (1927), pp. 306–309.
14. Foradada y Castán (1876), p. 139.
15. Sigüenza (1923), p. 403.
16. Pacheco (1933), pp. 155, 159.
17. Martínez (1934), p. 75.
18. Palomino (1947), p. 841.
19. Ibid., p. 894.
20. Ceán Bermúdez (1800), vol. 5, p. 5.
21. Lipschutz (1972).
22. Gautier (1878), p. 172.
23. Stirling-Maxwell (1891), vol. 1, p. 339.
24. Viardot (1855), p. 265.
25. Wethey (1962), p. 55, no. 80 (Delacroix); ibid., p. 113, no. 205 (Millet).
26. Leiris (1980), p. 97.
27. Ibid.
28. Lefort (1869), unpaged.
29. Justi (1908), p. 203.
30. Salas (1940–1941); idem (1954).
31. Cossío (1886). For an excellent account of developments in El Greco scholarship in the twentieth century, see Soehner (1956).
32. Lafuente Ferrari (1950), pp. 38–39.
33. Viniegra (1902).
34. Cossío (1908). He was also an innovative educator.
35. Ibid., pp. 538–539.
36. Jiménez-Landi (1959); Cacho Viu (1962).
37. Laín Entralgo (1955); Shaw (1975).
38. Unamuno (1895).
39. Cited by Laín Entralgo (1955), p. 345.
40. For an anecdotal biography of Cossío, see Xiráu (1944).
41. Cossío (1908), pp. 245–246.
42. Shaw (1975), pp. 207–208.
43. Byron (1929); Byron and Rice (1930).
44. For a sample of the debate, see the exchange between Mayer (1929) and Pijoán (1930).
45. Beritens (1913).
46. Marañón (1956a).
47. Fry (1920), p. 137.
48. Ibid., pp. 138–139.
49. Lafond (1906), p. 4.
50. Barrès (1911).
51. Meier-Graefe (1926), p. 128. See also Moffett (1973), pp. 103–107.
52. Meier-Graefe (1926), pp. 136–137.
53. Ibid.
54. Kandinsky and Marc (1974), p. 37.
55. Ibid., p. 59.
56. For instance, see Steinbart (1913) and Hatzfeld (1955).
57. Dvořák (1953), p. 23.
58. Carter (1980), p. 63.
59. Kubler and Soria (1959), p. 216.
60. Legendre and Hartmann (1937); Camón Aznar (1950).
61. Wethey (1962).
62. See respective entries in Bibliography.
63. Guinard (1956), p. 91. Also excellent is the biography by Pita Andrade in Lafuente Ferrari and Pita Andrade (1969).
64. Harris (1938); Blunt (1939–1940); Azcárate (1955).
65. Wittkower (1957); Soehner (1961); Davies (1973); Harris (1974).
66. Marías and Bustamante (1981).

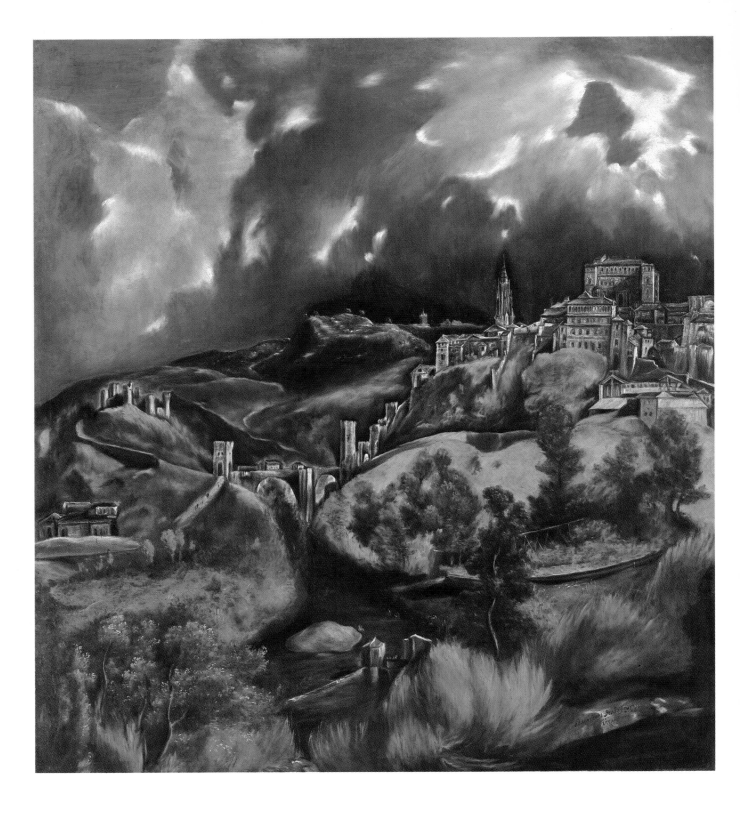

PLATE 4 (cat. no. 35). *View of Toledo*, 47 3/4 x
42 3/4 inches, circa 1600 (New York, The
Metropolitan Museum of Art. Bequest of
Mrs. H. O. Havemeyer 1929, H. O. Havemeyer
Collection)

1 The Toledo of El Greco

RICHARD L. KAGAN

No artist works in a vacuum. The culture, economy, and institutions that surround him, the people he knows—all influence his work, although in ways that are not always easily discernible. If we are to reach a full understanding of the achievement of an artist, we must have an accurate portrait of the world in which he lived. El Greco in Toledo exemplifies what can be learned by studying an artist in his milieu. Just as Titian cannot be separated from Venice, Rubens from Antwerp, Velázquez from Madrid, or Rembrandt from Amsterdam, El Greco and Toledo are one. But our image of the city of El Greco is somewhat cloudy. In the past, the Toledo of El Greco's time has been depicted as a city of decadence and decline, a mystical, intensely religious community given over to the spiritualism of Saint Theresa of Avila. Toledo has also been seen as a mysterious, "oriental" city in which an artist from Crete would immediately feel at home.

These broad and romanticized generalizations about Toledo have done little to enhance our understanding of El Greco. They have, in fact, contributed to some of the rather exotic interpretations of his art that have been outlined in the Introduction. Fortunately, new evidence is now available that allows us to reconstruct the milieu of this artist with greater clarity and precision than previously possible. This information can then be incorporated into a new interpretation of El Greco that portrays him as an artist in touch with the intellectual and spiritual currents of Toledan life rather than as a mystical painter, isolated from the world around him. A brief essay, of course, cannot do justice to such a complex subject, but it can serve as a useful introduction to the city in which El Greco lived and worked from 1577, the year of his arrival in Spain, until his death in 1614.

Toledo: The Economic Background

The state of the economy is relevant to every artist's work. The need to find commissions, patrons, and money to survive is often paramount in his life. This was particularly true in the case of El Greco. After he was finally rejected as a court artist by King Philip II in 1583, he worked in Toledo as an independent artistic entrepreneur, competing openly with other artists for commissions and inviting would-be buyers into his workshop to sample his wares. He was thus vulnerable to the vagaries of the market and sensitive to fluctuations in the local economy. It is useful, therefore, to begin this essay with a brief discussion of the economic setting in which El Greco attempted to carve out a livelihood for himself and his family.

It has long been thought that the Toledo of El Greco was in decline. This idea dates back to the nineteenth century and especially to the work of Antonio Martín Gamero, a Toledan scholar whose *Historia de la ciudad de Toledo*, first published in 1862, remains the only general history of the city. According to Martín Gamero, Toledo was a flourishing city during the Middle Ages because of its close association with the Spanish court. This connection was symbolized in the royal palace, or *alcázar*, one of the city's proudest possessions (fig. 2). But Toledo's fortunes changed abruptly in June 1561, when Philip II, after residing in the city for nearly two years, elected to move his court forty miles north to Madrid. This decision

supposedly spelled Toledo's ruin. "Our city," wrote Martín Gamero, "its career ended, stopped existing as a great city; it lost all of its influence with the crown and ceased hoping to receive from its rays the warmth that animates the dead."[1] The later history of Toledo, a city supposedly deprived of its lifeblood, was interpreted by the historian as an immediate and catastrophic decline—expressed in terms of depopulation, economic collapse, and cultural stagnation. Moreover, this view was picked up by other scholars, particularly by art historians interested in El Greco. Subsequently, this image of Toledo has remained practically unchallenged.

Although the image contains some elements of truth, it is based on a serious misrepresentation of the city's relationship with the royal court. The Spanish court in the Middle Ages was constantly moving; there was no traditional capital like London or Paris. Toledo's central location and the prestige of its powerful archbishop made it a favorite stopping place for royal travelers (see map, p. 12). Kings in the fourteenth century had even appropriated one of the chapels in the cathedral for use as a royal pantheon. Beyond this, the city had no special relationship with the monarchy, although it claimed to have been the Imperial City, capital of Spain under the Visigoths. In actuality, Toledo's relationship with the court was somewhat ambivalent. Although the city council often referred to Toledo as "His Majesty's Most Faithful and Noble City," the king might not have considered it a vassal he could trust. In 1519, for example, Toledo was a leader in the famous revolt of the Comuneros against Charles V.

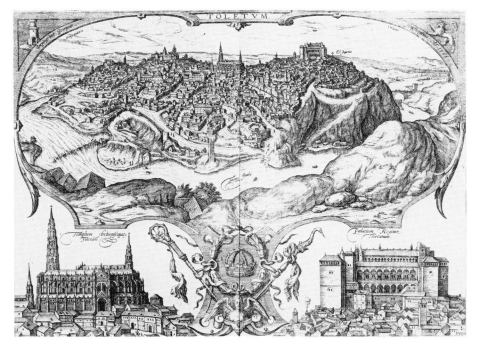

Figure 2. Joris Hoefnagel. *View of Toledo*, 1566 (from Georg Braun and Franz Hogenberg's *Civitates orbis terrarum* [Cologne, 1576–1618]). Insets depict the royal palace (*alcázar*), at lower right, and the cathedral, at lower left. The city itself is surrounded on three sides by the Tagus River.

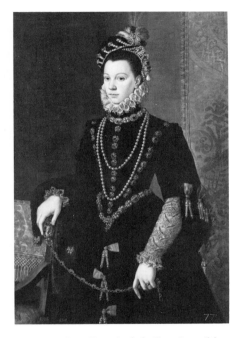

Figure 3. Juan Pantoja de la Cruz (possibly after Alonso Sánchez Coello). *Isabel de Valois*, 1604–1608, copy of a lost original of circa 1560 (Madrid, Museo del Prado). Isabel, queen of Spain from 1560 to 1568, was ill during much of her visit to Toledo in 1560, which may explain why she described the city to her mother, Catherine de Médicis, as "one of the most disagreeable places in the world."

Nor were the city's later relations with the court always smooth. In November of 1559 Philip came to Toledo accompanied by Don John of Austria (his illegitimate brother), the duke of Parma, and the rest of the royal court. Three months later, immediately following her marriage to Philip in Guadalajara, the new queen, Isabel de Valois (fig. 3), arrived. In her honor the city provided a costly and elaborate welcome, including bullfights, gypsy dances, mock battles, and other chivalric entertainments. But shortly after the celebrations, which lasted for several weeks, were over, the complaints began. The courtiers criticized the city for its lack of housing suitable for distinguished ambassadors and noblemen, for the shortage of water, good food, and other amenities to which they were accustomed, as well as for the "excessive heat" of the Toledan summer.[2] For their part, local residents discovered that the court seriously disrupted the city's routine. Churchmen expressed concern about the sin and corruption that the courtiers brought to a city formerly so sober that it was said to resemble "a continuous Holy Week."[3] And according to Sebastián de Horozco, a cleric turned chronicler, residents of Toledo did little except grumble about the high prices and shortages of food and housing that followed in the wake of the court's arrival. A long poem Horozco addressed to a friend began:

> We are so fed up with battling this court,
> That I don't know who can tell you
> How we are getting on without mentioning that
> Our lives are being cut short.
> We wait every day for the court to leave
> Because the cost of living is such that
> If it stays on here, we will all be ruined.[4]

Horozco may have believed Toledo would be better off with the court as far away as possible, but it was apparently not a view shared by all his fellow citizens. Members of the city council, for example, considered the king's move to nearby Madrid a serious threat to Toledo's reputation and prestige.

What is certain is that the court's transfer to Madrid did not affect Toledo as quickly as was once believed. Prior to the court's arrival Toledo was enjoying a period of relative prosperity. Population was rising and by 1560 it was a crowded city of almost 60,000 inhabitants, one of the largest in sixteenth-century Spain (fig. 4).[5] Even after the court left, however, the city continued to grow; by 1571 its population had reached at least 62,000. And Toledo was a cosmopolitan city; Luis Hurtado de Toledo, a local cleric, remarked: "To walk through Toledo is to walk through the world, because there you will find people of all nations, provinces, professions, crafts, walks of life, and languages. It is the center and heart of Spain and therefore of the world."[6] Yet by the time these words were written, in 1576, the city's population had begun to ebb. A census compiled in 1591 indicates that it had dropped to around 57,000, a figure slightly below that of previous decades but one that reveals that the city was not seriously affected

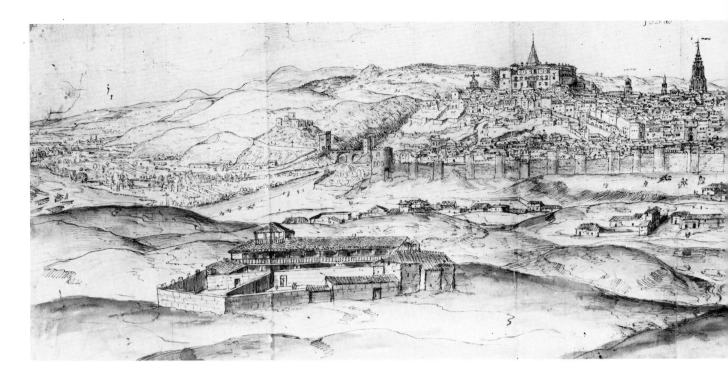

by the loss of the court. Although Toledo would continue to lose population in the years ahead, this reversal in the city's fortunes was only partly the result of Philip's decision to move to Madrid.

The last quarter of the sixteenth century was the great age of Spain's empire in Europe and in America. Philip II (fig. 5), its monarch from 1556 to his death in 1598, was the strongest ruler in Christendom. Yet for the cities of Spain this epoch was not especially propitious, particularly for those located, like Toledo, in Castile. In this region crop failures, food shortages, and plagues turned growth into stagnation, and in the case of some cities—Burgos, for example—into outright decline. Toledo weathered these calamities better than many of its neighbors, but it could not escape completely. The year El Greco arrived in the city, 1577, heralded the beginning of a two-year food crisis that was one of the worst in Toledo's recorded history. The resulting hunger and illness do not appear to have affected El Greco, but the general conditions may have; in 1579 the agents representing him in a dispute over the value of the *Disrobing of Christ* (pl. 16), a painting he had just completed for the cathedral, specifically alluded to "the misery of the times."[7]

The decade of the 1580s brought additional hardships. Toledo prided itself on its charity, but its welfare system was put to the supreme test as thousands of *moriscos*—remnants of Spain's Moorish population—were forcibly resettled in the city on the orders of the king. They were followed by an influx of peasants—refugees from the hunger in the countryside—who streamed into Toledo in search of food, shelter, and medical care. The city responded generously. Additional beds were set up in its hospitals, food was distributed, and the charitable archbishop, Gaspar de Quiroga, distributed alms on a regular basis. These were, of course, emergency measures, but by working together municipal authorities and the church enabled Toledo to escape the sharp losses in population experienced by cities farther north.

The best explanation for Toledo's relative success in combating the effects of famine and disease is economic. Whereas the economy of cities like Burgos and Segovia had begun to decay, Toledo remained relatively prosperous throughout the latter part of the sixteenth century. The famous Toledan swords were still produced, but the manufacture of textiles was the basis of the local economy. Toledan looms specialized in luxury

Figure 4. Anton van den Wyngaerde. *View of Toledo*, 1563 (Vienna, National-Bibliothek). This view—rare in that it depicts Toledo from the north—highlights the city's principal monuments as well as its walls, portions of which are still standing. Prominent on the skyline are the *alcázar*, on the left; the cathedral, in the center; and the magnificent town residence of the royal secretary, Francisco de Vargas, on the right. In the foreground at right is the Hospital of Saint John the Baptist.

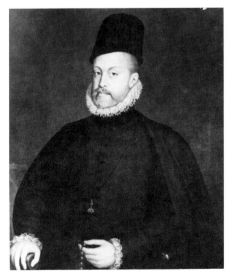

Figure 5. Alonso Sánchez Coello [?]. *Philip II*, circa 1575 (Madrid, Museo del Prado). King of Spain from 1556 to 1598, Philip was Europe's most powerful ruler, master of an empire that stretched round the world.

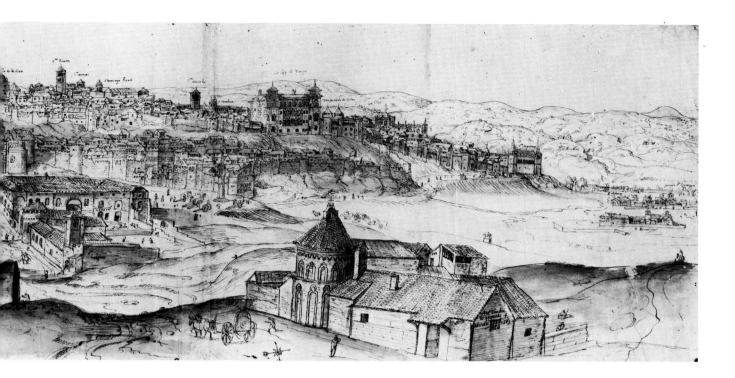

items, especially fine silks, taffetas, and high-quality linens, some of which were exported to foreign markets. The importance of this industry cannot be underestimated. Toledo is known for its churchmen and its nobles, but in 1575 it was estimated that one-third of the population was comprised of workers and artisans who depended, directly or indirectly, on the "manufacture of silks and cloths."[8] Some thirty years later, in a letter addressed to King Philip III, the city council was still emphasizing that "the principal profit of its citizens comes from the manufacture of silk."[9] Much of the city's wealth, therefore, was concentrated in a small but relatively prosperous merchant class whose fortunes were often derived from the manufacture and sale of cloth.

Unfortunately, the history of the Toledan textile industry has not yet been studied in great detail, but most evidence suggests that the period immediately following the exodus of the court was not one of economic stagnation. If anything, the opposite was true. Market taxes, a relatively good index of the health of the local economy, continued to rise until after 1600, although at a somewhat slower rate than that for the early part of the century. According to tax records, the first indication of weakness in the local economy does not appear much before the second and third decades of the seventeenth century—that is, long after Philip II abandoned Toledo for Madrid.[10]

On the other hand, Toledo's resistance to the forces undermining Spain's domestic economy was not inexhaustible. Signs of future trouble appeared as early as 1581, when certain members of the city's government protested that excessive royal taxation was threatening to destroy all of Toledo's trade; another petition, in 1583, informed the monarch that his punishing taxation was the reason why "four or five thousand Toledans, men of commerce and trade," had left the city to seek their fortunes elsewhere.[11] The accuracy of the Toledans' statements is open to question, but there is little doubt that Toledo's economy was already being affected by the same ailments that had weakened Spain's other industrial cities. These included uncertain supplies of raw materials, such as silk; lack of investment capital as merchants invested in land and government bonds in an effort to avoid high taxes on industry and trade; rising labor costs; and, finally, competition from the producers of cheap but high-quality textiles manufactured abroad.

By the opening of the seventeenth century, the accumulated damage caused by these multiple ailments was beginning to show. The city's once prosperous hat industry was said to be "practically ruined"; the cloth industry was said to be "almost dead."[12] Again, the accuracy of these statements may be questioned, but the increased emigration of Toledans to other cities, principally Madrid, was a sure sign of difficulty. What had begun as a trickle of emigrants in the 1580s developed into a flood. In 1621 Juan Belluga de Moncada, one of the city's parish representatives, estimated that in the years since 1606 more than 6,000 Toledans had left for Madrid.[13] The exodus consisted primarily of unemployed artisans and textile workers, but a report prepared by city authorities in 1611 indicated that some of Toledo's most illustrious nobles had also left, obviously preferring life at court to that in the provinces.[14]

The continuing migration of Toledans to Madrid in the early part of the seventeenth century suggests that the local economy had finally entered a period of crisis. Even then, the situation was not nearly as bad as previous generations of historians have believed. Their evidence was derived from a series of petitions prepared by the citizens of Toledo for the benefit of Philip III, beginning in 1618. As these petitions were intended to persuade the monarchy that the time had come to help Toledo toward economic recovery, they painted an exceedingly bleak picture. One of the city councillors asserted that Toledo was suffering from a "disease" that could only be cured by a strong medicine administered by the central government.[15] Other petitions referred to abandoned, crumbling houses, closed shops, and streets that had been emptied of their inhabitants. In sharp contrast, however, to those Toledans who described their city as moribund is the report sent in 1619 to the president of the Royal Council of Castile by Martín González de Cellorigo, a native of Burgos:

> As the voice of desolation in this city [Toledo] has sounded so frequently, I understand that Your Excellency finds its situation to be unique. But I have personally found it quite different from what has been described to you and the Royal Council. Although in previous years it enjoyed greater prosperity, the general decline from which the kingdom is suffering has affected Toledo less than any other place. Its streets are filled with people, the houses are occupied, the buildings well maintained, and everything very well kept up. Our city of Burgos would consider itself lucky to have one tenth as much.[16]

Although Cellorigo's report may have been overly optimistic, the rhythm of Toledo's economy suggests that the city was much better off than its citizens were prepared to admit. What is interesting, however, is that in the decades following this report, Toledo's economy appears finally to have deteriorated to the point the petitions had anticipated. A census completed in 1646 indicated that the city had fewer than 25,000 inhabitants, less than half as many as in 1591. The decline of Toledo therefore appears to have occurred primarily in the years following El Greco's death in 1614. Toledo during his lifetime is perhaps best described as a relatively prosperous city that was gradually edging its way into crisis.

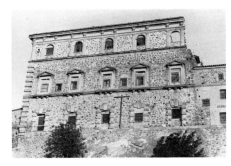

Figure 6. The Casa de la Cerda (built 1567–1577), one of the many townhouses built by the nobility in Toledo during the second half of the sixteenth century.

Toledo: The Imperial City

Though its future may have been bleak, the Toledo of El Greco was not a city whose economy had collapsed. It had, for example, sufficient resources to allow citizens to build or remodel houses, establish new chapels and monasteries, and to commission new works of art. Even more impressive was the city's ability to initiate a massive building program that was designed to restore some of the prestige lost when Philip II moved to Madrid. Horozco and other churchmen may have been critical of the court, but most of the merchants and nobles in charge of local government recognized that the free-spending courtiers had benefited the local economy. Consequently, they attempted to persuade the king to honor the city by returning with his court, and they joined in efforts to make Toledo more attractive to him.

Pedro de Alcocer's *Historia o descripción de la imperial ciudad de Toledo,* published in 1554, had reminded Toledans that their city was the *civitas regia*—the imperial city—traditional home of the royal court. Although Alcocer's interpretation of Toledo's history was far from accurate, the idea of Toledo as Spain's eternal capital appeared constantly in later books on the city's history, giving rise to a natural question: If Toledo was the kingdom's capital, why was the king in Madrid? So in 1583 the city council wrote to Philip II, specifically asking him "to come to Toledo with his court for a few years so that [the city] can return to what it used to be and recover from its losses."[17] To make the city more appealing to the king and his court, the city council promoted new construction in a modern design. Already in 1567 an ordinance had been enacted encouraging citizens to build the elegant new townhouses (*casas principales*) that would be needed whenever the court was in Toledo. The council declared the ordinance necessary for "the beauty and elegance of the city as well as for the construction of great and sumptuous buildings, which are the things that ennoble cities and towns."[18] Soon, several new townhouses were under construction, including that of the de la Cerda family, portions of which are still standing today (fig. 6).

A few years later the city embarked on an ambitious building program of its own. The aim was to remove as much of medieval Toledo as possible

Figure 7. Attributed to Joris Hoefnagel. *View of Toledo,* 1574 (from Georg Braun and Franz Hogenberg's *Civitates orbis terrarum* [Cologne, 1576–1618]). Open space was at a premium in densely populated Toledo.

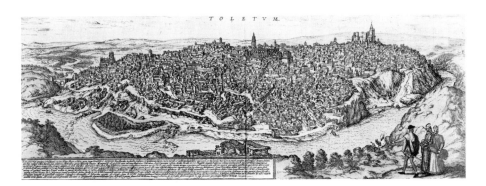

Figure 8. Plan of the Street of Saint Christopher (Toledo, Archivo Municipal). Toledo in the sixteenth century was filled with narrow, twisting streets. The city attempted to straighten and widen some of its principal thoroughfares, including the street shown in this plan; the shaded portions indicate parts of buildings that were to be torn down.

and to build in its place a modern city in an Italian Renaissance idiom. It is difficult to visualize the appearance of Toledo before these renovations were begun, but a few eyewitness descriptions suggest that it was not an attractive place. Andrea Navagero, a Venetian who saw Toledo in 1525, wrote: "The city is uneven and rough; its streets are narrow and it lacks plazas, except for a small one known as Zocodover."[19] Another Venetian, Sigismundo di Cavelli, who visited the city in 1567, had more or less the same impression. His description alluded to the narrowness of the streets, the lack of *piazze*, and the fact that the houses were "very small and sad, the people extremely poor." In his opinion the city's only asset was the cathedral, which he described as "the richest in Christendom."[20] Gregorio de Tovar, a Spaniard who passed through Toledo in 1580, was even more critical:

> I spent only three days there because although I was very much impressed by the cathedral, the site of the city seemed extremely poor. In my judgment it is one of the worst cities in the world because of its hills, narrow streets, darkness, dirt, tiny plaza, lack of water, the mosquitos, the bad manners of its people, and one hundred thousand things more. I am certain that nothing in the world would bring me to live in it.

Compared to the "grandeur and nobility" of Granada and Seville, Toledo was for Tovar an "evil and bewitched city."[21]

These criticisms may be exaggerated, but they do explain why, in the 1570s, the city council began to borrow heavily in order to expedite its plans to modernize and beautify Toledo. In the following years many of its narrow, twisting streets, unsightly reminders of its medieval past, were widened and straightened (fig. 8). The most obtrusive of the city's *cobertizos*, the overhanging galleries that darkened many of its principal thoroughfares, were also demolished so as to admit the light and the air that sixteenth-century physicians considered essential for good health (fig. 9). One of the streets so modernized was *calle de la Chapinería* ("Clog- or Shoemakers' Street"), located in the heart of the city. Previously, it was acknowledged that "the images carried in the processions do not fit [in this street] because its entrance is so narrow that two men cannot pass side by side. It is an ugly and indecent thing for an illustrious city that contains the most important cathedral in Spain to have such a narrow, nasty street lined with buildings so vile that they appear to date from Moorish times."[22]

Large-scale urban projects were also undertaken. Renaissance planners considered broad, symmetrical squares the hallmark of modernity, and Toledo's city council, well aware that its small plazas were out of date, began a concerted effort to correct this deficiency. Although work on enlarging the Plaza de Ayuntamiento, located between the cathedral and the city hall, had begun in the 1550s, most of the remodeling was done in the 1580s and 1590s. The Plaza Mayor, site of the main food markets, was reputedly so small that "when people gathered there to buy, it was so filled up and crowded that nobody, either on foot or on horseback, could pass through." In 1593, therefore, the city council initiated a series of costly reforms designed to give the plaza a "modern, square shape without un-

Figure 9. *Cobertizo* of the Convent of Santo Domingo el Real. *Cobertizos* built over the streets provided additional living space in a growing city, but by the late sixteenth century they were thought to be unsightly as well as unhealthy. Although many were torn down, this one survived.

Figure 10. Plan of the area around the Plaza Mayor (Toledo, Archivo Municipal). Site of Toledo's principal food markets, the Plaza Mayor was too small and too crowded. Beginning in 1593, the city, in cooperation with the cathedral, drew up plans to enlarge it. The shaded portions of the plan indicate parts of buildings that were to be removed in order to make the plaza into a square of Renaissance design.

Figure 11. Plan of the Plaza de Zocodover (Madrid, Archivo Histórico Nacional). Parts of the Zocodover were burned in 1589. The city wanted to remake the plaza as a square but was forced to compromise and wound up with an area that was roughly pentagonal. This eighteenth-century drawing gives an indication of Zocodover's shape following its reconstruction.

even corners or sides [fig. 10]."[23] Zocodover, the principal square in the city, was also given a face-lift, in the wake of a 1589 fire that destroyed one of its facades (fig. 11). This square, the traditional gathering place of Toledo's merchants, doubled as the city's bullring and entertainment center. It was also the site where the local tribunal of the Inquisition staged its autos-da-fé, the elaborate ceremonies in which those convicted of religious crimes were sentenced.

But new streets and new squares were only one facet of the council's grandiose schemes. The city hall, a Gothic structure that dated from the fifteenth century, was replaced with a modern, classically inspired edifice designed in 1574 by the famous architect Juan de Herrera and completed with the help of Jorge Manuel, El Greco's son, in 1618 (fig. 12). Other projects included a new public granary; new markets; a new municipal house of prostitution (the celebrated "House of Venus"); several promenades overlooking the Tagus River; a theater (corral de comedias), the decoration of which was also entrusted to Jorge Manuel; and, most spectacular of all, an ingenio de agua, a machine designed to raise water from the Tagus three hundred feet up to the alcázar, the highest point in the city, for farther distribution (fig. 13). The machine was the creation of Juanelo Turriano, an Italian clockmaker and engineer (fig. 14). Although it never quite lived up to its original expectations and eventually had to be abandoned, the ingenio was regarded as a marvel of engineering and became a major tourist attraction. Don John of Austria—Philip II's illegitimate brother—and France's Cardinal de Guise had admired the machine while it was still under construction in 1569, and the royal chronicler Ambrosio de Morales, who visited Toledo in 1575, described it as "one of the most notable things in the world."[24] Equally impressed was Federico Zuccaro, an Italian artist working at the Escorial, who visited Toledo in 1585. In his opinion Turriano's machine was "truly something of the greatest art, genius, and design," and he ranked it, along with the alcázar and the cathedral, as one of Toledo's principal sights.[25]

Assisting in the city's great enterprise of renovation was the church, particularly the overseers of the cathedral, without whose cooperation many of the city council's projects could not have succeeded. The cathedral itself was an imposing Gothic structure with a high tower that soared far above the rest of the city's buildings, and, as nearly all of the sixteenth-century views of Toledo suggest, dominated the landscape. Although most of this enormous edifice had been built before the end of the fifteenth century, work on various portions continued well into the seventeenth century. In El Greco's time the most ambitious undertaking was the expansion of the sagrario, a complex of rooms containing chapels, a sacristy, vestiary, and a treasury to store the cathedral's incomparable collection of jewels, relics, and other precious objects.[26] These building projects were important not just in architectural terms but also for their part in sustaining a local building trade of considerable importance. It should also be emphasized that the cathedral provided more or less steady employment to what amounted to a small army of artists, glaziers, sculptors, silversmiths, tailors, and other artisans needed to keep its fabric in good repair.

Moreover, as the single largest employer in Toledo, the cathedral had on its regular payroll well over six hundred persons. Among them were fourteen dignitaries, forty canons, fifty prebendaries, over two hundred chaplains, scores of choirboys, and a complement of lay personnel whose jobs ranged from supplying candle wax to keeping watch on visitors to the church. In this respect the cathedral can be likened to a huge engine that continued to pump money into Toledo, even as the rest of the economy began to decay.

Toledo's archbishop, who was easily the richest prelate in the peninsula, played a similar role. His annual rents amounted to well over 200,000 ducats, an enormous sum that not even the wealthiest of Spain's grandees was able to collect. Not all of this money was used for the benefit of Toledo, but it is clear that the city received its share. In 1541, for example, the city's archbishop, Cardinal Juan de Tavera (see cat. no. 65) established the Hospital of Saint John the Baptist, erecting one of the finest Renaissance buildings in the city (fig. 15). Tavera's successor, Juan Martínez de Siliceo, was a less ambitious builder, but still founded two colleges, one of which was expressly intended to train choirboys for service in the cathedral. Gaspar de Quiroga, archbishop from 1577 until his death in 1594, has already been mentioned for his charity. He also spent part of his vast income to help the Jesuits open a new college in Toledo, to found the Augustinian monastery of San Torcuato, and to build for his own enjoyment a country house (*cigarral*) overlooking the city from the other side of the Tagus River. Even after these expenditures, at his death Quiroga left an estate valued at nearly 2,000,000 ducats, one-third of which was donated to pious works, with the remainder being divided equally between the king and the pope.

Bernardo de Sandoval y Rojas (see pl. 10; figs. 29, 30), archbishop from 1599 to 1618, was equally generous. According to one contemporary, the historian Gil González de Avila, this wealthy prelate dispensed 50,000 ducats a year in alms, mostly to beggars who gathered at the door of his palace.[27] He is also remembered for having established a Capuchin monastery in Toledo and for the hundreds of thousands of ducats spent on the decoration of two chapels in the cathedral, one of which was designated as his tomb. But perhaps the greatest legacy left by Sandoval y Rojas was Buenavista, his elegant country house just outside the city, immortalized by Baltasar Eliseo de Medinilla, a local poet of considerable renown.[28] In this retreat, only fragments of which survive, Sandoval y Rojas installed his personal collection of fine paintings and built a garden filled with flowers, fountains, fruit trees, and exotic birds that had been brought to Toledo at his request. In these luxurious surroundings, Sandoval y Rojas patronized a famous literary academy, a gathering attended by Medinilla, Lope de Vega, and other literary figures. In many ways this learned, cultured churchman exemplified the city's efforts to maintain its cultural life despite the forces that were gradually undermining its economy.

The intellectual stagnation generally associated with decadence and decline cannot be found in El Greco's Toledo. The city held on to a small but relatively wealthy group of churchmen, merchants, and nobles who were prepared to extend patronage to poets and painters alike. This patronage, in fact, is the principal reason why Toledo, despite its impending

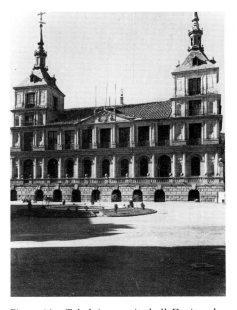

Figure 12. Toledo's new city hall. Designed by Juan de Herrera, this building was begun in the 1570s. Jorge Manuel Theotokopoulos, El Greco's son, redesigned the top stories, which were completed in 1618.

Figure 13. Sketch of Toledo's *ingenio de agua* (Simancas, Archivo General). Built in the 1560s, the *ingenio* was designed to raise water from the Tagus River to the *alcázar*; this drawing depicts its exterior housing. The machinery was said to be so noisy that it was rarely operated at night.

Figure 14. Jacome Trezzo. *Juanelo Turriano* (medal), before 1583 (Madrid, Museo Lázaro Galdiano). Turriano (d. 1583) was the Italian clockmaker who designed Toledo's *ingenio*. He also built a second one in order to increase the amount of water that could be brought to the *alcázar*.

Figure 15. Exterior, Hospital of Saint John the Baptist (also known as the Hospital of Cardinal Tavera). Located north of the city, beyond the city's walls, this hospital, established by Juan de Tavera in 1541, was the largest in Toledo.

economic difficulties, was able not only to support a whole colony of artists, scholars, and intellectuals, but also to remain one of the vital centers of Spanish cultural life.

Town and Gown

It is known that El Greco thought of himself as an intellectual. He is said to have written lengthy treatises on art and architecture, although all that survives of his writings on these subjects are his marginal notes to volumes two and three of Giorgio Vasari's *Lives of the Painters* (1568) and to Daniele Barbaro's edition of Vitruvius's *On Architecture* (Venice, 1556; see fig. 65). El Greco's library of approximately 130 books was small in comparison with that of a professional scholar, but it contained the books a busy artist required: various treatises on art, architecture, anatomy, and perspective; books of engravings of the Escorial, Italy, Rome and other European cities; the Old and New Testament, both in Greek, together with other works on church history, theology, and the saints; a few philosophical treatises, including works by Aristotle and Petrarch; and a number of other books pertaining to classical antiquity.[29] It was, in short, a working library, although it also included books on medicine, poetry, and politics that were less immediately related to the artist's craft. El Greco in this sense was a learned artist who, after having spent more than a decade in Venice and in Rome, was accustomed to associating with scholars, intellectuals, and learned connoisseurs. Toledo could offer him company of a similar kind.

Intellectual life in Toledo was organized in two centers—the university and the cathedral. The University of Saint Catherine, as it was called, established in 1485, cannot be compared with the famous Spanish universities located in Salamanca and Alcalá de Henares, but it was nevertheless an institution of which Toledo could be proud. With a total of twenty chairs distributed among the faculties of law, theology, medicine, and the arts, the university in some years may have enrolled as many as a thousand students. Many of the city's most prominent citizens were graduates, and in the ceremonies and processions that attended holidays and other special occasions, the university occupied a prominent position. For example, when the city gathered in 1587 to receive the remains of Saint Leocadia, a local martyr, chroniclers who witnessed the procession noted the importance accorded to the university's men of letters as opposed to the city's men of arms. They were also pleased that most of the 130 masters and doctors who represented the university were native sons. This, they attested, was proof of "the natural endowments, genius and rare capacity of the Toledan people."[30]

Although many of the scholars attached to the university were known only locally, others enjoyed an international reputation. Alvar Gómez de Castro was already a distinguished humanist at the University of Alcalá de Henares when he came to Toledo in 1548. Professor of Greek at the university until his death in 1580, Gómez de Castro, who was born in the nearby town of Santa Olalla, was described as a "learned and curious man skilled in the antiquities of Spain as well as Toledo."[31] He was in fact something

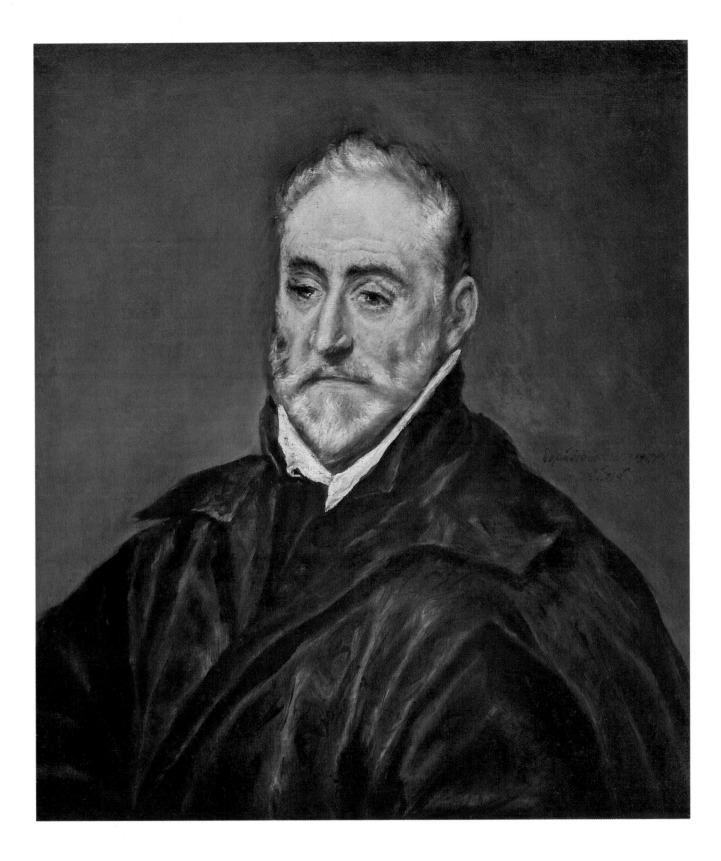

PLATE 5 (cat. no. 61). *Antonio de
Covarrubias*, 25 ⅝ x 20½ inches, circa 1600
(Paris, Musée du Louvre)

46

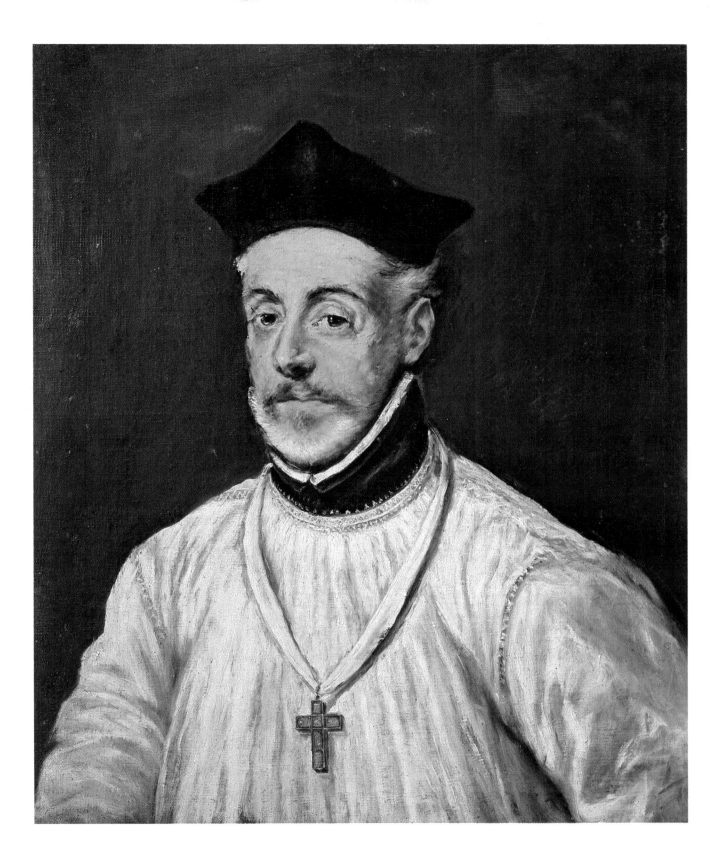

PLATE 6 (cat. no. 62). *Diego de Covarrubias,*
26 ³/₈ x 21 ⁵/₈ inches, circa 1600–1605 (Toledo,
Museo del Greco. Fundaciones Vega-Inclán)

47

of a polymath, learned in Greek and in Latin, an expert in the coins and medals of antiquity, and extremely well versed in history, both ancient and modern. His unpublished notebooks, which included his notes to Vasari's *Lives of the Painters*, suggest that he also had a strong interest in Italian art.[32] It is not known whether he and El Greco ever met, but it is possible. One of Gómez de Castro's closest friends in Toledo was Diego de Castilla, dean of the cathedral chapter and El Greco's first Spanish patron.[33]

Upon Gómez de Castro's death, the university's chair of Greek was assigned to another internationally known scholar, Andreas Schottus (1552–1629). A brilliant young Jesuit originally from Antwerp, Schottus had previously taught at the universities of Douai, Paris, and Louvain. While resident in Toledo, Schottus initially occupied himself with an edition of the works of Saint Isidore, a project that Gómez de Castro had initiated. He then began what eventually proved to be his greatest work of scholarship, an edition of the complete writings of Lucius Annaeus Seneca, first published in Paris in 1604. Although there is no recorded contact between El Greco and Schottus, this scholar collaborated with Antonio de Covarrubias y Leiva, one of El Greco's close friends.[34]

Son of the Toledan architect Alonso de Covarrubias, Antonio de Covarrubias y Leiva (1524–1602) had an older brother named Diego, a distinguished canonist who died in 1577 after serving as one of Philip II's advisers. Antonio, a graduate of the University of Salamanca, began his career as a royal magistrate. In 1563 he attended the final session of the Council of Trent in the company of his brother, and subsequently served as a member of the Royal Council of Castile until growing deafness compelled him to resign. He returned to Toledo in 1581 as *maestrescuela* of the cathedral, an office that gave him control of the university, and served in that capacity until his death. A skilled Hellenist with an interest in history and archaeology, Antonio de Covarrubias was reputed to be one of the most learned men of his time. According to El Greco, he was a veritable genius (the artist called him a "miracle of nature") who possessed "Ciceronian eloquence and elegance" as well as "a perfect knowledge of Greek."[35] El Greco painted his portrait (cat. no. 61; pl. 5) as well as a posthumous one of his brother Diego (cat. no. 62; pl. 6). For his part, Antonio gave El Greco a Greek edition of Xenophon that was in the artist's library at his death.[36]

Covarrubias was especially important to intellectual life in Toledo because he provided an essential link between the university and the city's other great center of learning, the cathedral chapter. The canons appointed to this august body, once referred to as the head of "the principal congregation in all Christendom, outside that of Rome,"[37] were ordinarily nobles of distinguished lineage. But many of them were especially selected because of their scholarly reputation in theology, Bible studies, and church history. Noteworthy in this respect was García de Loaysa Girón (1534–1599), appointed as canon in 1564. A native of Talavera de la Reina, he had studied Latin, Greek, philosophy, and theology at Salamanca and Alcalá de Henares. In 1577 he was named warden (*obrero*), in charge of the cathedral's artistic patronage, and in 1584 he resigned this post to become private almoner and chaplain to the king, two positions of considerable

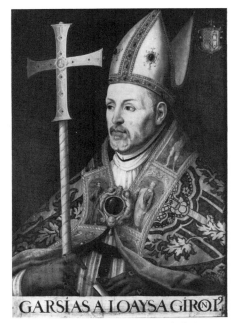

GARSÍAS A LOAYSA GIRO.P.

Figure 16. Luis de Velasco. *García de Loaysa Girón*, 1599 (Toledo, Cathedral Chapter Hall). Author, bibliophile, preacher, and tutor to the future Philip III, Loaysa became archbishop of Toledo just months before his death in 1599.

influence at court. Loaysa also served as principal tutor to the young prince, the future Philip III, and in 1594 the king appointed him acting governor of the archdiocese of Toledo in the absence of the archbishop, Archduke Albert of Austria. Finally, in August 1598, only months before his death, Loaysa himself became archbishop (fig. 16).

This was a remarkable career, and Loaysa appears to have been a remarkable man. As a young canon he had the reputation of being one of Toledo's best preachers. He was, in addition, an expert in church history and in 1593 published an important work dealing with the early history of church councils in Spain.[38] Although he never found time to complete a projected history of Toledo's archbishops, with the help of Francisco de Pisa (1537–1616), professor of Holy Scripture at the university, Loaysa produced a new prayer manual for the use of the Toledan church. His other collaborators included Diego de Castilla, Antonio de Covarrubias, Gómez de Castro, and Schottus, and he was in close touch with Juan de Mariana, the famous Jesuit historian and theologian who lived in Toledo from 1574 until his death in 1624.[39] Another friend was Benito Arias Montano, the famed Hebraist and biblical scholar who was the royal librarian at the Escorial. A lover of books, Loaysa collected a library that numbered over three thousand volumes at the time of his death; it eventually found its way into the royal collection at the Escorial. Loaysa's library contained a wide variety of books in Arabic, Hebrew, and Latin, but his specialty was ancient Greek manuscripts. When he was first in Toledo, he retained two scholars of Greek origin to copy manuscripts he could not purchase. On occasion he even made the copies himself. Loaysa's tastes, however, were not strictly literary. He also had a collection of several hundred paintings, including still lifes and portraits of contemporary figures, among them a "large portrait" of Philip II.[40]

Several of the numerous scholars attached to Toledo's cathedral deserve mention because of their connection to El Greco. One is Juan Bautista Pérez, the learned canon who continued work on the history of Toledo's archbishops begun by Loaysa and who, in 1584, succeeded him in the office of cathedral warden. It was in fact under his supervision that El Greco in 1587 completed the elaborate gilt frame in which the *Disrobing of Christ* was to be hung.[41] Pérez is also important because of his contribution to the reception that accompanied the return of the relics of Saint Leocadia to Toledo in 1587. Aided by Antonio de Covarrubias, Pérez designed a magnificent series of triumphal arches for the occasion. Unfortunately, the original designs of these arches have disappeared, but it is known that they were decorated by several Toledan artists, El Greco included.[42] In recognition of his diverse talents, Philip II, probably at the suggestion of Toledo's archbishop, appointed Pérez bishop of Segorbe in 1589.

Alonso de Villegas (1534–1615), a prebendary (*racionero*) of the cathedral, was another important member of Toledo's scholarly community. Among other works, he wrote a famous compendium of the saints' lives entitled *Flos Sanctorum* (see fig. 22), first published between 1578 and 1589, and subsequently reprinted in numerous editions. El Greco was undoubtedly familiar with this important work, a copy of which was listed in the

1621 inventory of his son's library; but it is not known whether El Greco was personally acquainted with Villegas. In the *Flos Sanctorum* Villegas specifically refers to the artist's *Burial of the Count of Orgaz* (pl. 3) as "one of the finest things to be seen in the city."[43] Yet when Villegas later commissioned an altarpiece for his family chapel, he chose another local artist, Blas de Prado (fig. 17).

Finally, mention should be made of Dr. Pedro Salazar de Mendoza (1550?–1629), a canon who also served in a variety of other positions. As a scholar Salazar de Mendoza was one of a number of local historians who set out to glorify Toledo's past. Interest in local history had been growing since the early part of the century, and Philip II's decision to select Madrid as his capital provided additional impetus: Toledans had to prove that Toledo, and only Toledo, deserved to be the site of the Spanish court. Local history, consequently, flourished as never before. Jerónimo Román de la Higuera, a Jesuit scholar who had been trained in Bologna, wrote a fascinating but largely fanciful account of Toledo's ecclesiastical history; Francisco de Pisa produced a new general history in 1605 to replace the one published by Pedro de Alcocer in 1554; and Salazar de Mendoza busied himself with a series of biographies of important Toledan prelates. Salazar de Mendoza's strong interest in local history is especially important in view of his close association with El Greco, which will be examined later in this essay.

There were also learned men on the city council (*ayuntamiento*). Headed by a royal governor (*corregidor*), the council consisted of a group of officials known as *regidores*. Their number varied, but the *regidores* were invariably wealthy and influential, and they comprised the city's secular ruling elite. By law, half of the councillor positions were reserved for the nobility (*caballeros*) and half for the ordinary citizenry (*ciudadanos*), although the distinction between the two groups became blurred as a result of intermarriage. In the main, the "citizen" councillors belonged to wealthy families who had established their fortunes in trade. A few were even merchants themselves. Alonso Franco, for example, city councillor after 1563, was a prosperous silk merchant in partnership with his two brothers, Pedro and Hernan.[44]

The nominal leaders of the noble contingent on the city council were the dukes of Maqueda and the counts of Cifuentes and Fuensalida, but because they usually lived away from Toledo, their influence in the city's affairs was relatively small. In practice, the city council was dominated by nobles of lower rank whose continued residence in the city allowed them to gain in political power. Their backgrounds varied, but on the whole they were an educated group, schooled in Latin and the liberal arts. Many had even attended university and, in keeping with Spanish custom, proudly displayed their academic titles before their names. One of these councillors was Licenciado Jerónimo de Cevallos (cat. no. 64; pl. 7; fig. 18). Born in 1562 in the nearby town of Escalona, Cevallos studied law at the prestigious University of Salamanca and came to Toledo around 1600 to practice. He had good local connections, including an uncle, Luis Davalos, from whom he inherited a place on the council in 1605.[45] For the next two decades, Cevallos was extremely active in local politics and was one of

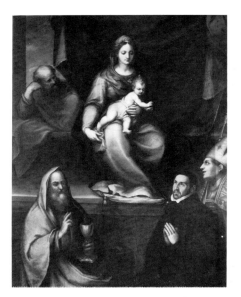

Figure 17. Blas de Prado. *Holy Family*, 1589 (Madrid, Museo del Prado). Alonso de Villegas, depicted here at the feet of the Virgin, praised El Greco's *Burial of the Count of Orgaz* but chose Blas de Prado to create this painting for his family chapel.

Figure 18. Pedro Angel. *Jerónimo de Cevallos*, 1613 (Madrid, Biblioteca Nacional). Cevallos is portrayed at the age of fifty-one in Angel's engraving. This work is the basis for the identification of Cevallos as the sitter in a portrait by El Greco (cat. no. 64; pl. 7).

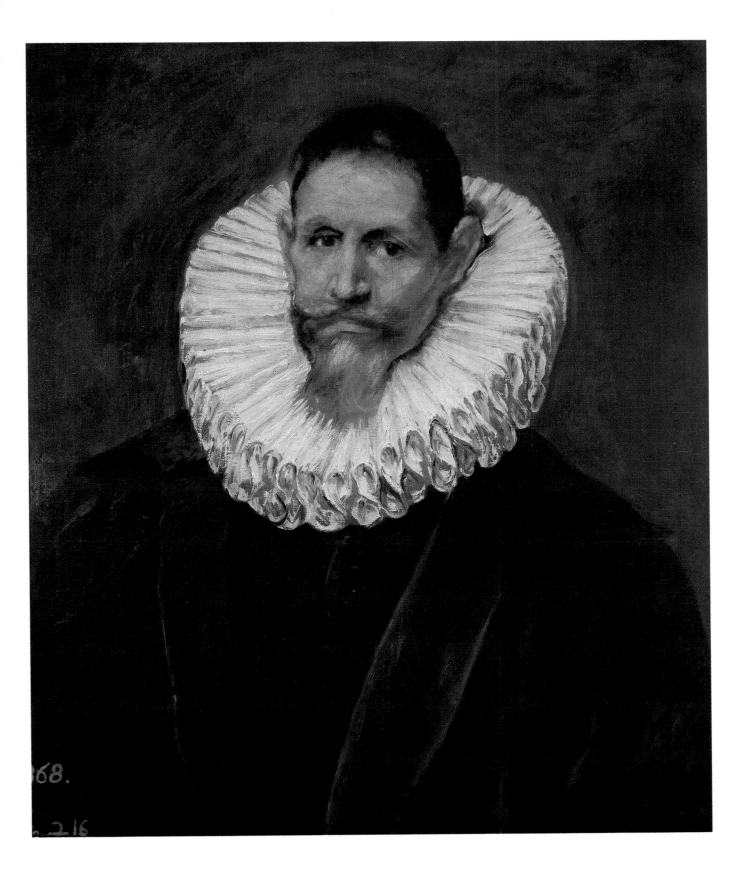

PLATE 7 (cat. no. 64). *Jerónimo de Cevallos,*
25⁵/₈ x 21⁵/₈ inches, circa 1605–1610 (Madrid,
Museo del Prado)

Toledo's most respected citizens. Author of several books on jurisprudence, he achieved national prominence in 1623 when he published his *Arte real para el buen gobierno*, a book of advice for the monarch on how he might arrest Spain's economic and political decline. Cevallos's literary interests are also exemplified by his membership in a literary academy that met in the house of the count of Mora, Francisco Rojas y Guzmán. There he met the poet Medinilla, who was himself the son of a city councillor; Tamayo de Vargas, a historian who was later appointed chronicler to the king; Francisco de Céspedes, dean of the cathedral; and the ever-present dramatist Lope de Vega, who was then residing in Toledo.[46]

Cevallos's literary interests were clearly exceptional, but he was by no means the only councillor with a taste for arts and letters. Another was Dr. Gregorio de Angulo, who became a close friend of El Greco. His family was prosperous, if not immensely wealthy, and it had been associated with municipal politics for quite a long time. Angulo's father, for example, a physician who taught medicine at the university, had served on the city's *cabildo de jurados*, the advisory board that assisted the city council in governing the city. Gregorio, like many of his contemporaries, studied law (in Toledo), earned the degree of doctor, and then opened a law practice before replacing his father on the *cabildo de jurados* as representative of the parish of San Antolín around the year 1600. He resigned this office in 1604 to become a city councillor, a position he obtained from a relative and one that enabled him to enter the highest circles in Toledan society. Lope de Vega was a close friend, and Angulo participated in several literary academies, including one that met at the home of Pedro López de Ayala, count of Fuensalida.[47]

Angulo was not a dedicated scholar, but he fancied himself a poet and on several occasions entered the poetic competitions (*justas literarias*) for which Toledo in this epoch was famous. One of these took place in 1605 to honor the birth of the prince, the future Philip IV. The theme was Toledo's relation to the monarchy, and in view of Toledo's conception of itself as the only legitimate home of the Spanish court, it attracted considerable attention. The participants numbered nearly forty and included representatives of the local nobility, members of the city council, scholars from the university, several friars, and four women. The guest of honor was Lope de Vega—dubbed a "Toledan poet" for the occasion—and he inaugurated the proceedings with a *canción* on the chosen theme. It began:

> *Finally Toledo, illustrious, glorious, powerful,*
> *Toledo the imperial, noble city,*
> *The capital of Spain, that onetime famous court of the Gothic kings,*
> *As the heart in the body is the core and fount of life,*
> *So is Toledo, heart of Spain.*[48]

Other contestants recited long homilies, but Angulo was content to submit a brief, four-line poem, known as a gloss, that lauded the young prince. For this effort he was awarded second place, behind Doña Isabel de Figueroa, an important noblewoman. Angulo, who often entered similar competitions but never quite managed to win first prize, was affectionately referred to by his friends as a "retired poet" (*poeta jubilado*).[49]

Toledo emerges, then, as a city governed by a learned elite with artistic interests, sophisticated literary tastes, and a strong sense of civic pride. In many ways, this elite thus resembled that which governed Florence in the quattrocento. And like their Florentine counterparts, the men who governed Toledo saw the city they served as one with a destiny. The destiny of Florence was to defend republican liberty against tyranny; the destiny of Toledo was to be the secular and spiritual capital of Spain.

Toledo and the Counter-Reformation

The Catholic church in Toledo, as in most Spanish cities of the sixteentl century, was a large and highly visible institution. Luis Hurtado de Toledo' 1576 description makes clear the importance of the church in the city's life. Apart from the cathedral, which he describes in great detail, Hurtado de Toledo alludes to over one hundred religious establishments. These include twenty-six churches, one for each of the city's parishes; thirty-six convents and monasteries; eighteen shrines, each dedicated to a different saint; twelve oratories named after Our Lady of the Devotion; as well as twenty hospitals and four religious colleges, each of which offered daily mass.[50] Unfortunately, Hurtado de Toledo did not indicate the number of ecclesiastics required to maintain these institutions, but the census of 159 suggests that churchmen amounted to nearly 5 percent of Toledo's population. There were 739 secular clergy (of whom nearly two-thirds were attached to the cathedral) and 1,942 regular clergy, one of the largest such concentrations in Spain. Large as it was, the religious population continued to expand.[51] Between 1591 and 1617 Toledo acquired nine new religious houses, and others were planned. With its lay population declining Toledo was becoming what has been described as a "convent" city—a city dominated, both physically and spiritually, by the church.[52]

The titular head of this imposing religious establishment was the archbishop. From his seat in Toledo, he presided over an archdiocese that encompassed most of central Spain. One early seventeenth-century docu ment reckoned that his realm included 6 cities, 287 towns (among them Madrid, which was classified as a town [villa] even though its population had reached 100,000), and 419 villages; 1,253 benefices, 435 ecclesiastical pensions; 164 monasteries; and a total of 600,000 persons, of whom at leas 5,000 were ecclesiastics.[53] This was an empire unmatched by that of any other Spanish prelate. According to one fifteenth-century observer, the archbishop of Toledo was so powerful that he was "more like a pope than a prelate,"[54] and there is no doubt that many in the seventeenth century still believed this to be true.

The archbishop of Toledo was also a powerful figure in the Spanish ecclesiastical hierarchy. At the end of the sixteenth century, he had jurisdiction over eight suffragan bishops, each of whom was subject to legislation enacted at provincial councils over which the archbishop presided. He was also primate of Spain, a title that was officially recognized by Urban II in 1088 and subsequently reaffirmed by other popes. Although largely honorific, the title implied that the archbishop was the official spokesman for the Spanish church. It also gave him the right to ceremonial precedence ahead of other Spanish churchmen.

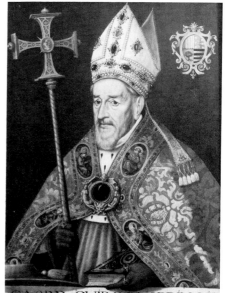

Figure 19. Luis de Velasco. *Cardinal Gaspar de Quiroga*, 1594 (Toledo, Cathedral Chapter Hall). Quiroga, archbishop of Toledo (1577–1594) and inquisitor general, was personally responsible for implementing the reforms of the Council of Trent.

The influence and wealth of Toledo's archbishops gave them a powerful role in government. Kings expected them to reside at court, to serve in high office, and whenever necessary, to employ their resources on behalf of the crown. This pattern was an old one, and meant that the majority of the archbishops spent little time in Toledo. Juan de Tavera, for example, archbishop from 1534 until his death in 1545, spent most of his tenure at Charles V's court, serving jointly as inquisitor general and as president of the Royal Council. Gaspar de Quiroga (fig. 19), archbishop from 1577 until 1594, was equally devoted to the service of the monarchy. Trained in canon law at Salamanca, Quiroga began his ecclesiastical career in 1543 as a vicar in the university town of Alcalá de Henares. Appointed a canon in Toledo in 1545, he made a name for himself by enforcing the notorious "purity of blood" statute. This had been initiated by Archbishop Juan Martínez de Siliceo in 1547 and was meant to bar *conversos* (Catholics of Jewish or Moorish descent) from offices within the cathedral. Soon afterward, Quiroga was in Rome, where, at the request of Philip II, he served as judge on the Sacra Rota, an important ecclesiastical court. In 1559 he traveled to Naples and Sicily on an inspection tour of the local monasteries. Two years later he was back in Spain, having been appointed by Philip to serve on the Royal Council. The king subsequently nominated him bishop of Cuenca (1571) and archbishop of Toledo (1577), but Quiroga was obliged to spend most of his time at court, where he served as president of the Council of Italy (1567) and then, jointly, as inquisitor general (1573) and councillor of state (1574). Although he would have liked to have spent longer periods in Toledo tending to his church, Quiroga was forced to live mainly in Madrid, within reach of the monarch who valued his services.[55]

With all these secular responsibilities, Quiroga delegated the administration of the archdiocese to what was called the *Consejo de la Gobernación*. The origins of this council date to the fourteenth century, and by Quiroga's time it was usually composed of four or five councillors, most of whom were canon lawyers. Unfortunately, only a few of Quiroga's councillors are known to us: two of them, Diego de Briviesca and Pedro de Carvajal, also held offices on the cathedral chapter; Juan Bautista Vélez belonged to the archbishop's household and was probably Quiroga's personal representative on the council; Pedro Salazar de Mendoza, the aforementioned historian, was a member of the council during the 1580s, when he also served as an adviser (*consultor*) to the Inquisition. The council was constituted primarily as a judicial body, but it also had a number of purely administrative functions, such as collecting tithes and other taxes, issuing dispensations and licenses to build or to remodel churches, appointing church officials, supervising parochial visitations, and overseeing "everything else for the good administration of the archdiocese."[56] Among its secondary tasks was the surveillance of the paintings that were hung in parish churches, a matter that personally interested Quiroga.

Quiroga's first and most important responsibility as archbishop was to implement the decrees of the Council of Trent. This council, which met intermittently between 1545 and 1563, attempted to clarify church doctrines that had been challenged by the Protestants and to eradicate

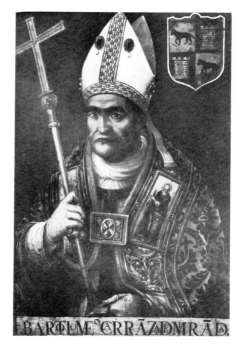

Figure 20. Luis de Carvajal. *Bartolomé de Carranza y Miranda*, 1578 (Toledo, Cathedral Chapter Hall). Appointed archbishop of Toledo in 1558, Carranza was arrested the following year on charges of heresy and spent the next seventeen years attempting to prove his innocence. In his absence, the administration of the archdiocese of Toledo fell into decay.

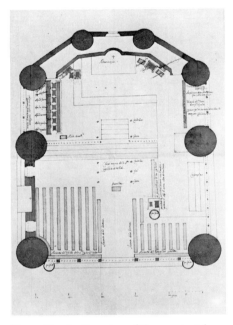

Figure 21. Seating plan of the provincial council on church reform summoned by the archbishop, Cardinal Quiroga, 1582 (Madrid, Instituto de Valencia de Don Juan). Meetings of the council took place in the Hall of Councils in Toledo's archiepiscopal palace. The archbishop's seat is located at the top of the plan, to the right of the main altar.

those abuses that were seen as having precipitated the schism within the church. Among other matters, Trent issued decrees calling for improved standards of discipline and education among the clergy, instituting a uniform breviary and catechism, and requiring the faithful to adhere rigorously to the basic dogma of the church. Philip II, as the great champion of Roman Catholicism, gave the council his full support, and in July 1564 he ordered the Spanish church to reform itself in accordance with the Tridentine decrees.

For the archdiocese of Toledo, Philip's orders could not have come at a less opportune moment. Quiroga's predecessor as archbishop, Bartolomé de Carranza y Miranda (fig. 20), had been arrested by the Inquisition in 1559 on charges of heresy and was still being held prisoner in Valladolid. Two years later, in 1566, on the order of Pius V, he was transferred to Rome to await trial. This process dragged on until 1576, at which time the most serious charges leveled against the archbishop were dropped. Carranza was vindicated, but he had little time to savor his victory: he was dead within a matter of months.

During Carranza's absence, the enforcement of the Tridentine decrees was left to a series of low-ranking ecclesiastics who had been appointed by Philip to govern the diocese. To help them to discharge this weighty obligation, the king summoned a provincial council in 1565. Its principal task was to make recommendations on the reform of the archdiocese, but from the outset its work was impeded by Toledo's cathedral chapter—especially its powerful dean, Diego de Castilla, who challenged the council's authority and blocked its attempts to put its recommendations into effect.[57]

Toledo, therefore, was essentially an unreformed diocese when Quiroga was appointed archbishop in 1577.[58] Diego de Castilla viewed the appointment of the new prelate as an opportunity to strengthen the authority of the Toledan church, and in a letter to Quiroga he agreed to support a program of reform so that "the archdiocese could be rebuilt, stronger and better adorned ... than ever before."[59] The energetic Quiroga immediately set to work. In April 1578, only a week after he first arrived in Toledo to take possession of his see, Quiroga established a commission to ensure that the ceremonies and offices performed in the cathedral were rewritten to conform with those decreed by Trent.[60] He also began preparation for a new provincial council (fig. 21) designed "to deal with the reformation of customs and the extirpation of abuses, to remove and put an end to dissension, enmity, and differences within the church and to make it conform to the execution and observance of the decrees of the Holy General Council of Trent and everything else that is necessary and convenient for the divine cult, good government, and administration of the ecclesiastical estate."[61] This council convened on September 9, 1582, and initiated a series of reforms that began with a general visitation of all the churches in the diocese.[62] Soon plans were being made for a new prayer manual and church calendar. New rules concerning the recruitment of clergy, the residency of priests in their parishes, and discipline among the churchmen were instituted. These and other regulations concerning the nature

of religious practice in the archdiocese were then outlined in a new and rigorous set of synodal constitutions, published in 1583.[63]

These constitutions are important because they provided Spain's other dioceses with a blueprint for reform. They are also interesting because they reflected Quiroga's personal view of the Counter-Reformation church. For example, he especially wanted to eliminate from church services anything that might be construed as secular or profane. He considered profane the masques, dances, and carnivalesque entertainments that traditionally accompanied important church holidays, and in 1581 he ordered the Cathedral of Toledo to eliminate the pageants and mystery plays that were celebrated on Christmas Night.[64] By this measure and others, Quiroga introduced into Toledo the austere and puritanical brand of Catholicism that followed the prescriptions of the Council of Trent.

Quiroga was equally opposed to church decoration that in any way deviated from the official dogma. The Council of Trent, recognizing the power of images to influence belief, ordered that churches display only images that had a didactic purpose; any that conveyed "false dogmas" or might give rise to "religious errors" were prohibited.[65] To enforce this ruling, Trent required the clergy to obtain the permission of the bishop for any new work of art to be installed in a church. Under Quiroga's guidance, the provincial council of 1582 ordered "bishops to prohibit paintings that cause laughter and those that are nothing more than profane, popular decoration."[66] A strict believer in doctrinal purity, Quiroga was determined to see this ruling enforced, and he therefore required every church within his jurisdiction to submit plans for intended artistic projects to the archdiocesan council, which could then issue or deny a license. It is not known when this ruling first took effect, but in 1584 Andrés Núñez de Madrid, priest of the Toledan parish of Santo Tomé, obtained the council's permission before he commissioned El Greco to execute the painting now known as the *Burial of the Count of Orgaz*.[67]

Personally devout, pious, and charitable, and known for his abstemious ways, Quiroga was the personification of the Counter-Reformation. A man of learning and experience, he fully recognized that the laity's knowledge of church doctrine was only rudimentary. To educate his flock, he began to establish new schools and colleges. He helped the Jesuits open a new college in Toledo, allocated funds for a number of other educational institutions in which Catholic doctrine was taught, and attempted to convince the cathedral chapter that Toledo needed a diocesan seminary in which clergy could be trained. In 1582, also to improve religious education, Quiroga ordered the cathedral to provide weekly sermons. Before his time, sermons were reportedly offered only on important holidays and during Lent.[68] Unfortunately, only a few of these weekly sermons have survived, but they are sufficient to show a general obedience to the "official" line of the Counter-Reformation church.[69] A typical sermon stressed the importance of the sacraments, especially that of the Eucharist, the essential sacrament of post-Tridentine Catholicism. Considerable attention was normally accorded to the Immaculate Conception, a doctrine of increasing importance in the sixteenth century, particularly in Spain. Another theme was worship of saints and their relics; saints were to be

FLOS SANCTORVM
SEGVNDA PARTE.

HISTORIA GENERAL EN QVE SE ESCRIVE LA
vida dela Virgen sacratissima madre de Dios y señora nuestra y las delos sanctos antiguos,
que fueron antes dela venida de nuestro Saluador al mundo collegidas assi dela diuina es-
criptura, como delo que escriuen a cerca desto los sagrados doctores, y otros autores gra-
ues y fidedignos. Ponese al fin de cada vida alguna doctrina moral, al proposito delo con-
tenido en ella con diuersos exemplos. Tratase delas seys edades del mun-
do: y en ellas los hechos mas dignos de memoria que enel succede-
ron. Puesto en estilo graue y compendioso.

DIRIGIDO AL ILLVSTRISSIMO SEÑOR DON GASPAR DE QVI-
roga Cardenal, Arçobispo de Toledo, y Inquisidor mayor.
Por el Maestro Alonso de Villegas Capellan en la capilla Moçarabe dela sancta yglesia de Toledo
beneficiado de san Marcos, y natural de la misma ciudad.
En esta vltima impression se han añadido algunas cosas, y puesto otras en
mejor estilo por el mismo autor.

CON PRIVILEGIO.

¶Impresso en Toledo por Ioan Iaure, a costa de los herederos del doctor
Francisco Vazquez. Año de. M.D.XCIIII.

Figure 22. Frontispiece from a 1594 edition of Alonso de Villegas's famous work *Flos Sanctorum*. The book was dedicated to Cardinal Quiroga, depicted here in profile.

praised as models of a perfect Christian life, workers of miracles, and intercessors on behalf of the faithful at the heavenly court.

The same range of ideas was expounded in devotional works written by some of Toledo's most prominent churchmen. Alonso de Villegas, in his *Flos Sanctorum* (fig. 22), emphasized the special role of saints in the history of the Catholic church. A series of books by Pedro Sánchez, a prebendary in the cathedral, stressed the need for every Catholic to live and to worship as the church decreed.[70] In writing *Paraíso de la gloria de los santos*, Diego de la Vega, a reader in theology at the Franciscan monastery of San Juan de los Reyes, explained that he wanted to show how the lives of saints could serve as "mirrors from whose light and example we can compose and adorn our own."[71]

Quiroga, for his part, actively encouraged the worship of relics and saints. He was himself devoted to Saints Augustine and Jerome, as well as to three Toledan saints: Eugenius, Ildefonso, and Leocadia.[72] He attempted —unsuccessfully—to obtain from the Cathedral of Zamora the relics of Ildefonso, the patron saint of Toledo. In 1587, however, he presided over the return of the remains of Saint Leocadia to Toledo from Flanders, where they had been threatened by the Protestants. According to eyewitnesses, the homecoming was a momentous event. The king, the royal family, and members of the court were on hand to take part in the celebrations, as were many nobles. Triumphal arches were erected in various parts of the city, in honor of the saint, King Philip, the church, and, of course, Toledo, the Imperial City. A huge Corinthian portico, built of imitation stone and decorated with paintings illustrating the life of Leocadia, was erected in front of the cathedral's facade. On April 26, after years of waiting and innumerable delays, the holy relics finally entered the city, accompanied by a solemn procession of representatives of the clergy, the government, the university, and the nobility. When the cortege reached the square in front of the cathedral, it was greeted by Philip and his family, who took possession of the relics and carried them into the cathedral with the assistance of some of Spain's grandees. There they were met by Quiroga, dressed in magnificent pontifical robes, and by the dignitaries of the cathedral chapter. The holy remains were then placed on the high altar. For two days pontifical masses honoring Saint Leocadia were celebrated, and the relics were finally deposited in the cathedral's sanctuary. The sermons that accompanied this glorious occasion compared Philip and Quiroga to the legendary King Pelayo and Archbishop Urban, famous for having rescued precious relics from the invasion of the Moslems that began in A.D. 711.[73]

By the time of Quiroga's death in 1594 he had achieved much as archbishop. He had restored discipline, purified ceremonial, and reestablished the authority and position of the church. But he also had his failures. He was unable, for instance, to persuade the cathedral chapter to establish a diocesan seminary. The canons argued that such a seminary would not only be too expensive but would also be superfluous in view of the fact that Toledo already had a university and several colleges expressly designed to train clergy.[74] Moreover, Quiroga's reforms, despite all of his efforts, had had only limited effect outside of Toledo. A report prepared in

1595 for the new archbishop, Archduke Albert of Austria, indicated that most villages in the diocese still offered little or no instruction in the basic tenets of Catholicism. Many rural priests, in violation of Quiroga's synodal constitutions, continued to collect fees for marriages, baptisms, burials, and other services. Some parishes also maintained the irreverent religious practices that were at odds with the puritanical spirit of the Counter-Reformation church. "In many villages of the archdiocese," the report indicated, "there is a custom on the night of May 1 for young adolescents to climb the towers and other high buildings. Then, while singing songs, they 'marry' young boys and girls. Many sins result from this act. It also gives rise to clandestine marriages, and leads to the excommunication of many young people."[75]

Quiroga would have been deeply disturbed by this report. At the same time, he would have been pleased by the zeal with which García de Loaysa, governor of the archdiocese in the absence of Archduke Albert, continued the work of reform. One of Loaysa's first orders after he was finally appointed archbishop in 1598 was to institute a general visitation of the archdiocese aimed at eliminating the abuses cited in the 1595 report. The clerics entrusted with this task were warned to keep an eye out for popular "superstitions" arising from "the rusticity of the people" and to make certain that paintings hung in parish churches did not contain "apocryphal, irreligious, and impertinent things."[76]

This visitation was barely under way when, in February 1599, Loaysa died; but the new archbishop, Cardinal Bernardo de Sandoval y Rojas (pl. 10; figs. 29, 30), carried it through to completion. Although this wealthy prelate is best remembered for his literary activities, he was also a dedicated reformer. Within a year of his appointment a new set of synodal constitutions had been drafted that emphasized the importance of "the reform of customs, correction of abuses, and the extirpation of vice."[77] Like his predecessors, Sandoval y Rojas also believed in strengthening orthodox belief, and he was especially insistent that the art displayed in Toledan churches be suitable for holy places. His constitutions, published in 1601, prohibited the hanging of profane paintings in churches. To enforce this ruling, he reformed the procedures by which the archdiocesan council gave approval to new works of art. For the first time, the council was required to maintain a permanent record of artistic activity within the archdiocese. Begun in 1603, this register indicates that the council regularly employed some of Toledo's leading artists to help decide whether licenses for new works of art should be granted. El Greco and Jorge Manuel were among the artists employed for this work, which suggests that they were considered qualified to judge whether a painting conformed to church doctrine.[78] It appears, then, that El Greco was enlisted to serve as a foot soldier in the battle that Quiroga had begun to reform the Toledan church.

The objective was ambitious: to make Toledo into an ideal diocese, an example for the rest of the Spanish church to follow. Part of this program involved keeping a close watch on the religious practices of individual citizens—a responsibility that was delegated to the local tribunal of the Inquisition. This tribunal consisted of a panel of three or four judges, or inquisitors, who were assisted by a dozen or so *consultores*—theologians

and canon lawyers who offered advice on important doctrinal matters. Some of Toledo's most prominent scholars, including Juan de Mariana, Francisco de Pisa, and Pedro Salazar de Mendoza, served in this capacity at one time or another.[79] Also helping the inquisitors was an extensive network of neighborhood spies (*familiares*) who were expected to keep a close watch on anyone whose belief was suspect. Inquisitor General Quiroga was especially determined to see that Toledo's tribunal did its job properly; in the capital of the Spanish church, there would be little room for— or tolerance of—doctrinal error and spiritual dissent.

The Spanish Inquisition had been established in 1478 in order to eliminate heresy among the *conversos*, the converted Jews whose allegiance to Catholicism was in doubt. The persecution of such individuals was particularly harsh; thousands were burned at the stake. In the wake of the Reformation, the Holy Office turned its attention to Protestantism. Under the direction of Fernando de Valdés, inquisitor general from 1547 to 1568, it began to arrest university scholars, particularly theologians influenced by the ideas of Erasmus. Quiroga, inquisitor general after 1573, was more moderate. He personally pardoned Fray Luis de León, the noted theologian and poet who had been arrested in 1572. He encouraged biblical scholarship, extending his patronage to such famous theologians as Benito Arias Montano and Francisco Sánchez ("el Brocense"), and in Toledo helped Loaysa, Juan Bautista Pérez, and other scholars attached to the cathedral chapter. But Quiroga was no liberal. In 1583 he introduced a revised *Index of Prohibited Books* and the following year instituted a new *Index of Expurgated Books*, both intended to keep the circulation of potentially heretical ideas under control. As one who firmly believed in the Counter-Reformation church, he also instructed the Holy Office to scrutinize the activities of mystics, illuminists, and other spiritualists. Their emphasis on inner piety, meditation, and private prayer represented a direct challenge to the established church, with its emphasis on sacramental piety and communal forms of worship.

Quiroga was particularly concerned about the orthodoxy of *beatas*, pious women known for their intense, personal devotion. Living alone and in groups, *beatas* wore habits (usually of their own making) and had often taken a private vow of chastity, but they normally did not belong to any religious order. At least eight communities of *beatas* existed in Toledo in 1575, and several of these were brought up on charges of heresy.[80] In the following years other *beatas* ran into trouble with the Holy Office, partly because Quiroga in 1582 ordered such women to be more "closely watched."[81] But mysticism was not a serious problem for the authorities, despite the activities of such well-known mystics as Saint John of the Cross and Saint Theresa of Avila. Both had their followers in the city, and Theresa was particularly popular. Although she was critical of the lack of fish in Toledo ("This is a terrible place in which not to eat meat; there is scarcely even a fresh egg"), Theresa admired the piety of the city and visited it on at least six occasions between 1562 and 1580.[82] In 1577, while living in the Toledan townhouse of Doña Luisa de la Cerda, one of her more fervent followers, Theresa began writing her famous work *The Interior Castle*. Her other supporters in the city included Diego de Yepes, a

Hieronymite who served as her confessor in 1576 and who later wrote a biography of this famous monastic reformer, and Dr. Alonso Velázquez, a member of the cathedral chapter who acted as her confessor during her last visit to Toledo, between March and June of 1580.[83] Another of her followers was Martín Ramírez, an important merchant who was said to have made a fortune in the Indies trade. His will included a bequest that helped establish in Toledo a religious house for Theresa's new order, the Discalced, or Reformed, Carmelites.[84]

But Theresa, although universally recognized as a devout and loyal Catholic, had her enemies. As in the case of the illuminists, her emphasis on private prayer and direct spiritual union with God was seen by many churchmen as a threat to those doctrines that made the church a necessary intermediary between God and man. For example, in 1568 Bernardino de Sandoval, *maestrescuela* of the cathedral, noted specifically that prayers recited communally in church before a priest were "more acceptable to God" than those recited privately.[85] Pedro Sánchez also attacked those who sought direct communion with God, reminding readers in his book *Arbol de la consideración* (1584) of the importance of the sacraments and of priestly confession.

More direct in his criticism of Theresa was Francisco de Pisa (fig. 23), professor of Holy Scripture at the university and a cleric in close touch with the church hierarchy in Toledo. In 1596 Fray Juan de Lorenzana, a Dominican monk, asked for the Inquisition's permission to publish a new edition of some of Theresa's writings. At the hearing in which this petition was discussed, Pisa submitted a long brief setting forth reasons why the Holy Office ought to deny this request. Describing Theresa as an "unlettered woman," he claimed to have found in her works "many things that appear to contradict true and correct doctrine as well as the good use of mental prayer." He found other ideas "which, if considered rigorously, appear to be errors, and doctrine that can encourage ignorant persons to become illuminists; they could even deceive the monks and friars of her own order, who consider it an obligation to imitate the spirit of their founder." After detailing the errors he attributed to Theresa, Pisa advised against wholesale publication of her works. He suggested instead that the Holy Office grant a license to publish certain "brief extracts" from her writings that would be limited to "some clear and secure spiritual questions." These, he observed, "would serve as a consolation for the monks and nuns in her order."[86]

Pisa's sharp criticism of Theresa was out of the ordinary, but it is worth remembering that Quiroga also had his doubts about her. In 1580, for example, he denied her permission to establish a priory in Madrid, granting permission only in 1586, four years after her death.[87] In the meantime, her reputation as a reformer and intensely pious woman grew. By the seventeenth century Theresa's following was so great that the Cortes recommended in 1617 that she be recognized as copatron of Spain along with Saint James. Five years later, Theresa was officially canonized, together with Ignatius Loyola, founder of the Society of Jesus. Toledo joined with the rest of Spain in celebrating the event, but the city's enthusiasm for Saint Theresa ought not to be interpreted as an indication that Toledo

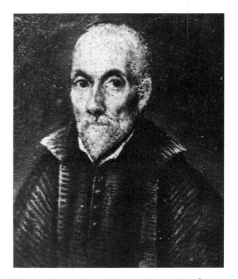

Figure 23. Artist unknown. *Francisco de Pisa*, late 1500s (Madrid, private collection). Professor of Holy Scripture at Toledo's university and an influential member of the Toledan church, Pisa described Saint Theresa of Avila as an "unlettered woman." Among his various works, Pisa wrote a history of the city of Toledo, first published in 1605.

was steeped in the mysticism that is generally associated with her name. The mystical aspect of her teachings was limited primarily to members of her own order, to certain convents and monasteries, and to groups of *beatas* who modeled themselves on Theresa's example. It never developed into a popular religious movement.

The religion practiced in Toledo was in line with the Counter-Reformation orthodoxy. The Roman Catholic hierarchy sought to have devotion centered on the church and, in keeping with Tridentine doctrine, wanted religion oriented around the worship of relics and saints and focused on the sacraments as performed by a priest. To be sure, this policy was not altogether successful; the church had to struggle continually against attempts to make spirituality more private, more personal. On the other hand, there is little evidence to suggest that religious practices in Toledo deviated much from those the church promoted.

On balance, Toledo appears to have been a city in the mainstream of the Counter-Reformation. Those who have proposed that El Greco found in Toledo an "oriental" city steeped in mysticism have misinterpreted Toledan spirituality. It is, of course, true that in the Middle Ages there were important manifestations of both Jewish and Moorish culture in Toledo, but by the end of the sixteenth century the city was profoundly Catholic and orthodox. Although it is correct to interpret El Greco as an artist in close touch with the religious mood of Toledo, the city was neither mysterious nor mystical. Its character was rather, as Toledans themselves claimed in 1605, that of a "second Rome," a new Rome.[88] Toledo was a city dominated by churchmen who emphasized the necessity for strict observance of the central doctrines of the church. And it was with members of this group that El Greco found many of the contacts that were crucial to his success in Toledo.

The Web of Friendship

Much of what has been written about El Greco's friends in Toledo is more the product of fertile imagination than fact. No proof exists that El Greco ever met Gaspar de Quiroga, Lope de Vega, or Saint Theresa. Nor is there any substantial evidence that he attended the meetings of Toledo's literary academies. There is, however, abundant documentary evidence that the artist was in close touch with representatives of the major intellectual and religious currents of his day — with men, now mostly forgotten, who were important figures in the cultural life of Toledo.

El Greco was able to establish these contacts because he considered himself a learned artist. In this he differed from the rest of Toledo's artists, most of whom were prepared to work as artisans, and consequently to be thought of as such. The prevailing attitude toward artists in Spain is neatly summed up in a book published in 1570 by Fray Miguel de Medina, guardian of the monastery of San Juan de los Reyes. Medina divided the arts into three basic categories. Highest in prestige were the liberal arts, so called because they had an abstract scientific or theoretical basis. In this category Medina placed arithmetic, geometry, mathematics, astronomy, perspective, music, grammar, and logic. Lowest were the purely "mechanical" arts, the manual crafts that produced useful objects but did not

depend on the knowledge of a science. As examples, he mentioned the art of the silversmith and the craft of the tailor. In the middle rank were the "mixed" arts, those that were essentially mechanical but also depended on a modicum of science. This category embraced architecture, because it depended on the science of geometry; choreography, which had its basis in music; and "painting, which in all its aspects and manners depends on perspective." Medina also labeled as "mixed" such diverse crafts as mirror-making, metallurgy, and glassmaking, although he was quick to point out that in the popular mind, these "mixed" arts, painting included, were thought to be purely mechanical.[89]

This conception of the artist as artisan was partly the result of the failure of local artists to promote their own interests. Toledo had neither a guild nor an academy, the organizations typically used by artists to define and regulate their activities. Working conditions were also difficult. The city, insofar as artists were concerned, was like a modern-day company town. The only major institutional patron was the church, especially the cathedral, whose powerful warden was in a position virtually to dictate terms to the artists, sculptors, and other craftsmen; those who challenged his authority could easily be denied future commissions. Thus artists who worked for the cathedral generally did so without questioning the remuneration offered.

El Greco had a different, and higher, sense of himself and his art. While living in Rome he had mingled with churchmen, nobles, and other connoisseurs with a taste for classics, literature, and art. When he came to Toledo, he expected to be treated as a Renaissance artist, only to find that he was regarded as a medieval artisan. But unlike most of the artists in Toledo, he was not prepared to give ground to his patrons. When the need arose, he was ready to defend his interests in the law courts.

In Toledo, therefore, El Greco represented a break from tradition. He regarded painting as one of the liberal arts, equal in status to mathematics, music, and poetry. The fact that he wrote treatises on art and architecture (to be examined more fully in the next chapter) demonstrates that he viewed himself as a learned painter, a practitioner of a noble art. This conception of the artist was widely accepted in Venice, Florence, and Rome, but in Spain, and above all in Toledo, it represented something entirely new. Yet there was in Toledo a nucleus of learned individuals, many of whom had been to Italy and to Rome, who were prepared to accept a talented, intellectual artist as an equal. They included members of the liberal professions, nobles interested in art and in literature, and, especially, influential ecclesiastics who were conscious of their dependence on artists to further the cause of the Counter-Reformation church. It was among these men that El Greco found the counterparts to the enlightened patrons he had known in Rome.

El Greco was almost certainly introduced to this circle of his future patrons by Luis de Castilla, the illegitimate son of the dean of the cathedral chapter.[90] Luis was a churchman who, like many of his contemporaries, had a degree in canon law, which he had studied at Salamanca and Bologna. But his interests also included the classics. While living in Rome in the early 1570s, he asked his friend Pedro Chacón, a learned churchman origi-

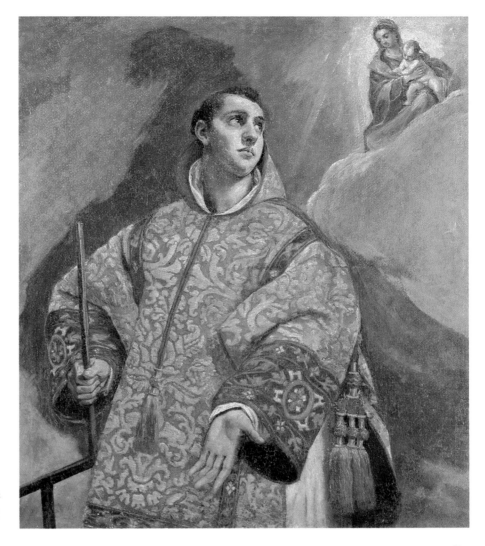

PLATE 8 (cat. no. 11). *Saint Lawrence's Vision of the Virgin*, 46⅞ x 40⅛ inches, circa 1578–1580 (Monforte de Lemos [Lugo], Colegio del Cardinal–Padres Escolapios)

nally from Toledo, to copy the works of various Greek and Latin authors.[91] Returning to Spain in 1575, he stayed briefly in Toledo and then took a position as canon of the Cathedral of Cuenca. There he quickly caught the attention of the bishop, Rodrigo de Castro. In a letter to Philip II, Castro described Castilla as "well lettered, of considerable prudence and wisdom, devout, and virtuous." The bishop added that "he will make a good account of himself in anything that he is asked to do because he is very cautious. It is certain that he is a person who can serve Your Majesty in important things."[92] Philip accepted this advice, and within a few years Castilla was sent on an important mission to Milan. This association between El Greco's friend Castilla and Rodrigo de Castro helps to explain how the latter came to acquire *Saint Lawrence's Vision of the Virgin* (cat. no. 11; pl. 8), a painting that El Greco completed sometime between 1578 and 1580.

Luis de Castilla apparently first met El Greco while the two were in Rome, while the painter was living at the palace of Cardinal Alessandro Farnese. The cardinal had surrounded himself with a coterie of artists and humanists of diverse nationalities, and Castilla had entrance to this circle through Pedro Chacón, a close friend of the cardinal's librarian, Fulvio Orsini.[93] Although little is known about Castilla's early contacts with El Greco, there is evidence that the artist came to Toledo in order to participate in the decoration of the convent church of Santo Domingo el Antiguo, whose patron was Luis's father. As it turned out, Luis left Toledo for Cuenca shortly after El Greco arrived in the city, but the two men never lost contact. In 1614 Castilla was named as an executor of El Greco's last will.[94]

63

It seems likely that Luis introduced El Greco to his father, Diego de Castilla (1510?–1584), the artist's first Spanish patron. The illegitimate son of Felipe de Castilla, dean of the Toledo cathedral chapter, Diego studied canon law at Salamanca and Valladolid, did postgraduate work in philosophy and theology at Alcalá de Henares, and then left the university to become dean of the cathedral chapter in Palencia. In 1551 he officially took his father's place as dean of the Toledo cathedral chapter, having unofficially exercised the duties of this position since 1546.[95] In view of his questionable origins, the chapter had opposed his appointment, and Diego had to use the courts to force the chapter to grant him the privileges and revenues of a canonry. But controversy was apparently to his taste. As mentioned earlier, it was Castilla who, almost single-handedly, impeded the work of the 1565 provincial council on church reform.

In addition to his activities as dean, Castilla pursued his interests in a variety of subjects, including art, architecture, history, and theology. An exacting patron, he is best remembered as organizer of the decoration of the church of the Bernardine convent of Santo Domingo el Antiguo (fig. 24), an ambitious project that was completed by El Greco in 1579.[96] Castilla's influence can also be detected in the decision of the cathedral chapter to hire El Greco to paint the *Disrobing of Christ* for the vestiary of the sacristy. This commission, which was also completed in 1579, ended in the first of many disputes between El Greco and his clients.[97]

Castilla died in November 1584, leaving El Greco without a principal patron. Having previously failed to win the patronage of Philip II, El Greco had already been forced to lower his ambitions and to set up shop as a contract painter. Fortunately, his altarpiece series in Santo Domingo el Antiguo had established his reputation as an artist of the first rank. Using this commission as a stepping-stone, he slowly built the network of friends and patrons that supported his career in Toledo.

Initially, El Greco's contacts in Toledo appear to have been limited. He arrived in the city speaking little or no Castilian. In 1579, in the midst of his dispute with the cathedral chapter over the *Disrobing of Christ*, he admitted to understanding only a little Castilian and asked the presiding judge for a written transcript of the proceedings.[98] Although his spoken command of the language must have gradually improved, he found many of his closest friends among Toledans with whom he could speak Italian, his second tongue. There was even a small community of Greeks in the city with whom he could speak his native language.[99]

El Greco's contacts also extended to kindred spirits among Toledo's intellectual community. One scholar with whom he was especially close was Antonio de Covarrubias y Leiva, the *maestrescuela* of the cathedral. Although Covarrubias did not himself offer any major altarpiece commissions to El Greco, it is possible that he intervened with Archbishop Quiroga to help El Greco win the contract to build the elaborate gilt frame for the *Disrobing of Christ*.

Covarrubias may also have helped El Greco meet other scholars who were then in Toledo. One mutual acquaintance was Dr. Rodrigo de la Fuente (d. 1589), a professor of medicine—Cervantes called him "the most famous physician in the city"[100]—who commissioned El Greco to paint his

Figure 24. Facade of the Bernardine convent of Santo Domingo el Antiguo. Beginning in 1577, El Greco painted a series of altarpiece images for its church (see fig. 74). This first Spanish commission was awarded him by Diego de Castilla, dean of Toledo's cathedral chapter and a patron of the convent.

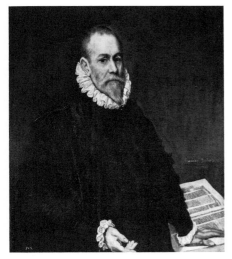

Figure 25. El Greco. *Rodrigo de la Fuente*, 36¾ x 33 inches, 1585–1589 (Madrid, Museo del Prado). The sitter was one of Toledo's leading physicians and a friend of El Greco's.

Figure 26. Exterior, Chapel of Saint Joseph. Martín Ramírez de Zayas, patron of this chapel, commissioned an altarpiece from El Greco in 1597.

portrait (fig. 25). La Fuente was a friend of Covarrubias, as El Greco himself noted in the marginalia to his copy of Vitruvius.[101] Another contact at the university was Dr. Martín Ramírez de Zayas (1561–1625), a professor of theology. The only surviving evidence of Ramírez's scholarship is his lecture notes on predestination and the role of divine grace, but he was evidently an influential figure in the city and belonged to an important literary circle of humanists, poets, and scholars.[102] He was a member of one of Toledo's wealthy merchant families, and it was his uncle, another Martín Ramírez, who, inspired by Theresa of Avila, established the Chapel of Saint Joseph (fig. 26) for the use of the Discalced Carmelite order. The younger Ramírez was the chapel's later patron, and in 1597 he chose El Greco to create its altarpieces, a major commission.[103] The painter won at least one more commission in the university world, an altarpiece intended for the chapel of San Bernardino College; he signed the contract on January 27, 1603.[104]

More important to El Greco than the university was the church. He had exhausted his credit with the cathedral canons as a consequence of the dispute over the *Disrobing of Christ* and, except for its frame, was never again to receive a commission from this important source of patronage.[105] But, fortunately, he managed to gain the confidence and respect of individual churchmen, who came to form the nucleus of his clientele.

First among them was Dr. Pedro Salazar de Mendoza, whose first recorded contact with El Greco occurred in 1586, when he agreed to serve as arbitrator in the event of a dispute over the price of the *Burial of the Count of Orgaz*.[106] A native Toledan of noble origins—his brother was a friar in the Military Order of Calatrava—Salazar de Mendoza was schooled in canon law.[107] But the contents of his writings suggest that this learned cleric, a specialist in Toledan history, was also trained in theology, church history, and the classics. Art was another of his special interests. He owned a collection of paintings, including several works by El Greco, and in his biography of Saint Ildefonso he expressed the view that painting was an invaluable tool for the study of history because it "excited and roused the spirit more than writing."[108]

Salazar de Mendoza took advantage of his position as administrator of the Hospital of Saint John the Baptist to provide El Greco with several important commissions. In 1596 he contracted with the artist for a wooden tabernacle to be installed in the hospital's chapel. Then, in 1608, he commissioned him for a series of altarpieces for the same chapel.[109] Salazar de Mendoza's long association with the institution suggests that the *View and Plan of Toledo* (cat. no. 55; pl. 9) was also commissioned by him. In this painting the artist gave particular prominence to the hospital, for reasons that are explained in an internal inscription. Salazar de Mendoza may have played a role in formulating the theme of El Greco's other painting of the city, *View of Toledo* (cat. no. 35; pl. 4). In his biography of Saint Ildefonso, the cleric attempts to determine the site of the Agaliense monastery that the saint once used as a retreat. Salazar de Mendoza thought it was situated on the north side of the city, near the Tagus River, set above some mills in a formerly unpopulated area filled with "fissures, cliffs, and thickets."[110] A close look at the left side of El Greco's famous

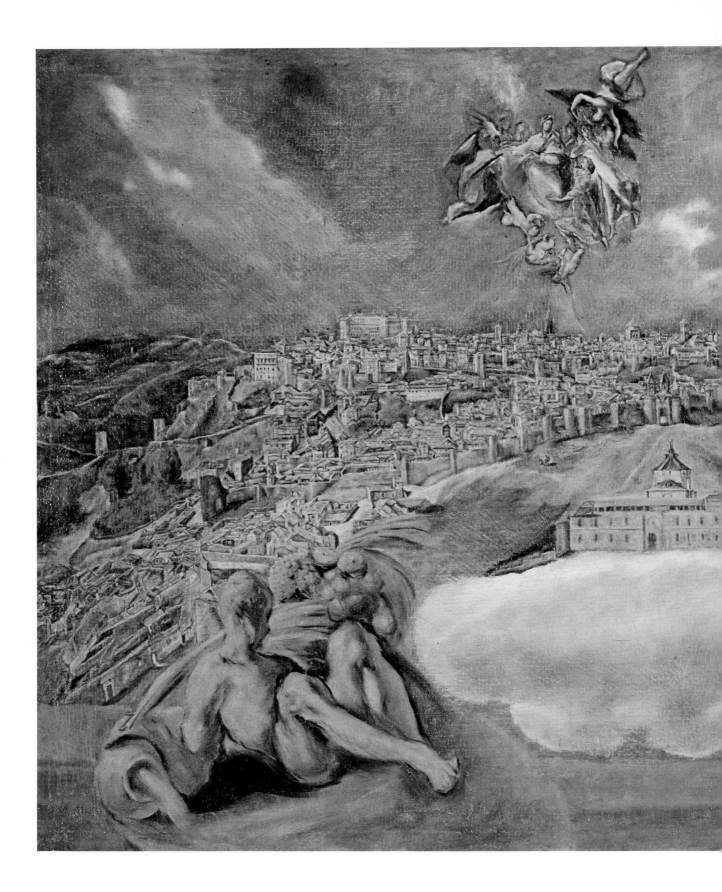

PLATE 9 (cat. no. 55). *View and Plan of
Toledo,* 52 x 89³/₄ inches, circa 1610–1614
(Toledo, Museo del Greco. Fundaciones Vega-
Inclán)

painting reveals a structure sitting on a cloud. Is this perhaps the Agaliense monastery?

Another ecclesiastical patron of El Greco was Dr. Jerónimo de Chiriboga. Canon of the collegiate church in Talavera de la Reina, Chiriboga belonged to Quiroga's household, served as one of his executors, and was an important figure in the ecclesiastical life of Toledo and Madrid. Like most of El Greco's other ecclesiastical patrons, Chiriboga was trained in canon law, but he had also studied Greek, Latin, and the liberal arts. Although little of his life is documented, it is known that he was an executor for Doña María de Aragón, a lady-in-waiting at the royal court. Before her death in 1593, Doña María established in Madrid the Augustinian seminary officially known as the College of Our Lady of the Incarnation, popularly referred to as the College of Doña María de Aragón. As its patron, Chiriboga commissioned from El Greco, in December 1596, a major altarpiece to decorate the college church.[111] Although it is not known how the two men became acquainted, they may have met in Toledo, where the canon often resided. The patronage of Chiriboga is typical of how El Greco's benefactors helped him to secure additional commissions. One of Chiriboga's fellow executors for Cardinal Quiroga was Dr. Rodrigo Vázquez de Arce, president of the Royal Council of Castile; El Greco painted his portrait, although it is now known only in a copy (fig. 27).[112]

Another ecclesiastical patron was Dr. Juan Bravo de Acuña. Trained in canon law and theology at the universities of Alcalá de Henares and Salamanca, he entered the service of Archduke Albert of Austria and was appointed a canon of the cathedral in 1595; he wrote an important treatise on the history of the Toledan church, and was an important figure in Toledan literary circles.[113] He was serving on the archbishop's council in 1602 when it approved the plans for the altarpiece El Greco designed for the College of San Bernardino (see cat. no. 39; pl. 53).[114] Although Juan Bravo de Acuña's personal relations with El Greco are not documented, his younger brother, Luis, Spanish ambassador to Venice and later viceroy of Navarre, at the time of his death in 1633 owned four of El Greco's works.[115] Presumably, Luis had inherited these paintings from his brother, who must have acquired them directly from the artist.

One churchman who was clearly a close acquaintance of El Greco was Francisco Pantoja de Ayala, secretary to the archbishop's council during the tenure of both Quiroga and Archduke Albert of Austria. Although Pantoja de Ayala did not award the artist any commissions, he did agree to serve as one of his bondsmen (*fiadores*) in the artist's contract with the College of Doña María de Aragón.[116] When important altarpieces were commissioned, the patron customarily gave the artist a down payment at the time the contract was signed, and the artist was required to put up a financial guarantee pending completion of the project. If the artist did not have sufficient funds available, he normally turned to one or more bondsmen to act in his name. Pantoja de Ayala's willingness to serve in this capacity suggests that he enjoyed a relationship of trust with El Greco.

Finally, mention ought to be made of Bernardo de Sandoval y Rojas, the cardinal and archbishop of Toledo famous for his love of learning and the visual arts. Although El Greco in the past has never been directly linked to

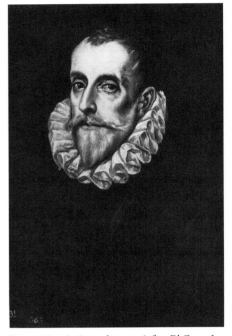

Figure 27. Artist unknown (after El Greco). *Rodrigo Vázquez de Arce*, 1600s (Madrid, Museo del Prado). This is a copy of a now lost portrait of Vázquez de Arce, president of the Royal Council of Castile.

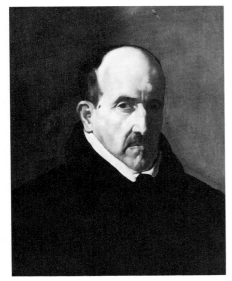

Figure 28. Diego Velázquez. *Luis de Góngora y Argote*, 1622 (Boston, Museum of Fine Arts. Maria Antoinette Evans Fund). Góngora (1561–1627), a famous court poet, wrote an epitaph celebrating El Greco and his art.

this important patron, recent research suggests that the well-known portrait in the Metropolitan Museum of Art identified as Cardinal Fernando Niño de Guevara (pl. 10) is actually a portrait of Sandoval y Rojas—a point further supported by comparing this painting with other likenesses of the Toledan prelate (figs. 29, 30).[117] Unfortunately, the precise nature of El Greco's relationship with the archbishop is still somewhat hazy, but the existence of this portrait suggests that the artist's rift with the cathedral chapter did not prevent him from receiving a commission from the head of Toledo's church. It is likely, in fact, that El Greco received at least one other commission from Sandoval y Rojas. In his will the cardinal bequeathed to his successor as archbishop "images of our Saviour and of the twelve Apostles."[118] Although these paintings have not been identified, the possibility exists that the famous Apostle series by El Greco that has been hanging in the sacristy of Toledo's cathedral at least since the eighteenth century (see cat. nos. 46, 47; pls. 59, 60) once belonged to the personal collection of this powerful archbishop.

Members of the lay community who became El Greco's friends and supporters were as important to him as his ecclesiastical patrons. Like the churchmen, they were often university graduates who pursued intellectual interests. Licenciado Domingo Pérez de Ribadeneira, for example, a judicial officer (*relator*) attached to the archbishop's council, was a lawyer who helped El Greco in a suit he brought against the Hospital of Charity at Illescas in August 1605. At issue before the council was the price of the altarpiece El Greco had just completed for the hospital's chapel; in view of the original terms of the signed contract, the council ought to have rejected the artist's demand for a new evaluation of the altarpiece, but instead it agreed to it. In the midst of the dispute, the hospital's lawyers asked Pérez de Ribadeneira to withdraw from the proceedings, alleging bias. The reason for this request is not entirely clear, but the incident suggests that Peréz de Ribadeneira had not acted impartially.[119] Three years later he was still on El Greco's side, serving as his bondsman under the terms of the 1608 contract with the Hospital of Saint John the Baptist.[120]

Two other influential Toledans who helped El Greco were Dr. Alonso de Narbona and Dr. Gregorio de Angulo, both of whom held important positions in the municipal government. Narbona, one of the city's parish representatives, was the lawyer who represented El Greco in his suit against the Illescas hospital. As one of the leading legal practitioners in the city and a professor of law at the university, Narbona had been asked to prepare a new edition of Toledo's municipal ordinances, published in 1603,[121] and he later wrote a long commentary on various aspects of royal law. But Narbona, like many members of Toledo's secular elite, also had literary interests. He belonged to a circle of erudites that included the famous jurist Dr. Jerónimo de Cevallos; Dr. Martín Ramírez de Zayas, the theologian who had awarded El Greco an important commission; and Dr. Luis de Belluga, a member of the San Bernardino College, another of El Greco's patrons.[122] Another member of this group was Narbona's brother, Eugenio, a learned churchman who had written a controversial book of political aphorisms.[123] Eugenio was especially close to Lope de Vega and to Luis de Góngora y Argote (fig. 28), the famous court poet who in 1614 wrote an

epitaph for El Greco's tomb. Were the Narbona brothers El Greco's link with Góngora? The answer is uncertain. There is, however, reason to believe that the Narbonas put the artist in touch with the Trinitarian friar and poet Hortensio Félix Paravicino, a famous court preacher whose portrait was painted by El Greco around 1609 (cat. no. 63; frontispiece).[124]

Among El Greco's friends in the civic elite there was none to compare with Dr. Gregorio de Angulo, the learned city councillor referred to earlier. Beginning around 1600, Angulo became a mainstay of El Greco and his family, helping the artist whenever he was in need. He served as El Greco's bondsman in 1603 and again in 1608, and lent both him and his son substantial amounts of money on several occasions. In 1604 he acted as godfather for one of the painter's grandchildren, a good indication that he had become a close family friend. Angulo also helped El Greco in his suit with the Illescas hospital, and in November 1607 he recommended that the city council accept El Greco's proposal for an altarpiece in the Oballe Chapel.[125] This chapel was part of a legacy left to the city in 1557 by Isabel de Oballe, the wife of a wealthy Toledan merchant. The money was intended to provide dowries for orphan girls and to endow a chapel in the parish church of San Vicente.[126] Work on the chapel project began in 1597, and in January 1606 the altarpiece commission was awarded to Alessandro Semini, an Italian artist then active in Toledo. When Semini died the following year with the altarpiece only partially finished, the city council appointed Angulo and the *jurado* Juan Langayo to find another artist to carry on the work. They proposed El Greco, who agreed to finish the project if he was allowed to make substantial changes in Semini's designs. El Greco's recommendations were submitted to the city council on December 11, 1607. After a brief discussion, during which a councillor praised El Greco as "one of the most outstanding artists in this or any other kingdom," the council voted to accept his proposal and to pay him 1,200 escudos (about 1,280 ducats).[127] Angulo's intervention on behalf of El Greco was evidently decisive on this occasion, as it had been once before. In 1606 Angulo's uncle Juan Bautista de Ubeda, a parish representative, and his brother, a local merchant, asked El Greco to execute an altarpiece for their family chapel in the parish church of San Ginés.[128] It seems reasonable to assume that Angulo had been instrumental here.

The commissions, connections, and loans provided by Angulo, Covarrubias, Salazar de Mendoza, and other acquaintances were obviously crucial to the advancement of El Greco's career in Toledo. Having failed to gain royal patronage, he was forced to compete against the rest of Toledo's painters for commissions; this hardly seems serious competition, but if El Greco was clearly the greatest Toledan artist, he also demanded higher fees than his competitors. This alone may account for his failure to obtain more commissions. Also, without an office or pension to support him, El Greco's income was subject to fluctuation. There were good times, when he was said to live like a prince, dining to the accompaniment of a band of musicians; and there were bad times, such as the years between 1608 and 1611, when he could not keep up with his rent payments.[129] But in good times and bad, he at least had the generous support of friends

Figure 29. Luis Tristán. *Cardinal Bernardo de Sandoval y Rojas*, 1619 (Toledo, Cathedral Chapter Hall). Sandoval was archbishop of Toledo from 1599 until his death in 1618. A dedicated church reformer, this wealthy prelate was builder of the villa Buenavista and was a celebrated patron of the arts. A comparison of Tristán's painting with the well-known portrait by El Greco long identified as the inquisitor general Cardinal Fernando Niño de Guevara (pl. 10) supports the recent reidentification of the El Greco as a portrait of Sandoval.

Figure 30. Artist unknown. *Cardinal Bernardo de Sandoval y Rojas*, early 1600s. (Madrid, Biblioteca Nacional)

PLATE 10. *Portrait of a Cardinal* — long identified as Cardinal Fernando Niño de Guevara; here identified as Cardinal Bernardo de Sandoval y Rojas — 67¼ x 42½ inches, circa 1600 (New York, The Metropolitan Museum of Art. Bequest of Mrs. H. O. Havemeyer 1929, H. O. Havemeyer Collection) >

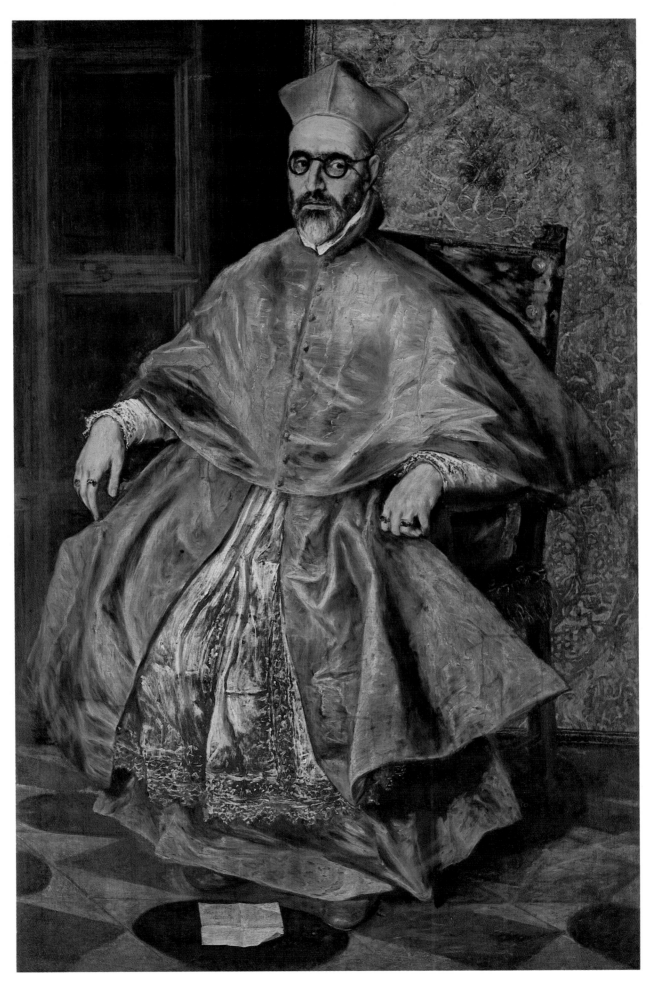

who recognized his genius and rewarded his decision to make his home in Toledo.

In 1589 El Greco formalized his commitment to Toledo by becoming a citizen (*vecino*). There were good grounds for this decision. Toledo was a prosperous, cosmopolitan city with numerous artists, but it did not yet possess an artist versed in the latest canons of Italian Mannerist art. As Spain's spiritual capital, Toledo also had a pressing need for an artist acquainted with the aesthetic principles and theological doctrines of the Counter-Reformation church. And in Toledo El Greco discovered a small but relatively wealthy group of scholars, intellectuals, and learned churchmen who were prepared not only to be his patrons but to accept him as a friend. Having found a milieu that offered him an opportunity to develop his unique artistic style, El Greco elected to remain in Toledo.

NOTES

Research for this essay was made possible by a grant from the U.S.–Spanish Joint Committee on Educational and Cultural Affairs; but without the help of archivists and librarians in the Escorial, London, Madrid, Simancas, and Toledo, very little could have been accomplished. I am particularly grateful for the support provided by Doña Esperanza Pedraza, Toledo's municipal archivist; Don Ramón Gonzálvez, archivist at the Cathedral of Toledo; and Don Ignacio Gallego, the diocesan archivist of Toledo. Fernando Marías was willing not only to share with me his extensive knowledge of Toledan architecture, but also to supply many of the photographs that accompany my text; I am forever in his debt. Others to whom I owe a special vote of thanks include Don Gregorio de Andrés, Jonathan Brown, John Elliott, Don Gregorio Marañón y Bertrán de Lis, Linda Martz, Mary Ellen Michel, Julian Montemayor, Sarah Nalle, Don Julio Porres, and Michael Weisser. I am also indebted to the Casa de Velázquez in Madrid and its director, Didier Ozanam.

The following abbreviations are used in these notes:

ACT	Archivo de la Catedral de Toledo
ADT	Archivo Diocesano de Toledo
AGS	Archivo General de Simancas
AHN	Archivo Histórico Nacional (Madrid)
AHPM	Archivo Histórico de Protocolos de Madrid
AHPT	Archivo Histórico y Provincial de Toledo
AMT	Archivo Municipal de Toledo
BL	British Library (London)
BE	Biblioteca de El Escorial
BN	Biblioteca Nacional (Madrid)
CODOIN	*Colección de documentos inéditos para la historia de España*
IVDJ	Instituto de Valencia de Don Juan (Madrid)
leg.	*legajo*
RAH	Real Academia de la Historia (Madrid)

1. Martín Gamero (1862), p. 981.
2. *Calendar of State Papers* (1890), vol. 7, pp. 144, 219.
3. Alcocer (1554), p. 124.
4. Horozco y Covarrubias (1874), p. 182.
5. Martz and Porres (1974), p. 12. Subsequent population figures are also from this work.
6. Viñas y Mey and Paz (1963), p. 567. The translation is a slightly amended version of that of Christian (1981), p. 150.
7. CODOIN, vol. 55, p. 600.
8. AMT: Libros del Cabildo de Jurados, 26 Mar. 1575. Hereafter cited as Libros de Jurados.
9. AMT: Cartas y Varios, 3 Aug. 1607.
10. Ringrose (1973), pp. 780–783.
11. AMT: Libros de Jurados, 2 Nov. 1581; AGS: Patronato Real, *leg.* 79, fol. 24 ("Memorial de la ciudad de Toledo," 26 Oct. 1583).

12. AMT: Cartas y Varios. Letter of the Cofradía de Nuestra Señora del Rosario, 21 Jan. 1605.
13. Cited in Domínguez Ortiz (1963), p. 352.
14. One of these émigrés was Pedro Laso de la Vega, Count of los Arcos, a man known to have been associated with El Greco. AMT: Cartas y Varios. Report of Manuel Pantoja, 1611.
15. RAH: Ms. N-40 ("Discursos y parecer del Lic. Jerónimo de Ceballos..."), fol. 2.
16. BL: Additional ms. 14,015, fol. 216.
17. AGS: Patronato Real, *leg.* 79, fol. 24.
18. AMT: Cabildo de Jurados, *caja* (1505–1593), 8 July 1567.
19. Cited in García Mercadal (1952), vol. 1, p. 879.
20. Aliaga Girbes (1968), p. 446.
21. BN: Ms. 19,344, fol. 47.
22. AMT: Archivo Secreto, *caja* 4, *leg.* 1, no. 64.
23. AMT: Archivo Secreto, *caja* 4, *leg.* 2, no. 70.
24. Morales (1575), p. 90 v.
25. Domínguez Bordona (1927), p. 88.
26. This project began in 1593. See Marías (1978), p. 1527.
27. Cited in Laínez Alcalá (1958), p. 169.
28. The poem is published in Martín Gamero (1857), pp. 175–187.
29. For a complete description of his library, see San Román (1910), pp. 195–197; San Román (1927), pp. 306–309; idem (1940–1941); and Marías and Bustamante (1981), appendix 2.
30. Hernández (1591), p. 220. For more on this university, see Beltrán de Heredia (1943), pp. 201–247.
31. Andrés (1975), p. 612.
32. BE: Ms. K.III.31, fol. 213 ff.
33. Gómez de Castro refers to his friendship with Castilla in AGS: Consejo Real, *leg.* 207-1, fol. 313 v.
34. For a brief biography of Schottus, see Sáinz Rodríguez (1975), p. 450. On his relations with Covarrubias, see Denucé (1918), vol. 8, p. 1206.
35. Marías and Bustamante (1981), p. 168.
36. San Román (1940–1941).
37. ACT: Libros de Actas, no. 14, 19 Feb. 1563.
38. This was the *Collectio concilorum hispaniae* (Madrid, 1593). He also published an edition of Saint Isidore's chronicles.
39. Fragments of their correspondence are in the BL: Egerton ms. 1875, fols. 37–38.
40. AHPM: *leg.* 1811, fol. 1494 ff., contains an inventory of Loaysa's collections at the time of his death.
41. For this commission see CODOIN, vol. 55, p. 607. See also chapter 2, p. 101.
42. See García Rey (1926), pp. 125–129.
43. Villegas (1578), vol. 1, p. 32.

44. See AGS: Expedientes de Hacienda, *leg.* 185, fol. 870. (This is a 1574 listing of silk merchants active in Toledo.)

45. For a brief biography of Cevallos, see Gómez Menor (1966b), pp. 81–84.

46. See Marañón (1956a).

47. For a brief biography of Angulo, see Millé y Giménez (1935). López de Ayala's academy is discussed in Salas (1931), pp. 178–181.

48. *Relaciones de las fiestas* (1605), p. 20. The translation is published in Lafuente Ferrari and Pita Andrade (1972), p. 110.

49. BN: Ms. 4100, fol. 31.

50. Viñas y Mey and Paz (1963), pp. 528–533.

51. Martz and Porres (1974), p. 14.

52. Marías (1978), vol. 1, p. 118.

53. BL: Egerton ms. 342, fol. 22.

54. Rodrigo de la Torre, cited in Mansilla (1957), p. 47.

55. For biographies of Quiroga, see Boyd (1954) and BN: Ms. 13044, fols. 128–135.

56. ADT: Legajos Diversos, 1500–1600. "Instrucción para el despacho de los negocios del Consejo," 22 Aug. 1598. Although these are the instructions of Archbishop García de Loaysa Girón, Quiroga had required that the council perform similar duties.

57. For more on the 1565 council, see Santos Diez (1967).

58. On the state of the diocese in 1577, see IVDJ: *Envío* 89, fol. 485.

59. BL: Egerton ms. 1873, fol. 138 v.

60. ACT: Libros de Actas, no. 16, 5 Apr. 1581.

61. ACT: Libros de Actas, no. 17, 3 June 1581.

62. For more on the 1582 council, see BN: Ms. 13019; and AGS: Estado, *leg.* 62.

63. *Constituciones sinodales hechas* (1583).

64. ACT: Libros de Actas, no. 17, 23 Dec. 1581.

65. *Canons and Decrees* (1950), session 25.

66. IVDJ: *Envío* 89, fol. 285.

67. San Román (1910), p. 145.

68. Cited in Porreño, fol. 1177.

69. For examples of these sermons, see Villegas (1589), vol. 4.

70. These included studies of three of Toledo's archbishops: Saint Ildefonso, Juan de Tavera, and Bartolomé de Carranza y Miranda.

71. Vega (1602), prologue.

72. Regarding Quiroga's personal devotions, see his last will (a copy is in the AHN: Consejos Suprimidos, *leg.* 27831).

73. The best account of the return of Leocadia's relics is Hernández (1591); another version is that in Pisa (1605).

74. For a debate over this issue, see ACT: Libros de Actas, no. 17, 17 July 1584.

75. BN: Ms. 12974–23 ("Representación al Archiduque Alberto de Austria, Arzobispo de Toledo, en el año 1595, sobre varios abusos que se notaban en el Arzobispado, y su remedio").

76. ADT: Legajo: Visitas, 1595–1598. "Instrucciones de don García de Loaysa . . . ," 6 Oct. 1598.

77. *Constituciones sinodales* (1601). p. 93.

78. García Rey (1931), p. 78.

79. For lists of *consultores* in the 1590s, see AHN: Inquisición, *leg.* 3097, no. 83; *leg.* 3080, no. 77; *leg.* 3082, no. 54.

80. On *beatas*, see Christian (1981), pp. 16–17.

81. BN: Ms. 1293 ("Historia eclesiástica de la ciudad de Toledo"), fol. 199 v.

82. Teresa de Avila (1951), p. 942.

83. Regarding Theresa's friends in Toledo, see Peers (1952).

84. Soehner (1961), pp. 15–17.

85. Sandoval (1568), p. 89.

86. For a transcript of this proceeding, see Llamas Martínez (1972), pp. 486–488.

87. Peers (1952), pp. 64, 81.

88. *Relaciones de las fiestas* (1605), p. 54 v.

89. Medina (1570), p. 238.

90. Long thought to be Diego de Castilla's brother, Luis was actually his "natural" son. See IVDJ: *Envío* 55, no. 13, fol. 15 (Luis de Castilla to Mateo Vázquez, 9 Feb. 1590; on the dorse is written "*su genealogía*"). This document was brought to my attention by Gregorio de Andrés, who in a forthcoming article will publish other information concerning Luis de Castilla's life.

91. For a short biography of Chacón, see BN: Ms. 1293, fols. 187–190.

92. AGS: Patronato Eclesiástico, *leg.* 137 (no fol.), letter dated Cuenca, 20 Mar. 1579.

93. On El Greco's life in Rome, see chapter 2 and Vegüe y Goldoni (1926–1927).

94. San Román (1910), p. 187.

95. For a biography of Castilla, see García Rey (1923).

96. Chapter 2 discusses the circumstances surrounding this commission.

97. The dispute is explained in chapter 2.

98. CODOIN, vol. 55, p. 605.

99. See San Román (1927), pp. 165–171.

100. *La Ilustre Fregona*, in Cervantes (1980), vol. 2, p. 186.

101. Marías and Bustamante (1981), p. 170.

102. Beltrán de Heredia (1943), p. 220 ff. On Ramírez's literary contacts, see BN: Ms. 4100, fol. 31. See also Alonso de Zayas, *Vida y virtudes del venerable . . . Doctor Martín Ramírez de Zayas* (Madrid, 1662).

103. For more on this commission, see Soehner (1961).

104. San Román (1910), p. 217.

105. See chapter 2 on El Greco's difficulties with the cathedral.

106. San Román (1910), p. 143.

107. For a brief autobiographical sketch, see Salazar de Mendoza (1603), p. 305. See also AHN: Consejos Suprimidos, *leg.* 15191, *consulta* of 25 July 1591. This document indicates that he was a graduate of Osuna, a small Andalusian university, where he also served as a professor.

108. Salazar de Mendoza (1618), p. 123. On his art collection, see San Román (1914), p. 115.

109. See San Román (1914), pp. 112–124.

110. Salazar de Mendoza (1618), p. 33.

111. See San Román (1927), p. 162; Bustamante (1972); and Marías (1979). For a brief biographical sketch of Chiriboga, see AHN: Consejos Suprimidos, *leg.* 15201, *consulta* of 17 Nov. 1602.

112. AHN: Consejos Suprimidos, *leg.* 27831; Wethey (1962), vol. 2, p. 207, cat. no. X197.

113. His treatise, "Libro de la fundación de la santa iglesia de Toledo, sus grandezas, primacía, dotaciones, y memorias," was never published. For a copy, see AHPT: Colección Lorenzana, ms. 198. For a brief biographical sketch, see AHN: Consejos Suprimidos, *leg.* 15199, *consulta* of 20 Feb. 1599.

114. See AHPT: Ms. I/87, no. 8. The license is dated 12 Dec. 1602; the contract was signed in July of 1603.

115. See Wethey (1962), vol. 1, p. 15; and García Caraffa (1952–1963), vol. 19, p. 13.

116. San Román (1927), p. 162.

117. Jonathan Brown and Dawson Carr, "A Case of Mistaken Identity: El Greco's 'Portrait of a Cardinal,'" in Brown (1982).

118. AHPM: *Leg.* 2310, fols. 1202–1218 (testament dated 12 Apr. 1618).

119. San Román (1927), p. 182.

120. San Román (1914), pp. 112–124.

121. These were the *Ordenanzas y privilegios de la ciudad de Toledo.*

122. BN: Ms. 4100, fol. 31.

123. See Vilar (1968), pp. 7–28.

124. For a biography of Paravicino, see Alarcos (1937), pp. 162–197, 249–319. Regarding Eugenio Narbona's ties to Góngora, see Jammes (1967), pp. 180, 504. Paravicino, incidentally, was a life-long friend of Góngora.

125. Details of Angulo's relationship with El Greco may be found in San Román (1910), pp. 161, 166–167, 183–184, 223, and idem (1927), pp. 194–195, 275–277.

126. See AMT: Libros de Actas, 24 Oct. 1581.

127. See San Román (1927), p. 280.

128. Ibid., pp. 196–197. Bautista de Ubeda was married to a sister of Angulo's father. See AHPT: *Leg.* 1899, last will of Francesca de Valladolid, 17 Oct. 1593.

129. Jusepe Martínez, a seventeenth-century artist writing long after El Greco's death, mentioned his extravagance; see Marañón (1956b), p. 308. On his rent problem, see San Román (1910), pp. 170–177.

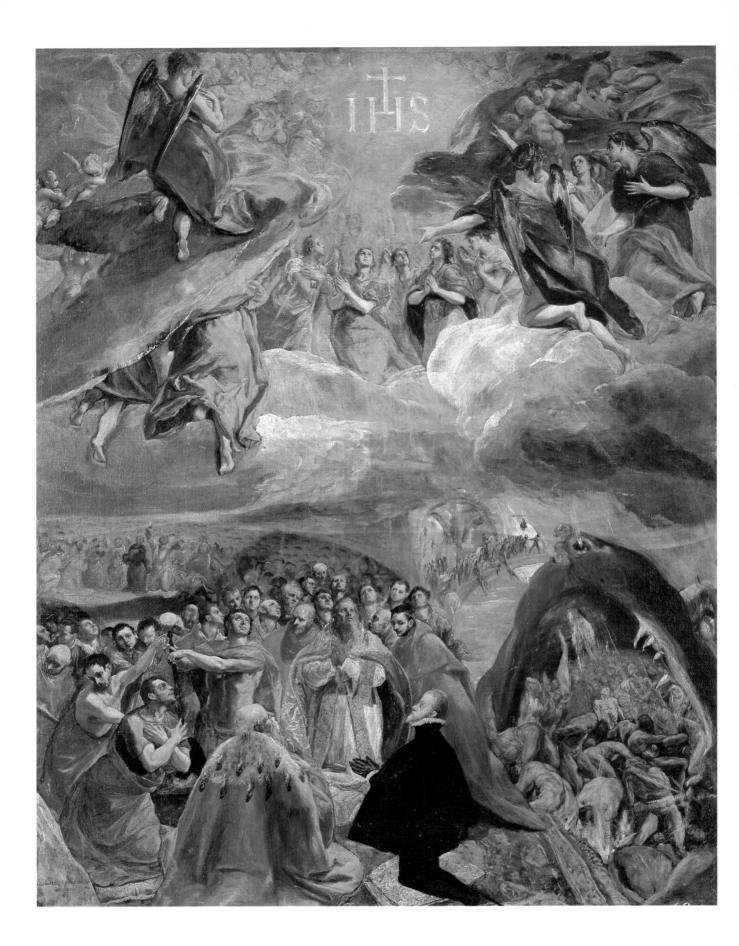

PLATE 11 (cat. no. 12). *Allegory of the Holy
League* (*Adoration of the Holy Name of
Jesus*), 55⅛ x 43¼ inches, circa 1577–1579
(El Escorial)

2 El Greco and Toledo

JONATHAN BROWN

Crete gave him life and the painter's craft,
Toledo a better homeland, where through
Death he began to achieve eternal life.[1]

In these lines of a sonnet first published in 1641, Fray Hortensio Félix Paravicino skillfully compressed two important elements of El Greco's biography into a telling metaphor of his artistic development. Paravicino, famous in his day as a preacher and poet, had become acquainted with El Greco around 1609, when he sat for his portrait in Toledo (cat. no. 63; frontispiece). Because of this connection, Paravicino's poem has come to be regarded as a significant historical document, testifying as it does to the importance of Toledo as the source of El Greco's artistic inspiration. This idea has now become widely accepted, and not without reason. After all, there can be little doubt that before his arrival in Toledo, El Greco was not a distinguished or successful painter, whereas almost from the moment he set foot in the city, he created masterpiece after masterpiece. But what exactly did Toledo contribute to El Greco's development as an artist? Not surprisingly, there is no simple reply to this essential question. But in the search for an answer, it is important to remember that El Greco was not a young man when he came to Toledo. In 1577, the year of his arrival, he turned thirty-six years old. This fact suggests that it would be wise to go back to El Greco's beginnings and discover what can be learned from the little that is known about his activities during the first half of his life. In this way we may be better able to understand the events and developments of the second half, the crucial years in Toledo.

El Greco in Crete

The reconstruction of El Greco's life and development from 1541, when he was born, until 1577, when he appeared in Toledo, is largely a matter of supposition. Only a handful of sources and documents attest to his pre-Spanish existence, and most of these relate to the ten-year period when he lived in Italy. Then there are the paintings, which have proved to be as difficult to interpret as the documents. Fortunately, discoveries of the last few years can now provide some important information about these blank chapters of El Greco's biography.

By his own testimony, El Greco was born in 1541, the place being Candia, capital of the island of Crete.[2] Nothing is known of his early life on the island, and it is not until June 6, 1566, that his existence is recorded for the first time.[3] On that date, the name of El Greco (or Domenikos Theotokopoulos, as he was known in Greek), then twenty-five years old, appeared in the registers of a notary public in Candia. There he is mentioned as a master painter, the son of "Jorghi," the brother of Manoussos. Six months later, his activities as a painter are documented for the first time. On December 26, 1566, El Greco obtained authorization to sell a painting by lottery.[4] The painting represented a scene from the Passion of Christ and was executed on a gold background; in other words, it was probably what is now called a Byzantine icon. One day later, the value of the painting was appraised by two fellow painters, one of whom was George Klotzas, a well-known Cretan icon painter and miniaturist.

The importance of these newly found documents is greater than might appear, especially when they are considered in the light of earlier attempts to reconstruct the style of the youthful artist. In the first place, they establish that El Greco learned how to paint in Crete, probably in Candia. Therefore, he was trained as an icon painter, working in the late-medieval style properly known as post-Byzantine. It would be almost impossible to identify works from El Greco's Cretan period, but we can reconstruct an idea of the style simply by looking at paintings by contemporary Cretan painters. For instance, a *Madonna and Child* (fig. 31) attributed to Andreas Ritzos, who is documented as working at Candia in the 1560s, shows the characteristic post-Byzantine style that prevailed at Crete in this period.[5]

The style, in effect, is simply a continuation of the highly formalized manner of Byzantine icon painting that had been traditional in the Greek Orthodox world since the early Middle Ages. Using egg tempera as a medium, gold as a ground, and wood as a support, these paintings made only a minimal attempt to imitate reality. Neither were they much influenced by the naturalism of Italian Renaissance art. The figures are modeled on established prototypes, not on life studies. Interest in illusionistic space is almost nonexistent; depth is represented by the vertical arrangement of figures and accessories instead of by more sophisticated three-dimensional perspective. Little attempt is made to reproduce accurately the colors of nature. And finally, the style is nearly devoid of psychological insights into the people and events portrayed. In short, the post-Byzantine style was artificial art, resolutely unconcerned with the imitation of nature, devoutly dedicated to working artfully within a fixed set of rules.

El Greco's schooling in the style is not entirely a matter of supposition. The document of December 26, 1566, specifically mentions that his painting had been executed on the customary gold background. Also, the employment of George Klotzas as an appraiser of El Greco's painting is significant, because he was a talented practitioner of the post-Byzantine manner. His opinion would have been valuable only if El Greco's painting had been done in a style and technique similar to his own. Finally, there is the fact that the post-Byzantine style was the prevalent style practiced on Crete. The so-called Veneto-Cretan manner, in effect a westernized Byzantine style, was used on the Venetian mainland, but only rarely on Crete.[6] Therefore every significant painter who learned his craft in Candia was almost certainly a Byzantine painter.

Figure 31. Attributed to Andreas Ritzos. *Madonna and Child*, circa 1560 (Princeton, The Art Museum, Princeton University. Gift of Allen Marquand)

The Venetian Sojourn, circa 1567–1570

El Greco's ambition to transform himself from Byzantine icon painter to Italian Renaissance master was a bold one. There was, to be sure, a school of painters working in and around Venice who practiced a "mixed" style compounded of Italian and Byzantine elements. These painters have become known as *Madonneri*—painters of devotional images, often representations of the Madonna and Child. But the impact of the *Madonneri* on El Greco was negligible. They were Italianized Greek folk painters who mass-produced inexpensive religious paintings in a clumsy technique, often borrowing their compositions from engravings after works by Italian masters. During the 1930s and 1940s, dozens of their low-quality pictures

Figure 32. Master Domenikos. *Modena Triptych* (front), circa 1560–1565 (Modena, Galleria Estense)

Figure 33. Attributed to Michael Damaskinos. *Annunciation*, 1570s (Venice, San Giorgio dei Greci)

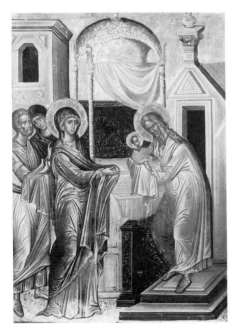

Figure 34. Attributed to George Klotzas. *Presentation of Jesus in the Temple*, 1570s (Venice, San Giorgio dei Greci)

were thought to have been painted by El Greco in the period of circa 1560–1565. But since it has now been established that he was living in Crete instead of Venice at this time and was working in the post-Byzantine style, it is improbable that any of these pictures was executed by him.[7]

The hackwork of the *Madonneri* is useful as a negative point of comparison, however. These artisans had neither talent nor ambition and were content to grind out their clumsy little pictures in wholesale quantities (fig. 32). El Greco, on the other hand, appears to have decided to remake his art from the ground up, to become an accomplished master of the Italian style. The enormous dimensions of this task can be gauged by studying the pictures not only of the *Madonneri* but also of two of the major Cretan painters of the time, Michael Damaskinos and George Klotzas (the man who appraised El Greco's icon painting in 1566), both of whom spent time on the mainland.

Damaskinos went to Venice in 1577 to work on the decoration of San Giorgio dei Greci, the Orthodox church, and remained until 1582.[8] He then returned to Crete, where he decided to stay despite attempts to lure him back to Venice. The impact of Venetian art on his Byzantine style was minimal (fig. 33); it succeeded in transforming him from a Paleogean to a trecento painter. Much the same occurred in the art of Klotzas, who also worked at San Giorgio in the late 1570s.[9] Although he possessed a more individualized manner, Klotzas left Venice with his Byzantine style largely intact (fig. 34).

By contrast, El Greco began to retrain himself as an Italian artist as soon as he arrived in Venice. Now that it is known that his Venetian sojourn lasted no more than three and a half years (rather than a decade, as had formerly been thought) and that he was probably trained within the Byzantine style, it is worth reevaluating the evidence of this critical period in his life.

The date of El Greco's arrival in Venice is unknown, but it might have occurred in 1567. Certainly by August 18, 1568, he was living in the city, as proved by the only document of his presence so far discovered. Unfortunately, the additional information contained in this document is only of marginal interest (it concerns some drawings, probably cartographic drawings, that El Greco had sent to a Cretan mapmaker).[10] The Venetian

period ended just two years later. By the autumn of 1570, he had left Venice for good and was en route to Rome. Upon arriving in Rome in November, he made contact with a miniature painter, Giulio Clovio, who in a letter of November 16, referred to the foreigner as a "young Candiot, who is a disciple of Titian."[11]

This reference to El Greco as a "disciple" of Titian has always been accepted as proof of the fact that he had worked in the studio of the great Venetian master, who was in his eighties when El Greco came to Venice. But no firsthand evidence of the apprenticeship or assistantship is known, perhaps because it never occurred. There are two reasons for casting doubt on the supposed relationship. First is the purpose of the letter, which was written by Clovio to his patron, Cardinal Alessandro Farnese, requesting that El Greco be given temporary lodgings in the cardinal's palace. In these circumstances, Clovio might have decided for strategic reasons to enhance the stature of an unknown foreign painter (Clovio does not bother to mention the artist by name) by linking him with the great Titian. Second, the word *disciple* as used in sixteenth-century Italy did not necessarily mean "pupil"; it could also be used to mean "follower," a term that might be applied to anyone who imitated another master, whether or not there was a working relationship between the two.[12]

The consequences of "removing" El Greco from Titian's atelier are not as great as might first be imagined. For one thing, it has often been noted that the debt of El Greco to Titian is by no means obvious or overwhelming in the few surviving works from his Venetian period. Moreover, it is clear that El Greco was also inspired by the paintings of other contemporary Venetian painters, notably Tintoretto. Finally, the detachment of El Greco from Titian's workshop allows us to see the Venetian pictures in a different light — as the work of an autodidact in the Italian Renaissance style who had to struggle to overcome his Byzantine origins, rather than as an immediate disciple of a great painter.

The key piece for understanding El Greco's Venetian period is the *Purification of the Temple*, in the National Gallery of Art, Washington (cat. no. 2; pl. 12), which is signed by the artist. The first point of note is the medium and dimensions of the work. It is painted with tempera on a wooden panel measuring 25³/₄ inches high by 32³/₄ inches wide. The medium and support, and to a lesser extent the modest size, are characteristic of the icon painter and were employed by El Greco in all the works that can be surely assigned to his Venetian period. Also typical of icon painters is the technique, which is based on a multitude of short, unblended, somewhat labored brushstrokes. But the composition and the coloring clearly belong to the sphere of Italian painting.

Because he was not yet accustomed to the intricacies of Italianate pictorial composition, El Greco appropriated a design created by Michelangelo that was circulated through copies in other media (fig. 35).[13] The figural composition in the El Greco painting is set within an elaborate perspective construction, comprised of various architectural elements. It quickly becomes apparent that the architecture is illogical and the perspective overcomplicated for the small scale of the work. The floor is divided into steps and articulated by alternating colored tiles or marble squares, the

Figure 35. Marcello Venusti (after Michelangelo). *Purification of the Temple*, circa 1560 (London, The National Gallery. Reproduced courtesy of the Trustees)

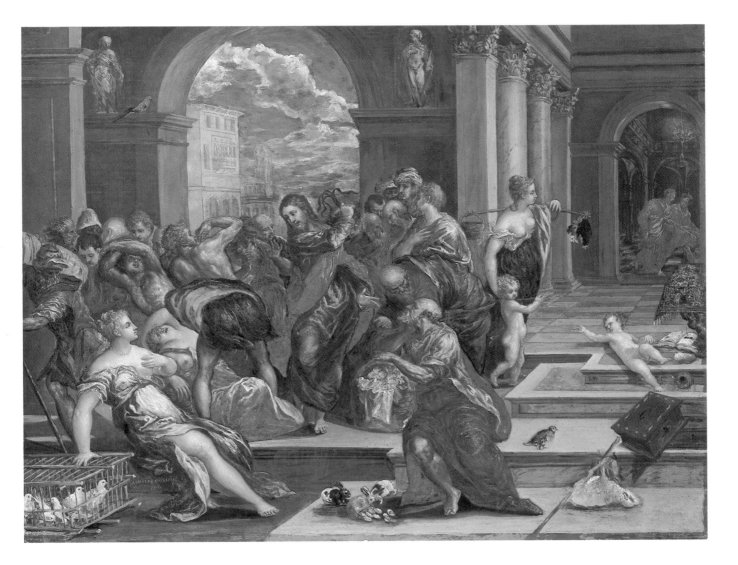

PLATE 12 (cat. no. 2). *Purification of the
Temple*, tempera on panel, 25 3/4 x 32 3/4 inches,
before 1570 (Washington, National Gallery
of Art. Samuel H. Kress Collection 1957)

typical Renaissance device for creating the illusion of receding space. The elevation of the building combines colonnades, arches, columns, and pilasters without much thought for the rules of harmonious architecture. The result resembles a pastiche from a Renaissance architectural treatise and suggests that El Greco culled motifs from one of the most important of these, Sebastiano Serlio's *First Book of Architecture* (Venice, 1551; fig. 36), and combined them with a lack of restraint and understanding typical of a novice.

Figure 36. Page from Sebastiano Serlio's *First Book of Architecture* (Venice, 1551)

As for the figures, they are drawn by a hand still uncertain of its grasp of High Renaissance figure style. The proportions are squat, the poses are awkward and imperfectly realized, the spatial relationships are crowded and jumbled. Certain individual figures are closely modeled on the work of the leading Venetian painters of the day, notably the half-clad woman seated in the lower left, whose pose and proportions reveal the study of Tintoretto. As a matter of fact, we know from a comment later written by El Greco that he admired Tintoretto and considered his *Crucifixion* in the Scuola di San Rocco (completed in 1565) to be the "greatest painting that exists today in the world."[14]

Yet it is difficult to isolate the preponderant influence of any single Venetian painter in this work. El Greco's stay in Venice coincided with the greatest moment in the city's artistic history. Not only Titian and Tintoretto, but also Veronese and Jacopo Bassano were active in the mid- to late 1560s, and El Greco seems to have studied the works of them all. If the rich colors seem to be derived from Titian, the movement and attempt at drama are closer to Tintoretto. In other words, the *Purification* is a patchwork of ideas, motifs, and techniques that has been stitched together by an eager but uncertain hand. Consequently, all the seams are visible.

A reasonable explanation for the eclectic character of this picture is that its author was, in effect, a twenty-six- or twenty-seven-year-old novice who, in a short space of time, was trying to teach himself a new style of pictorial representation. This style was in many ways the antithesis of the one he had learned as a youth, and the conquest would be difficult. But the fierce ambition to succeed as a modern painter must have spurred El Greco on to complete his education. By late in 1570, having absorbed the painterly technique and the rich, expressive colors of Venetian painting into his style, he set out for Rome to refine what he had learned and to improve his skill in depicting the human figure.

El Greco in Rome

El Greco arrived in Rome in November 1570, as we learn from the letter of Giulio Clovio to Cardinal Farnese. His route from Venice to the south seems to have passed through Parma, where he saw paintings by Correggio, an artist whom he greatly admired. Years later he mentioned the figure of the Magdalen in Correggio's *Madonna and Child with Saints Jerome and Mary Magdalen* (Parma, Galleria Nazionale) as "the most singular figure in all of painting."[15] This famous picture hung in its original location in the Church of San Antonio until 1712; hence El Greco could only have seen it in Parma. El Greco also had lavish words of praise for

Correggio's painting in the dome of Parma's cathedral, which further proves his firsthand knowledge of the city.

The documented events of El Greco's life in Rome, once again, are meager and can be quickly recounted. The first of them suggests that he indeed found a place in the sizable entourage of Cardinal Farnese. On July 18, 1572, the cardinal's majordomo wrote his master a letter that, in passing, mentioned the fact that *"il pittore greco"* was working on the decoration of the Hall of Hercules in the Farnese villa at Caprarola.[16] Circumstances suggest that the Greek painter and El Greco were one and the same. The project was then under the supervision of Jacopo Bertoia, a painter from Parma, whom El Greco was presumably assisting. No trace of his hand can be detected in the work.

Exactly two months later, El Greco was admitted to membership in the Roman Academy of Saint Luke.[17] The entry beside his name reads *"pittore a carte"* ("miniature painter"), which suggests that the miniaturist Giulio Clovio was still lending his support to El Greco. Admission to the Academy, then still essentially a guild, was determined by a practical examination, and the fact that El Greco entered as a miniature painter indicates that he might have felt more confident about working on a small scale. Once inscribed in the guild rolls, El Greco was entitled to open a workshop and could begin to earn a living as an independent master. Finally, the guild membership means that El Greco was now planning to settle in Rome and start his career as an Italianized painter. But we hear no more of him, at least from documents, until he had left the city and arrived in Spain.

Fortunately, two sources give us some additional information about El Greco's life in Rome. The earliest of these comes from the pen of a contemporary of El Greco—Pirro Ligorio, a former papal architect who had fallen from favor in 1564 and had left Rome in 1568 to become court antiquarian in Ferrara. Ligorio had had contacts with Cardinal Farnese and his entourage during his Roman years and when he returned to the city in 1573, he went to see his friends at the Farnese Palace. By this time, Ligorio had become an embittered man, whose temper flared whenever his exaggerated sense of self-esteem was injured. Apparently something said or done by Giulio Clovio wounded Ligorio's sensitive ego and sent him into a fit of anger, which he memorialized in his journal. Ligorio's diatribe, besides casting aspersions on Clovio's pretensions to mastery of drawing, mentions in passing Clovio's "friend who has come to Rome from overseas."[18] It has been plausibly suggested that this friend was El Greco, which if true would provide further evidence of the close connection between the two artists and of the fact that El Greco was still associated with the Farnese circle in 1573.

The second source of additional information about El Greco's career in Rome was not written by a contemporary of the artist. This is a manuscript composed around the years 1617 to 1621 by a Roman physician who was an amateur of art, Giulio Mancini.[19] Despite the fact that Mancini wrote his account some forty years after El Greco's departure from Rome, his main informant appears to have been trustworthy—an obscure painter named Lattantio Bonastri da Licignano, El Greco's only known Italian pupil (active

1580s). Mancini's account is brief, but it contains a few important observations that can be verified by later events in El Greco's life. First, Mancini takes note of El Greco's "fresh" approach to painting in a Venetian manner. He also makes passing reference to the fact that El Greco painted for private (as opposed to institutional) patrons, to whom his paintings gave great satisfaction. Finally, he relates an anecdote that has become famous in the literature on El Greco. According to Mancini, Pope Pius V was offended by some of the nudes in Michelangelo's *Last Judgment* in the Sistine Chapel and ordered them to be painted over. On hearing of this, El Greco offered to repaint the entire fresco with "honesty and decency," and equal mastery, if it were knocked down. The next statement by Mancini appears to be fanciful—that El Greco's presumptuous challenge to the great Michelangelo so infuriated the painters of Rome that El Greco was forced by their ire to flee to Spain.

The information communicated by Mancini, if vague in details, is fundamentally credible. El Greco's lack of admiration for Michelangelo as a painter was expressed by the artist when he was in Spain. The implication that El Greco had an arrogant, contrary side to his personality also is borne out by events in his Spanish career. And, finally, Mancini's observation that El Greco's patrons were to be found among individual collectors seems to be correct as well, if difficult to substantiate.

The answer to the riddle of El Greco's patronage in Rome seems to lie within the walls of the Farnese Palace.[20] Cardinal Alessandro Farnese (1520–1589) was a powerful member of the papal court. His family had come to prominence when one of their number was elected pope, reigning from 1534 to 1549 as Paul III. After establishing their wealth and position, the Farnese family became important patrons of art and architecture, a tradition continued by Cardinal Alessandro, who supplied funds for the building of the Church of the Gesù in Rome and who also undertook the construction of the magnificent villa at Caprarola, where El Greco was at work in 1572.[21]

Cardinal Farnese also bestowed his patronage on writers and scholars, who worked in the library of his palace under the aegis of the librarian, Fulvio Orsini. Orsini (1529–1600), renowned in his time as the greatest living scholar of classical antiquity, maintained a correspondence with classicists all over Europe.[22] In addition to caring for the Farnese library, Orsini was an avid collector in his own right, specializing in rare books, antiquities, and works of art. His picture collection was small but choice and contained works by or attributed to the greatest names of Renaissance art—Michelangelo, Titian, Bellini, Raphael—as well as a host of other well-known artists. Orsini also acquired seven paintings by El Greco, which were listed in an autograph inventory drawn up in January 1600.[23] Only one of these paintings, four of which were miniatures, is known today—the splendid portrait of El Greco's friend Giulio Clovio (cat. no. 57; pl. 13).

El Greco's acquaintance with Orsini was important in another respect: the Farnese librarian was at the center of an impressive group of classical scholars, theologians, artists, and connoisseurs. Guided by Orsini's inspiring example, they achieved an exemplary union of art and learning. Cooperation between artists and scholars was not unusual in sixteenth-

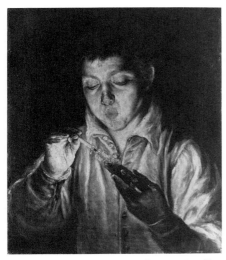

Figure 37. El Greco. *Boy Lighting a Candle*, 23¼ x 20 inches, circa 1570–1575 (Naples, Museo e Gallerie Nazionale di Capodimonte)

century Italy. In fact, the desire of artists to be considered men of learning and high culture brought them into ever-closer contact with scholars like Orsini. The benefits of such collaboration were manifold. The men of letters put their store of knowledge at the disposal of the artists, assisting them in the formulation of learned subject matter for their paintings. Orsini, for example, was twice commissioned to provide the programs for the decoration of rooms in the Villa Farnese at Caprarola.[24] At the same time, the scholars provided an understanding audience for artists who were attempting increasingly complex compositions and choosing increasingly recondite subjects. The sophisticated, elitist art that resulted from this collaboration could flourish only in the hothouse atmosphere of the scholar's study or the learned painter's atelier, or in the protected environment of a princely court. In the Farnese Palace all these conditions were combined, and it became therefore the ideal center for this characteristic expression of late sixteenth-century culture. El Greco, as a visitor and possibly a resident of the palace, was profoundly affected by the activities of its privileged circle of select spirits. Their influence on his art is difficult to detect in the small corpus of works that survive from his Roman period (although it was decisive for his art in Spain), but there is at least one painting, known in two autograph versions, that evinces the spirit of the Orsini circle—*Boy Lighting a Candle* (cat. no. 4; pl. 30; fig. 37).

At first glance, this picture's content seems remote indeed from the empyrean intellectual realms inhabited by Orsini and his friends. But there is good reason to interpret this apparently inconsequential subject as a type of painting called an *ekphrasis*. The purpose of such pictures, which were frequently painted in the Renaissance, was to recreate famous lost masterpieces of antique painting on the basis of remaining literary descriptions of the ancient works. The *Boy Lighting a Candle* is an ekphrasis of Antiphilus's painting of the subject as described by the elder Pliny in his *Natural History* (35.138).[25] Once we know the literary source of the picture, we can understand it as an intellectual as well as an artistic tour de force and see how it relates to the learned ambience of the Orsini circle. It is even possible that Orsini played a role in the conception of the picture. The Naples version of the *Boy Lighting a Candle* is known to have been part of the Farnese collection and was in the palace in Rome until the early seventeenth century.[26] These circumstances invite speculation that its genesis involved collaboration between a painter and a humanist who perhaps intended to present the work to their mutual patron.

Orsini's patronage of artists seems to have been generous, if we can judge by the contents of his collection. He owned paintings by many important artists who worked in Rome in the 1560s and 1570s, including Daniele da Volterra, Francesco Salviati, Jacopino dal Conte, Girolamo Siciolante, Marcello Venusti, and Federico Zuccaro, several of whom had been employed by Cardinal Farnese. Some of these painters were dead or gone before El Greco came to Rome, but he could have seen works by them all. In fact, the paintings done by these artists and their contemporaries in Rome are of fundamental importance to an understanding of how El Greco's style of painting and thought matured.

El Greco's arrival in Rome coincided with a particularly unsettled period

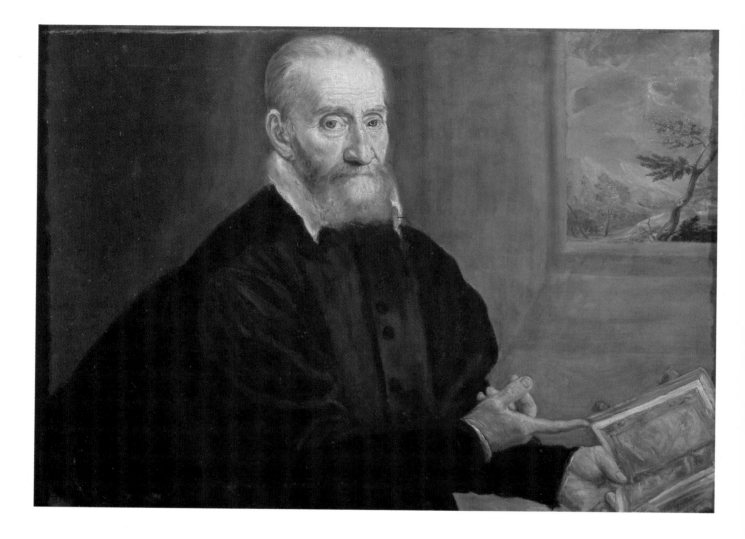

PLATE 13 (cat. no. 57). *Giulio Clovio*, 22⁷/₈ x
33⁷/₈ inches, circa 1570 (Naples, Museo e
Gallerie Nazionale di Capodimonte)

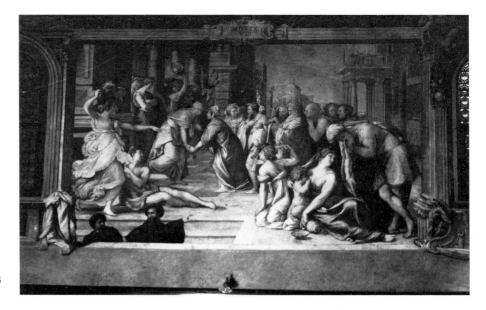

Figure 38. Francesco Salviati. *Visitation*, 1538 (Rome, Oratory of San Giovanni Decollato)

Figure 39. Battista Franco. *Arrest of the Baptist*, 1541 (Rome, Oratory of San Giovanni Decollato)

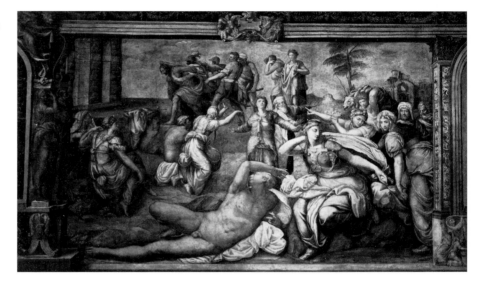

in the history of Italian painting. The attempts to clarify and reform Catholic doctrine and practice initiated at the Council of Trent in 1545 had begun to have an impact on religious art in central Italy, especially after 1560. The leading painters of Rome in the 1550s had worked in a style that has come to be known as High Mannerism or Maniera.[27] This style was based in principle on the works of Raphael and Michelangelo. But the effortless grace of the former and the powerful figure style of the latter were systematically elaborated and exaggerated by artists who were concerned both with art as an expression of abstract aesthetic ideas and with technical virtuosity. The balance between style and content is always fragile, and when it is upset, the results are almost predictable — either impenetrable preciosity or unbearable banality, depending on which way the scale is tipped.

The painters of mid-sixteenth-century Rome had clearly come down on the side of art for the sake of artificiality. In the hands of the talented painter Francesco Salviati, the studied elegance of the figures and the controlled complexity of design and composition in the *Visitation* (fig. 38) compensate for the subordination of the dramatic encounter of Saint Elizabeth and the Virgin Mary. But in the painting *Arrest of the Baptist* (fig. 39) by Battista Franco, a decidedly less-gifted painter, the self-conscious posturing of the ancillary figures overwhelms the main event and

makes it seem like a trivial and secondary part of the story. The artful representation of the human figure was not regarded as a central tenet of Catholic theology by the ecclesiastical authorities concerned with the reform of their church, and they began to apply pressure on artists to reorder their priorities. In the new order of things, content was to take precedence over style. One writer of the period, G. A. Gilio da Fabriano, succinctly stated the new aesthetic of "truth": "A thing is beautiful in proportion as it is clear and evident."[28]

Thus, beginning around 1560, painters of the Maniera began to reform their styles in an attempt to meet this prescription.[29] Their efforts resulted in a compromise that had a greater impact on composition than on style, as can be seen in two versions of the same theme executed about thirteen years apart. In Francesco Salviati's fresco *Conversion of Saint Paul* (fig. 40), the principal effect of the miracle is to tie Saint Paul into a bizarre human knot. Around him animals prance and soldiers strut and dance. The figure of Christ is small in scale and set back in the space of the picture. Taddeo Zuccaro's representation of the episode (fig. 41), painted in 1563, still employs the same well-muscled figure types and displays a certain amount of self-conscious posing. But the primacy of the narrative has been restored by placing the emphasis on the dramatic communication between Christ and Saint Paul.

The union between Catholic doctrine and Maniera style was never a happy one. Once the elements of capriciousness and showmanship were suppressed, the Maniera style became merely ponderous (fig. 42). The strong emphasis on the propagandistic function of art produced clarity and decorum to be sure, but also tedium. The 1570s in Rome thus witnessed the development of an official style that, like all official styles, left little room for the imagination of the artist or the pleasure of the viewer. El Greco had a chance to observe the phenomenon at close hand while he worked at the Villa Farnese at Caprarola, whose decoration is a prime example of the style, called Counter-Maniera. In the Hall of Farnese Deeds were narratives of Farnese history painted by Taddeo Zuccaro.[30] In the Hall of Hercules, the decoration was being carried out by Jacopo Bertoia, who had succeeded Federico Zuccaro, an important Counter-Maniera painter whom El Greco knew well. By 1580 a new influx of younger artists was arriving in Rome, a group who would begin the process of enlivening this desiccated style of the Counter-Reformation; but by that time, of course, El Greco had gone.

Fortunately, there was more to see in Rome than the work of contemporary artists, notably the by-then-classic works of Michelangelo and Raphael. Michelangelo in particular exercised a great hold on El Greco's imagination. He had died only six years before El Greco came to Rome and his example was still fresh in the minds of artists who had known him and submitted to his overpowering influence. Among these was Giulio Clovio, whose workshop, like the workshop of almost every artist of the day, contained dozens of copies after the master's compositions. Clovio also owned a priceless original drawing by Michelangelo, the *Resurrection* (fig. 43), which El Greco saw in Rome and would later recall in a painting done in Spain (fig. 56).[31]

Figure 40. Francesco Salviati. *Conversion of Saint Paul*, circa 1550 (Rome, Cancelleria, Capella del Palio)

Figure 41. Taddeo Zuccaro. *Conversion of Saint Paul*, 1563 (Rome, San Marcello al Corso, Capella Frangipane)

Figure 42. Giorgio Vasari. *Return of Pope Gregory XI from Avignon*, 1572. (Vatican, Sala Regia)

Figure 43. Michelangelo. *Resurrection*, 1532–1533 (Windsor Castle, Royal Library. Reproduced by Gracious Permission of Her Majesty Queen Elizabeth II)

El Greco, however, was not among the unqualified admirers of the "divine Michelangelo." On the one hand, El Greco disliked Michelangelo's paintings because of their deficient mastery of color. As he was to write later in his life, "Michelangelo did not know how to paint portraits or represent hair or imitate human fleshtones. . . . And as for imitating colors as they appear to the eye, it cannot be denied that this was a fault with him."[32] Such antipathy also applied to Michelangelo's followers, as these harsh words about Giorgio Vasari and Battista Franco demonstrate: "The poorest thing by Tintoretto will have more pictorial grace than the best of Battista Veneziano [Franco] and will make Giorgio Vasari look like a fool."[33] Obviously El Greco's opinions on the much-debated question of the superiority of drawing versus color, which preoccupied artists and theorists of the time, had been shaped by his stay in Venice.

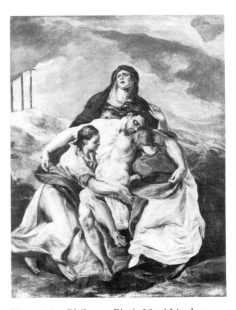

Figure 44. El Greco. *Pietà*, 26 x 19 inches, circa 1574–1576 (New York, Hispanic Society of America)

But despite these sincere and strong views, El Greco was captivated by Michelangelo's inspired treatment of the human form. He had only words of praise for Michelangelo's drawings: "This is what he knew how to do best, and he did it better than anyone [*sin comparación*]."[34] Furthermore, while in Rome, El Greco stocked his mind with images of Michelangelo's work, especially his sculpture, and drew on this store of material for the rest of his life. An early example of El Greco's use of a motif from Michelangelo is seen in a painting of the *Pietà* (fig. 44; see also fig. 58; cat. no. 17; pl. 36) that combines elements from Michelangelo's Florence and Colonna *Pietàs*.[35] Later in his career El Greco would use Michelangelesque motifs with greater subtlety (see, for example, fig. 56).

The impact on El Greco of Michelangelo and his Roman followers can be clearly seen in the few paintings that survive from this period of activity. Throughout his life, El Greco habitually reworked certain of his compositions, retaining the basic disposition of figures and background but introducing variations in pose, gesture, narrative emphasis, and scale. During his Italian years, he created three versions of *Christ Healing the Blind* (figs. 45–47), in which the course of his artistic development can be lucidly observed and charted.

The impact of Rome on El Greco's style is unmistakable in a comparison of the first and second versions (figs. 45 and 46).[36] The principal difference between the paintings—one executed in Venice circa 1567–1570, the other in Rome just after 1570—can be found in the figure style and in the relationship of figures to background. In the Venetian picture, which is the larger by some nine inches on all sides, the figures are modest in proportion and arranged into tight groups at the left and right. A small, still-life detail with a dog somewhat perversely occupies the center of the composition. In the Roman work, the scale of the figures and architecture alike has been enlarged. More important, El Greco borrowed an idea from Maniera artists by including at the left an outsized, seminude male figure who points upward with a sweeping gesture of the arm. This figure is a kind of rhetorical embellishment to the narrative intended only to display the artist's requisite command of the art of representing the human body. Another important change can be seen in the architectural perspective, which is complicated by a drastic change in levels and which terminates in the far distance with a "quotation" of an ancient Roman monument, the

Figure 45. El Greco. *Christ Healing the Blind*, tempera on panel, 26 x 33 inches, circa 1567–1570 (Dresden, Staatliche Gemäldegalerie)

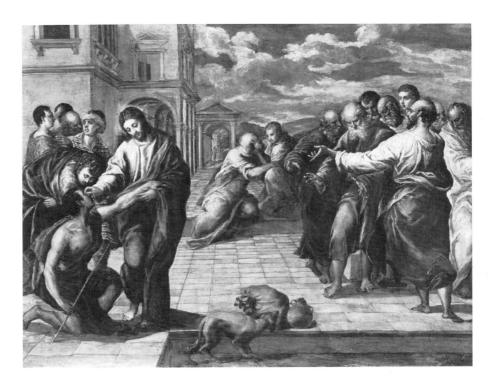

Figure 46. El Greco. *Christ Healing the Blind*, 18⅝ x 24 inches, circa 1570 (Parma, Galleria Nazionale)

Figure 47. El Greco. *Christ Healing the Blind*, 47½ x 57⅝ inches, circa 1577–1578 (New York, The Metropolitan Museum of Art. Gift of Mr. and Mrs. Charles Wrightsman 1978)

Baths of Diocletian. The syntax of the second version is no more harmonious, but the vocabulary has changed from Venetian to Roman dialect.

El Greco's third version of *Christ Healing the Blind* (fig. 47) is thoroughly Romanized—except, of course, for the rich color, which continues to show the lessons of Venice.[37] In the first place, the dimensions of the picture are substantially increased; this version is almost three times as large as the one painted in Venice. But El Greco is undaunted by the resultant need to enlarge the scale of the figures. Furthermore, the elements of the composition are more harmoniously combined; the gesturing figure at the left is less obtrusive, the disconcerting recession of illusionistic space is made more orderly and measured. A final sign of El Greco's assimilation of Roman style is the pair of truncated figures at the lower edge of the picture. This is a device much favored by Maniera artists and points unmistakably to their impact on El Greco.

The same process of transformation and assimilation can be seen in the Roman version of the *Purification of the Temple* (cat. no. 3; pls. 14, 15), which corresponds in date to the second painting of *Christ Healing the Blind*. In addition to the changes in scale, proportion, and perspective (see pl. 12), there is a group of four figures clustered in the lower right corner who constitute a kind of footnote in which the artist acknowledges his sources of inspiration. From left to right, they are identifiable as Titian, Michelangelo, Giulio Clovio, and probably Raphael. The company is admittedly exalted for the likes of Clovio; reasons of friendship must account for his otherwise unwarranted presence. But El Greco's recognition of the other three artists as sources should be taken seriously as a statement of his ambition to synthesize the great traditions of the Venetian and Central Italian Renaissance. Of course, this act of homage can also be interpreted as a self-conferred warrant of the attainment of this synthesis.

There is, however, a great deal more to achieving success than self-advertising. Unfortunately, El Greco was not to discover what this was. As time went on, it probably became apparent that his chances of recognition in Rome were diminishing. In 1572 a new pope came to the throne as Gregory XIII. His predecessor, Pius V (1566–1572), had been famous for his religious zeal and austerity, but not for his artistic interests. Gregory XIII, by contrast, was an active patron of the arts and sponsored numerous decorative commissions in the Vatican.[38] The painters he employed are

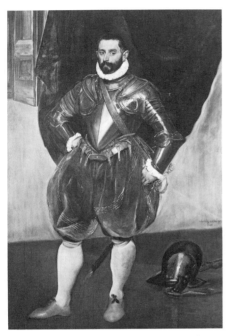

Figure 48. El Greco. *Vincenzo Anastagi,* 74 x 50 inches, circa 1576 (New York, copyright The Frick Collection)

now, for the most part, remembered only by specialists. The achievements of Marco da Siena, Livio Agresti da Forli, Pietro de Santi, Tomaso Laureti, Ottavio Mascherino, and Marco da Faenza, all of whom worked at the Vatican in the 1570s, are as nothing compared to those of El Greco. Yet they were employed on major projects and he was not. Nor did El Greco find a steady patron among the College of Cardinals or the religious orders. Even his undoubted talents as a portraitist in the Venetian manner appear to have gone unrecognized. Only two portraits, both among his finest works in Italy, have been identified (cat. no. 57; pl. 13; fig. 48),[39] in addition to the four miniatures mentioned in Fulvio Orsini's inventory but never found.

In these circumstances, it would have been logical for El Greco to take stock of his career. This he appears to have done in 1576, the year he turned thirty-five. At an age when a successful artist could expect to be well regarded and well established, El Greco had little to show for his efforts. He may have enjoyed the esteem of the habitués of the Farnese Palace, but his reputation appears to have been confined to within those walls. We will probably never know exactly why he decided to leave Rome, but it is safe to suggest that the combination of thwarted ambition and the still-lingering hope for success motivated him to look for new circumstances that might favor his aspirations to fame and fortune.

The decision to go to Spain, insofar as it can be reconstructed, appears to have been based partly on the hope and partly on the promise of winning the important patronage he had not found in Rome. The hope centered on the person of the king of Spain, Philip II. Philip was not only the wealthiest and most powerful ruler in Europe, he was also one of the greatest patrons of the arts. From his early years, Philip had been an avid admirer of Italian art, especially the paintings of Titian, which he commissioned and purchased in great numbers in the 1550s, 1560s, and 1570s. His patronage had made Titian into a rich and honored man, thus establishing a model for painters from all over Italy. Among the many who aspired to the king's favor was Giulio Clovio. In 1567 Clovio made contact with Juan de Verzosa, the secretary to the Spanish ambassador at the Vatican, with an eye to enlisting his support for a commission from the king.[40] Verzosa communicated Clovio's request for a commission in a letter to the royal secretary Zayas, together with a sample of several images. Thus, El Greco's principal supporter in Rome had already tried his luck in attracting the patron upon whom El Greco also pinned his hopes.

By 1576, there was even greater reason to believe that Philip would be receptive to the works of foreign artists: his great building project, the Escorial, was entering the final stages of construction. Philip planned elaborate and extensive decorative programs for the building and intended to recruit painters from Italy for the job. The recruitment was executed by agents in Italy, principally the ambassador to the Holy See, who was ordered in 1577 to appraise the local talent and to report the results to the king. On February 10, 1578, the ambassador, Juan de Zúñiga, sent a letter to Philip with the names of the painters who would be suitable for assisting in the decoration. The names he reported are the names of older, more established painters—Muziano, Marcello Venusti, and Federico Zuccaro.[41]

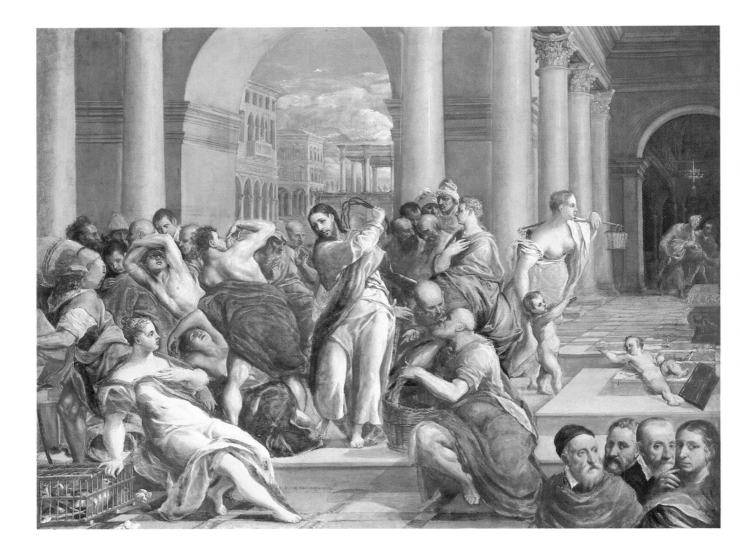

PLATE 14 (cat. no. 3). *Purification of the Temple*, 46⅝ x 59⅜ inches, circa 1570–1575 (Minneapolis, The Minneapolis Institute of Arts. The William Hood Dunwoody Fund)

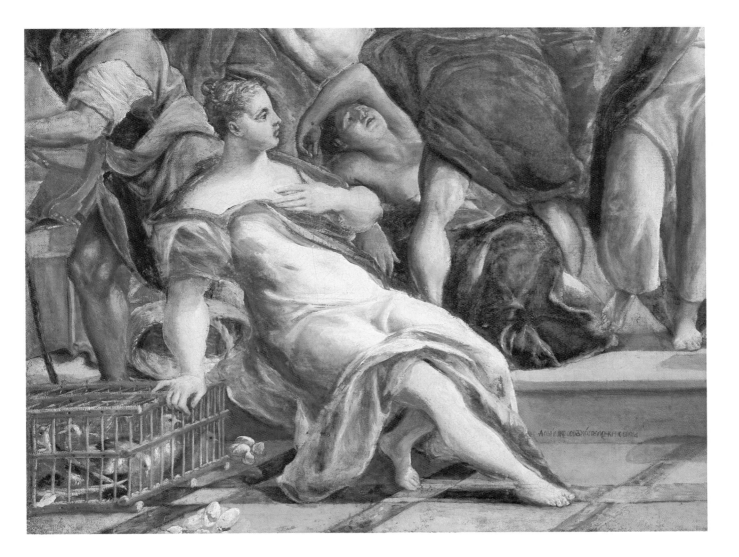

PLATE 15. Detail of *Purification of the
Temple* (cat. no. 3; pl. 14)

El Greco obviously was not among them, having already found his own way to Spain in pursuit of royal favor.

One more link can be forged in this chain of circumstantial evidence connecting El Greco and Philip II. In the summer of 1575, an important Spanish scholar, Benito Arias Montano, came to Rome on a mission for the king. On December 29, 1576, he wrote a letter to Fulvio Orsini from Spain that not only proves the fact of their acquaintance but also that of Arias Montano and Giulio Clovio.[42] This opens the way to the supposition that Arias Montano had met El Greco, a supposition that becomes intriguing when considered with the fact that Arias Montano had been appointed as librarian of the Escorial that same year.[43] In this capacity Arias Montano — much as Orsini, for Farnese — helped to devise iconographical programs for the Escorial, and he therefore may have been in a position to bring El Greco to the notice of the king.

Whatever the truth of the matter, El Greco did not have to pin his hopes solely on royal patronage; there was something more concrete to bolster his decision to go to Spain. Through his acquaintance with Orsini, El Greco had come into contact with a small group of Spanish theologians and scholars who frequented the Farnese Palace.[44] Two of these men, Pedro Chacón and Luis de Castilla, were from Toledo, and they had traveled together to Rome in 1570. Chacón, a great scholar of Latin and Greek, became a close friend of Orsini and stayed in Rome until his death in 1581. About Luis de Castilla's stay in Rome less is known, but he presumably met Orsini through his friendship with Chacón. Castilla was back in Spain by 1575, but he had had time enough to become acquainted with El Greco. Out of this friendship, which is documented in Spain, came the commission in Toledo that finally would give El Greco the chance of his lifetime.

Yet before we consider the next and central phase of El Greco's career, a final word should be said about the years in Italy. The pattern of El Greco's life between 1567 and 1576 for the most part must be woven with threads of circumstantial evidence and is therefore apt to look flimsy. In fact, the true significance of these years is revealed only in the paintings he produced after settling in Toledo, where he had artistic opportunities that were denied him in Rome. These Spanish works, the works by which we know him, unmistakably demonstrate that El Greco's art was decisively shaped in every way by the visual images and aesthetic and social ideas acquired in Italy. Crete may have given him life and the painter's craft (to return to Paravicino's memorial sonnet) and Toledo a better homeland, but it was in Italy that he learned what he would need to become a great artist.

The Search for Patronage in Spain, 1577–1583

The precise dates of El Greco's departure from Rome and arrival in Spain are unknown. However, by July 2, 1577, he was in Toledo, about to begin the first major commissions of his career. But Toledo was not the first stop on El Greco's Spanish journey. Several documents of his activity during the period 1577–1580 indicate that he was in the city as a transient. Logically, his prior stop would have been in Madrid, which since 1561 had been the seat of the court. This hypothesis is strengthened if we accept the idea that El Greco's primary aim had been to win the favor of Philip II.

The question of El Greco's whereabouts and activities in Spain before July 1577 is virtually unanswerable without resorting to conjecture that centers on the picture *Allegory of the Holy League* (cat. no. 12; pl. 11). The main subject of this bizarre painting is the commemoration of the defeat of the Turks at the Battle of Lepanto in 1571 by the combined forces of Spain, Venice, and the papacy.[45] The authors of the alliance, namely the king of Spain, the doge of Venice, and the pope, are represented as kneeling figures in the foreground of the lower zone. Philip II, of course, is the man wearing the black costume and ruff collar, and his presence is the clue that suggests that this picture was done either as a royal commission or as an attempt to attract the notice of the king. Whatever the original intention and purpose of the picture, it is clear that El Greco's hopes of gaining favor at court were still alive in 1580, when he accepted a commission for an altarpiece at the Escorial.

In the meantime, his friend from Rome, Luis de Castilla, had arranged El Greco's introduction to an important patron in Toledo. Luis's father, Diego, was dean of the cathedral chapter, and therefore a major figure in the ecclesiastical world of Toledo.[46] Thus, it seems logical to suggest that Diego de Castilla was the moving force behind the decision to commission El Greco to paint a scene of the Disrobing of Christ for the vestiary of the cathedral sacristy. By July 2, 1577, when he received a payment on account, El Greco was at work on the picture.[47]

Diego de Castilla also engaged El Greco's services for a personal project. In 1575 Castilla had begun to execute the last will of a noblewoman, Doña María de Silva, whose testament called for a church to be built adjoining the convent of Santo Domingo el Antiguo. On August 8, 1577, he and El Greco signed a contract stipulating that the painter would execute eight pictures, six for the main altar and one for each of two side altars. According to a previous memorandum of understanding drafted by Luis de Castilla, El Greco was obliged to reside in Toledo while he painted the pictures, presumably because Diego wanted to keep an eye on the progress and results. The memorandum and contract both stipulated the sizable sum of 1,500 ducats for the work, but El Greco reduced the price by 500 ducats as a sign of respect for Diego de Castilla.[48]

Over the next two years, El Greco appears to have stayed in Toledo working on the pictures for the cathedral and Santo Domingo, which were finished within a few months of each other. First to be completed was the *Disrobing of Christ* (pl. 16), a painting now recognized as one of El Greco's first masterpieces, but which was the subject of a dispute between the painter and the cathedral's representative, the learned canon García de Loaysa Girón.[49] The two parties met before a notary public on June 15, 1579, to initiate the process customarily used to determine the value of a work of art. The procedure, called *tasación*, was simple in theory. The artist and the client each nominated an appraiser or team of appraisers (*tasadores*) who independently set a value on the work of art. In case of an irreconcilable difference, the final determination was made by an arbitrator, who was often named in advance. The procedure, despite its appearance of fairness, worked against the artists, because it postponed the determination of value until after a work was finished. Even if partial

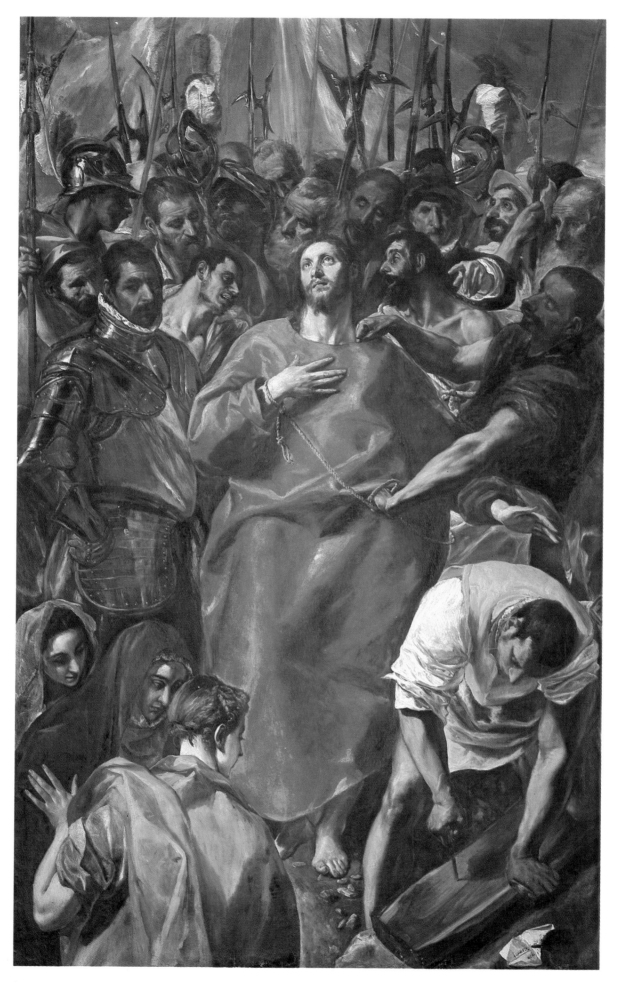

advance payments had been made, as they usually were, to help cover the cost of materials, the artist was still, in effect, forced to seek payment from the client, who therefore could bargain from a position of superior strength. El Greco, for reasons to be discussed later, could never reconcile himself to a system that inherently put the artist at a disadvantage.

In July of 1579 the two sets of appraisers made their reports. The representatives of El Greco set the value at 900 ducats, a very large sum of money for a single work. The cathedral's appraisers, both of whom enjoyed the patronage of the church and were therefore keen to serve its interests, found this price to be excessive and unreasonable and countered with a mere 228 ducats. They also cited certain improprieties—probably discovered by the zealous García de Loaysa—in the representation of the subject. Their first complaint was that some of the heads in the crowd were placed above the head of Christ; the second objection concerned the presence of the Three Marys in the lower left, which was not mentioned in the text of the Gospel.[50]

No agreement could be reached on these points, and therefore the arbitrator was summoned to decide the matter. In his opinion, delivered on July 23, he acknowledged that the picture was among the best that he had ever seen. But after taking into consideration the going price for pictures of this quality and the fact that times were bad, he set the figure at 318 ducats. On the theological question he deferred to the competent authorities. If Loaysa was expecting El Greco to comply with this judgment, he was unrealistic, because the artist had decided not to deliver the painting until he was satisfied with the price.

During the next two months, Loaysa took no further steps in the matter. But on September 22, he was stirred into action by the inauguration of the Church of Santo Domingo el Antiguo. The completion of this commission, as the canon understood it, meant that El Greco would now be leaving Toledo, taking with him the *Disrobing of Christ* and the sum of 150 ducats that had been advanced as partial payment for it. One day after the inauguration of Santo Domingo, the lawyer for the cathedral appeared before the magistrate of Toledo and made his case. The artist, he argued, had come to Toledo to paint the altarpieces of Santo Domingo and would soon be leaving town now that they were completed. He requested, therefore, that El Greco immediately deliver the disputed picture to the cathedral as security against the advance of 150 ducats. He also insisted that the artist correct the "errors" in the picture.

El Greco's reply to this representation was simple but defiant. In effect he said, pay me first and then I will make the changes and deliver the picture. He also refused to answer a question about his reasons for coming to Toledo, asserting that he was not under any obligation to do so. The impasse between the two parties lasted until December 8, 1581, when El Greco accepted a payment of 200 ducats, which brought the total only slightly beyond the amount stipulated by the arbitrator, far short of his early expectations. But if he lost the battle of money, he won the war of ideas, for the group of the Three Marys is still to be seen where it was originally painted. On the other hand, the wisdom of declaring war on the most important patron in Toledo was certainly questionable. One

< PLATE 16. *Disrobing of Christ*, 112¼ x 68⅛ inches, 1577–1579 (Toledo, Cathedral)

plausible explanation for El Greco's boldness is that he was not planning at that time to settle in Toledo, a notion that is corroborated by the statement to this effect made by the cathedral's lawyer.

Fortunately, the other Toledan commission (cat. nos. 7, 8; pls. 22, 23, 33; figs. 55, 56, 74–82) had gone well. In the center of the high altar of Santo Domingo was the masterpiece of the ensemble, the monumental painting *Assumption of the Virgin* (pl. 22), which bears the artist's signature and the date 1577. After his name—written, as always, in Greek—El Greco added the Greek word for "one who displays," almost as if he wanted to call attention to the mastery of an art that could at last find expression.

The first two years in Toledo, then, did not bring unqualified success, at least from the standpoint of El Greco's professional aspirations. Yet it may be that he was simply biding his time until he could have an opportunity to win the favor of the king. Toledo, for all its importance as an ecclesiastical center, could not offer the rewards of a court appointment. By April 1580, while continuing to live in Toledo, he had managed to secure a royal commission that seemed to bring the desired goal within reach.

This commission entailed a depiction of the Martyrdom of Saint Maurice and the Theban Legion, to be installed in the church of the Escorial as a pendant to Luca Cambiaso's *Martyrdom of Saint Ursula*. El Greco worked on his painting for over two years, receiving periodic payments totaling 300 ducats as an advance against the final appraisal.[51] The picture was completed by the autumn of 1582, and was delivered in person to the Escorial on November 16. Now came the moment for the all-important appraisal. Only one relevant document is known, but it is sufficient to inform us that once again the intervention of an arbitrator was required. He arrived at the Escorial in April 1583 and set the value at 800 ducats, a sum that ought to have satisfied El Greco. But then something else went wrong: the king did not like the picture and ordered it removed. A replacement was commissioned from the arbitrator of the appraisal, a mediocre Italian painter named Romulo Cincinnato, whose version of the scene still hangs in the Chapel of Saint Maurice at the Escorial. A comparison of the two versions leaves no room to doubt that King Philip rejected a masterpiece in favor of a dull picture.

The reason for the king's decision was reported by a contemporary eyewitness, Fray José de Sigüenza.[52] In a word, El Greco had violated the paramount rule of Counter-Reformation taste by elevating style above content. The *Martyrdom of Saint Maurice* (pl. 2; fig. 49) is a superb, fully realized example of the Roman Maniera style and, as such, demonstrates the style's principal shortcoming as a vehicle for expressing religious content. Instead of concentrating attention on the decapitation of the martyrs, El Greco emphasized the moment when Saint Maurice and his companions decide to die for the faith. The elegant poses and languorous gestures, for all their studied artfulness, were regarded as a distraction from the main event. Sigüenza, writing of the picture, voiced the main objection in language typical of the Counter-Reformation: "The saints should be painted in a way that does not remove the desire to pray before them."

El Greco obviously had made a serious miscalculation of the king's taste. Philip was considered to be a discerning connoisseur, as indeed he was.

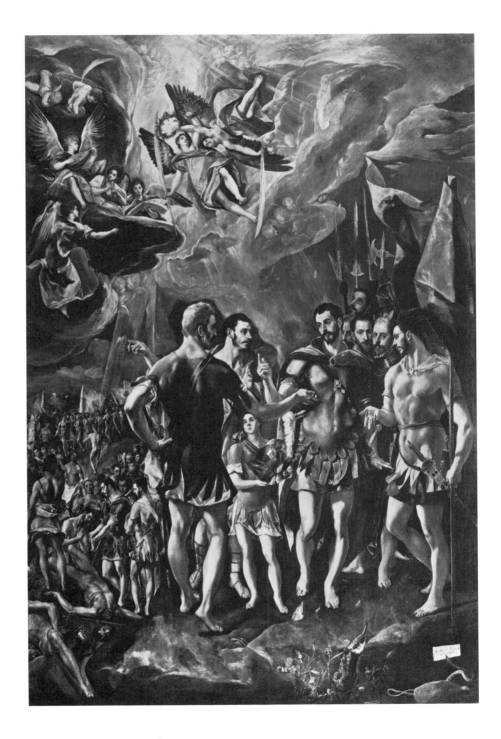

Figure 49. El Greco. *Martyrdom of Saint Maurice*, 176 3/8 x 118 1/2 inches, 1580–1582 (El Escorial)

But he valued beauty above content only when articles of faith were not at issue. When it came to the decoration of the Escorial, that fortress of Catholicism, his actions suggest he was fully prepared to agree with the aforementioned dictum of Gilio da Fabriano: "A thing is beautiful in proportion as it is clear and evident."

The failure to win the patronage of the king must have been a serious disappointment. Hopes for the riches and glory of a court appointment could now be laid forever to rest. The setback also meant that he would now have to reconsider the question of staying in Toledo. At this point, the prolonged dispute over the *Disrobing of Christ* must have come back to haunt El Greco. Whether he suspected it or not, there would be no more commissions from the canons of the cathedral except for the frame of his completed picture. Thus, within the space of six years after arriving in Toledo, El Greco found himself excluded from two of the principal sources of institutional patronage in central Spain.

But Toledo still had its attractions and possibilities. First was the dearth of good painters, which left the way open to an artist of talent—and despite his troubles with the cathedral canons, El Greco had won admiration for his paintings. Second, during his stay in the city, he had begun to make friends and contacts with members of Toledo's scholarly and professional community, some of whom were in a position to help him find commissions. Moreover, time was no longer on his side. In 1583 he became forty-two years old; it was now too late to begin all over again in a place where he was unknown. It was the moment to settle down.

The Making of a Career, 1583–1595

El Greco's output during the first stage of his Spanish period appears to have been small, perhaps because he spent much of his time working on the commissions that he hoped would bring substantial rewards. Although we cannot be sure exactly when he set up shop in Toledo to begin work as an independent painter, it seems likely that by 1585 he had begun to establish a flourishing business. One indication of this is a seemingly mundane event in that year. On September 10, El Greco signed a lease for three apartments in the palace of the marquis of Villena.[53] This palace, one of the largest in Toledo, had for many years been subdivided into several apartments. El Greco's new dwelling was spacious, consisting of the so-called royal quarters, which included the main kitchen and another space between two of the courtyards. The motive for renting these ample quarters perhaps involved a need to expand the scope and size of the workshop to accommodate a growing volume of business.

Evaluating El Greco's career as a business venture may seem somewhat frivolous, if not misguided. But there is reason to believe that the subject of money was never far from his mind and that, to some degree, he organized his workshop to maximize his earning power. It is worthwhile, therefore, to survey his career from a financial point of view, at least initially. This approach also helps us to see how he developed the patronage that sustained and influenced his artistic development.

A successful artist working in Spain during the late sixteenth century could earn a substantial income by manufacturing altarpieces, the

principal form of church decoration. These altarpieces usually comprised three elements—paintings, polychrome sculpture, and a gilded wooden architectural framework. In some instances, the individual components of the altarpiece were provided by a consortium of painter, sculptor, and architect, each maintaining his own workshop. However, it was also possible for an individual artist to establish a corporate workshop to create a complete altarpiece under one roof. The second method of operation was potentially more lucrative for the artist-in-charge because he could make a profit on the entire altarpiece rather than on just his own part and could reap the economic benefits of dealing in volume if there was sufficient work available. A corporate workshop also permitted the artist to maintain sole control over the design and execution.

This entrepreneurial mode naturally offered risks as well as rewards. In the first place, the artist-in-charge had to drum up the business to keep the shop operating. Second, the overhead costs—rent, labor, materials—were obviously substantial and could only be carried by a steady flow of commissions; otherwise, debts quickly began to accumulate.

The evidence that El Greco established a corporate workshop during this period of his life is somewhat sketchy, although there can be no doubt of its existence in later years.[54] Certainly he considered himself to be a qualified builder of architectural frameworks as well as a serious student of architectural design. He had supplied the drawings for the architecture of the Santo Domingo altarpieces, although they were partly redesigned by the architect, Juan Bautista Monegro. And in 1582 he had received a small payment for the design of a frame for the *Disrobing of Christ*. However, it was not until July 9, 1585, that a contract for the frame was signed with the new warden of the cathedral, Juan Bautista Pérez, who had recently replaced García de Loaysa.[55] The contract specified the construction of a gilt-wood frame with sculptural decoration, and it may be that the procurement of this sizable project motivated El Greco to lease the large quarters in the Villena Palace just two months later. In any event, the framework was completed in early February 1587 and evaluated without incident at just over 570 ducats. After the price of the gold for the gilding was subtracted, the frame brought as much money as the picture, a fact that illustrates the financial advantages of the corporate workshop.

Shortly after his workshop started to build the large picture frame, El Greco obtained another commission that required the participation of a team of artisans. The relics of an important Toledan saint, Leocadia, were to be brought to Toledo to be enshrined in the cathedral. A series of wooden arches with painted and sculpted decoration would be erected along the route of the elaborate triumphal procession, and the municipality commissioned two of them from El Greco.[56] Contemporary descriptions of the ceremony, which took place on April 26, 1587, help in visualizing El Greco's enormous constructions, which were decorated with wooden sculpture painted to imitate marble and with monochromatic paintings depicting scenes from the life of the saint. The scale and nature of this project again suggest that El Greco was building an all-purpose business as an independent contractor.

A third substantial commission during the mid-1580s was won in March

1586. In 1584 Andrés Núñez de Madrid, priest of the parish church of Santo Tomé, had petitioned the archbishop's council for the right to commission a painting for an important burial chapel. The subject was to be the miraculous entombment in the chapel of a charitable nobleman who had bequeathed an endowment to the church in the fourteenth century. This benefactor was Gonzalo de Ruiz, Lord of Orgaz. (The Ruiz family title was elevated to the status of count in 1522.) Permission was granted by the council on October 23, but the contract with El Greco to paint what has become his most famous picture, the *Burial of the Count of Orgaz* (pl. 3; figs. 61, 62, 68), was not executed until March 18, 1586.[57]

The work on this monumental picture (about sixteen feet high by ten feet wide) was finished in the spring of 1588, when it was ready for appraisal. The first set of appraisers put the value at 1,200 ducats, a sum that the priest Núñez regarded as exorbitant and that caused him to petition the archbishop's council for a reduction. A second appraisal was therefore arranged, with unfavorable consequences for the church—it amounted to 1,600 ducats. Núñez, who, incidentally, was El Greco's parish priest, asked that this second appraisal be set aside. Finally, on May 30, 1588, the council decided that the first appraisal be allowed to stand and ordered the church to pay El Greco the 1,200 ducats within nine days' time. El Greco, as usual, was initially in no mood to compromise and immediately appealed the council's decision to the papal nuncio in Madrid. But, also true to form, he retreated in the face of the threat of a long and costly legal battle, finally agreeing to accept 1,200 ducats.

This pattern of disputatious behavior became characteristic of El Greco's professional life and has given rise to numerous theories that attempt to explain it. The truth of the matter is probably not very complicated. El Greco was well aware of the high quality of his art and believed that it should be rewarded with correspondingly high payments. But his financial expectations tended not only to exceed those of his patrons, but also the prevailing price structure. These discrepancies were magnified by the appraisal process, which encouraged hard bargaining tactics and therefore conflict. But when the bargaining collapsed, the disadvantaged position of the artist inherent in the system forced him to compromise or capitulate for one simple reason: he had bills to pay and needed the money, especially if he had to meet the expenses of a corporate workshop. Thus, of the 1,200 ducats received from the Church of Santo Tomé, almost 420 ducats was set aside to be paid directly to the artist's creditors. This explains why only one of El Greco's many legal disputes over finances ever went to trial. It made much more sense to settle for something less than the full amount than to waste the money, time, and energy in a proceeding that could produce little or no gain and also tied up the cash needed to finance other projects. So, after an initial attempt to force a higher settlement, El Greco usually swallowed his pride and accepted what was offered.

The period of El Greco's life from 1588 to 1595 is poorly documented. We know that he continued to live in the Villena Palace at least until 1590, but his domicile is unrecorded for the succeeding ten years, after which he is again documented as a tenant of the palace. In 1588 he made an effort to collect money for paintings of Saint Peter and Saint Francis that had

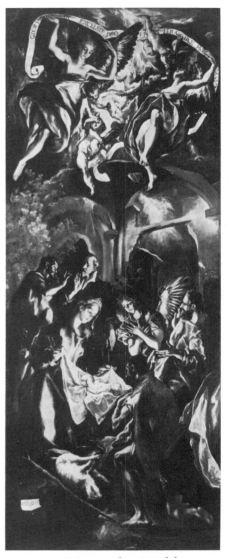

Figure 50. El Greco. *Adoration of the Shepherds*, 136¼ x 54 inches, 1596–1600 (Bucharest, Rumanian National Museum)

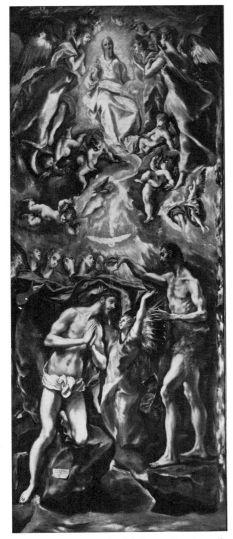

Figure 51 (cat. no. 33). El Greco. *Baptism of Christ*, 137 3/4 x 56 3/4 inches, 1596–1600 (Madrid, Museo del Prado)

been sent to Seville.[58] This suggests that El Greco was seeking to widen the market for his pictures, a notion that is confirmed by a document of a similar transaction from a later period in his life.[59] Only two altarpieces are known to have been done in these years. The first, for the parish church in Talavera la Vieja, was commissioned on February 14, 1591, and executed with the collaboration of the workshop.[60] The contract price of 300 ducats was too small to buy El Greco's exclusive participation, but large enough to help meet expenses and possibly to return a small profit.

El Greco and Son, 1596–1614

Starting in 1596, there was a tremendous surge of activity in the workshop that continued unabated until El Greco's death in 1614, although it reached a peak in the ten-year period between 1597 and 1607. There appear to be several reasons for El Greco's success at this time. First, and most obvious, the reputation earned during ten or twelve years of good work was proving to be a valuable asset. Also, El Greco had succeeded in attracting a group of prestigious local patrons who now consistently provided him with important commissions. And last, starting around 1600, there was an infusion of new blood into the business in the person of his son, Jorge Manuel (see fig. 64). El Greco's only child, born in 1578, had been trained by his father in all three major arts.[61] His participation in the workshop as a junior partner is marked by an increase in commissions from churches in the towns and villages surrounding Toledo, which Jorge Manuel actively solicited.

The first major commission of this period came from an Augustinian seminary in Madrid, the College of Doña María de Aragón.[62] Doña María, a devout noblewoman and lady-in-waiting at court, had funded the college during her lifetime. By the time of her death in 1593, much of the construction had been finished. With funds specified in her will, the executors were to complete the task of building and decorating the church. The contract for the altarpiece from El Greco was negotiated during December 1596, and according to the terms, El Greco was to receive advances totaling 2,000 ducats against a final price to be determined by appraisal. The date of delivery set forth in the contract was Christmas Day, 1599. Given the magnitude of the commission and the sums of money involved, El Greco was called upon to find three bondsmen who would jointly guarantee the return of the advances in the event of failure to perform under the terms of the contract. Three important citizens of Toledo agreed to assume the risk on behalf of the artist: Pedro Laso de la Vega, count of los Arcos; Alonso de la Fuente Montalbán, treasurer of the royal mint of Toledo; and Francisco Pantoja de Ayala, secretary of the archbishop's council. Representing the College of Doña María in the negotiations were the prior, Fray Hernando de Rojas, and the executor of Doña María's estate, Jerónimo de Chiriboga, a doctor of canon law who had been a member of Cardinal Quiroga's staff and was a sometime resident of Toledo, where presumably he had come to know El Greco.

The altarpiece (see cat. nos. 32, 33; pls. 1, 27; figs. 50, 51) was delivered in July 1600, seven months late, and was appraised in August by two court painters, Juan Pantoja de la Cruz, acting for the college, and Bartolomé

103

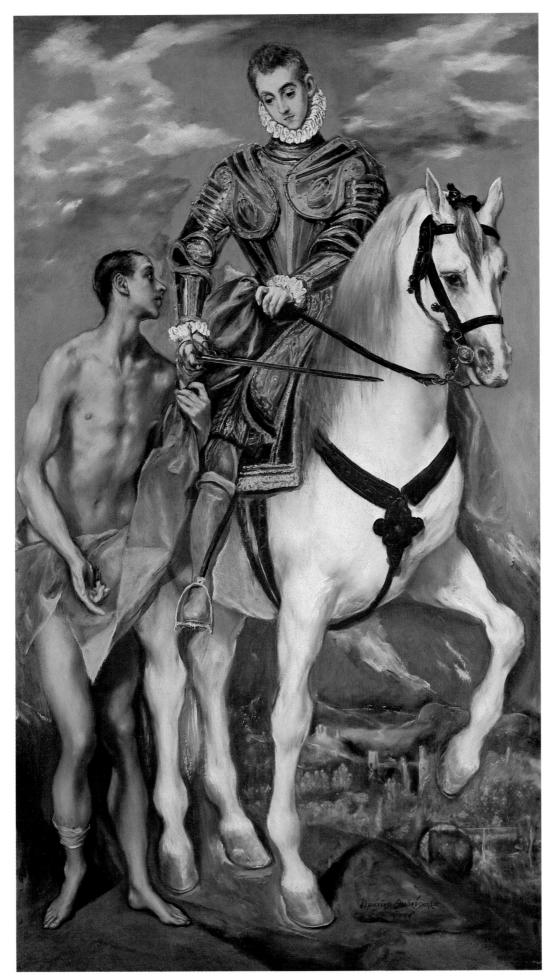

Carducho, for El Greco. Their judgment could not be faulted by El Greco: it came to just under 6,000 ducats, an enormous sum of money. Unfortunately, the full amount was as difficult to collect as it was generous, mainly because the income of Doña María's estate was derived from various rents and bonds that were not always paid on time. In June 1601, El Greco's agent was seeking to collect 500 ducats directly from the tax collector in Illescas, who owed this amount to the estate.[63]

Four months after signing the contract for the altarpiece in Madrid, El Greco landed the most lucrative commission of his career—the high altar of the church of the Hieronymite monastery at Guadalupe. The contract stipulated the impressive sum of 16,000 ducats.[64] For reasons yet to be discovered, however, El Greco never executed the work.

But later that year, another substantial piece of business came his way. On November 9, 1597, El Greco and Dr. Martín Ramírez de Zayas, a professor of theology at the University of Toledo, executed an agreement that obligated the artist to furnish three altarpieces for a private family chapel in Toledo dedicated to Saint Joseph (see figs. 26, 93–97).[65] The main altarpiece was to contain the pictures *Saint Joseph and the Christ Child* (fig. 94; see also replica, cat. no. 29; pl. 48) and *Coronation of the Virgin* (fig. 95). The subjects of the lateral altarpieces were unspecified, but eventually came to be *Saint Martin and the Beggar* (cat. no. 30; pl. 17) and the *Madonna and Child with Saint Martina and Saint Agnes* (cat. no. 31; pls. 49, 50). A date of August 1598 was set for completion but, as often happened with El Greco's altarpieces, the work may have been delayed. Nothing more is heard of the commission until December 13, 1599, when Dr. Ramírez agreed to withdraw an action to have the appraisal reduced and to pay a total of roughly 2,850 ducats. Of that sum about 636 ducats was to be withheld and paid directly to creditors—136 ducats to a linen merchant who probably supplied material for canvases, and 500 ducats to the famous still-life painter Juan Sánchez Cotán for a claim whose nature is unfortunately not specified.

In 1603, the name of Jorge Manuel begins to appear regularly in the documents concerning El Greco's workshop, making it likely that he had now become the chief assistant to his father. Since El Greco's arrival in Spain, this position had been filled by an Italian painter who had accompanied him from Rome—Francisco Preboste, a man some thirteen years younger than El Greco. From 1580 to 1607, Preboste also frequently acted as El Greco's business agent. His name last appears on a document of April 29, 1607, that grants him power of attorney for El Greco.[66] The subsequent disappearance of his name from the record suggests that he died not long after. In any event, on May 29, 1607, El Greco granted the same power to Jorge Manuel, thus confirming his predominant role in the shop.[67]

In the years between 1600 and 1608, the atelier worked to full capacity as commissions poured in from Toledo, Madrid, and the surrounding countryside. A good deal of activity was sparked by the zeal with which the new archbishop of Toledo, Cardinal Bernardo de Sandoval y Rojas, supported the program begun by Cardinal Quiroga to refurbish and modernize the churches in the diocese. When a parish church wanted to commission a new altarpiece, it was required to obtain a license from the archbishop's council, which administered the program. The council,

< PLATE 17 (cat. no. 30). *Saint Martin and the Beggar*, 76⅛ x 40½ inches, circa 1597–1599 (Washington, National Gallery of Art. Widener Collection 1942)

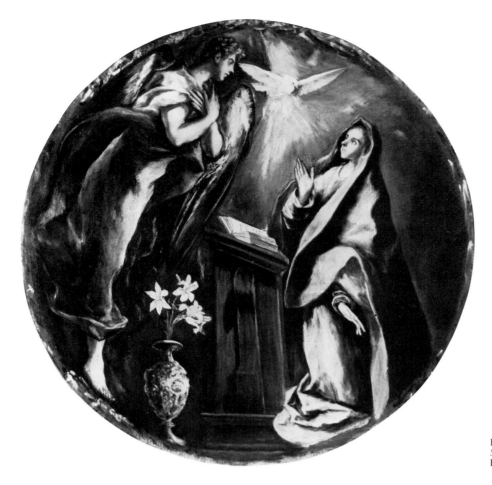

Figure 52. El Greco. *Annunciation*, circular, 50 3/8 inches in diameter, 1603–1605 (Illescas, Hospital of Charity)

when it received a petition, would then send a local artist to review the proposal. Beginning in February 1603, thanks to El Greco's friends on the council, Jorge Manuel was frequently delegated to carry out these inspections.[68] On at least four occasions his visitations resulted in commissions for the workshop, indicating that he regularly used such council appointments as a means to produce new business.

One of these commissions resulted in a financial disaster. On April 7, 1603, Jorge Manuel was authorized to inspect the proposal for a new altarpiece for the Hospital of Charity, Illescas, a town on the main road between Toledo and Madrid. The contact resulted in an agreement by El Greco, signed on June 18, 1603, to execute the work (cat. no. 42; pl. 18; figs. 52, 63, 98–102).[69] For unknown reasons, El Greco agreed that the final appraisal would be executed solely by the hospital's nominees. Not surprisingly, they determined an absurdly low value, about 2,410 ducats. Thus began a lengthy, fiercely contested dispute that was carried beyond the archbishop's council to the royal chancellery in Valladolid and to the papal nuncio in Madrid, only to be settled in June 1607 for a figure close to the original amount. This experience should have erased any doubts on El Greco's part about the wisdom of litigation; it was a foolish course of action indeed.

The fiasco at Illescas seems to have inflicted heavy damage on El Greco's finances. From a business standpoint, he was a construction contractor. Like anyone engaged in this occupation, he did not receive full compensation until the completion and approval of his work. He therefore required either a substantial cash reserve or, in the language of accountancy, a substantial cash flow to finance the costs of labor and material stemming from work in progress. If cash was short, there were three means to finance the work until final payment: (1) borrow the money; (2) delay remittances to suppliers and subcontractors; or (3) use a down payment from a new job to cover the costs of the one already under way. The

danger of the third practice is obvious; if for any reason the payment for completed work was delayed, then the new work had to come to a stop, unless the procedure was repeated with yet another commission. This was at best a risky way to do business—especially since the amount of the final payment was subject to a biased method of negotiation—and it required a lot of luck, pluck, and financial agility to keep the system from collapse.

Prior to the Illescas dispute, El Greco seems to have succeeded fairly well in juggling his finances. There were times, of course, when some of the final proceeds of a commission had to be paid directly to creditors, as we have seen. Although the evidence for the cause of El Greco's gross indebtedness after 1607 is admittedly difficult to interpret, there is some reason to assign part of the blame to problems at Illescas. Not only was the final payment for the work frozen, but there were also legal expenses to be met. And when he finally received the money, the amount was no more than half of what was expected. During the course of the litigation two additional appraisals were made, each of which was well over 4,000 ducats, an amount comparable to other commissions in this period of El Greco's life. The effect of the delay and the reduced payment was to remove a large amount from the cash flow of the business—a fact confirmed by a petition to the archbishop's council, dated December 14, 1605, in which El Greco said that "the delay continues to cause me much damage and loss."[70]

El Greco sought to cover his deficits through a variety of tactics. One was to borrow money from friends. After 1600, Dr. Gregorio de Angulo not only acted as bondsman for El Greco, but also made him loans of at least 2,000 ducats.[71] In addition, a second time-honored method of keeping afloat was used—delaying payments to creditors. In January 1609, Jorge Manuel assigned the final payment for an altarpiece to the marquis of Moya, in compensation for wood that had been supplied from his estates in 1605.[72] By August of 1611, El Greco and his son had fallen two years behind in their rent and had to negotiate a postponement of the back payment with the agents of the marquis of Villena.[73]

In an effort to balance the books, there was a determined attempt to win new commissions. Late in 1607, El Greco made a bid for the contract to complete a private chapel, the Chapel of Isabel de Oballe (see pl. 24), which had been left unfinished on the death of the painter Alessandro Semini.[74] The presentation was made by the now-aged El Greco (he was sixty-six), and an aggressive presentation it was. First, he criticized his predecessor's design of the altarpiece and the frescoes he had painted on the vault of the chapel. Then he promised to correct the proportions of the altarpiece and to substitute, at no extra cost, a painting of the Visitation for the frescoes (cat. no. 52; pl. 65). Thanks to this forceful presentation, and to the influence of Dr. Angulo, who was a member of the selection committee, a contract and a generous advance of over 400 ducats was awarded to the artist on December 11.

El Greco's last important altarpiece commission was arranged for on November 16, 1608, when he signed a contract with his friend Dr. Pedro Salazar de Mendoza to execute three altars for the Chapel of the Hospi-

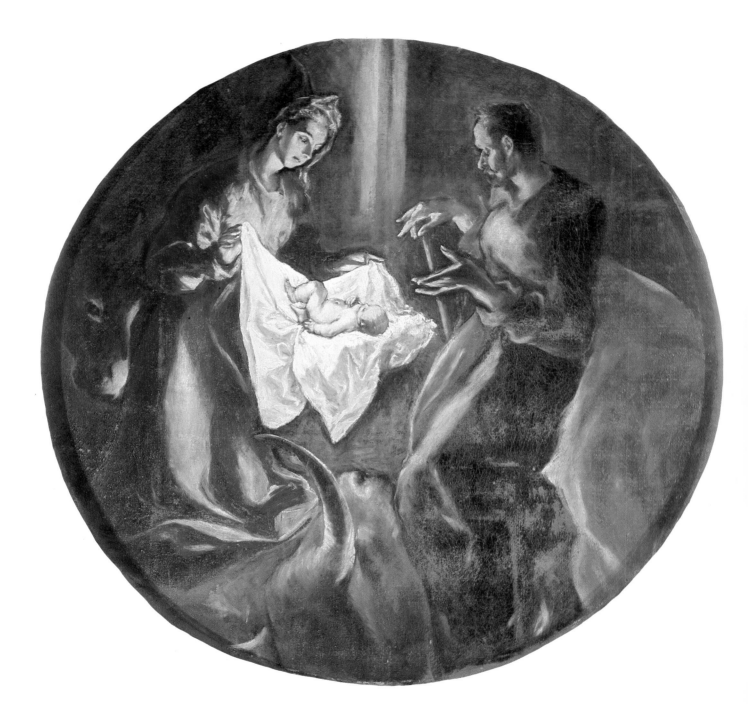

PLATE 18 (cat. no. 42). *Nativity*, circular,
50 3/8 inches in diameter, 1603–1605 (Illescas,
Hospital of Charity)

tal of Saint John the Baptist, Toledo (pl. 28; figs. 104–107).[75] Salazar de Mendoza seems to have taken account of El Greco's straitened economic condition by providing a five-year schedule of advances of 1,000 ducats per annum, presumably to ensure regular progress on the work. But these good intentions were subverted by the artist's pressing needs, and on August 12, 1611, El Greco and his son agreed to pay the arrears in their rent, totaling 400 ducats, from the proceeds of the annual installment from Salazar de Mendoza. In both transactions, the hospital contract and the rental agreement, Dr. Angulo guaranteed the payment, which suggests that El Greco's credit was by then nearly exhausted.

The last years of El Greco's long life, then, were clouded with financial worries that must have absorbed considerable time and energy. But the facts and figures of his plight can be misleading about his personal and professional status. Despite the endless round of financial problems, or perhaps because of them, El Greco continued to paint into his old age, producing some of his greatest pictures in the last fifteen years of his life. On December 12, 1607, one of the men who proposed awarding the Oballe Chapel commission to El Greco recognized the artist's skill by praising him in these terms: "It is said that Dominico Greco is held to be one of the most outstanding practitioners of this art in this or any other kingdom."[76]

El Greco's fame also brought in dozens of clients who wanted to buy replicas of well-known compositions. These purchases are undoubtedly represented by the mass of studio replicas that still clutter the corpus of authentic works. El Greco seems to have catered to this clientele by resorting to a simple but efficient system. He kept small-scale copies of many of his works, which served as a sample case for prospective customers.[77] Presumably there was a range of prices, determined by whether the master or an assistant was to produce the copy.

The search for patronage that brought El Greco to Toledo in 1577 was eventually rewarded with success, but it was not success of the easy kind. The setbacks at the court and cathedral removed the possibility of secure, prestigious, and lucrative employment. Instead, El Greco was forced to compete against the other painters of Toledo and suffer the trials and tribulations of the open market. The competition at first glance appears one-sided. He was a great artist; they were journeymen. He was a brilliant man of independent spirit; they were complacent conformists to a system they never questioned. But sixteenth-century Spanish society was mistrustful of nonconformers, especially when they were foreigners. El Greco required a special kind of patron to understand his original style of painting and thought, and by a stroke of great luck, he found just this type of patron in Toledo.

The Patrons of El Greco

To understand the reason for El Greco's success in Toledo we must return to Rome. There, in the select circle of Fulvio Orsini and his learned friends, and in the wider circle of the Roman artistic world, El Greco acquired, or, more probably, developed, the habits of mind characterized by the term *learned artist*. The concept of the learned artist was a creation of the Italian

Renaissance. In essence, it derived from the ambition of painters, architects, and sculptors to be regarded as artists, not artisans — as the equal of poets, philosophers, and rhetoricians, not of craftsmen who worked with their hands. To achieve this end, artists began to study letters, to elaborate the intellectual defense of the nobility of their pursuits, and to structure a professional curriculum that, in many respects, was modeled on the traditional humanist education. By the second half of the sixteenth century, the concept of the learned artist, or painter-philosopher, was well established in the major artistic centers of Italy; figures such as Leonardo, Michelangelo, Titian, and Raphael seemed to offer incontrovertible proof of the truth of the proposition. It was also a concept very well suited to artists of the Maniera, for whom sophistication of style and thought was an essential goal of art.

El Greco's aspirations to the status and condition of learned painter are well documented and were noted even during his lifetime by Francisco Pacheco, himself a famous example of the type. Pacheco visited El Greco in 1611 and later recorded his impression of the man: "It was not only the ancients who elevated themselves by erudition. In our own century, there have been learned men not only in painting, but also in humane letters, such as . . . Dominico Greco, who was a great philosopher and wit, and wrote on the subject of painting."[78]

The artist also possessed a library of books in Greek, Italian, and Spanish, which covered such fields as philosophy, literature, poetry, religion, art, and architecture.[79]

Finally, as Pacheco stated, El Greco wrote treatises on art. This pursuit was the unmistakable hallmark of the learned artist, because it demonstrated his mastery of language and philosophy as well as a grasp of the intellectual foundations of art. El Greco appears to have written one treatise on painting and another on architecture. Unfortunately, neither has survived, but vestiges of the endeavor have come down to us in the form of autograph marginal notations to two famous examples of Renaissance art literature — the second edition of Vasari's *Lives of the Painters* (1568) and Daniele Barbaro's edition of Vitruvius's *On Architecture* (Venice, 1556; see fig. 65).[80] Although El Greco's comments to these texts are brief and fragmentary, they leave no room to doubt that he had versed himself in the history and theory of art, especially the theory inspired by Michelangelo, and had arrived at original ideas of his own.

On the specific question of the importance of the artist as philosopher, El Greco is unmistakably clear. In *On Architecture*, Vitruvius remarks that an architect also ought to be master of other fields, such as geometry, astrology, and music, because through this knowledge he could achieve the condition of a mathematician and philosopher. To this statement, El Greco adds one of his own, expressing vigorous assent: "This manner of going beyond the limits of architecture I find to be the greatest of truths, and this is the thing that is most to be followed of everything written by Vitruvius, and that which should be understood as the most illuminating thing that he wrote, even if he had not written another thing."[81]

Even more explicit is a marginal note that occurs later in the book, in which El Greco assigns to painting a central place in human experience.

"Painting, because of its universality, becomes capable of speculation...."[82] This lofty definition of painting as a form of speculation, or thought, makes it comparable to philosophy. In these words, and others that we shall soon discuss, El Greco revealed his faith in painting as a form of knowledge. This point of view is entirely an outgrowth of El Greco's reading of Central Italian art theory, which he would have become acquainted with in Rome. As a matter of fact, his copy of Vasari's *Lives* was acquired from one of the leading art theoreticians of the day, the painter Federico Zuccaro.

El Greco's theory of art is clearly elitist. By associating art with philosophy and other intellectual pursuits, he intended to put himself in a class with men of letters, aspiring both to their company and status. Indeed, El Greco had nothing but scorn for popular taste. "Although it may seem that the masses have a vote in architecture and in music or rhetoric or painting, the fact is that this happens only when time and informed opinion have revealed the truth. And if once in a while popular taste is right, it is usually by accident and is not worth taking into account."[83]

A painter committed to these ideals required a certain kind of patron. Ideally, he would be a man of learning and letters with a sympathetic understanding of the visual arts and a willingness to accept a like-minded artist as a peer. Fulvio Orsini could stand as a paragon of the type and may have come to be regarded as such by El Greco. Therefore, it was probably no accident that El Greco's road to success began in the Farnese library, where he met the man who would open the way to his career in Toledo: Luis de Castilla.

The direct result of the association with Castilla was the important commission for the altarpieces of Santo Domingo el Antiguo. This work not only provided a theater for the display of El Greco's genius, but also put him into contact with the small group of men who were equipped to understand the subtleties of his art and thought. As we have seen in chapter 1, these men, almost without exception, were men of letters— specifically, doctors of canon law, who in most cases had studied theology. Several had also found a place in the administration of the church, which permitted them to dispense patronage of all sorts. And among El Greco's friends and supporters outside the church a comparable degree of learning and local influence is apparent. This select group of Toledans discovered in El Greco a painter who was their peer; his intellectual approach to painting stimulated their cultivated minds, and his brilliant artistry satisfied their refined sense of taste. This clientele, in turn, established a fashion for El Greco's art and brought to his studio new customers seeking paintings by the most prestigious artist in the city. Here is the "secret" of his success in Toledo—and it has nothing to do with mystics or mysticism, which were regarded with ambivalence by the representatives of the establishment who favored El Greco. Nor does it relate to the supposed "orientalism" of Toledo. In chapter 1 it was shown that El Greco's Toledo was a prosperous city, sustained by the industries of cloth manufacture and religion, a city that was then being reshaped by Italianate ideas and culture. Thus, although it had not been El Greco's first intention to settle in Toledo, he eventually came to realize that the city possessed the right

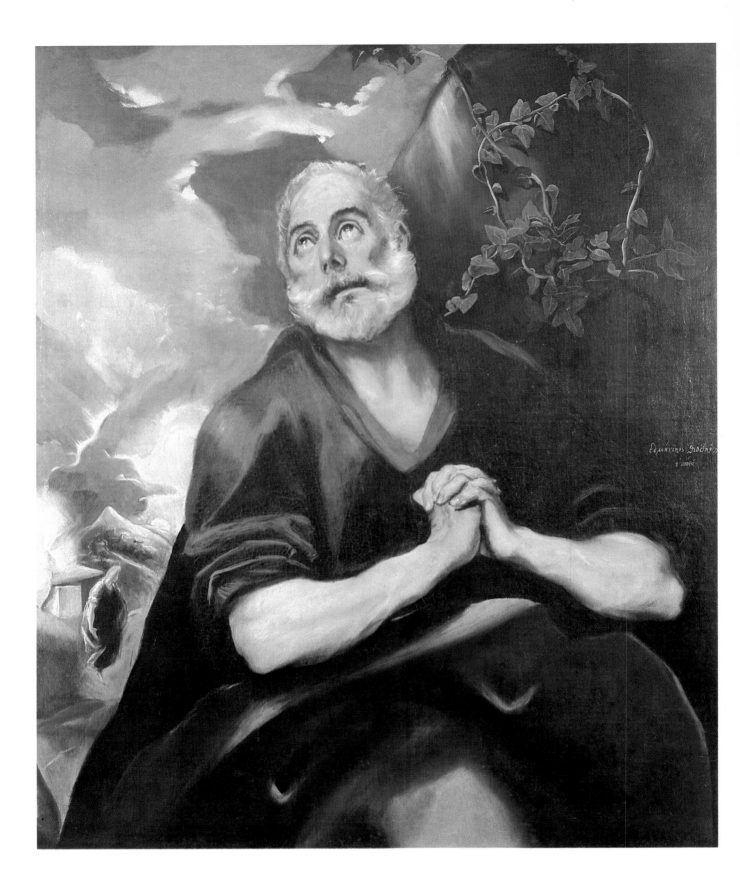

PLATE 19 (cat. no. 15). *Saint Peter in Tears*,
42½ x 35¼ inches, circa 1580–1585 (Barnard
Castle [County Durham, England], The
Bowes Museum)

combination of wealth and a cultured elite, a mixture that has traditionally fostered the creation of great art. If, despite the claims of local patriots, the city on the Tagus was not fully deserving of the epithet "a new Rome," it did at least possess many of the characteristics needed to satisfy an artist whose style and outlook had been molded in the city on the Tiber.

El Greco as a Counter-Reformation Artist

Defining El Greco's principal patronage is an important step in interpreting the character of his art, but it is only a beginning. The dynamics of the interrelationship between artist and patron are difficult to reconstruct by generalizing. Each new patron and each new set of circumstances pose different problems for the artist to solve as he seeks to give form to abstract ideas in a way that will satisfy the prevailing requirements of artistic taste. And yet the possibilities for variety are not infinite. Every historical epoch has common concerns that are interpreted in a consistent style. This broad statement is particularly true when the conditions of artistic creation are bound to a specific time and place. Thus, in attempting to reach a new understanding of El Greco's art, we have to consider two elements at once: first, the basic shared assumptions and ideals of El Greco's patrons; and second, the particular conditions surrounding each specific commission. After these factors are understood, we may be in a better position to evaluate the methods of the artist's translations of thought into image.

The basic shared assumptions and ideals of El Greco's patrons can be stated briefly: the propagation of Counter-Reformation doctrine. The interpretation of El Greco as an artist of the Catholic Reformation is well established.[84] But its central place in his art is confirmed by the identity of his patrons. El Greco's friends and clients, by and large, were learned clergymen associated with the official center of Spanish Catholicism, the archdiocese of Toledo. They were also subjects of a monarch who had come to regard himself as the temporal defender of the faith. In these circumstances, orthodoxy was the watchword of every religious artistic commission. Furthermore, El Greco's career coincided with the height of the struggle against Protestantism. The Council of Trent, which was concluded in 1563, had redefined and reinforced the articles of faith. Now it was the responsibility of the bishops to see that the doctrines were faithfully observed within their dioceses. As we have seen in the first chapter, the archbishops of Toledo in the late sixteenth century took this charge with the utmost seriousness and enforced obedience to the reforms primarily through the council of the archdiocese. The council, to which El Greco had close connections, was empowered to approve every artistic project for every church in the diocese, and seems to have carried out the charge with diligence. In accordance with these trends, the leitmotif of El Greco's art became the accurate and intelligent representation of Catholic theology.

El Greco's adherence to the doctrines of the Counter-Reformation is apparent first of all in his thematic repertory. A significant portion of El Greco's oeuvre is dedicated to the representation of saints, whose role as intercessors of man before Christ was defended by the church. In

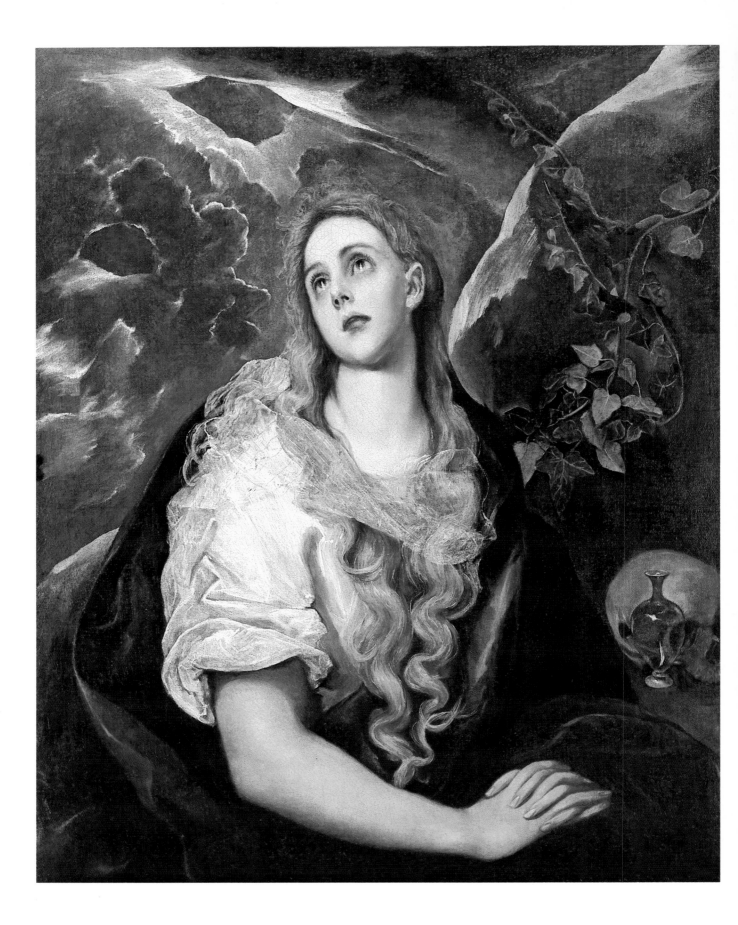

PLATE 20 (cat. no. 14). *Mary Magdalen in Penitence,* 41¼ x 33¼ inches, circa 1580–1585 (Kansas City [Missouri], Nelson Gallery – Atkins Museum. Nelson Fund)

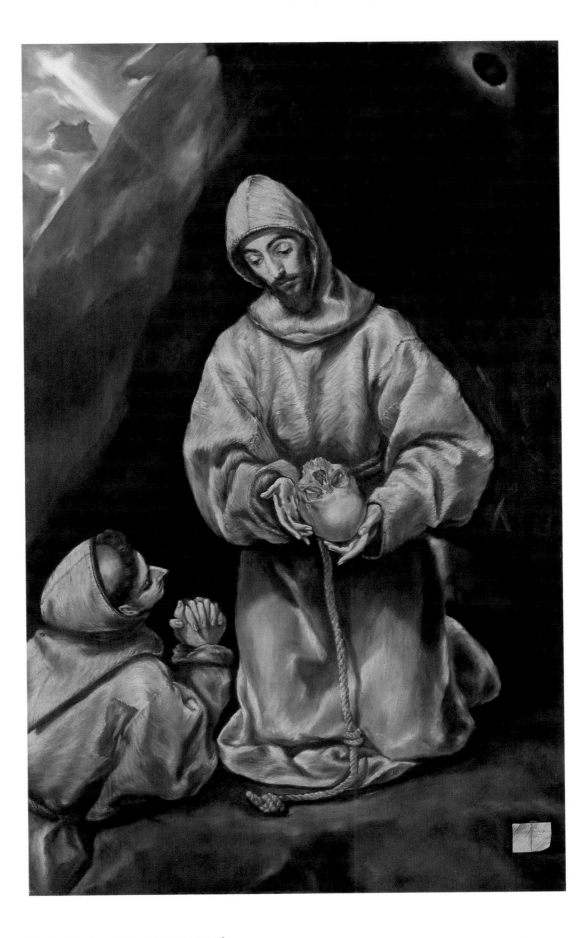

PLATE 21 (cat. no. 38). *Saint Francis and*
Brother Leo Meditating on Death, 66 3/8 x 40 1/2
inches, circa 1600–1605 (Ottawa, National
Gallery of Canada/Galerie Nationale
du Canada)

addition, El Greco frequently used images of saints to illustrate the sacrament of penance. The value of penitence, which had been downgraded by the Protestants, was upheld by Catholics as an essential part in the process of justification, by which man was put into a saving relationship with God. El Greco reflected this belief in numerous versions of the Penitence of Saint Peter (cat. nos. 15, 51; pls. 19, 64; fig. 53) and the Penitence of Saint Mary Magdalen (see, for example, cat. nos. 9, 14; pls. 20, 34). Even Saint Francis, hitherto a symbol of charity, poverty, and obedience, was transformed into a penitent (cat. no. 38; pl. 21) and became one of the artist's most popular subjects.

Another substantial part of El Greco's work was devoted to the glorification of the Virgin Mary. Mariolatry was a predominant characteristic of Spanish Catholicism. Thus, Protestant attacks on her divinity were vigorously opposed in Spain, a phenomenon accurately reflected in El Greco's art. The numerous versions of the Holy Family (for instance, cat. no. 26; pl. 45; fig. 54) attested to Mary's role as the Mother of God. In his paintings of the Annunciation, El Greco laid stress on Mary as the receptacle of God's grace (for example, cat. no. 32; pl. 1). The artist also took sides in the famous dispute within the Catholic church over the doctrine of the Immaculate Conception. The majority of Spanish theologians and the faithful believed in the Virgin's miraculous conception, which liberated her from the taint of original sin. El Greco's magnificent painting for the Oballe Chapel (pl. 24; fig. 69) is a standard representation of the theme, which shows the Virgin Immaculate in the midst of the traditional repertory of symbols used to express her purity (crescent moon, lilies, roses, City of God, et cetera). Immaculist symbols are also insinuated into depictions such as the Annunciation (burning bush — cat. no. 32; pl. 1) and the Assumption of the Virgin (crescent moon — pl. 22).

Most of these pictures illustrate standard ideas of the Counter-Reformation that were used throughout the Mediterranean Catholic world in the late sixteenth century and do not presuppose the intervention of a specific patron in the choice of subject matter. El Greco represented some of these themes by following established formulas, while in other cases he made substantial, often original, variations on the traditional compositions.[85] But in the altarpiece commissions he had to work closely with the patron, who generally had a specific purpose in mind when he decided to order a work for the decoration of a church or chapel. The planning stage for these commissions presumably entailed discussions between artist and client in which the subjects and general disposition of the altarpiece were established. Then El Greco would execute a drawing or drawings to give the patron a clear idea of how he proposed to carry out the work. The final version of the drawing was attached to the contract as a document of the agreement. Although an attached drawing is mentioned in virtually every one of his extant contracts, none has survived with the original document. (This is not exceptional for contract drawings in Spain; nearly all of them have long since been removed from the archives by unscrupulous collectors, never to appear again.)

This process of discussion and planning, culminating in a drawing by

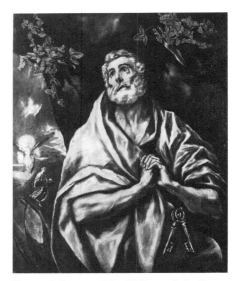

Figure 53 (cat. no. 51). El Greco. *Saint Peter in Tears*, 40⅛ x 31¼ inches, circa 1610–1614 (Oslo, Nasjonalgalleriet)

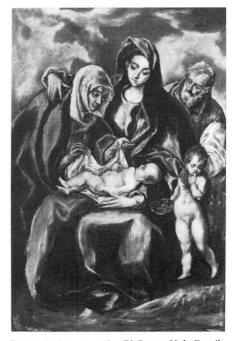

Figure 54 (cat. no. 26). El Greco. *Holy Family with the Sleeping Christ Child and the Infant Baptist*, 20⅞ x 13½ inches, circa 1595–1600 (Washington, National Gallery of Art. Samuel H. Kress Collection 1959)

the artist, was logical and necessary given the purpose of the altarpiece. It was intended to be a permanent display of the principal devotions and purposes of the client institution, knowledge of which could only come from the person in charge, who also had to answer to the authorities in the event that improprieties were detected. In the archdiocese of Toledo, however, the risk of improprieties was greatly reduced by the requirement that all designs for church decoration be submitted for approval to the archbishop's council. Obviously, deviations from the contract drawing were made at the artist's risk.

On the face of it, this process would appear to reduce the artist to the role of a puppet in the hands of the client. But in fact there was plenty of room for maneuver, because only an artist could mediate between idea and image; here it was that a great artist could produce great art. El Greco's particular strength in this situation derived from his capacity to grasp the subtleties of the intellectual program and his ability to represent them without sacrificing either complexity or legibility. The point is better understood by examining briefly two representative altarpiece commissions.

Santo Domingo el Antiguo, 1577–1579

The theme of the Santo Domingo altarpieces was determined by the purpose of the church's foundation. Money for the construction and decoration had been willed to the convent by Doña María de Silva, who lived as a member of the community for thirty-eight years.[86] The purpose of the gift was not only to provide a grandiose temple for the order of Bernardine nuns but also a funerary chapel for the donor. The latter function was expanded by the decision of Diego de Castilla to have his own remains interred in the church (which was done after his death in 1584). Santo Domingo in this way assumed the character of a personal funerary monument, a character made explicit by the dedicatory inscriptions and the coats of arms of Doña María and Castilla that are prominently displayed on the walls of the church (fig. 74).[87]

In keeping with this purpose, the imagery of the main altar was designed to commemorate the founder and her belief in salvation through Christ and the Virgin Mary. The centerpiece, the largest of all the pictures, shows the donor's namesake and patron as she ascends into heaven (pl. 22). The picture also affirms the belief in the Virgin Mary's purity and divinity, which were understood to be inherent in the subject of the Assumption. But to make the point unmistakably clear, a crescent moon, the most common symbol of the Immaculate Conception, was placed beneath Mary's feet.

Above the *Assumption* was the *Trinity* (cat. no. 7; pl. 23), here represented in a form known as the Throne of Grace. This composition, which had long been in existence, showed the dead Christ supported by God the Father, rather than Christ enthroned, and was meant to emphasize Christ's dual nature as man and God, and the acceptance of his supreme sacrifice, through which man was given redemption and salvation.[88]

The cycle of birth, death, resurrection, and salvation is echoed in the side altars—the *Adoration of the Shepherds* (fig. 55), which depicts the

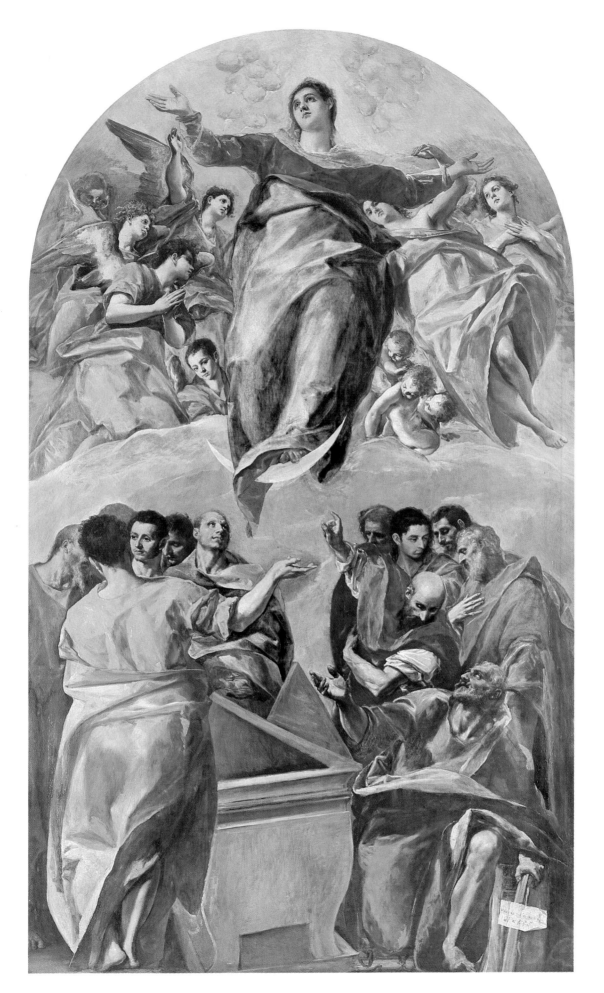

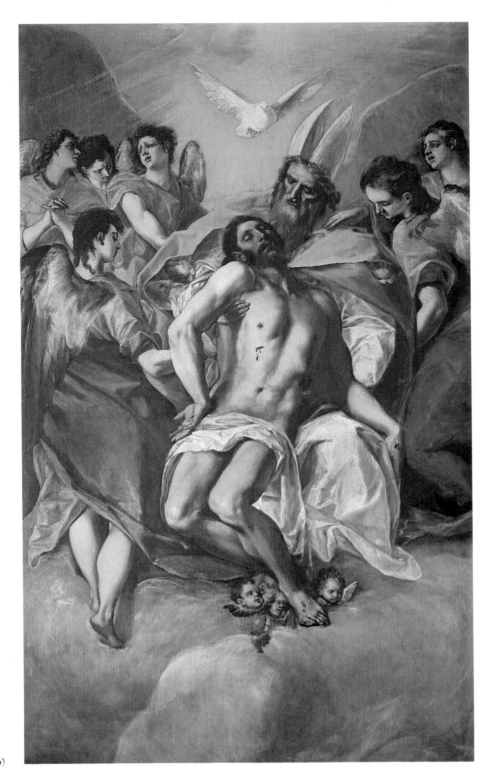

< PLATE 22. *Assumption of the Virgin,* 158 x
90 inches, 1577–1579 (Chicago, The Art
Institute of Chicago)

PLATE 23 (cat. no. 7). *Trinity,* 118⅛ x 70⅛
inches, 1577–1579 (Madrid, Museo del Prado)

119

beginning of Christ's earthly life, and the *Resurrection* (fig. 56), portraying his triumph over death and the affirmation of his saving power. El Greco subtly enriched the meaning of these pictures by evoking the sacramental character of the subjects. In each case, the composition alludes to the mysterious communion with Christ in the Sacrament of the Eucharist. In the *Adoration of the Shepherds*, attention is focused on the naked body of the Christ Child, before which the Holy Family and the shepherds kneel as if in prayer. This version of the scene, which lays stress on the body of Christ, was common in Counter-Reformation art and was intended to remind the spectator of the words spoken during the unveiling of the Host during the mass: "Here is the true body of Christ born of the Virgin Mary."[89] In addition, the sacramental dimension of the picture, and of the *Resurrection*, was emphasized by the fact that it was made to rest directly on the altar table beneath it. The *Adoration* also restates the belief in the Virgin Mary as the Mother of God and her freedom from original sin by the inclusion of the crescent moon in the upper right. And the presence of Saint Jerome (holding a candle) is another reminder of the Virgin's purity, which he had defended in a famous treatise, *Adversus Helvidum*.

On the opposite side of the chapel is the *Resurrection*. The composition of this picture conforms to a tradition that had evolved gradually in the sixteenth century and that became popular after the Council of Trent, especially once it was sanctioned by the Counter-Reformation theologian Johannes Molanus in 1570.[90] In this version of the scene, some of the soldiers surrounding the tomb are shown as awake and recognizing the divinity of Christ, whereas before the sixteenth century all usually had been represented as asleep.[91] The awakened soldiers react to the miraculous appearance of Christ and hide their eyes from the supernatural glow of his body. The emphasis on the almost naked body of Christ, surrounded by an aura of light, parallels the treatment of the body of the Christ Child in the *Adoration of the Shepherds* and turns the *Resurrection* into a vision of the living God, who is embodied in the Sacrament of the Eucharist. Thus, this painting is also concerned with the exaltation of the mystery of the Eucharist as well as with the role of Christ as redeemer. In the lower left of the canvas stands Ildefonso, patron saint of Toledo and a renowned defender of the Virgin's purity. The saint wears white Easter vestments appropriate to the feast commemorating the Resurrection.

The references and cross-references in the program of ideas in Santo Domingo are almost symphonic in their complexity. On the first level, there is the funerary message, determined by the function of the chapel as the burial site for Doña María and Diego de Castilla. Both the founder and her executor are memorialized in the altarpieces—the first by the representation of the Assumption of the Virgin Mary, the second by the inclusion of Saints Jerome and Ildefonso, both of whom were especially venerated by Diego de Castilla. In fact, it has even been suggested that Saint Ildefonso is a portrait of Castilla, which is plausible if not provable. Then, in the side altars, the message is embroidered by interweaving the theme of Christ as man and Redeemer, through whose sacrifice humankind would be saved. This idea is given a doctrinal dimension by the refer-

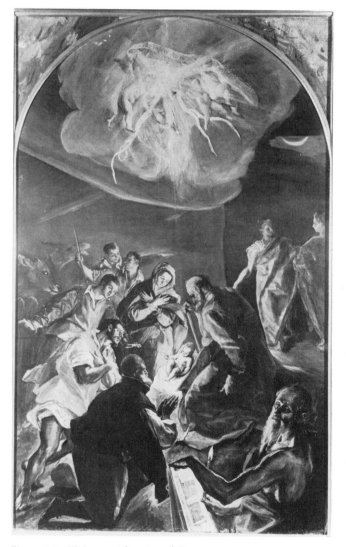

Figure 55. El Greco. *Adoration of the Shepherds*, 82⅝ x 50⅜ inches, 1577–1579 (Santander, Emilio Botín Sanz Collection)

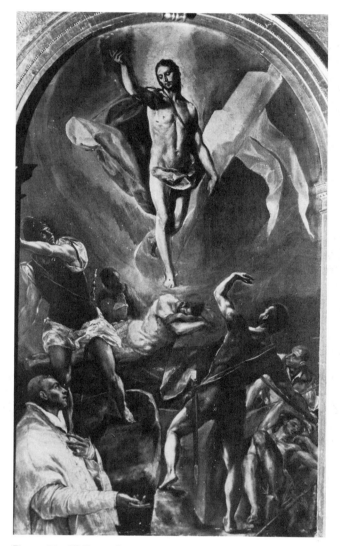

Figure 56. El Greco. *Resurrection*, 82⅝ x 50⅜ inches, 1577–1579 (Toledo, Santo Domingo el Antiguo)

ences to the mystery of the Eucharist, symbolized by the revelation of the Body of Christ.

Translating these abstract ideas into works of art could not have been easy. It is certainly not easy to reconstruct how El Greco accomplished the feat, but there are some indications. As the memorandum attached to the contract states, Diego de Castilla had the sole and complete authority to accept, reject, or order alterations to the finished pictures. "If any of these paintings are not satisfactory in part or in whole, the said Dominico is obliged to correct them, or remake them, so that the work is perfect and acceptable to Don Diego, canon, whose opinion will be submitted to said Dominico.... And whatever is said must be done, without any appeal except to that of the wishes of said dean."[92] Naturally the subjects of the painting were also specified in the contract, and those intended for the high altar were indicated on a drawing that was also incorporated into the agreement. These conditions leave no room to doubt that the commission was under the strict control of the patron. Yet Diego de Castilla was not an artist. Thus, when all was said and done, he had to entrust to El Greco the task of inventing suitable visual equivalents for theological ideas, although it seems safe to assume that, if only out of prudence, the artist would have discussed his plans with Castilla both before and during the execution.

The first step in the process involved a review of existing formulas for representing the required scenes. During his years in Italy, El Greco had had the chance to build up a repertory of images from the countless paintings, drawings, and sculptures that he had seen. When confronted with the task of depicting a certain subject, he would draw on this repertory for a suitable motif or composition. Also, like most artists of his day, he kept a file of prints and drawings for reference; his death inventory listed 200 prints and 150 drawings.[93] Time and again throughout his career, El Greco "borrowed" motifs from works by other artists to use as a starting place for his own compositions, transforming them to suit his own style and purpose.

The clearest example of this practice in the Santo Domingo commission is seen in the *Trinity*, which is based on a composition by Albrecht Dürer (fig. 57).[94] In adapting Dürer's model, El Greco first of all eliminated the numerous symbols of the Passion held by the attendant angels, which are distractions from the pathos of the scene. Then he replaced Dürer's bony, angular Christ with a figure comprised of two motifs culled from works by Michelangelo, one of El Greco's favorite sources of ideas. The sinuous pose of the figure derives from the Colonna *Pietà* (see fig. 58), except for the position of the left arm, which is adapted from the figure of *Duke Lorenzo de' Medici* in the Medici Chapel in San Lorenzo, Florence (fig. 59).[95]

Another example of this "composite" procedure is apparent in the *Assumption of the Virgin*. The pose of the Virgin refers to the famous version of the scene by Titian in the Church of the Frari, Venice.[96] However, the kneeling figure holding a book in the lower right corner is a recast version of Saint Bartholomew in Michelangelo's *Last Judgment*.[97]

The importance of Michelangelo as a source of images for El Greco is reaffirmed in the *Resurrection*, which is modeled in part on a beautiful chalk drawing of the subject, the very one owned by Giulio Clovio (see fig.

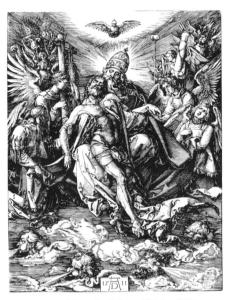

Figure 57. Albrecht Dürer. *Trinity*, 1511 (Boston, Museum of Fine Arts. Bequest of Francis Bullard, Special Purchase Fund 1905)

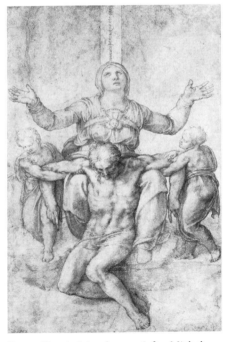

Figure 58. Artist unknown (after Michelangelo). *Pietà*, circa 1550–1560 (Boston, Isabella Stewart Gardner Museum)

Figure 59. Michelangelo. *Duke Lorenzo de'
Medici*, 1520–1534 (Florence, San Lorenzo,
Medici Chapel)

Figure 60. Francesco Salviati (after
Michelangelo). *Apollo*, after 1534 (Vienna,
Graphische Sammlung Albertina)

43).[98] The positions of the soldiers in the right and left foreground echo those in the drawing (although El Greco reversed the pose of the retreating soldier to the left of Michelangelo's Risen Christ). Just beneath Christ's feet is a supine figure, head resting on his arms, who has migrated from the lower right of Michelangelo's composition. Along the right edge of the picture is another sleeping figure, seen in foreshortening with bent legs, whose prototype is the famous *"Night"* from the Medici Chapel.[99] Finally, the Risen Christ depends ultimately on Michelangelo's unfinished *Apollo*, which El Greco may have known from drawings of it by other artists (fig. 60).

In piecing together El Greco's visual sources there is a risk of making him appear to be a *pasticheur*, an artistic magpie gathering a pose from here, a gesture from there, as if he lacked sufficient imagination of his own. But the practice was a common one at the time; indeed, Maniera artists took special pleasure in demonstrating their knowledge of the great masters and displaying their skill and wit in using existing motifs as raw material for their own creations. The use of borrowed motifs not only conferred a measure of authority on their own works, it also gave the artists access to a sort of visual shorthand for the expression of their patrons' ideas. Great artists were always able to adapt the motifs to fit their own ideas and circumstances and to unify them through their own personal style.

The mode of operation exemplified in the Santo Domingo commission persisted throughout El Greco' life. The patron determined the subject; the artist gave it form and visual meaning by recasting traditional motifs in his original style. In some instances, however, El Greco appears to have been allowed a freer hand in the formulation of subject matter than in others. The creation of his greatest work, the *Burial of the Count of Orgaz*, helps us to see how the artist's mind worked when the patron was less intrusive than Diego de Castilla.

The Burial of the Count of Orgaz, *1586–1588*

As with the Santo Domingo altars, an understanding of El Greco's greatest picture hinges on its function as the decoration of a funerary chapel (fig. 61). Also significant is an episode of local history.[100] The parish church of Santo Tomé housed the remains of Gonzalo de Ruiz, Lord of Orgaz, who had died in 1323 after a lifetime distinguished by generous gifts to religious institutions in Toledo. According to local legend, Gonzalo de Ruiz's charity had been rewarded by a miracle that occurred at his funeral. Just as the body was being prepared for burial, Saints Stephen and Augustine appeared and lowered the deceased into his tomb.[101]

In his will, Ruiz had bequeathed an annual donation to Santo Tomé, to be collected from the citizens of Orgaz, a town that was his seignurial possession. Around 1562, the people of Orgaz decided to stop making the annual donation, probably hoping that the memory of the bequest would slip into oblivion. However, in 1564, Andrés Núñez de Madrid, then the parish priest of Santo Tomé, brought litigation against the town to enforce resumption of the payment. In 1569 the royal chancellery in Valladolid

Figure 61. Interior, Orgaz Chapel, Santo Tomé, Toledo, showing El Greco's painting in its original location

decreed a verdict favorable to Núñez, who then decided to use the money to improve the burial chapel of the Lord of Orgaz.[102] The first step was to commission a lengthy Latin inscription describing the miracle from Dr. Alvar Gómez de Castro, which was incised on a stone and set into the wall of the chapel above the floor tomb containing the remains of Gonzalo de Ruiz.[103]

Núñez next set out to obtain official recognition of the miracle, which was granted by a royal decree on September 24, 1583. Now the time had come to commission a painter to represent the scene of Gonzalo de Ruiz's miraculous entombment. In 1584 Núñez applied to the archbishop's council for permission to order a painting for the chapel; authorization was granted on October 23 of that year.[104] The license specifically required that the contents of the picture conform to the text of the inscription composed by Gómez de Castro.

The contract with El Greco, signed on March 18, 1586, included among its conditions a description of the subject and of the principal elements the artist agreed to represent. The relevant text is short and worth quoting in full:

> [The artist] agrees to paint a picture that goes from the top of the arch to the bottom. The painting is to be done on canvas down to the epitaph. Below the epitaph there is to be a fresco in which the sepulcher is painted.

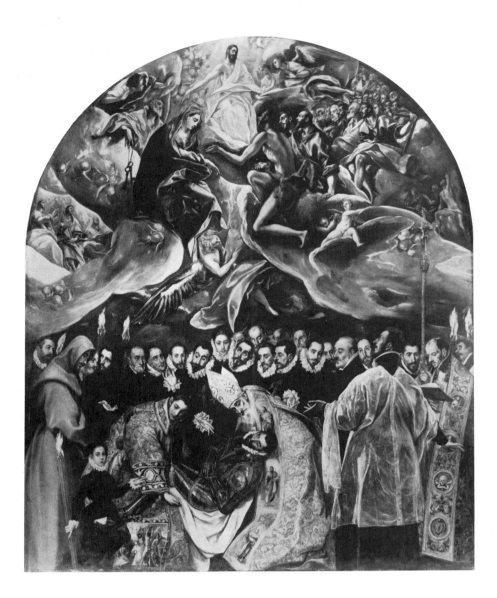

Figure 62. El Greco. *Burial of the Count of Orgaz*, 189 x 141¾ inches, 1586–1588 (Toledo, Santo Tomé)

On the canvas, he is to paint the scene in which the parish priest and other clerics were saying the prayers, about to bury Don Gonzalo de Ruiz, Lord of Orgaz, when Saint Augustine and Saint Stephen descended to bury the body of this gentleman, one holding the head, the other the feet, and placing him in the sepulcher. Around the scene should be many people who are looking at it and, above all this, there is to be an open sky showing the glory [of the heavens].[105]

From this simple description came the masterpiece we know as the *Burial of the Count of Orgaz* (pl. 3; fig. 62).

It is immediately apparent from the contract that the parish priest granted El Greco more freedom than was allowed by Diego de Castilla. Núñez was fairly explicit about the contents of what became the lower zone of the picture. This was to be a reenactment of the miraculous burial, with a novel feature—namely, the illusionistic deposition of the body into a feigned tomb, to be painted in fresco below the epitaph. In the end, however, this feature was eliminated, perhaps because the intermediate position of the inscription would have destroyed the intended illusion. As for the upper zone, it appears to have been left entirely to El Greco's imagination; thus we can see how he synthesized several visual sources into an amalgam of Counter-Reformation ideas.

The principal purpose of the *Burial of the Count of Orgaz* is clear enough

from the document: to commemorate the benefactor of the Church of Santo Tomé and the miracle of his entombment. El Greco seems to have taken his initial inspiration from the text of Núñez's instructions, specifically the part that required him to show "the parish priest and other clerics . . . saying the prayers, about to bury Don Gonzalo de Ruiz." Accordingly, the artist cast the composition as a funeral mass — specifically, the moment when the body is lowered into the grave. In the center, two saints hold the armor-clad body of Gonzalo de Ruiz and bend over to deposit him in the tomb (which in fact was in the wall of the chapel). At the right, the officiating priest, sometimes said to be a portrait of Andrés Núñez himself, reads from a prayerbook. The text that would be chanted at this moment of the funeral liturgy is a ninth-century hymn, *In Paradisum*, whose lyrics may have supplied the inspiration for the composition of the upper half of the picture:[106]

> May the angels lead you into paradise; may the martyrs welcome you on your arrival and bring you into the city of Jerusalem. May the choir of angels receive you, and may you rest eternally with the once-poor man Lazarus.

On one level, then, the *Burial of the Count of Orgaz* is a surprisingly literal representation of the culminating moment in the Office of the Dead. The body is being lowered into the tomb while the priest chants the hymn. Above, an angel is guiding the soul of Gonzalo de Ruiz to judgment before Christ, where the Virgin Mary and Saint John the Baptist are already interceding on his behalf to obtain a place in heaven among the saints. The next step was to explain how the Lord of Orgaz had won his privileged place in paradise. To do this, El Greco referred to the information contained in the epitaph composed by Gómez de Castro.

The text of the epitaph informs us that the chapel is dedicated to "*Divis Beneficis et Pietati*" — to the beneficent and pious saints, the saints who performed good works. The words *good works* were loaded ones in the sixteenth century, because the Protestants had denied the value of charitable deeds as a means to bring the soul into a state of grace, believing instead that justification resulted solely from acts of faith. The importance of good deeds and charity as a way to salvation was tenaciously defended by the Catholic church both in writing and in art, and that concept is reiterated in El Greco's picture. The miraculous intervention of the two saints in the burial is meant as a reward sent from heaven to honor Gonzalo de Ruiz's life of charity. And to remove any doubt on this point, El Greco showed the soul of Ruiz, an infant-shaped protoplasm held by an angel, as it ascended into heaven for judgment and salvation. There, amongst the congregation of the blessed (including, somewhat prematurely, the figure of the king, Philip II), Gonzalo de Ruiz took his place and so affirmed the unmistakable message of the picture: that charity triumphs over death and leads to salvation.

The proclamation of this message also determined the most unusual feature of the earthly zone of the canvas. Here El Greco used a device that may be called anachronistic representation, showing the fourteenth-century burial as witnessed by a group of men dressed in sixteenth-

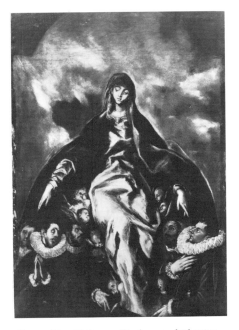

Figure 63. El Greco. *Madonna of Charity,*
72½ x 48¾ inches, 1603–1605 (Illescas,
Hospital of Charity)

century costume. All of these men, it seems, were portraits of people then living in Toledo, although only one has been surely identified—the painter's close friend Antonio de Covarrubias y Leiva (cat. no. 61; pl. 5). The reason for this bold defiance of chronology may perhaps be found in the desire to express the idea that charity and good works were a fundamental doctrine of the faith, and therefore no less relevant to the present than to the past. This didactic function is reinforced by the boy at the left who directs the viewer's attention to the scene by pointing his finger at the miracle, a gesture commonly used in Renaissance art to draw attention to the divine presence. The boy, by the way, is thought to be El Greco's son, Jorge Manuel, and his presence is accounted for by the fact that he, like his father, was then a parishioner of Santo Tomé.

One more important Counter-Reformation theme was incorporated into the *Burial of the Count of Orgaz,* the glorification of the saints as divine intercessors. According to the terms of the contract, El Greco was to paint a scene of "the glory," which was usually understood to mean some or all of the Christian divinities represented in heaven, surrounded by the angelic host. In the *Burial,* the glory becomes a synthesis of two compositional types often represented in religious art—the Last Judgment and the All-Saints picture.[107] The glorification of the saints and their role as intercessors for man before God are fundamental to Counter-Reformation thought. By combining two iconographical types, El Greco in effect expanded the implications of the miraculous intervention of Saints Stephen and Augustine in the burial of Gonzalo de Ruiz, and again gave the picture additional relevance to a contemporary audience.

The process by which El Greco turned ideas into images in the Santo Domingo and Santo Tomé commissions is characteristic of his usual practice and could be illustrated just as well by analyzing his other commissions. Like virtually all artists of his time, he was familiar with a wide repertory of standard compositions for popular subjects—one of which he alluded to in a document of 1605. During the litigation with the Hospital of Charity at Illescas, the artist was attacked by the appraisers for having represented the supplicants in the *Madonna of Charity* (fig. 63) with ruff collars, which were alleged to be improper. El Greco's reply to the charge was that this subject matter was customarily represented with supplicants in contemporary dress, and his words of rebuttal were delivered with a thick coating of scorn.

> The job of the appraisers was to set a value [on the work] but they decided to censure and correct the picture. And what they consider to be a fault—namely, that some among the crowd of people painted beneath the mantle to Our Lady of Charity are wearing ruff collars like the ones that some people wear today—is a fault worth pondering, because what they hold to be indecent for that place is a practice in use throughout Christendom.[108]

As any art historian can attest, El Greco's assertions were accurate: the painting's composition fully corresponds to a well-established tradition.

El Greco's command of prevailing artistic traditions is not really surprising in view of his Italian training. In fact, his methods were the same

ones used by artists the length and breadth of Europe in the sixteenth century. But if the procedure was routine, the result was obviously extraordinary. El Greco had the mind of a humanist, schooled to appreciate the intricacies and subtleties of artistic theory and theological doctrine (although certainly not to the same degree as a professional scholar). He also had friends like Antonio de Covarrubias and Pedro Salazar de Mendoza who could assist him in formulating ideas and who could guarantee that he stayed on the straight and narrow path of Catholic orthodoxy. As fully detailed studies of the content of his commissioned works show, El Greco's paintings were at times virtual dissertations on aspects of Counter-Reformation doctrine.[109] Yet complexity was never permitted to overwhelm clarity of thought. There was a message for the faithful, no matter how unschooled, and a deeper message for clerics and scholars who were versed in Catholic theology.

The notion that El Greco's pictures comprise layers of theological meaning becomes more plausible if we remember that most of his major altarpiece commissions were designed for places of limited access. In other words, El Greco's art played in special "theaters" that were not normally open to the general public. Only once did he paint a major picture for a parish church—the *Burial of the Count of Orgaz*. All the other major commissions were for private chapels (Chapel of Saint Joseph) or specialized religious institutions, such as a convent (Santo Domingo) or a seminary (College of Doña María de Aragón) or a hospital (Saint John the Baptist). This circumstance, taken together with the learned character of his principal patrons, gave him ample scope to develop an intellectual's art. These same conditions also encouraged his propensity to develop a pictorial style that was fully equal to the complex content of his pictures. The evolution of this style was based on the deliberate cultivation of a particular aesthetic shared by many painters of the time. But the execution of these aesthetic ideas was carried out with a boldness and daring unmatched by any of his contemporaries.

The Aesthetic Ideas of El Greco

El Greco's ideas on the theory and practice of art have come down to us only in fragmentary form. At some point during his years in Toledo, he undertook to write treatises on painting and architecture. The reasons why he embarked on this enterprise are nowhere stated, but it seems logical to assume that he was influenced by the example of Italian artist-writers whose works he had come to know in Venice and Rome. These men, in turn, had taken up the pen for two reasons. Treatises on art, which in general were designed to provide a philosophical basis for artistic practice, equipped artistic pursuits with intellectual credentials. Thus, an important aim was served: to elevate painting, sculpture, and architecture to the level of the other liberal arts, especially poetry and music. Once established, the intellectual status of the visual arts conferred an exalted social status on the practitioners.[110]

Yet more was at stake than mere social climbing. The redefinition of the visual arts opened the way to a fundamentally new conception of their purpose and function. We now take for granted that artists can be endowed

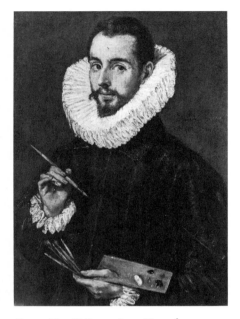

Figure 64. El Greco. *Jorge Manuel Theotokopoulos*, 31⁷/₈ x 22 inches, 1600–1605 (Seville, Museo de Bellas Artes)

with a special capacity for understanding and communicating important aspects of thought and experience. But this idea was being shaped precisely in the period in which El Greco lived, and it is one in which he was keenly interested both for aesthetic and practical reasons.

The practical reasons are perhaps more easily explained. During his years in Italy, El Greco saw that artists were gradually winning acceptance as superior members of society and he must himself have aspired to be regarded as a gentleman and artist-scholar. Indeed, at one point he visualized his conception of the artist as gentleman in a portrait of his son (fig. 64). In this work, Jorge Manuel is dressed in the elegant fashion of the day, which serves to identify him as a person of the upper classes. He also displays his brushes and palette for all to see, thus proclaiming his profession as a noble one.

By the end of the sixteenth century, the concept of painting as a liberal art was well established in Italy. But in Spain, painting was still generally regarded as a craft and its practitioners as little more than craftsmen involved in manual labor.[111] In a way, El Greco never recovered from the surprise of discovering this attitude and, to the end of his life, engaged in a one-man battle against those who thought to demean his profession. His frequent recourse to arbitration proceedings to settle disputes over prices for his work is one manifestation of his professional pride; although he wanted and needed money for practical reasons, he also recognized that higher prices reflected greater esteem. His writing of treatises may be construed as another method of winning acceptance for his profession in a prejudiced society. As an author of learned works on the arts of painting and architecture, El Greco could fairly claim the status of philosopher or humanist and the respect that was attached to persons who cultivated those studies.

Alongside these practical considerations for writing on art were others that can be called aesthetic. Through years of study and experience, El Greco had developed ideas on beauty that he had sought to express in his art and now wanted to communicate in writing. As mentioned earlier, it appears that El Greco wrote two separate treatises—one on painting, which was alluded to by Pacheco,[112] and a second on architecture, mentioned by Jorge Manuel.[113] Neither, unfortunately, has come down to us. But some of El Greco's working papers have quite recently come to light, offering precious glimpses of his ideas on art, expressed in his own handwriting (fig. 65).

El Greco's working papers are in fact marginal annotations, written in a strange mixture of Italian and Spanish, to two of the books on art most widely read in the later sixteenth century. One is Giorgio Vasari's *Lives of the Painters*. El Greco owned the second edition (1568); only the second and third tomes of this three-volume edition have been found with El Greco's annotations, and his notes are only partly published.[114] But his comments on Vasari's biographies of Michelangelo and Correggio contain much fascinating information about El Greco's tastes in art.

More important still are the extensive marginal comments the artist made around 1590 in the 1556 version of Vitruvius's famous work, *On Architecture*, an edition published with comments by the Italian humanist

Figure 65. Page from Vitruvius's *On Architecture* (Daniele Barbaro edition, Venice, 1556), with annotations in the hand of El Greco

Daniele Barbaro. The recent discovery and exemplary publication of El Greco's annotations to this book, considered with his remarks on Vasari, make it possible to arrive at a more accurate understanding of the aesthetic aims of his art.[115]

In the broadest terms—and to use words that were current in the sixteenth century—El Greco appears to have been aiming to achieve a synthesis of Venetian color and Florentine design. Toward the middle of the century, a great debate had opened between Venetian and Florentine-Roman artists and theorists over the priority of color versus drawing as the essential element of great painting.[116] Venetian writers exalted Titian as the greatest of painters and attacked Michelangelo, symbol of the Florentine school, because he failed to master the use of color. Florentines, along with Romans, naturally praised Michelangelo and disparaged Titian. El Greco, as an artist who had worked in both places, took a middle ground between the two camps, recognizing Titian as the master of color, Michelangelo as the master of design. But, like some Venetian theorists, he was remorseless in criticizing Michelangelo as a painter. For instance, Vasari's praise of Michelangelo's *Last Judgment* in the Sistine Chapel—Vasari considered it

to be the acme of painting—drew this sarcastic retort from El Greco: "You don't mean to say that you can't paint better than this! Giorgio is not to be blamed for what he says."[117] And next to Vasari's admiring comment on the frescoes in the Capella Paolina, El Greco wrote: "Oh, what a great shame [that he should praise such a work]."[118]

Yet El Greco's negative remarks on Michelangelo can be deceiving, because his aesthetic was thoroughly imbued with Michelangelesque ideals. Michelangelo had been a serious and original thinker on artistic questions.[119] Although he had intended one day to write a treatise on art, he had never managed to do so. But his ideas had spread freely through artistic circles in Florence and Rome and had been partially published by such writers as Vasari and Lomazzo. El Greco not only owned the books by these authors but also had contact in Rome with people who had heard the master himself expound his ideas on art and artistic creation. In fact, one of the annotations to Vitruvius specifically mentions an occasion when Giulio Clovio told El Greco of a conversation he had held with Michelangelo on the subject of the value of measurements or geometry to artistic creation.[120]

Michelangelo's theory of art is difficult to reconstruct with precision and, therefore, to summarize. He had read widely in ancient and modern philosophy, was acquainted with the subject of poetics, and, of course, had vast experience as an artist. The resulting theory was therefore rich, eclectic, and diffuse. But despite its undoubted complexities, Michelangelo's thinking on art was clear on one central point: the primacy of imagination over imitation in artistic creation. Put another way, he prized the subjective quality of artistic creation rather than its objective function of recording the appearance of man and nature. This idea and its many ramifications were essential in shaping the outlook and style of painters working in Florence and Rome around the middle years of the sixteenth century, the painters who practiced the Maniera style still current when El Greco arrived at the Farnese Palace in 1570. There is ample evidence from El Greco's writings that he fully shared the belief in artificial art and expressed his belief in terms of what we can conveniently call Mannerist art theory.

At the heart of Mannerist theory was the belief in the "judgment of the eye," which elevated the judgment of the artist above all other criteria for excellence.[121] Vasari makes frequent references to the concept in *Lives of the Painters*, including once in the biography of Michelangelo. In his copy of the book, El Greco sketched a picture of an eye in profile in the margin alongside the passage as if to draw attention to a statement of supreme importance.[122] It is in fact a cornerstone of his own aesthetic.

> He [Michelangelo] would make his figures nine, ten and even eleven heads long, for no other purpose than the search of a certain grace in putting the parts together which is not to be found in natural form, and would say that the artist must have his measuring tools, not in the hand but in the eye, because the hands only operate; it is the eye that judges.[123]

In one of his annotations to the text of Vitruvius, El Greco recasts this statement in his own words:

As I understand it, the eye of the painter is like the ear of the musician, namely a great thing.... In art, things cannot be put into words because, in truth, the most supreme element of these arts (not to say all the arts) cannot be put into words. And thus those painters who have done something never dealt with measurements. Thus, Giulio Clovio used to tell this story. When he asked Michelangelo about [the value] of measurements [in art], he told him that... anyone who dealt with measurements was very stupid and wretched.[124]

The Mannerist criteria for judging beauty, which El Greco shared, were therefore largely intuitive and rested to a large extent on the concept of what was called *grazia*. A difficult word to translate, *grazia* referred to the beauty of the spirit made visible and was often said to make itself manifest by the quality of facility. The effortless solution of a difficult artistic problem—foreshortening was a frequently cited example—denoted the possession of *grazia*. El Greco's subscription to this idea is stated more than once in his annotations to Vitruvius, but nowhere more directly than in these words: "As you can see in the work of eminent practitioners of any art, it is in the difficulties where facility appears."[125] "The art that contains the greatest difficulties will be the most agreeable and consequently the most intellectual."[126]

El Greco enshrined only a few artists in his temple of *grazia*, and the list of those honored is a valuable indication of his tastes in art.[127] Among architects, there were no qualified practitioners. And among sculptors only Michelangelo was deemed to have possessed *grazia*. The list of "graceful" painters is longest, although somewhat inconsistent from a purely Mannerist standpoint. Titian heads the list, because of his excellence in imitating nature (a quality about which El Greco was usually ambivalent). Then come Tintoretto, Raphael, Correggio, and Parmigianino. Unfortunately, according to El Greco, Tintoretto, Raphael, and Correggio had not fully lived up to their potential, for reasons beyond their control; the first had failed to win the favor of princes (an indirect but important sign of El Greco's own ambitions to be a court painter), while the latter two had died while still young. Parmigianino is specifically praised by El Greco for "what is called the elegance and grace of his figures." El Greco's honor roll seems both short and safe, but in fact it reads almost like a formula, reflecting his great ambition to combine the best of Venetian and Roman painting into a graceful synthesis.

Another aspect of the quality of *grazia* was spontaneity; careful planning and elaboration of a work was thought to produce a labored, unpleasant effect. Although El Greco does not mention the subject in his extant annotations, his desire to achieve a spontaneous effect in his painting is referred to in a passage in Pacheco's *Arte de la pintura*: "Who would believe that Dominico Greco put his hand to his paintings many times and retouched them over and again to leave the colors unblended and distinct, and left rough blotches [of paint] to affect virtuosity?"[128] If this description of El Greco's technique is accurate, then it would seem that he worked hard to produce the desired effect of spontaneity.

El Greco also accepted the importance of complexity, variety, and nov-

elty as worthy goals of the artist, once more following the example of the Mannerist theorists. In one of his frequent attacks on Daniele Barbaro's remarks on the text of Vitruvius, El Greco rejects the claim of the superiority of antique art:

> What would Barbaro say if he found among the ancient temples the Basilica of St. Peter, [a temple] with so much variety [of design] and novelty and so removed from that simplicity [prized by] the ancients. And with all this, Michelangelo never had studied architecture except to look at buildings and the ruins of Italy and [had only to use] his great [ability] to draw the human figure.[129]

Even though these remnants of El Greco's thought are fragmentary, they indicate his allegiance to the theories of Mannerist writers. Unlike the followers of Michelangelo, however, he had room in his scheme of things for Titian and his genius as a colorist. As a matter of fact, El Greco emphasized the importance of color (which sets him apart from the Florentine-Roman school of thought), stating explicitly at one point, "I hold the imitation of color to be the greatest difficulty of art."[130] This is a vital point, to be discussed subsequently. But otherwise, the qualities prized by El Greco—grace, intuition, facility, complexity, novelty, and variety—were the same ones propounded by the Mannerist writers. They also corresponded to a range of ideas often associated with Neoplatonic philosophers, who were influential in shaping Renaissance thought. For this reason, it has sometimes been said that El Greco was influenced to a substantial degree by Neoplatonism, especially where it touched on the phenomenon of light metaphysics as a means for understanding the visible relations between the hierarchies of heaven and earth.[131] El Greco owned a few books devoted to the subject, but it is difficult to know to what degree, if any, his art was specifically motivated by an intention to give visual form to these abstract ideas. By the last third of the sixteenth century, Neoplatonism had become such a commonplace element in art theory that it was impossible to discuss artistic matters without recourse to its ideas and terminology. This almost ritual use of the language of Neoplatonism probably ought not to be isolated as the sole motivating force in the art of El Greco or any painter of this time. It was but one element among many that helped to set the tone and give direction to philosophical speculations about painting in the late sixteenth century, an element emphasized by some writers, minimized by others.

A final point revealed in El Greco's writings has already been touched on previously: his belief in painting as an intellectual pursuit. This belief, once again, is typically found in Mannerist theory and it is a logical result of efforts to replace imitation as the central aspect of artistic creation. Instead of using nature as a model, Mannerist writers posed an otherworldly ideal of beauty, one that was formed in the mind of the artist. By substituting intuition for imitation they necessarily changed painting to a speculative art from a mimetic one and defined the artist as an inventor instead of an imitator of forms. El Greco's statement of the Mannerist painter's creed is admittedly somewhat contradictory—he could not completely reconcile his Venetian and Florentine-Roman allegiances—but

133

his definition of painting as a "speculative" art is inherent in what he says.

> Painting is the only thing that can judge everything else because its ob-
> jective is to imitate everything. In sum, painting occupies the position of
> prudent moderator of all that is visible. And if I could express in words
> what a painter sees in his sight, it would seem a strange thing because
> sight shares aspects of many faculties. But painting, because of its uni-
> versality, becomes speculative and never lacks substance to speculate
> on because even in partial darkness there are things to see and to enjoy
> and to imitate.[132]

El Greco's thoughts on art and painting are of enormous value in defin-
ing the nature and evolution of his style. In the first place, his ideas reveal
him to have been a typical artist of his time. El Greco lived during a period
when the writing on art was flourishing as never before. The very fact of
his dedication to the pursuit is therefore significant. It was a fashionable
thing to do and he followed the fashion. The next point is that El Greco's
ideas are rather conventional. El Greco the theorist slips easily into the
mold of sixteenth-century Italian art theory. His attempt to synthesize
sometimes contrary theories and tastes does, however, represent an impor-
tant, original mode of thought. The final point revealed by El Greco's writ-
ings is that he adopted an intellectual stance toward his art. Painting for
him was an art governed by ideas, which guided execution, and painters
were therefore philosophers who, through their art, shaped ideas and
communicated knowledge.

Theory and Practice: Toward an Understanding of El Greco's Style

But do El Greco's ideas help us to understand the character of his art?
The gap between artistic theory and practice is often wide, but in El Greco's
case, the theoretician is also a practitioner. His writing has a great deal to
contribute to grasping the essence of his style.

First and foremost, it leads us to understand that the subjective, anti-
naturalistic character of his painting was not the result of spiritual visions
or emotional reactions to his subject matter. Rather, he was attempting to
create an artificial art dedicated to the expression of abstract ideas on
beauty—art that would exhibit his ingenuity and prove his status as an
intellectual artist. For instance, El Greco's use of elongated figure propor-
tions, one of the most familiar features of his art, was motivated by the
belief that such figures were inherently more beautiful than normal-sized
figures. The quotation from Vasari's life of Michelangelo that El Greco
drew attention to in his copy of the book states the point succinctly. "He
[Michelangelo] would make his figures nine, ten and even eleven heads
long, for no other purpose than the search for a certain grace in putting
the parts together which is not to be found in natural form."

El Greco's treatment of human anatomy is, moreover, based in Manner-
ist theory. During his years in Italy, El Greco became a consummate drafts-
man of the human form. His figures are consequently always firmly
modeled; their sense of structure is never weakened despite the distortions.
But progressively the outlines of the figures became not only longer but
also more sinuous and undulating, the poses more twisted and complex,

producing what Mannerist theorists called the *figura serpentinata*, the serpentine figure.[133] The invention of this type was credited to Michelangelo, and its effect, as perceived in the later sixteenth century, was described by one of the theorists as follows: "The greatest grace and liveliness that a figure may have is that it seems to move itself; painters call this the *furia* (soul) of the figure. And to represent this movement, no form is more suited than a flame of fire. . . . So that when the figure will have this form it will be most beautiful."[134] As this passage states, this type of movement imparts not only beauty but also feeling to the figure—which helps to explain an intriguing paradox in El Greco's art: El Greco seldom used facial expressions to convey an impression of the thoughts and feelings of his characters, yet the pictures vibrate with a strange intensity that derives in part from the peculiar energy of his figure style.

El Greco's interest in manipulating the human body also appears in his fondness for almost acrobatic foreshortenings. Many of his pictures contain audaciously foreshortened figures, especially in the groups of angels and putti who fly in the heavens, twisting and turning in impossible somersaults. These figures are intended as demonstrations of his virtuosity, the effortless conquest of difficulty so much admired by artists of the Maniera.

Another important feature of El Greco's art is the general exclusion of inanimate nature. His art looks into the mind, not over the landscape, for inspiration, just as the Mannerist theorists prescribed. This approach was instrumental in shaping his conception and treatment of pictorial space, notably his avoidance of the illusion of depth achieved by means of linear perspective. El Greco usually set his subjects in an indeterminate space that is sealed off from naturalistic elements by a backdrop of clouds. The gigantic figures are consequently concentrated in a narrow zone of space close to the picture plane, which often causes them to overlap and collide with each other in remarkable ways. In the *Assumption of the Virgin* begun in 1577 (pl. 22; fig. 66), to take a lucid example of the phenomenon, the head of the apostle in the left foreground seems to be on the same plane as the face of the apostle immediately to his right, whose position in the composition otherwise suggests that he is standing in the middle ground. And the head of the angel floating to the immediate right of the Virgin (fig. 67) is wedged into the angular space formed by her outstretched arm and the side of her body, like the piece of a puzzle.

The conflation of space is achieved here and in other works not only by the bold manipulation of scale but also by two other devices. One involves combining the contours of distinct figures that are on separate spatial planes, which causes the interval between them to collapse. The other is the arbitrary use of light and shadow. The illusion of distance between two figures placed side by side on a canvas is also partly achieved by careful gradations of light. Normally the contours of adjacent figures in different planes are represented with one in shadow, the next in light, and so on throughout the composition. The alternation of dark and light zones encourages the eye to perceive the figures as if they were in distinct planes of depth. El Greco, however, frequently left the contours in light, or even intensified the light as it approached the boundary of a background figure, thus "bringing it forward" into the space of a foreground figure.

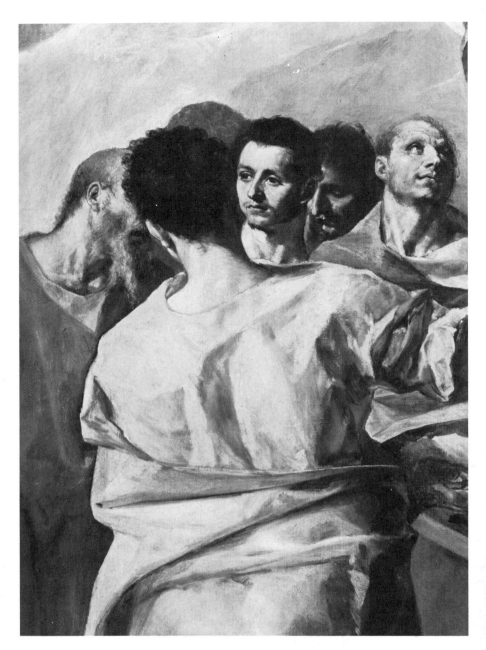

Figure 66. El Greco. Detail of the *Assumption of the Virgin* (pl. 22)

The ultimate effect of these devices is to confound the illusion of space, producing a compositional pattern that hovers ambiguously between the second and third dimension—an effect that caused early-twentieth-century artists and critics to liken El Greco to Cézanne. The effect is a subtle one, but makes an important contribution to the otherworldly effect of El Greco's paintings, because it contradicts the standard method of representing the world employed in naturalistic art.

El Greco's treatment of light is equally unconventional. In El Greco's world, the sun never shines. Instead each figure seems to carry its own light within or reflects the light that emanates from an unseen source. In his later years, the light seems to become ever brighter and stronger, sometimes bleaching the depth from the colors. This use of light is consistent with El Greco's antinaturalism and also with his unending search for an ever-more-abstracted style. Recently, it has also been interpreted as the best evidence of his commitment to Christian Neoplatonic thought, which, in simplest terms, equated light with God. In this scheme of things, light was the agency of transmission between the godhead and the lower orders of being, including mankind; it also, according to some philosophers, helped to determine the essence of the visible world.[135]

Assessing the influence of Neoplatonic thought on El Greco's art, a sub-

Figure 67. El Greco. Detail of the *Assumption of the Virgin* (pl. 22)

ject touched upon earlier in this essay, depends largely on interpreting his effects of light. El Greco unquestionably was familiar with Neoplatonic light metaphysics, but it remains to be seen how, or even if, this concept influenced his art.

Although El Greco's art was solidly grounded in Central Italian thought of Michelangelesque origin, it had other theoretical underpinnings as well. As indicated earlier, his years in Venice made a powerful impact on his style and approach to art. In simplest terms, El Greco was a "painterly" painter, a category that has become synonymous with artists who claimed descent from Titian and other sixteenth-century Venetian masters. In comparison to Central Italian artists of this period, these painters developed a more normative style, one that preserved the link between art and nature to a much greater extent. Richness and variety of color were also essential to the style. And, finally, Venetian painters liked to manipulate pigment as an expressive device. In contrast to the smooth, enamellike finish prized by Roman and Florentine painters, Venetian artists, and especially Titian in his later years, modeled figures and objects in a bold, sketchlike technique that imparted a rich texture to the surface and great depth and radiance to colors.

El Greco's debt to his Venetian heritage hardly needs to be explained; it

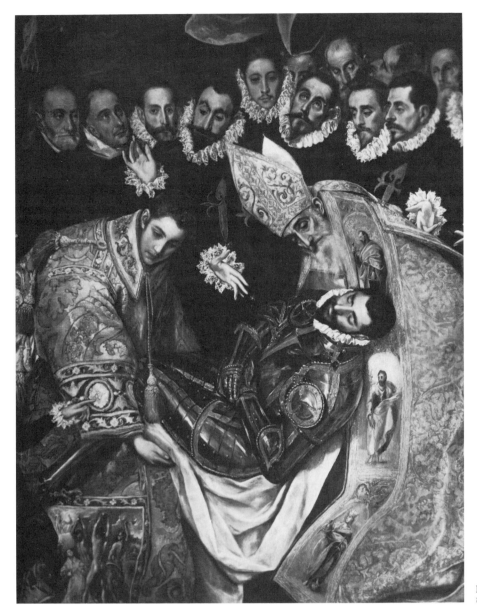

Figure 68. El Greco. Detail of the *Burial of the Count of Orgaz* (pl. 3)

Figure 69. El Greco. Detail of the *Virgin of the Immaculate Conception* (pl. 24)

is an obvious feature of his style and is explicitly stated in one of his anno-
tations to Vitruvius: "I hold the imitation of color to be the greatest diffi-
culty of art."[136] His achievement in conquering this difficulty has always
been acknowledged, even by his detractors. It should be noted, however,
that his palette was only partly determined by Venetian examples. In
addition to the rich, full, deeply saturated Venetian hues, El Greco also
employed the shrill, arbitrary shades favored by painters of the Maniera.
High-keyed yellow-green, fiery red-orange, and flinty gray-blue are among
the "Mannerist colors" that occur frequently in his pictures, especially in
the later years.

The brushwork was also influenced by Venetian examples. As Pacheco
stated after his visit to the artist's studio in 1611, El Greco retouched his
paintings over and over again in order to achieve a sketchy, seemingly
spontaneous finish that, for him, denoted virtuosity and facility. Close
inspection of the pictures reveals a tangle of unblended brushstrokes on
the surface, the *"crueles borrones"* noted first by Fray Juan de Santa María,[137]
then by Pacheco and subsequent observers. This technique, first used in
the works painted during the Venetian period, was consistently developed
by the artist as an element of his virtuoso style.

A last Venetian aspect of El Greco's art involves imitation of nature,
which is most importantly manifested in his portraiture. Also, on occasion,
El Greco included passages of startling realism in his other pictures. The
best examples are found in the lower part of the *Burial of the Count of
Orgaz* (pl. 3; fig. 68), where the ecclesiastical vestments and the armor
are masterpieces of naturalistic painting. In a late work, the *Virgin of the
Immaculate Conception* from the Oballe Chapel (pl. 24; fig. 69), the lilies and
roses in the lower right corner are painted with marvelous fidelity to na-
ture. The insertion of these details into compositions otherwise devoid of
natural imitation might suggest an unresolved duality in El Greco's style.
In these examples, however, it is possible that the artist was turning his
Venetian skills to Roman purposes. The real function of these quotations
from nature seems to be to draw attention to the inherent artificiality of the
painter's style. Thus, by including realistic "clues" amid the more abstract
elements of his pictures—a device known as antithesis (*contrapposto*),
much favored by Maniera artists—El Greco was able to emphasize the
distance that separated his art from nature.[138]

In general, El Greco's art seems to be broadly consistent with his theory.
The synthesis between Venice and Rome, between color and drawing, be-
tween naturalism and abstraction that is suggested in his writings is real-
ized in his paintings. It is a synthesis that was effected by grafting Venetian
technique onto Maniera thought and style. But such a simple formulation
of El Greco's art still leaves us short of understanding the essence of his
genius. In fact, the words alone are almost belittling: they seem to suggest
that the artist confected his paintings much in the way that a cook uses a
recipe, measuring predetermined quantities to produce a predictable re-
sult. Obviously El Greco was no ordinary Mannerist painter. To understand
how and why he developed as he did, we must return to his adopted city
of Toledo.

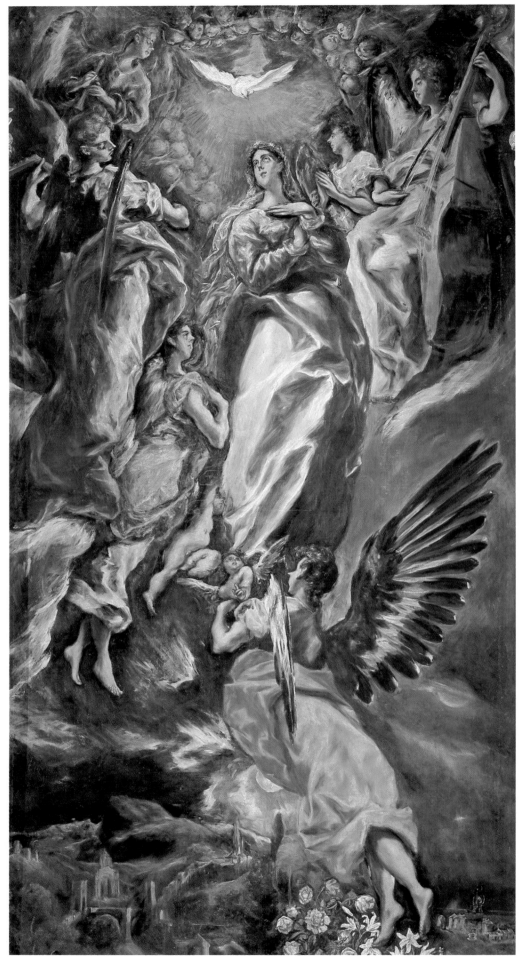

PLATE 24. *Virgin of the Immaculate Conception*, 136 x 68½ inches, 1607–1613 (Toledo, Museo de Santa Cruz)

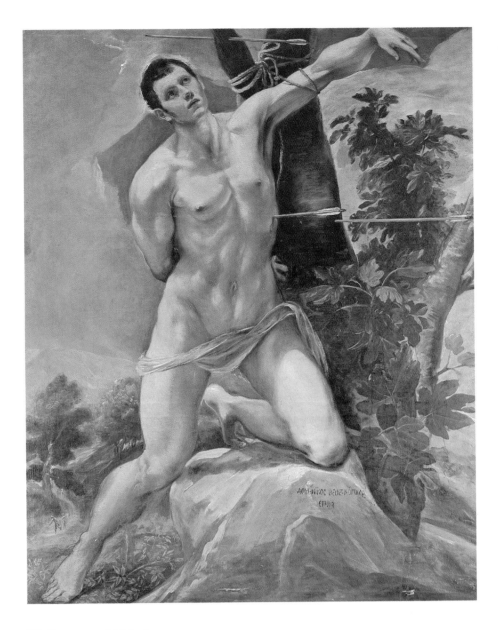

PLATE 25 (cat. no. 10). *Saint Sebastian,*
75¼ x 59⅞ inches, circa 1577–1578
(Palencia, Cathedral Sacristy)

El Greco and Toledo

During his thirty-seven years in Toledo, El Greco's style underwent
a profound transformation. By analyzing the nature and causes of this
change we may be able to come closer to understanding his art. In his
first decade in Spain, El Greco remained in close touch with his Italianate
sources. For instance, the little-seen painting *Saint Sebastian* (cat. no. 10;
pl. 25), possibly painted for Diego de Castilla around 1577–1578, is a splen-
did demonstration of El Greco's mastery of Michelangelesque figure style.
The heroic proportions represent his "search for a certain grace ... which
is not to be found in natural form," and the skillful modeling emphasizes
the musculature and latent power of the physique. In *Crucifixion with Two
Donors* of circa 1580 (fig. 70), the elegance and beauty of the Maniera are
embodied in the figure of Christ, in which all traces of pain and suffering
have been suppressed. The flowing contours of the body play against the
swelling shapes of the clouds, producing a complex pattern of undulating
lines. This air of elegant restraint is completed by the gentle piety of the
two worshiping figures in the lower part of the picture. The languorous
mood of the Maniera style reaches its fullest expression in El Greco's work
in the *Martyrdom of Saint Maurice* (1582; pl. 2; fig. 71), which is also the
"showiest" exhibition of his talents in an Italianate vein. Saint Maurice and
his companions stand in studied, artful poses, gesturing theatrically, as if
all were speaking at once. The angels holding the palms and crowns of

141

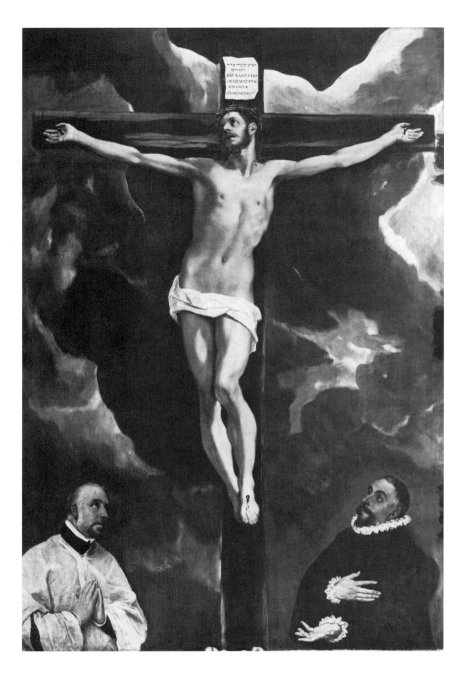

Figure 70. El Greco. *Crucifixion with Two Donors*, 98 x 70⅞ inches, circa 1580 (Paris, Musée du Louvre)

Figure 71. El Greco. Detail of the *Martyrdom of Saint Maurice* (pl. 2)

martyrdom turn lazily like a wheel in the sky, their foreshortened forms interlocked in a complicated pattern of heads, arms, and legs. Below, at the far left, a tireless executioner wields a sword with an almost effortless elegance. All emotion has been purged from this production line of death.

By the year 1600 El Greco had dramatically transformed his style by thoroughly and systematically intensifying its artificial, antireal elements. In comparing *Crucifixion with Two Donors* with a version of the Crucifixion done some twenty years later, we can see the differences. Around 1600–1605 El Greco executed *Crucifixion* (fig. 72)—this time to illustrate an allegory of the Holy Blood of Christ.[139] The differences in style from the earlier work can be seen at once. Figure proportions are notably longer; small heads rest on bodies of inordinate length. Christ's body has been flattened, reducing the illusion of corporeality. Also, the light is brighter and more strident, tending to bleach the colors of the garments by its brilliance. And the space is not only shallow, but is crowded with figures, compelling us to see the composition as a pattern arranged on a flat surface. The visual intensity that results from these changes contrasts with the quiet elegance of the earlier version.

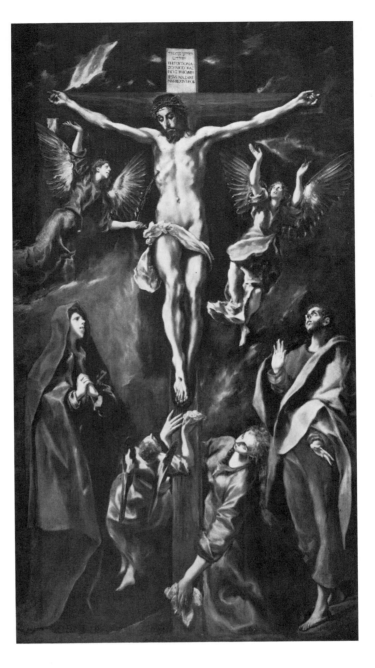

The same process can be seen in two versions of the Resurrection, one
painted in 1577–1579 for Santo Domingo (fig. 56), the other (fig. 73) exe-
cuted around 1600–1605, possibly for a church in Madrid.[140] In the later
work, El Greco has again carried out a number of changes that push the
composition into a more abstract realm. Beneath the figure of the Risen
Christ, the soldiers turn and writhe in a variety of complex poses, includ-
ing that of the daringly foreshortened central figure, who tumbles in a
headlong fall toward the viewer. His right foot almost collides with the
enigmatic, dwarflike soldier whose head is covered by an oversized hel-
met with a flamboyant plume. On the right, an incredibly tall figure clad
in blue reaches up toward Christ, his arm echoing the gesture of the
Saviour.[141] Above the suffocating space of the soldiers rises the triumphant
body of Christ, his feet crossed as a reminder of his sacrifice on the Cross,
his body surrounded by a celestial glow. Next to this densely packed, un-
real world, the earlier version of the Resurrection, although hardly a para-
gon of naturalism, looks almost real.

In the last fifteen years of his life, El Greco stretched the abstracting ca-
pacities of his style to amazing lengths. In 1600 he completed the *Baptism*

143

of Christ (cat. no. 33; pl. 27) for the College of Doña María de Aragón;
in the narrow vertical format that he preferred to use in his later years,
El Greco projected a scene of great subtlety and studied complexity. Very
near the end of his life, he designed another version of the scene for the
Hospital of Saint John the Baptist, a work left unfinished and completed
by his son (see fig. 105). Once again, comparison reveals a consistent exag-
geration of every element of El Greco's art — space, light, color, composi-
tion, proportion — toward an extreme of abstraction. The ultimate effect
is otherworldly; the campaign to divorce art from nature, while obviously
not arriving at total abstraction, was brought to a successful conclusion.

The intensity of El Greco's last works is clearly extraordinary and power-
ful, and it is no wonder that critics and scholars looked to the heavens
beyond for its causes, casting him in the role of seer and mystic, or, alter-
natively, as a proto-Expressionist. But El Greco's "expressionism" is differ-
ent from twentieth-century Expressionism. His distortions of form are
primarily the result of intellectual imperatives; he is expressing ideas
about the nature of art itself. Yet this is not to deny the undoubted spiritual
impact of his works. Almost by definition, religious paintings are meant
to inspire feeling as well as thought. In their dramatic, at times theatrical
presentation of the subject, El Greco's images were vivid reminders of
the glories of the Lord. But at the same time, a careful balance between
thought and feeling was attained through the subtle calculations of an
intellectual artist. In pitting his artificial image of the world against its
image as perceived by the eye, El Greco created a world of his own, where
both the mind and the heart could seek refuge.

Yet, as we have seen, El Greco was very much a man of the everyday
world, struggling for success and recognition, building a network of sym-
pathetic friends and patrons in Toledo who made it possible for him to
work on a grand scale and to find an outlet for his genius. How do we
reconcile El Greco's drive toward an increasingly artificial art with the
realities of artistic practice in late-sixteenth-century Toledo? Or, to refor-
mulate the question in the familiar terms of El Greco studies, what did
Toledo give to El Greco?

The first part of the answer to this question has a negative aspect. When
El Greco arrived in Toledo, he was in command of a style that soon became
outmoded in Rome. By around 1600, Michelangelo da Caravaggio and
Annibale Carracci had successfully devised a style of painting that returned
to the sources of authority accepted in the Early and High Renaissance,
sources that had been explicitly rejected by the Mannerists — nature and
classical art. It seems safe to assume that had he remained in Rome, El
Greco would have needed to make concessions to the new standards or
else would have risked falling completely out of favor. But in Toledo, he
was free to go his own way, without serious competition from either inno-
vative or merely talented painters.

The panorama of Toledan painting in the late sixteenth century is still
beclouded by a lack of knowledge, but as far as we can see, the view is not
inspiring. Luis de Velasco (see figs. 16, 19) and Hernando de Avila were two
of the leading painters, both employed by the cathedral and other eccle-
siastical patrons and both mediocre artists.[142] Blas de Prado (see fig. 17)

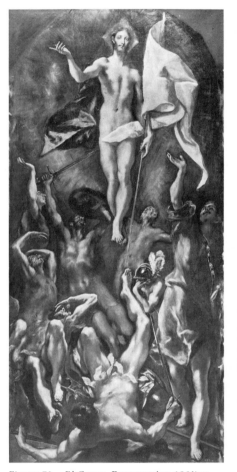

Figure 73. El Greco. *Resurrection*, 108¼ x
50 inches, circa 1600–1605 (Madrid, Museo
del Prado)

was a competent practitioner of a Counter-Maniera style and is said to have been a novel still-life painter, but none of his few known works suggests that he possessed even a touch of genius.[143] Only one artist of Toledo has risen to the surface of this shallow pool of talent: Juan Sánchez Cotán, whose still-life paintings are among the best ever created.[144] Sánchez Cotán's figure paintings, however, are disappointing for one so gifted in imitating the effects of inanimate nature. It was not until around 1611, three years before El Greco died, that a talented, up-to-date painter arrived in Toledo. This was Juan Bautista Maino, whose paintings of 1612 for the Dominican monastery of San Pedro Mártir reveal the close study of Caravaggio and, to a lesser extent, of Annibale Carracci.[145] By that date, of course, El Greco was an old man whose time was nearly over and who showed no inclination to change his ways.

The vacuum of local talent in Toledo was filled by El Greco alone, which gave him the opportunity not only to make a living and a reputation, but also to pursue the consequences of his aesthetic — the Mannerist aesthetic — to unimagined extremes. El Greco's freedom from the pressure of competition may also have permitted him to tap his Byzantine heritage for ideas that might not have been permitted in an artistic culture that recognized certain limits on the distortion of the human figure.

The best Italian artists were rigorously trained from an early age in drawing the human figure, using live models as well as casts of classical and Renaissance sculptural masterpieces. They copied the great paintings of Raphael and Michelangelo and became steeped in a classical tradition and style, which could be manipulated but not abandoned. El Greco, by contrast, had begun to master this tradition only after being trained as a Byzantine painter. Somewhere beneath the veneer of Italianate style was a core of Byzantine art that he had acquired in the workshops of Candia.[146] In fact, Byzantine art shared many fundamental assumptions with the Maniera: both sought inspiration in abstract artistic sources rather than in nature; both prized stylishness as an aesthetic quality; both regarded distortion and exaggeration of the human figure as pleasing effects. In other ways, of course, the two styles were not compatible, primarily because in Byzantine art, unlike Italian art, the abstract and the anticlassical were essential rather than superficial characteristics. Nevertheless, as El Greco continued to extend the arbitrary qualities of his style, he seems to have called upon his earlier experiences as an icon painter not only to provide the occasional composition or motif, but, more fundamentally, to help him break through the constraints of Renaissance style into a realm in which the very elements of art itself — space, form, light, color — became a subject of painting in their own right.

El Greco's fusion, in Toledo, of two artistic cultures is unique in this period, though it might have occurred had he lived anywhere except a major Italian center. Certainly there were other provincial locales throughout Western Europe in the late sixteenth century where artists were granted greater freedom for fanciful invention and caprice than they were in the cultural centers of Italy. But the absence of a vital indigenous, classicizing style was a precondition for this extreme kind of art, and in this respect Toledo was an ideal place for El Greco.

145

Of more direct importance to the development of El Greco's art were his patrons in Toledo, the men of learning and taste who could admire the artist on his own terms and who were willing to follow him into unexplored realms of art. Some of his most unconventional late pictures were painted to adorn the religious institutions administered by these men. Yet they were more to El Greco than just an appreciative audience. Their commitment to the ideals of the Counter-Reformation helped to lead El Greco toward a central achievement of his art. For all their complexity of thought and style, El Greco's paintings represent their religious subjects with unmistakable clarity. The artists of the Maniera in Italy foundered exactly on this requirement of Counter-Reformation thought. Unable to reconcile artistic complexity with doctrinal orthodoxy and authentic spirituality, Maniera lost its vitality as a style and withered away. El Greco, almost alone among the practitioners of artificial art, found the means to reconcile the seemingly irreconcilable goals of Mannerist aesthetics and Counter-Reformation theology and practice. This brilliant achievement could only have occurred in a place where men possessed of great wealth, high culture, and sophisticated taste had yet to find a painter capable of expressing their artistic, intellectual, and religious aspirations. El Greco's career in Toledo may have required him to be more of a professional painter than the gentleman-artist he would have wished to be, but at least there he found a rarefied society of kindred spirits who sustained his ambition to achieve the "grace that gives sign and splendor to the beauty of the mind."[147]

NOTES

This essay was written for an audience of nonspecialists and is intended to be read as an outline for a new interpretation of the life and art of El Greco. Almost all the ideas could and should be explored and tested by those who are interested in the study of this great master. For several scholars' detailed studies of certain commissions and individual pictures, see Brown (1982), which is intended to complement this text. Much of the material in the essay was developed in seminars given at the Institute of Fine Arts, New York University, in 1975 and 1979. The following participants in those seminars made important contributions to my understanding of the subject: Susan Barnes, Dawson Carr, Sam Heath, Richard Mann, Susanna Meade, and Sarah Schroth. I also benefited from a stimulating exchange of ideas on El Greco with Richard Kagan and Fernando Marías. Finally, I am grateful to the John Simon Guggenheim Memorial Foundation for generously supporting my work on El Greco.

1. Cossío (1908), p. 661.
2. On his age, see San Román (1927), p. 180; on his birthplace, see Cossío (1908), p. 17.
3. Mertzios (1961), p. 218.
4. Constantoudaki (1975), pp. 296–300.
5. For Ritzos's dates of activity, see Mertzios (1961), p. 217.
6. Chatzidakis (1976), pp. 5–31.
7. Wethey (1962), vol. 1, pp. 32–33. The recent attempt by Bettini (1978) to defend the attribution of the *Modena Triptych* to El Greco in the light of Constantoudaki's documentary discoveries is not convincing.
8. Chatzidakis, *Icônes* (n.d.), pp. 51–54.
9. Ibid., pp. 74–75.
10. Constantoudaki (1975), pp. 305–308.
11. Ronchini (1865).
12. I am grateful to John Shearman for his advice on this point. See also Vasari (1896), vol. 4, on Titian as a teacher of young artists, which lends confirmation to this suggestion.
13. Tolnay (1960), p. 78.
14. Salas (1967a), p. 33.
15. Salas (1967b), p. 179.
16. Partridge (1971), p. 480, n. 61.
17. Martínez de la Peña (1967).
18. Coffin (1964), p. 203.

19. Mancini (1956), vol. 1, pp. 230–231.
20. Trapier (1958b), pp. 73–90.
21. Navenne (n.d.), pp. 615–704.
22. Nolhac (1887).
23. Nolhac (1884).
24. Partridge (1972), pp. 53–54. See also Martin (1956), which discusses Orsini as the author of the program executed by Annibale Carracci for the Camerino Farnese.
25. Bialostocki (1966).
26. Wethey (1962), vol. 2, pp. 78–79, cat. no. 122.
27. Freedberg (1971), pp. 285–328.
28. Gilio da Fabriano (1564), as quoted in Blunt (1940), p. 111.
29. Freedberg (1971), pp. 323–343; Shearman (1967).
30. Partridge (1971, 1972).
31. Trapier (1958a), p. 12.
32. Salas (1967a), p. 38.
33. Ibid., p. 33.
34. Ibid., p. 38.
35. Tolnay (1960), p. 64. An earlier version of the composition is in the Philadelphia Museum of Art.
36. Wethey (1962), vol. 2, p. 43, cat. no. 61, and pp. 43–44, cat. no. 62.
37. Ibid., p. 44, cat. no. 63.
38. Pastor (1891–1953), vol. 20 (1930), pp. 650–652.
39. Wethey (1962), vol. 2, pp. 87–88, cat. no. 130.
40. "Libros para Felipe II" (1948).
41. Marías and Bustamante (1981), p. 216, n. 164.
42. Nolhac (1887), p. 60, n. 1.
43. Rekers (1972), p. 60.
44. Vegüe y Goldoni (1926–1927).
45. Blunt (1939–1940); Waterhouse (1972), p. 111.
46. Chapter 1 discusses the Castillas.
47. Zarco del Valle (1916), p. 217.
48. San Román (1910), pp. 129–140; idem (1934); García Rey (1923); idem (1924). A ninth painting, *Veronica's Veil* (cat. no. 8; pl. 33) was not mentioned in the contract (see chapter 3).
49. For the documents of the dispute, see Zarco del Valle (1870), pp. 591–607.
50. On the source of El Greco's iconography, see Azcárate (1955).
51. For the documentation, see Zarco Cuevas (1931), pp. 139–142.
52. Sigüenza (1923), p. 424.
53. San Román (1910), pp. 140–142.
54. Soehner (1960) discusses El Greco as a designer of altarpieces. See also Marías and Bustamante (1981), pp. 17–41.
55. On this commission, see Zarco del Valle (1870), pp. 607–613.
56. García Rey (1926).
57. For the documents, see San Román (1910), pp. 142–155.

58. San Román (1910), p. 155.

59. San Román (1927), p. 163.

60. Mélida (1924), vol. 2, pp. 343–345; Wethey (1962), vol. 2, pp. 7–8.

61. For a biography of Jorge Manuel, see Wethey (1962), vol. 1, pp. 119–122.

62. Documents for this commission are published by Cossío (1908), pp. 674–675; San Román (1910), pp. 160–161; Pérez Pastor (1910), pp. 361–362; idem (1914), pp. 65, 84; San Román (1927), pp. 161–163, 164; García Chico (1946), pp. 289–290; Bustamante (1972); and Marías (1979).

63. It is probably this event that provoked the famous lawsuit between the artist and the tax collector of Illescas, not the subsequent commission in Illescas from the Hospital of Charity, which became the subject of an unrelated action.

64. San Román (1910), p. 156.

65. For the documents, see Cossío (1908), pp. 667–669, and San Román (1910), p. 157. Also important is Soehner (1961).

66. San Román (1927), pp. 276–277.

67. Ibid., p. 277.

68. García Rey (1931), pp. 77–78.

69. The documentation is published in San Román (1910), p. 161, and idem (1927), pp. 171–195. For a partial English translation, see Enggass and Brown (1970), pp. 205–211.

70. San Román (1927), p. 182.

71. See chapter 1, p. 70, on Angulo's help.

72. San Román (1910), p. 164.

73. Ibid., pp. 173–177.

74. For the documentation, see Cossío (1908), pp. 663–664, and San Román (1927), pp. 278–280.

75. For the documentation, see Cossío (1908), pp. 680–689, and San Román (1927), pp. 310–329.

76. San Román (1927), p. 280.

77. Pacheco (1933), p. 168.

78. Ibid., p. 193.

79. See chapter 1, p. 45, on El Greco's library.

80. For the annotations to Vasari, see Salas (1966 and 1967b). For the annotations to Vitruvius, see Marías and Bustamante (1981).

81. Marías and Bustamante (1981), p. 87.

82. Ibid., p. 165.

83. Ibid., p. 159.

84. See Mâle (1932), Mayer (1940–1941), and Waterhouse (1972).

85. Harris (1974).

86. García Rey (1923); idem (1924).

87. The contents of the inscriptions are summarized by Parro (1857), pp. 113–114.

88. Schiller (1972), pp. 219–224.

89. Glen (1977), pp. 173–179.

90. Cope (1979), pp. 81–87.

91. For an example that could have been known to El Greco, see Resurrection with Saints Cassiano and Cecilia by Tintoretto (Venice, S. Cassiano, 1565).

92. San Román (1934), p. 3.

93. San Román (1910), p. 195.

94. Cossío (1908), p. 67.

95. Trapier (1958a), p. 8, unconvincingly connects the pose of Christ with a drawing by Palma the Younger. In one of his annotations to Vasari's Lives, El Greco signified his agreement with Vasari's praise of the modeling of the legs of Duke Lorenzo; see Salas (1967a), p. 35. As Salas notes, this passage suggests that El Greco had visited Florence and actually seen the sculpture.

96. Wethey (1962), vol. 1, p. 34.

97. Braham (1966).

98. Trapier (1958a), p. 12.

99. Wethey (1962), vol. 1, p. 92, n. 130.

100. The following discussion is based in part on Sarah Schroth, "The 'Burial of the Count of Orgaz' by El Greco," in Brown (1982). See also Waterhouse (1972), p. 113.

101. The basic sixteenth-century source of the legend is Alcocer (1554), chap. 21.

102. Ramírez de Arellano (1921), p. 274.

103. The text is reproduced by Cossío (1908), pp. 672–673.

104. San Román (1910), pp. 144–146.

105. Ibid., pp. 142–143.

106. Schroth makes this observation in the article cited in n. 100.

107. For prototypes of the upper zone that might have been used by El Greco, see Titian's Gloria (Madrid, Museo del Prado) and the fresco by Luca Cambiaso on the choir vault of the church at the Escorial.

108. San Román (1927), p. 175. For another example of El Greco's knowledge of iconographical traditions, see ibid., p. 278. For a detailed study of the Illescas commission, see Susan G. Barnes, "El Greco and the Decoration of the Church of Charity, Illescas," in Brown (1982).

109. For examples, see Harris (1938), Soehner (1961), and the studies in Brown (1982).

110. For an introduction to the concept of the learned artist, see Blunt (1940), pp. 48–57.

111. Gállego (1976); Brown (1978), pp. 87–110.

112. Pacheco (1933), p. 193.

113. Martín González (1958), p. 86.

114. Salas (1966); idem (1967a); idem (1967b).

115. See Marías and Bustamante (1981) for an excellent discussion of this matter.

116. Roskill (1968).

117. Salas (1967a), p. 40.

118. Ibid., p. 41.

119. Summers (1981), on which this discussion of Michelangelo's theory is based.

120. Marías and Bustamante (1981), p. 143.

121. Summers (1981), pp. 368–379.

122. Salas (1967a), p. 37.

123. Vasari (1896), vol. 4, pp. 204–205.

124. Marías and Bustamante (1981), p. 143.

125. Ibid., pp. 131–132.

126. Ibid., p. 80.

127. For the list and El Greco's comments, see ibid., pp. 131–132.

128. Pacheco (1933), p. 179. See also Vasari (1896), vol. 4, pp. 291–292, for a description of Titian's technique, which was clearly the model for El Greco.

129. Marías and Bustamante (1981), p. 151.

130. Ibid., p. 80.

131. Davies (1973); idem (1976).

132. Marías and Bustamante (1981), p. 165.

133. Summers (1972).

134. Lomazzo (1584), pp. 22–24; as cited and translated in Summers (1981), p. 81.

135. See Marías and Bustamante (1981), pp. 182–192, for a lucid argument for the impact of Neoplatonic writings on El Greco.

136. See also Pacheco (1933), p. 155, for another statement by El Greco to this effect.

137. Santa María (1615), as cited by Pérez Martín (1961), p. 178. This reference was brought to my attention by J. H. Elliott.

138. Summers (1977).

139. Wethey (1962), vol. 2, pp. 49–50, cat. no. 75. See also chapter 3, where Pérez Sánchez connects this work and the Resurrection (fig. 73) with the College of Doña María de Aragón.

140. Ibid., p. 71, cat. no. 111. See also n. 139.

141. For an interpretation of the meaning of this gesture, see Wittkower (1957).

142. On Hernando de Avila, who held the commission for the altarpieces of Santo Domingo el Antiguo before he was replaced by El Greco, see Sánchez Cantón (1923), pp. 299–304.

143. On this artist, see Gómez Menor (1965–1968).

144. Angulo Iñiguez and Pérez Sánchez (1972), pp. 39–102.

145. Angulo Iñiguez and Pérez Sánchez (1969), pp. 299–325.

146. There are numerous books and articles on El Greco's debt to Byzantine art, most of which attempt to be too specific about the relationship. For a balanced assessment of the question and further references, see Wethey (1962), vol. 1, pp. 52–53.

147. Vincenzo Danti, as quoted in Summers (1981), p. 58.

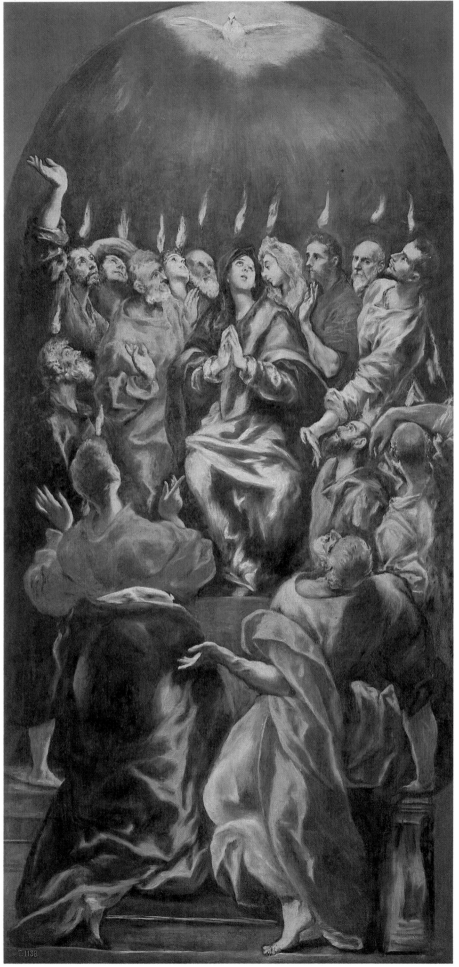

PLATE 26 (cat. no. 34). *Pentecost*, 108¼ x
50 inches, circa 1600 [?] (Madrid, Museo
del Prado)

3 On the Reconstruction of El Greco's Dispersed Altarpieces

ALFONSO E. PÉREZ SÁNCHEZ

When discussing, or simply enjoying, the paintings of El Greco now scattered in various museums and collections, we tend to forget an important circumstance that conditioned their basic meaning: these pictures, now hanging on museum walls next to works of diverse subjects, periods, and schools—Spanish and Italian, Renaissance and Baroque—were in many cases originally parts of much larger entities that have been dispersed. Survivors of complex iconographic and devotional programs, these isolated works were, in fact, parts of a whole that must be reconstructed, even though only in the mind, if we are to enjoy and understand them fully.

Although a great part of El Greco's popular reputation was the result of his codification of certain pious iconographical types (Francisco Pacheco, for example, named him as the best interpreter of the life of Saint Francis), he undoubtedly put his greatest creative efforts and genius into those large and ambitious altarpieces that he could most fully develop through his own familiarity with the theological texts or through the advice of his erudite friends.

The explicit statements the artist made in the course of the frequent lawsuits in which he found himself involved attest to his proud assurance of his own worth, and it is obvious that in those altarpieces with complex programs he could best exploit his desire to be "extraordinary in all things" (a trait that amazed the modest Pacheco).

Some of these series are relatively well known because they were dispersed only recently and records exist of their original configuration. Concrete information on others has, unfortunately, been lost, and their arrangement can be reconstructed only hypothetically. In some cases all the components survive, and it is not difficult to imagine the effect of the series. In others, some of the elements that would allow us to enjoy them completely and to understand their original intention are lost, and therefore proposed reconstructions are speculative.

It is clear that in creating these series (which undoubtedly represented a substantial financial investment on the part of the artist) El Greco made use of his workshop, about which we are insufficiently informed. We have the name of Francisco Preboste, who appears to have been El Greco's trusted confidant for many years; we know that Luis Tristán was in the workshop between 1603 and 1607; and, of course, we know the artistic personality of the painter's son, Jorge Manuel Theotokopoulos, whose technique was dry and brittle and can be identified with relative ease. Beyond this, though, it is difficult to separate the work of other assistants from that of the master in the large commissions. Given the extraordinary nature of the large-scale projects, however, there was perhaps less intervention on the part of assistants in these than in the countless series of smaller devotional paintings made for oratories or private chapels; numerous versions of these smaller paintings, of varying quality, survive, and they can be safely attributed to the workshop. On the other hand, some of the paintings for the large projects now dispersed are in fact unique; they are works that the painter preferred not to repeat outside of their original context.

The Altarpieces of Santo Domingo el Antiguo
(cat. nos. 7, 8; pls. 22, 23, 33; figs. 74–82)

It is well known that the first major project El Greco realized after his arrival in Toledo in 1577 was the one for the Bernardine convent of Santo Domingo el Antiguo in that city (see fig. 24). A distinguished Portuguese noblewoman, Doña María de Silva (who died in 1575), left her estate to this institution, which made it possible to build the severely beautiful church designed by Nicolás de Vergara the Younger and by Juan de Herrera, the architect of the Escorial who was so favored by King Philip II. Designs for the altars (a main altar of two stories and two broad side altars of a single story) were submitted by the painter Hernando de Avila and by Herrera himself, but, for unknown reasons, these were not used and new plans were commissioned from El Greco. The final project was executed in accordance with these plans, although Juan Bautista Monegro, the sculptor who undertook the actual architectural and sculptural work, introduced some modifications in proportion.

It is not our task here to analyze the architectural structure and its precedents, nor the scope of Monegro's modifications.[1] We will, however, consider the arrangement of the original series, long ago dispersed. Fairly good copies of the paintings occupy the place of some of the originals and permit us to reconstruct in our imagination the original configuration of

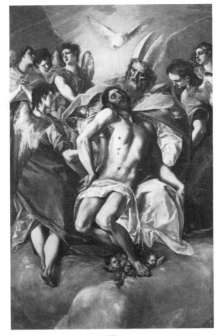

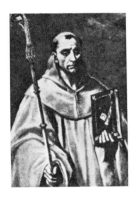

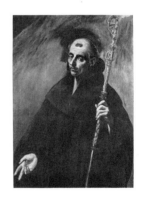

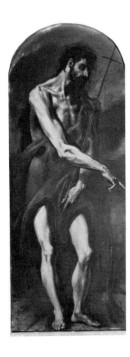

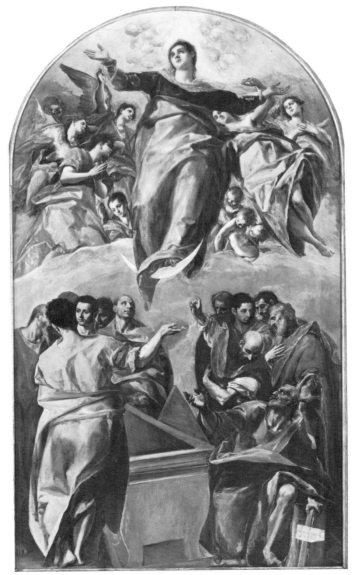

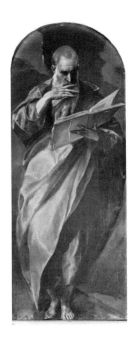

El Greco's project.[2] The execution of the series can be dated between 1577 and 1579; Diego de Castilla, dean of the cathedral chapter and executor of the will of Doña María de Silva, sent a contract to El Greco on August 8, 1577, stating that within the space of twenty months he was to deliver the paintings, for a price of 1,500 ducats. El Greco agreed and even lowered the payment to 1,000 ducats. The large central painting is signed and dated 1577; in 1578 the artist received his entire payment, apparently before the final delivery of the pictures, and in September of 1579, when the church was consecrated, the series was in place.[3]

The main retable of Santo Domingo el Antiguo is chiefly surprising in that it does not include the image of the monastery's patron, the Benedictine Saint Dominic of Silos. No doubt Doña María de Silva's substantial donation to the institution made it necessary to concede the place of honor to her patroness, the Virgin Mary, who appears in the center of the altarpiece in a scene of her Assumption (pl. 22). The Virgin—who hovers amid angels above the tomb, which is surrounded by gesticulating apostles—is shown standing on a crescent moon; this is typical in scenes of the Immaculate Conception. But there is a surprising and unusual element in the ensemble: in the upper story, above the *Assumption*, is the *Trinity* (cat. no. 7; pl. 23), with the dead Christ in the arms of his Father—an iconographic element of Germanic origin that was later developed by other artists of Toledo.

Between the two large paintings, in the pediment of the architectural framework of the *Assumption*, is a painted wooden cartouche held by two beautiful sculpted youths; it encloses *Veronica's Veil*, a *Santa Faz* of sublime intensity (cat. no. 8; pl. 33).[4]

In each of the side compartments of the main altar, both of which are divided into two unequal spaces by horizontal imposts, are two paintings; the lower two are arched at the top, while the upper two are rectangular. The lower paintings are full-length representations of Saint John the Baptist and Saint John the Evangelist; those above, in half length, are of Saints Bernard and Benedict.

The side altars are devoted to the *Adoration of the Shepherds* and the *Resurrection*, with the surprising inclusions (expressly stipulated in the contract) of Saint Jerome in the former and Saint Ildefonso in the latter.

The iconography of this series cannot be easily interpreted. The dedication to Mary is clear in the central panel; the representations of the two Saint Johns (who were traditionally much venerated in Spain) may also refer to the Virgin—especially the Evangelist, who is seen as a very old man, at the time of his retirement to the island of Patmos, when he had his vision of the Woman of the Apocalypse, which could be considered as a prefiguration of the Immaculate Conception. Moreover, the Virgin of the *Assumption* is seen standing on a crescent moon, which matches the description of the Woman of the Apocalypse. As for Saint John the Baptist, he is, especially in the Greek church, the companion of Mary in the "Deesis," or Intercession, and it is this role of saints as intercessors that El Greco emphasized in the heavenly glory of the *Burial of the Count of Orgaz* (pl. 3), painted ten years later.

The two monastic saints, Benedict and Bernard, are obligatory images in Cistercian convents, as they were both founders—the former of the Benedictine order, the latter as reformer of the Benedictines and creator of the Cistercians and the Bernardines, a branch of the Cistercians. Both saints, especially Bernard, are also associated with the devotion to Mary Immaculate.

The dispersal of this series, which was always praised as one of the artist's most beautiful, began in 1827, when Prince Don Sebastián Gabriel de Borbón acquired the great *Assumption* from the monastic community. After numerous vicissitudes—it was among paintings confiscated from the prince for his Carlist activities and was exhibited for several years in the Museo Nacional de la Trinidad, Madrid, before being returned to its owner—the work now hangs in the Art Institute of Chicago. The *Trinity* of the attic of the altarpiece was also sold at this time, bought by the sculptor Valeriano Salvatierra (he was the intermediary in the sale of the *Assumption* to the prince), who sold it to Ferdinand VII; it entered the Prado in 1882. The paintings of Saint Benedict and Saint Bernard were sold at this time too. The former is in the Prado, having come from the Museo Nacional de la Trinidad as *Saint Basil* with an unknown provenance (it is possible that it also belonged to the prince and that this information was either forgotten or omitted when the painting was returned). The *Saint Bernard* passed into the art market and nothing is known of it since it was acquired in 1908 by Simon Oppenheimer.

The medallion with *Veronica's Veil* remained in situ until recently: it was sold in 1964 to a private collector, along with its sculpted frame.

At present, then, only the two *Saint John*s are still in their original places in the high altar. Both are works of enormous interest that synthesize, as does the altarpiece as a whole, the dual Venetian and Roman influences the newly arrived artist brought with him to Toledo, at a moment when he still had not definitely decided to establish his residence in that city. The *Saint John the Baptist*, while containing elements that are supremely personal, such as the figure's sharp and nervous profile, owes much to Titianesque prototypes. The *Saint John the Evangelist*, in the saint's grand solemnity and in his profound absorption in reading the text he holds in his left hand, brings to mind Michelangelo's *Moses*, as Cossío has pointed out.

Among the dispersed pictures, the large *Assumption* in Chicago has always been considered a homage to Titian's great composition in the Church of Santa Maria dei Frari in Venice, but the Venetian influence is combined with an obvious striving for Roman monumentality. The *Trinity* in the Prado also fuses these two ingredients, although the Michelangelesque factor is the dominant one, splendidly evident in the grave and monumental anatomy of the dead Christ, a direct evocation of Michelangelo's *Pietà* in the Florence cathedral. The rich tones and surprising harmonies (violets, yellows, greens, and blues) point more toward Tintoretto than to Titian. *Veronica's Veil* and the half-length figures, *Saint Benedict* and *Saint Bernard*, with their loose technique (especially in the backgrounds), are composed with a blending of color that is surprisingly light of touch, foreshadowing the audacities of the artist's later years.

The two side altars, with the *Adoration of the Shepherds* (now in the Botín Collection, Santander) and the *Resurrection* (still in situ), are exceptional works, early examples of El Greco's distinctive way of treating light, which derives from Venetian models (in this case from Bassano) and from Correggio. The use of luminous contrasts between zones of strongly defined color became a constant in his production and constitutes one of the most characteristic aspects of his style. The presence of Saint Jerome in the *Adoration*, as directed by Diego de Castilla, has been heretofore insufficiently explained. I believe that the traditional representation of the saintly theologian beside the Cave of Bethlehem, where he retired to a penitential life, may be relevant here. Since El Greco shows the saint reading a book by the light of a large candle he holds in his right hand and with his head turned toward the viewer as if to invite him to read or to meditate, the painting might be understood as representing the "vision" of the Father of the Church as conjured up from his reading of the sacred text—something that can be depicted only through the magic of the painter (the signature on the *Assumption* itself includes ὁ δείξας, "one who displays").

The *Resurrection*, which includes at lower left the figure of Saint Ildefonso in an ecstatic pose (also following the stipulations of Castilla), attests to El Greco's evolution toward a more personal style. This is seen in the Christ, a noble figure still reverberating with echoes of Roman beauty and classicism; it is also apparent in the sudden movements of the startled soldiers infused with the dynamism of the painter's brush. The presence of Saint Ildefonso, archbishop of Toledo, patron of the diocese, as witness to the Resurrection (he wears white liturgical vestments befitting this feast day) is not too surprising, even though his presence is more generally associated with scenes of the life of Mary.

If we pair the *Resurrection* with the *Adoration of the Shepherds* and interpret the saints' gestures of ecstatic contemplation in a similar manner, we can establish a correlation between the Adoration "imagined" by Saint Jerome and the Resurrection "contemplated" by Saint Ildefonso: the opening and closing, respectively, of the cycle of Christ's earthly life.

The Altarpiece of the Rosary, Talavera la Vieja (figs. 83–86)

Commissioned in 1591, the altarpiece of the Virgin of the Rosary in the town of Talavera la Vieja (Cáceres) is another series that has been disbanded. It is of somewhat lesser quality, although of considerable interest for its architectural scheme. Its design has been criticized as "poor, weak, a regression to the plan of the main altar of Santo Domingo el Antiguo," but it nonetheless serves as a link between the scheme of Santo Domingo and the one I suggest was used for the altarpiece of the College of Doña María de Aragón, which, as we shall see, was commissioned five years later. The altarpiece is also of interest because it marks the first appearance of some of the artist's most successful iconographical formulations.

What remained of the retable was destroyed in 1936 and only three of its paintings survived (now in the Museo de Santa Cruz, Toledo). However, several old photographs, though poor, allow us to form an idea of how the altarpiece looked, while reports of those who actually saw it (José R. Mélida and Paul Guinard) complete the information.

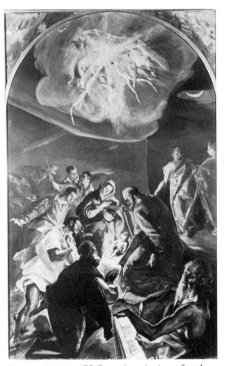

Figures 81, 82. El Greco's paintings for the side altars of Santo Domingo el Antiguo, Toledo, 1577–1579. Above: *Adoration of the Shepherds*, 82⅝ x 50⅜ inches (Santander, Emilio Botín Sanz Collection). Facing: *Resurrection*, 82⅝ x 50⅜ inches (in situ).

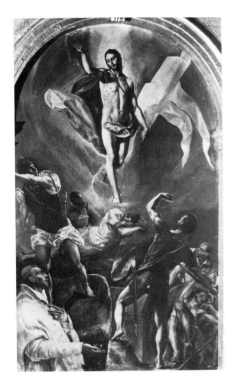

The contract, which has not always been accurately interpreted, is especially precise in its stipulations, though it allowed the artist certain liberties, of which he doubtlessly availed himself when determining the subjects of the paintings. The altarpiece (which was not the main retable of the church, as it is often described, but rather that of the epistle, or right, side of the altar) was divided into a central section, flanked by two Doric columns supporting a triangular pediment, and two narrower side sections, all of the same height. Both the central and side sections were divided into two stories by a horizontal impost, forming six compartments. The central compartment of the lower story, a vaulted niche, contained the sculpted image of the Virgin of the Rosary, now lost. The five remaining compartments, flanked by Doric pilasters disproportionately small in relation to the giant central order, contained paintings.

According to the contract there was to be "a Coronation of Our Lady in a heavenly glory, in which there should be painted the blessed Saints John the Baptist and Dominic with the Rosary and Saint Anthony and Saints Sebastian and John the Evangelist and other saints which said Dominico [El Greco] deems suitable for the decoration and proper appearance of said retable." This describes the painting that occupied the central compartment of the second story, one of the works of the series that have been preserved.

"In the lower part of said retable there is to be . . . the figure of Saint Joseph, and at the left side there should be the figure of Saint Andrew, [both] with their attributes, done with brush on canvas affixed to panels." The editing of this document in the transcription published by Mélida has led to error, for it supposes that the figures ("*de bulto*") were to be sculpted images, which contradicts the actual stipulation, that they be done "with brush on canvas" affixed to panels. Also, although it is expressly indicated in the contract that the figures of the saints should be placed "in the lower part of said retable," it has recently been stated that the "sculptures" would "possibly have bordered the lateral wings."[5]

Two paintings from the lower story are preserved; these are certainly those that were in the side compartments. The first represents Saint Andrew—the patron saint of the parish—who embraces the cross of his martyrdom, thus appearing "with his attributes" (although his image was evidently painted for the right side compartment, not the left as the contract stipulates). The other represents Saint Peter—not Saint Joseph, as the document specifies (nor Saint John, as a recent erroneous interpretation of the contract supposes, failing to take into account the fact that the two Saint Johns were already explicitly assigned to the heavenly glory of the *Coronation*). The contract makes no reference to the upper side compartments, which in 1926 contained paintings, now lost, of the Annunciation and the Presentation in the Temple, apparently not by El Greco.

The three surviving paintings were relined and restored at the Prado in 1935[6] and survived the Spanish Civil War (since they were kept in the parish house, while the church was burned). A more recent restoration (1963) revived much of their often underrated quality.

The *Coronation of the Virgin with Saints* is undoubtedly a work of importance and high quality, although it has been damaged. The

155

composition of the principal group, as has been noted numerous times, was inspired by a print by Dürer, although with notable changes. One of these — of particular iconographic significance — was the transformation of the lower curve of the mantle of the Virgin in the German print into a pointed crescent moon, which thus changed the image from a Virgin crowned in heaven to an Immaculate Conception, such as the one we have seen in the painting from Santo Domingo el Antiguo (pl. 22). Actually, this is the first version of a scene that El Greco repeated in later years, in the Chapel of Saint Joseph (1597–1599; fig. 95) and the Hospital of Charity at Illescas (1603–1605; fig. 100). A painting in the Prado, of small size and sparkling quality, is so similar to the upper part of the *Coronation* that it has been thought to be a sketch for it; but the fact that it is signed seems to indicate that it is one of the models or reduced versions that the painter kept in his house. Its dimensions almost coincide with those of the painting that figured as number 26 in the inventory of Jorge Manuel.[7]

The saints in the *Coronation*'s lower part, identifiable by their attributes, include those in the contract: Saint Francis of Assisi; Saint John the Baptist (with his back turned almost completely to the viewer, and closing with his outstretched arm the ideal circle in which the celestial scene transpires); Saint John the Evangelist (shown as a young man with chalice, a representation similar to the one in the Apostle series and quite different from the treatment of the Evangelist as an old man in Santo Domingo el Antiguo); Saint Sebastian; Saint Paul (also, like the Baptist, in the foreground with his back turned almost completely toward us, and closing the circle); Saint Anthony Abbot; and Saint Dominic with the rosary in his hands, as specified in the contract and required by the committee that commissioned the altar.

The two full-length saints in the lower compartments are excellent and offer surprising iconographical formulations that were not repeated by El Greco, who so often duplicated his compositions, groupings, and types. The *Saint Peter* shows some similarity to a painting of the same subject now in the Escorial (originally from the Oballe Chapel in Toledo), although it is rather different in pose as well as in the attitude and expression of the face and in the gestures of the hands. The *Saint Andrew* is completely different from all other known versions and contains passages, such as the left hand and the feet, that are of notable quality.

The substitution of the *Saint Peter* for the figure of Saint Joseph specified in the contract is easily justified, since Saint Joseph is an unlikely companion for Saint Andrew and Saint Peter is an Apostle, a keystone of the church, and the brother of Saint Andrew, with whom he is traditionally paired.

The Retable of the College of Doña María de Aragón in Madrid
(cat. nos. 32–34; pls. 1, 26, 27; figs. 87–92)

Of all El Greco's dispersed altarpieces, the retable of the College of Doña María de Aragón in Madrid is perhaps the one about which we are the least well informed. It has so far been impossible to gain a clear, definitive, and unanimously accepted idea of its structure, the paintings it included, or their present whereabouts.

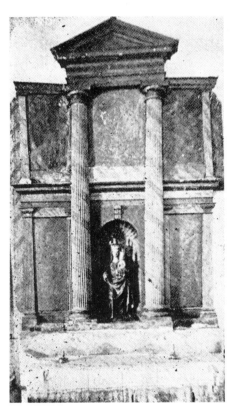

Figure 83. Altarpiece of the Rosary, Talavera la Vieja (destroyed in 1936). El Greco received the commission in 1591.

Figures 84–86. Original arrangement of El Greco's surviving paintings for the Talavera la Vieja epistle altarpiece, 1591–1592 (all three are now in the Museo de Santa Cruz, Toledo). Upper story: center, *Coronation of the Virgin with Saints*, 41½ x 31½ inches; above left and above right, subjects unknown, paintings lost. Lower story: below left, *Saint Peter*, 49½ x 18 inches; below right, *Saint Andrew*, 49¾ x 18 inches; center, a sculpture of the Virgin of the Rosary, now lost (the 1591 contract specified such a sculpture by El Greco; at one time the central compartment contained a sculpted Virgin, though reportedly of the eighteenth century). >

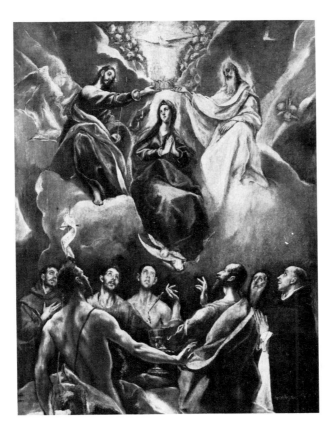

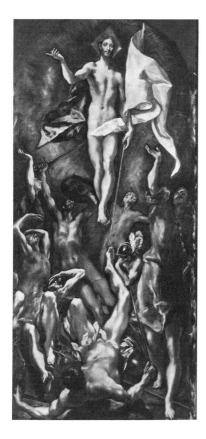

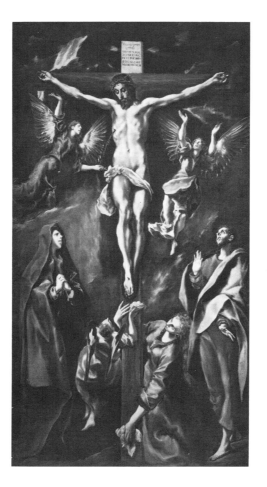

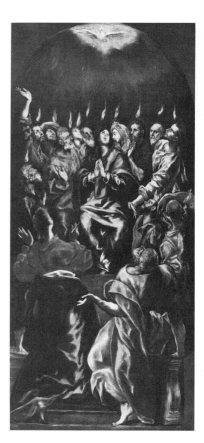

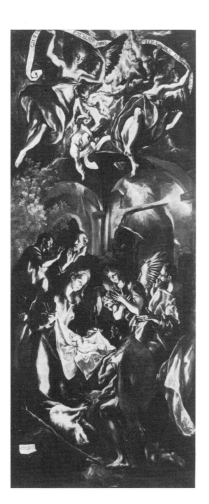

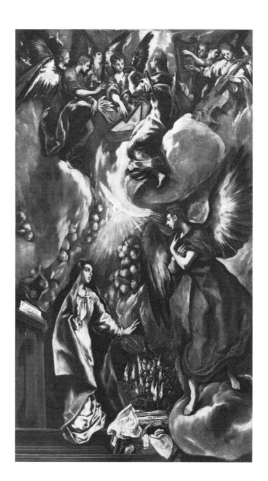

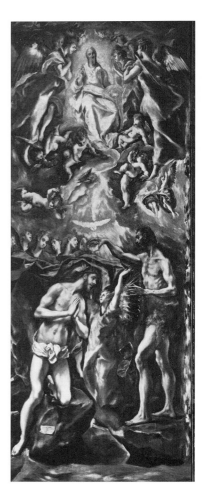

The church of the Augustinian college, dedicated to the Incarnation (the Annunciation to the Virgin) was begun about 1581 through the donation of the noblewoman whose name it bears. It was constructed rapidly, for masses were already being said in the church in 1591, yet work on the college itself was still in progress in 1618. Recent research has completely documented the architectural work on the building,[8] which, after being sacked and partially destroyed by invading French forces during the War of Independence, was reconstructed as the headquarters of the Cortes in 1814; it was returned briefly to the Augustinian monks, before once again becoming the parliamentary seat between 1820 and 1823. It served as a church between 1823 and 1835, and from 1836 onward was the Palace of the Senate. Today it serves as headquarters of the Upper Chamber, though nothing remains of the original construction.

We are less well informed, however, about the church's altarpiece. In 1596, in Toledo, El Greco contracted for its execution "according to the conditions and designs for it which I will be given."[9] This statement seems to preclude the design's being his own (as has been supposed), unless it refers to an original idea, drawing, or general pattern upon which El Greco was to create his own detailed plans. This interpretation seems to be supported by another statement in the same document—that one of the artist's payments would be made when he "sent the design." The work was to be done within three years, and he promised to complete it by Christmas of 1599. El Greco gave power of attorney in the matter to his Italian employee Francisco Preboste, who would arrange all of the transactions that had to be executed in Madrid (collection of payments, and so forth).

By 1597 El Greco had already collected certain payments according to the specified terms. But difficulties arose over the amount of his compensation and a lawsuit ensued, one of many brought by El Greco, a perpetual litigant. In 1598 he obtained an injunction against the estate of Doña María de Aragón for 1,000 ducats he was owed. The injunction was lifted in June of 1599, perhaps, as Cossío supposes, because El Greco wished to remain in the good graces of the heirs and to hasten a resolution of the conflict. In July of 1600 a Toledan mover transported the parts of the altarpiece from Toledo to Madrid "with all ornaments with which it is adorned," and in October and December of that year a total payment of 65,300 reales (5,920 ducats) was apparently made, a great amount of money, indicating the significance of this work.

We have no precise description of the retable except for the indication that it had various "paintings" (Palomino) and that these "dealt with the life of Christ" (Ceán Bermúdez). An erroneous interpretation of the words of Pascual Madoz, who referred to "a high altar, a work in three parts of painting, sculpture, and architecture,"[10] has led to the supposition that the work contained only three paintings, of almost equal dimensions. Of these, the central image had to have been of the Annunciation, to which the college was dedicated, and indeed during the last period in which the building was used for religious purposes (1823–1835) the *Annunciation* by El Greco from the original altarpiece was prominently displayed in the church, according to Madoz.

Apart from the *Annunciation*—which is undoubtedly the painting now

Figures 87–92. Proposed reconstruction of El Greco's altarpiece for the College of Doña María de Aragón, commissioned in 1596. Upper story (all three paintings are now in the Museo del Prado, Madrid): left, *Resurrection*, 108¼ x 50 inches; center, *Crucifixion*, 122⅞ x 66½ inches; right, *Pentecost* (cat. no. 34; pl. 26), 108¼ x 50 inches. Lower story: left, *Adoration of the Shepherds*, 136¼ x 54 inches (Bucharest, Rumanian National Museum); center, *Annunciation* (pl. 1), 124 x 68½ inches (Madrid, Museo del Prado. On loan to Museo Balaguer, Villanueva y Geltrú); right, *Baptism of Christ* (cat. no. 33; pl. 27), 137¾ x 56¾ inches (Madrid, Museo del Prado).

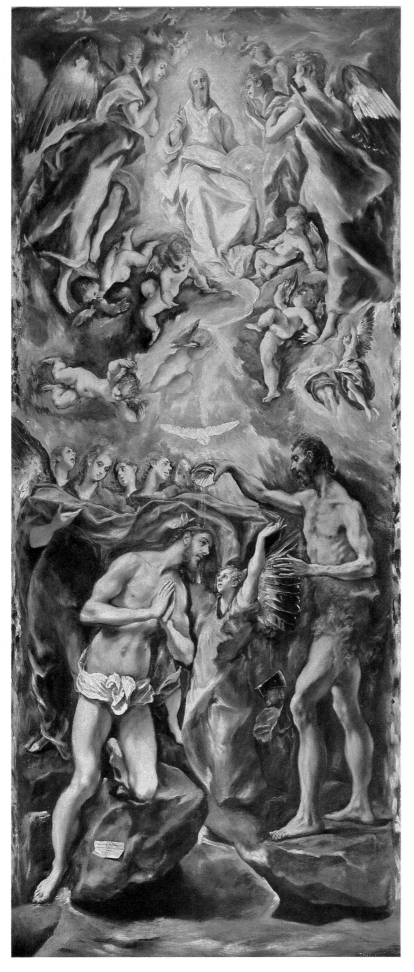

PLATE 27 (cat. no. 33). *Baptism of Christ*,
137 3/4 x 56 3/4 inches, 1596–1600 (Madrid,
Museo del Prado)

in Villanueva y Geltrú (on loan from the Prado; cat. no. 32; pl. 1) — and the *Baptism of Christ* (cat. no. 33; pl. 27) — which, according to an explicit statement in the 1889 catalogue of the Prado, came from the college — no other painting has been documented as having formed part of this ensemble. However, the *Adoration of the Shepherds* (acquired by Louis Philippe in 1836; now in the Rumanian National Museum, Bucharest) has traditionally been considered part of the original altarpiece. It has the same dimensions as the *Baptism*. If we accept only these three paintings as components of the series — as do recent critics — then the retable would indeed have been formed of three pictures of almost equal size (not including any unspecified sculptural elements) — a most exceptional format for a Spanish altarpiece of this period.

I believe it is necessary to consider an arrangement of the altarpiece in the traditional format of two stories, each with three compartments — which is the norm for works of this type and which, with some architectural variations, is common in contemporary retables by El Greco and other artists working in Toledo or Madrid. Consider, for example, that of Juan Bautista Monegro and Luis de Velasco in the Franciscan Church of the Concepción in Toledo[11] or those by El Greco in Santo Domingo el Antiguo and, above all, in Talavera la Vieja. The last was designed only shortly before the work in question and was, as we have seen, composed of six compartments of similar dimensions, each containing paintings (with the exception of the central panel of the lower story, which housed the sculpted image of the Virgin of the Rosary, patroness of the brotherhood).

Considering this more likely distribution, the high price stipulated, and the format of the surviving works, I believe that three other paintings in the Prado with similar dimensions and technique can be regarded as having belonged to the same project (though much has been said to the contrary). These have been accepted as being from this series by Mayer, Gómez Moreno, and now by Pita.[12] They are the *Pentecost* (cat. no. 34; pl. 26), the *Resurrection*, and the *Crucifixion*. The last has been thought — without sufficient reason — to have come from a Jesuit church in Toledo (San Ildefonso or San Juan Bautista),[13] where Ponz and Ceán Bermúdez saw paintings by El Greco *"en los postes"* — that is, affixed to the pillars of the nave, an unlikely place for a painting of such dimensions as the *Crucifixion* to have hung. The composition, furthermore, demands that the viewer see the work from a vantage point well below the picture so as to make comprehensible the inordinate foreshortening of the angel who is shown almost horizontally at the feet of Christ. Also unacceptable is the hypothesis of San Román, who asserts that this is the painting referred to in the 1606 contract for the chapel of the Ubeda family in San Ginés, Toledo, which mentions "a crucified Christ, still living, with Saint John and Our Lady and a landscape on the opposite side." It is obvious that the Prado picture does not correspond to this description; it does, however, fit the painting in the museum at Sarasota, as Wethey has pointed out. The subject and composition of the Madrid painting are logical ones for a work placed in the upper story of a retable; surely this *Crucifixion* comes from the attic of the altarpiece of Doña María de Aragón.

The other two paintings, the *Pentecost* and *Resurrection*, are obviously

a pair. The upper parts of both are arched, a logical shape for paintings
in the lateral compartments of an altarpiece. While their technique has
been described as more advanced than that of the works discussed above,
this does not seem to be a convincing argument against their provenance
in this series, since in paintings done close in time to those of the college's
retable, such as the *Saint Bernardino* (1603; cat. no. 39; pl. 53) or the paint-
ings at Illescas (commissioned a few years later, in 1603–1605), we find
passages of similar freedom of brushwork.

Various critics have proposed that the *Resurrection* is the "Cristo resu-
citado" seen by Palomino in the Chapel of Atocha ("lifesize—an excellent
thing"),[14] but this raises certain problems that I do not believe have been
dealt with previously. The first is that since the *Resurrection* clearly forms
a pair with the *Pentecost*, it is surprising that none of the early writers,
neither Palomino, Ponz, nor Ceán—cite the latter, instead referring to the
Resurrection as a single piece. The second problem is that Palomino men-
tions the Atocha painting as an example of what he considers the best of
El Greco, "the most gifted thing that he did," and a work that "looks to be
by Titian," rather than showing the great "extravagance that made his work
disdained and ridiculous as much for its distorted drawing as for its un-
pleasant color"—the most significant example of which he cites precisely
as the paintings for the College of Doña María de Aragón.

The Atocha painting was undoubtedly a work of the artist's early pe-
riod, perhaps similar in style and composition to the paintings of Santo
Domingo el Antiguo. It would be difficult indeed for Palomino, the painter
and biographer, to have lauded the Prado *Resurrection* in such terms.

If the altarpiece is reconstructed in the manner I propose, the iconog-
raphy becomes perfectly coherent, presenting the life of Christ from the
Incarnation (to which the college is dedicated) to the Pentecost, which
represents his enduring presence among men through the Holy Spirit.

The paintings are certainly all masterpieces from the artist's middle
period, at the time when he was turning toward the lyricisms of his late
years. The rich colorism of this series is especially surprising and auda-
cious, with strange harmonies and unusual scintillations. In the three
paintings I believe occupied the upper parts of the retable (*Crucifixion,
Resurrection,* and *Pentecost*), there is an uncommon freedom of han-
dling suggestive of the extreme agitations of the work of El Greco's final
period.

The large *Annunciation,* the principal image of the altarpiece, is certainly
one of the painter's masterworks and displays an iconographic singularity
that separates it conclusively from all of its precedents, especially the ver-
sions of this subject by the young El Greco himself (Museo del Prado—
cat. no. 1; pl. 29; and Barcelona, Muñoz Collection—fig. 108), which are still
derived from Venetian prototypes of Titianesque origin. Here is the de-
finitive creation of a supernatural ambience in which light and shapes
sparkle, released from all references to the objective world. Even the
sewing basket that is so often found in the traditional iconography of this
scene is tranformed into a magical receptacle for a flaming bush, which in
itself has symbolic significance, referring to the burning bush of Moses,
a prefiguration of the Redemption.

The *Adoration of the Shepherds* in Bucharest also represents a considerable advance over earlier versions (Kettering [England], Buccleuch Collection; Santander, Botín Collection [from Santo Domingo], fig. 81). Bassanesque elements are still present, such as the motif of the Virgin holding the ends of the infant's diaper and the inner light emanating from the Christ Child, his glowing body illuminating all who bend over it; more concrete motifs, such as the lamb in the foreground and the kneeling shepherd also recall Bassano. Yet the treatment in the lower area is more nervous and vibrating than in earlier versions of the subject, while in the upper portion the blazing rhythm of the bodies, wings, and hands of the angels shows the most characteristic features of the master's mature art.

In the *Baptism* (cat. no. 33; pl. 27) the contrast between the two zones is heightened even more through the corporeality of the muscular mass of the bodies of Christ and the Baptist, which are elongated though still three dimensional (as the cast shadows denote), and the lively colors of the drapery held by and enveloping the angels in the lower zone. The luminous sparkle of the dove of the Holy Spirit leads the eye into the upper region, in which a silvery white God the Father presides over a dazzling assembly of adoring angels.

The paintings I ascribe to the upper part of the altarpiece maintain, and even surpass, the pulsating, flaming rhythm of those in the lower story. The fluttering of the hands in the works in the lower story is heightened in those of the upper. The central attic image, the *Crucifixion* (perhaps the most magical version of this scene ever painted), surprises us by the marvelous serenity of Christ, still living but with eyes closed, who seems to float, almost in triumph, amidst the angels, rather than hang from the Cross. In the verticality of their red and green robes, the Virgin and Saint John accompany the upward movement of the group. The daring figure of the flying angel who is seen from the back, receiving the blood from the feet of Christ, together with the enraptured Magdalen, echoes the momentum of the upper zone of the *Annunciation*, and the same hues (red and green) are observed in the drapery of the angel and the Virgin Mary in the *Annunciation*.

In the *Resurrection* the undulating rhythm is emphasized by the gesticulations of the arms and torsos, and culminates in the elegant figure of Christ, around whose head is a rhomboidal halo. His flowing red cloak is counterbalanced by the white flag whose silhouette further reinforces the ascending rhythm of the assembly of paintings.

Here also, the strong horizontality suggested by the arms and shoulders of the fallen soldier in the foreground—a figure still Michelangelesque in its anatomy and pose—finds its counterpart in the strongly undulating line of the banderole seen in the upper part of the *Adoration*.

In the *Pentecost*, the mass of the two apostles in the foreground corresponds to that of the figures of Christ and Saint John in the *Baptism*, which I believe was hung below it, while the horizontal frieze of heads and the tongues of fire that crown them, as well as the upward gesturing hand at the left of the painting, leads the eye upward to the luminous apparition above of the dove of the Holy Spirit.

If the altarpiece was, as I believe, organized in this way, it would cer-

tainly have been a spectacular work, of extraordinary formal coherence as well as stunning tonal and rhythmic unity.

It is also important to point out that for practically all of the paintings discussed here there exist reduced versions of high quality. The *Annunciation* in the Thyssen-Bornemisza Collection, Lugano, that measures 114 x 67 centimeters (somewhat cropped in the lower portion) is of such high quality that it leads me to believe that it is an autograph sketch or *modello*. The same subject in a painting in the museum at Bilbao (110 x 65 centimeters) is probably a later reduced version and is a companion piece to the *Adoration of the Shepherds* and the *Baptism* (111 x 47 centimeters each) in the National Gallery, Rome, which attests to the coherence of the series. There also exist versions of the *Resurrection* and the *Pentecost* of analogous size, although their quality is not so high as that of the other reduced versions, which has led to their being attributed to the workshop. The *Resurrection* (113 x 53 centimeters) is now in the St. Louis Art Museum, and the *Pentecost* (104 x 52 centimeters), which is sometimes thought to be a work of Jorge Manuel, is in the Zogheb Collection, Montfort-l'Amaury. All of these are most likely the paintings that appear in the inventory of Jorge Manuel with dimensions listed as "a vara and a third in height and two thirds of a vara in width" (110 x 55 centimeters). This would affirm Pacheco's statement that El Greco kept models of the paintings he had completed. We must also keep in mind, in this regard, that there are two drawings by El Greco relating to the Baptism and the Crucifixion.[15]

The Chapel of Saint Joseph in Toledo
(cat. nos. 30, 31; pls. 17, 49, 50; figs. 93–97)

The ensemble for the Chapel of Saint Joseph in Toledo, whose altarpiece was commissioned in 1597 (making it contemporary with the paintings for the College of Doña María de Aragón), was a work of particular importance in the oeuvre of El Greco. However, because of modifications to the original design of the retable's architecture undertaken in 1613 and 1665, it is difficult (or at least problematical) to imagine its original appearance, and few of the discussions and studies of it have shed much light.[16]

The ensemble, composed of a main altarpiece with two paintings and two side altarpieces with one painting each, remained intact until 1908, when the paintings from the side altars were, regrettably, removed and sold (these paintings are now in the National Gallery of Art in Washington). The main altar, fortunately, remains intact.

The chapel was founded by Martín Ramírez with the intention of establishing there the Convent of the Discalced Carmelites, which Saint Theresa of Avila had hoped to set up in Toledo. Although she herself was prevented from founding it, the heirs of Ramírez (he died in 1569), erected the chapel and dedicated it to Saint Joseph, the saint for whom Theresa had the greatest devotion. It was, in fact, the first church or chapel dedicated to Saint Joseph in the entire history of Christianity.

El Greco's work, probably finished by August of 1598, was not paid for until December of the following year. The payment of 31,328 reales

Figure 93. Main altar, Chapel of Saint Joseph, Toledo, 1597–1598 >

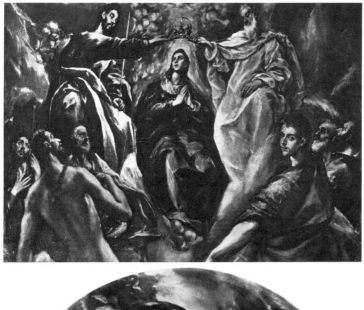

Figures 94, 95. El Greco's paintings for the main altar of the Chapel of Saint Joseph, Toledo, commissioned in 1597 (both in situ): *Coronation of the Virgin*, 47¼ x 57⅞ inches, and *Saint Joseph and the Christ Child*, 113¾ x 57⅞ inches.

Figures 96, 97. El Greco's paintings for the side altars of the Chapel of Saint Joseph, Toledo, circa 1597–1599: *Madonna and Child with Saint Martina and Saint Agnes* (cat. no. 31; pls. 49, 50), and *Saint Martin and the Beggar* (cat. no. 30; pl. 17), each 76⅛ x 40½ inches (both Washington, National Gallery of Art. Widener Collection 1942).

(roughly 2,850 ducats) seems to have been only for the main altar, yet the work on the side altars was certainly done at the same time, as has been recognized by all who have commented upon it.[17] There appears to have been a lawsuit over the appraised value of the work—the heirs of the founder considered the price too high—but an accord was reached at the above-stated sum.

The main altar, which in its original arrangement was quite high, includes the figure of the chapel's patron saint leaning toward the Christ Child—an image of paternal protectiveness. Angels bearing crowns of flowers hover above them. As in several other compositions by El Greco, the city of Toledo is seen in the background; here, however, it appears strangely unreal, for the figure of Saint Joseph divides the city in half—as if the well-known *View of Toledo* in New York (cat. no. 35; pl. 4) had been bifurcated by the image of the saint. The slender body of Joseph, dressed in gray tunic and yellow mantle, is set against a sky resplendent with billowing clouds. Above his head a glory of angels and flowers enriches the composition with coloristic splendor, complemented in the lower portion of the painting by the carmine red of the Christ Child's tunic.

A reduced version of the painting is in the Museo de Santa Cruz, Toledo (cat. no. 29; pl. 48). It comes from the Church of La Magdalena and is certainly the work of matching dimensions mentioned in the 1621 inventory of Jorge Manuel.

Devotion to the husband of the Virgin Mary, a virtual obsession of Saint Theresa, is celebrated in this work, which was executed in the same year that the Carmelite priest Gracián de la Madre de Dios published his *Grandeza y excelencias del glorioso San José* (Madrid, 1597), one of the earliest and most successful formulations of the iconography of the saint as a strong and vigorous man, the earthly protector of the Virgin and the Christ Child. It is precisely the gentle and protective gesture of this man of little more than thirty years (according to Pacheco, the ideal age for representing the saint) that gives this canvas such singular beauty. It is also worth noting that about this time José de Valdivieso, prebendary of the Cathedral of Toledo, composed the poem *Vida, excelencias y muerte del gloriosísimo patriarca San José* (1604), a work of exalted lyricism that sings the praises of the saint.

The *Coronation of the Virgin* in the attic story can be related to the painting of the same subject from Talavera la Vieja (fig. 84), although the former's proportions are squarer and the two zones (the "divine" upper zone with the Trinity and the Virgin and the lower zone with the adoring saints in a semicircle) are less separated from each other. Among the saints easily recognizable in the lower area are James Major, John the Baptist, and Peter. The young saint with a book who turns toward the viewer has been identified as Saint John the Evangelist, while the two bearded figures at right may be Andrew and Paul.

The lateral retables, each with a single painting, today contain copies of their original pictures, the ones now in the National Gallery, Washington. One of these, the *Madonna and Child with Saint Martina and Saint Agnes* (cat. no. 31; pls. 49, 50), is beyond doubt one of the painter's noblest and most harmonious works. (Although no other example of this composition

167

is known, two small versions, now lost, were recorded in the inventories of El Greco and Jorge Manuel.) The other, *Saint Martin and the Beggar* (cat. no. 30; pl. 17), is one of the artist's most successful compositions; there are five workshop versions. One of these—in Washington, like the original—is of such high quality that it could also be entirely by the hand of the master.

The presence of Saint Martin is perfectly understandable, for he was the patron of the chapel's founder, Martín Ramírez. The patron's name also explains the inclusion of Saint Martina in the pendant. El Greco's initials, in cursive Greek, appear on the head of the lion, her attribute.

In composing the two paintings for the side altars, El Greco looked back to his Italian years. The two half-length female saints in the lower portion of the composition with the Madonna and Child are reminiscent of Venetian *sacre conversazioni*, while the Saint Martin, who rides a dazzling white steed seen at a slightly oblique angle, brings to mind analogous compositions by Tintoretto and Pordenone, and anticipates (as has been suggested) Rubens's striking equestrian portrait of the duke of Lerma. Between the horse's legs a marvelous vision of the Imperial City once again appears below a hallucinatory sky—more phosphorescent and spectral than ever.

The Hospital of Charity at Illescas (cat. no. 42; pl. 18; figs. 98–103)

The series of paintings for the Church of the Hospital of Charity in the town of Illescas is one of the richest executed by El Greco, as well as one of the most iconographically complex. It, too, is a series with an unfortunate history. In addition to problems connected with the architecture (the seven retables were created to complement the church design of 1592 by Nicolás de Vergara the Younger), the paintings have been moved from their original places.

On June 18, 1603, El Greco was commissioned to execute "a retable for the altar of Our Lady of Illescas in the hospital of its sacred house." The creation of this altarpiece occasioned another extended lawsuit, settled only in 1607 by an accord between the parties concerned—El Greco, proud of his work and never satisfied with the amount of payment offered to him, and the hospital, which objected to various aspects of the paintings and found grave improprieties in their iconography.

In the extensive documentation published regarding this commission,[18] we read that the retable (the high altar) was to contain four canvases: *Charity, Coronation of the Virgin, Annunciation,* and *Nativity.* All of these remain in the hospital, although none is in the place originally intended.

The *Charity,* as it is called in the original documents (after El Greco's time it received the popular title *Madonna of Charity*), was surprising, in its day, for its prolific use of portraits of recognizable individuals "wearing ruffs." (Among these, Jorge Manuel, the painter's son, can be identified at the viewer's right; see fig. 64.) The appraisers for the hospital made much of the impropriety of this contemporary element and even stated that "one can see nothing else of the entire altarpiece but this painting."

The work must have been removed from the attic of the retable and repainted to mask the ruffs (*lechuguillas*), which were overpainted with open Vandyke collars until the 1938 restoration.[19] Today the painting is in

Figure 98. Interior, Church of the Hospital of Charity, Illescas

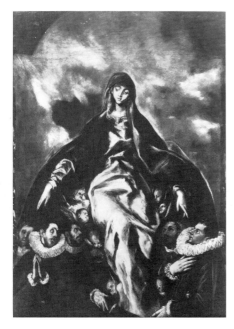

Figure 99. El Greco. *Madonna of Charity*, 72½ x 48¾ inches, 1603–1605. Originally in the attic of the main altar of the Church of the Hospital of Charity, Illescas; now in a side altar.

one of the side altars, its format having been modified by the addition of an arched area at the top in order to accommodate it to the space it now occupies.

Iconographically, the canvas is the traditional "Virgin of Mercy" who envelops representatives of mankind within the folds of her cloak. This image was later faithfully imitated by Luis Tristán in a painting for the Hospital de la Misericordia in Toledo.[20] Luis Tristán no doubt saw his master paint the Illescas work, for his presence in El Greco's studio between 1603 and 1607 is documented.

The other three pictures were placed in the vault, and are described in the documents thus: "All the paintings are done in such a way that they are indistinguishable one from another." Indeed, the narrow, dark space of the sanctuary where they were hung was not conducive to their contemplation. Yet they are certainly masterpieces, among the most beautiful of El Greco's works; it is only now, with their new installation in the former reliquary, that they can be adequately appreciated.

The *Annunciation* and the *Nativity* (cat. no. 42; pl. 18), both in roundels, contain reminiscences of Italian Mannerism in their composition. The structure of the *Annunciation* is different from that of other versions of this theme by El Greco, and the figure of the angel Gabriel repeats, with slight changes, that of one of the angels in the heavenly glory in the *Baptism of Christ* in the College of Doña María de Aragón (pl. 27). The *Nativity*, with the Virgin, the Infant Christ, and Saint Joseph only, is an intensely emotive, magical work, with the surprising inclusion of an ox's head in the foreground.

The oval *Coronation of the Virgin* presents a somewhat different treatment of this subject from those in Talavera la Vieja (fig. 84), the Chapel of

169

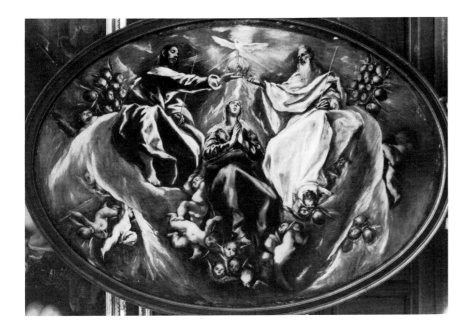

Figure 100. El Greco. *Coronation of the Virgin*, oval, 64¼ x 86¾ inches, 1603–1605. Originally in the center of the vault over the main altar of the Church of the Hospital of Charity, Illescas; now in the former reliquary.

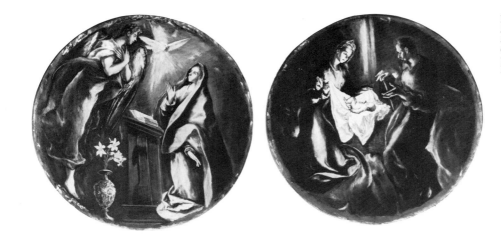

Figures 101, 102. El Greco. *Annunciation* and *Nativity* (cat. no. 42; pl. 18), each circular, 50⅜ inches in diameter, 1603–1605. Both originally in the vault over the main altar of the Church of the Hospital of Charity, Illescas; now in the former reliquary.

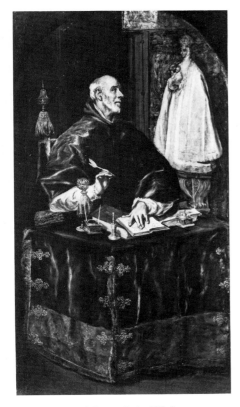

Figure 103. El Greco. *Saint Ildefonso,* 73½ x 40½ inches, circa 1600–1603. Now in a side altar of the Church of the Hospital of Charity, Illescas, but not part of the commission of 1603.

Saint Joseph (fig. 95), or the Prado. The Virgin here is more frontal and directs her gaze toward the Holy Spirit rather than to Christ, as in the other paintings. The crescent moon, which in the other versions connects the image with the Immaculate Conception, has disappeared, and a multitude of putti now surrounds Mary. The resplendent color is enormously attractive, and the *di sotto in su* perspective effect, demanded by the painting's original position, lends a certain visual unity to the three compositions.

In the church at Illescas there is another exceptional painting now exhibited in one of the side altars of the nave, forming a pendant to the *Madonna of Charity.* It represents Saint Ildefonso writing before an image of the Virgin, and corresponds stylistically to the same moment of the artist's career as the other paintings for Illescas; in its quality it perhaps surpasses them. None of the documents of the protracted lawsuit cites this work, thereby making it difficult to determine if *Saint Ildefonso* was painted before the paintings for the high altar, as Wethey believes (he suggests that its success led to the artist's receiving the commission for "subsequent" works), or whether it was painted later for the altar where it now hangs, as has also been proposed. In fact, the latter hypothesis can be discounted in view of the greater precision of technique, as well as because of what might be described as personal reasons: after such a long court case, it would hardly have been logical for the artist to take such risks with the hospital again. The *Saint Ildefonso* is indeed one of the most emotional, intense, and expressive works by the painter, who in a sense inaugurates here an iconographic scheme that would enjoy great success in the Spanish Baroque period — that of the sacred doctor at his desk, pausing in his writing for a moment, in a meditative or inspired attitude, surrounded by everyday objects and an ambience of profound spirituality.

At the beginning of the eighteenth century there was a painting of the *Marriage of the Virgin* in the same altar that today houses the *Charity.* This work, already lost at the time of Ceán Bermúdez, has been identified with a painting in the museum in Bucharest, but it could not possibly be the same work, given its dimensions and stylistic characteristics.

The Hospital of Saint John the Baptist (pl. 28; figs. 104–107)

El Greco received his last large commission (and also one of the most important) in 1608 — for the main and side altars of the Chapel of the Hospital of Saint John the Baptist, also known as the Hospital of Cardinal Tavera (see fig. 15). He had already executed for the hospital a gilded wood tabernacle with sculptures, from which a *Risen Christ* and part of the architectural structure survive.[21]

The artist was able to execute only a small portion of the works for which he contracted, however. At his death in 1614, "the paintings of the Hospital," the subjects of which were not specified, had been started. Jorge Manuel assumed responsibility for the project, though he did not complete it. The architecture of the altars was completed by 1621, but the main altar was not executed according to the original plans, which were modified a number of times, provoking a protracted lawsuit against Jorge Manuel that ended with a lien against his assets. In 1635 Félix Castelo was

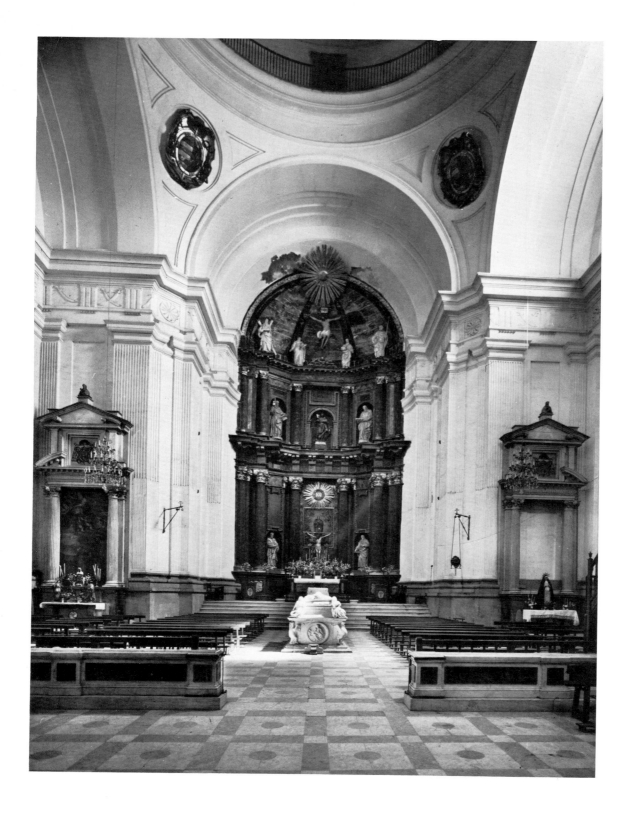

Figure 104. Interior, Chapel of the Hospital
of Saint John the Baptist, Toledo, showing
the main altar and side altars for which El
Greco received a commission in 1608

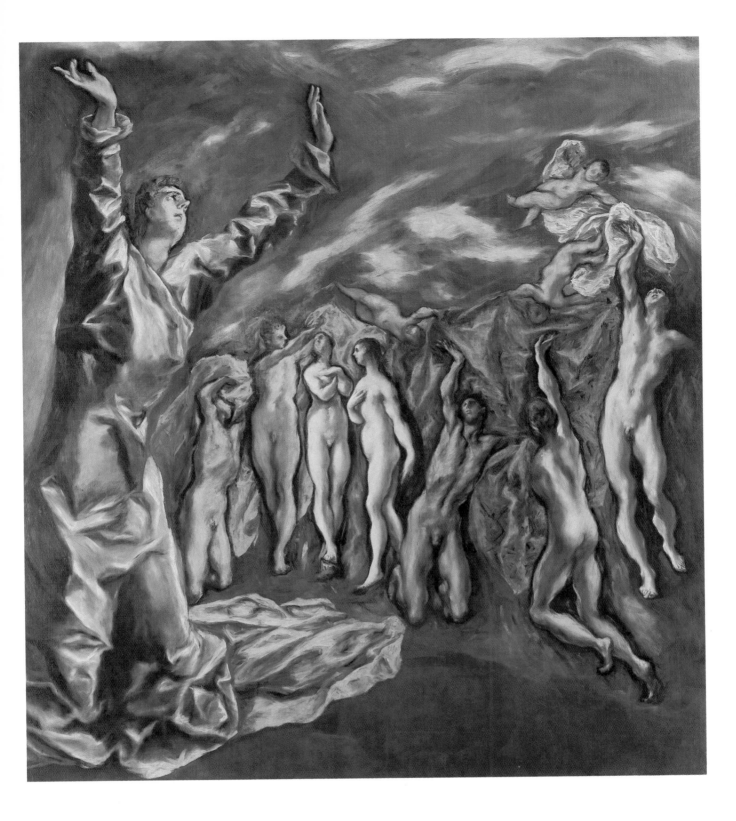

PLATE 28. *Fifth Seal of the Apocalypse*
(*Vision of Saint John*), 88½ x 76 inches, 1608 –
1614 (New York, The Metropolitan Museum
of Art. Rogers Fund 1956)

173

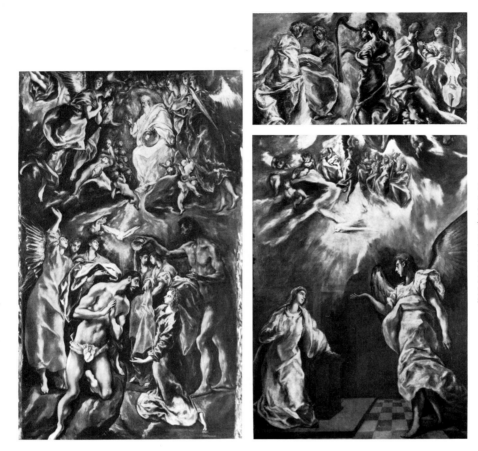

Figure 105 (far left). Begun by El Greco. *Baptism of Christ*, 130 x 83 inches, circa 1608–1622. Intended for the main altar of the Chapel of the Hospital of Saint John the Baptist, Toledo; though never installed in the altar, it is still in the building.

Figures 106, 107. Begun by El Greco. *Annunciation*, circa 1608–1622. Intended for a side altar of the Chapel of the Hospital of Saint John the Baptist, Toledo, but never delivered. Upper part, cut long ago from the canvas: *Concert of Angels*, 45 1/4 x 85 1/2 inches (Athens, National Pinakothiki and Alexander Soutzos Museum). Lower part: *Annunciation*, 115 3/4 x 82 1/4 inches (Madrid, Banco Urquijo). The *Fifth Seal of the Apocalypse* (pl. 28; upper part now lost) was intended for the other side of the chapel.

commissioned to execute paintings for all of the retables; this project likewise remained unfinished.

From the inventories drawn up at El Greco's death (1614) and at the time of Jorge Manuel's second marriage (1621), we can gain an idea of what the altarpieces would have been like had the initial projects been realized.

Because the hospital was dedicated to Saint John the Baptist, there was to be a *Baptism of Christ* in the chapel's high altar, and the 1621 inventory refers precisely to "the principal Baptism of the Hospital." Such a painting is still in the building, although it was never part of the high altar, having occupied one of the side altars until 1936.

For the side altarpieces (whose architecture is the only part of the project known to have been executed by Jorge Manuel), an *Annunciation* and an *Apocalyptic Vision* were apparently intended, for these were the subjects commissioned from Félix Castelo in 1635. In the inventory of Jorge Manuel are listed "two large sketched paintings for the side altars of the Hospital." It seems that these paintings, which had been sketched by El Greco (and which Jorge Manuel probably intended to finish), were not accepted, because they were unfinished and because the growing interest in a naturalistic style made them unsuited to contemporary taste. It is now unanimously agreed that the works in question are the *Annunciation* in the Banco Urquijo, Madrid—the upper portion of which is the *Concert*

of Angels in the National Pinakothiki, Athens—and the *Fifth Seal of the Apocalypse* in the Metropolitan Museum, New York (pl. 28), whose upper part is now lost.

The attic stories of the side altars contain compartments that now carry the coats of arms of the founder, although they were originally intended to hold paintings. In the inventory made at the time of El Greco's death "a pair of paintings for the attic stories of the lateral altars" is mentioned. According to Castelo's contract, he was to execute a *Preaching of Saint John* and a *Martyrdom of Saint John* for these places. It is possible that these were the subjects of the works assigned to El Greco, although, curiously, no version of these themes either by the hand of the master or by members of his shop is known.

In the paintings destined for the hospital we observe the last and most extreme phase of the work of this great artist, who died before completing them. Jorge Manuel's collaboration in these paintings would explain a certain surprising hardness in them. But the amazing coloristic effects, extraordinarily audacious, must be considered entirely as El Greco's, representative of the last phase of his genius, when his mannerism represented a deviation from the widely growing taste for naturalism and when he abandoned himself to the most arbitrary aspects of his extravagant imagination in his paroxysmal desire for invention.

The *Baptism* introduces new, unusually ecstatic elements, despite the fact that the principal figures are derived from those in the Prado version (cat. no. 33; pl. 27; fig. 88), which was painted for the Doña María de Aragón series. At the same time, however, El Greco rejected the older frontal, symmetrical arrangement for this subject, adopting an oblique placement for the figure of God the Father, who seems to cast a shower of light upon the lower area.

The *Annunciation*, its beauty aside, is a curious work because the iconographical scheme of earlier versions (cat. nos. 1, 6; pls. 29, 32) has been completely transformed in it: the angel, gesturing in a lively manner to the Virgin with his right hand, is shown with both feet on the ground; even more curious is the inclusion of seated figures of the Virtues in the heavenly glory, close to the dove of the Holy Spirit (which appears to be attended by a retinue). Among the Virtues the most easily recognizable are Charity, isolated to underline her importance in a hospital where this virtue is primary; Faith, with the cross; and Prudence, with her mirror. In the upper part of the heavenly glory (now in Athens) the angelic chorus playing musical instruments and singing from choir books seems to restate motifs from similar scenes, such as in the *Martyrdom of Saint Maurice* (pl. 2) or the *Annunciation* in Villanueva y Geltrú (cat. no. 32; pl. 1), where the musical elements are also amply developed.

The *Fifth Seal of the Apocalypse*, certainly one of the painter's strangest and most personal compositions, depicts a most unusual theme in Christian iconography. The hallucinatory image of the immense, ecstatic kneeling Apostle and the bizarre nude figures of radiant, exalted souls set against drapery of meteoric yellow and green represent the culmination of El Greco's lyric expressionism.

(Translated by EDWARD J. SULLIVAN)

NOTES

1. On the architecture of Santo Domingo el Antiguo, see Fernando Marías, *La Arquitectura del Renacimiento en Toledo, 1531–1631*, forthcoming. El Greco's role as architect and his theoretical attitudes on architecture are examined in Marías and Bustamante (1981).

2. The copy of the central *Assumption of the Virgin* is signed by the Neoclassical painter José Aparicio (1773–1838). He may also be responsible for the *Saint Benedict* and *Saint Bernard*. Between 1827 and 1958 El Greco's *Birth of Christ* (now in the Prado) occupied the attic story; there is now a modern copy (1961) of the *Trinity* in this position, the original location for this subject. The *Adoration of the Shepherds* in the side altar is a copy signed by Jerónimo Seisdedos, noted conservator of the Prado, now deceased.

3. The history of the retables and the paintings for Santo Domingo el Antiguo is well known. Ample documentary information on this project is published in San Román (1910), pp. 27–34, 129–140, and idem (1934).

4. In the published documents there is no reference to *Veronica's Veil*, whose theme is iconographically difficult to justify in the context of this altarpiece. It must have been included at the last moment, for originally the escutcheon of the convent's founder was intended for this space.

5. Marías and Bustamante (1981), p. 28.

6. This is stated by Natalia Cossío de Jiménez in a note to her father's text — Cossío (1972), p. 36.

7. The inventories of El Greco's workshop — one from 1614 made upon the painter's death, a second taken in 1621 on the occasion of Jorge Manuel's second marriage — have been published often; the first were San Román (1910), pp. 189 ff., and idem (1927), pp. 67 ff. of the offprint, respectively.

8. See especially the two recent and well-documented works Bustamante (1972) and Marías (1979), which discuss the earlier literature.

9. The contract and other information discussed below were published by San Román (1927), pp. 9, 23 ff. This publication complemented Cossío (1908).

10. Madoz (1848).

11. Marías (1975).

12. Mayer (1931); Gómez Moreno (1943); José Manuel Pita Andrade, *El Greco* (Milan 1981), p. 105.

13. The 1889 catalogue of the Prado states that it came from the Church of the Inquisition in Toledo (in error for the Church of the Jesuits), indicating, however, that this cannot be proved. Later editions state, with the same reservation, that it came from "San Juan Bautista" (formerly Jesuit), an assertion that has been subsequently repeated.

14. Wethey (1962), vol. 2, p. 10; Lafuente Ferrari and Pita Andrade (1969).

15. On El Greco's drawings, see Angulo Iñiguez and Pérez Sánchez (1975), nos. 155–161, and its bibliography.

16. For example, Soehner (1961). On the successive fortunes of the chapel's decoration, see Marías and Bustamante (1981), pp. 29–32.

17. On the painting and its cost, see Cossío (1908), appendix 12, and San Román (1910), document 14.

18. On the Illescas altarpieces and the lawsuits, see Cossío (1908), pp. 307–315, 690–696; San Román (1910), pp. 49–51; idem (1927), pp. 148–151; and the monographs of Wethey and Camón Aznar, in which old photographs are published.

19. Jerónimo Seisdedos, "La restauración de cuadros y algunas restauraciones recientes," *Arte Español* (1944): 100–107.

20. Angulo Iñiguez and Pérez Sánchez (1972), p. 166, pl. 109.

21. On the retable and works for the hospital, see San Román (1914).

Color Plates 29–73

177

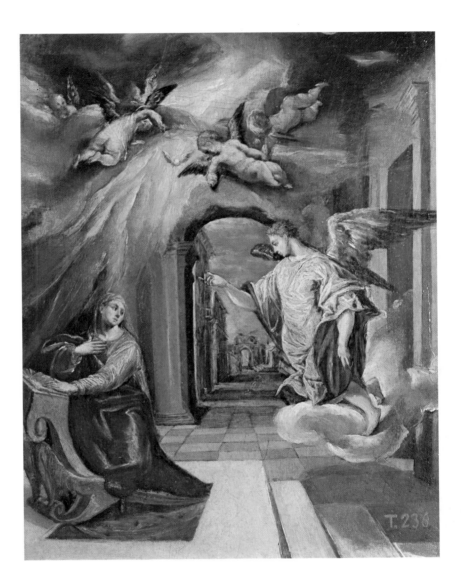

PLATE 29 (cat. no. 1). *Annunciation,* tempera
on panel, 10¹/₄ x 7⁷/₈ inches, before 1570
(Madrid, Museo del Prado)

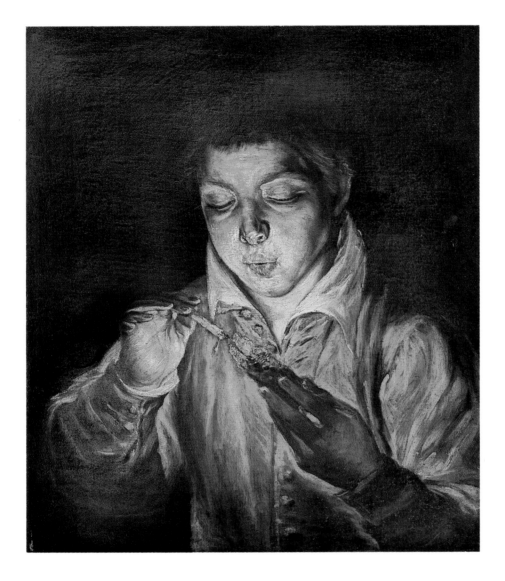

PLATE 30 (cat. no. 4). *Boy Lighting a Candle*
(*Boy Blowing on an Ember*), 24 x 20 inches,
circa 1570–1575 (New York, Charles S.
Payson Collection)

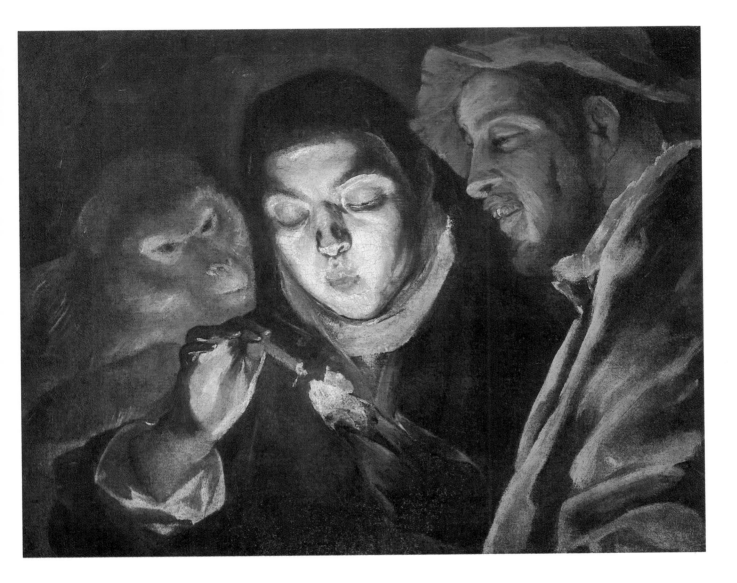

PLATE 31 (cat. no. 5). *Fable*, 19 5/8 x 25 1/4
inches, circa 1570–1575 (New York, Stanley
Moss Collection)

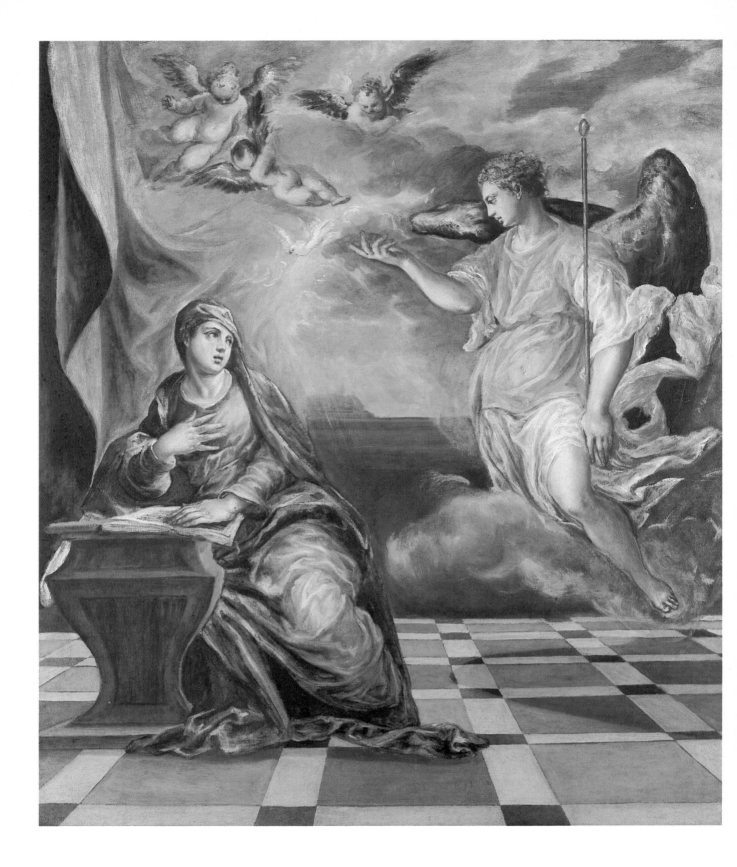

PLATE 32 (cat. no. 6). *Annunciation*, 46⅛ x
38⅝ inches, circa 1575–1576 (Lugano,
Thyssen-Bornemisza Collection)

PLATE 33 (cat. no. 8). *Veronica's Veil,* oil on
panel, oval, 29⁷/₈ x 21⁵/₈ inches, 1577–1579;
the cartouche was sculpted by Juan Bautista
Monegro, after El Greco's design (Madrid,
private collection)

181

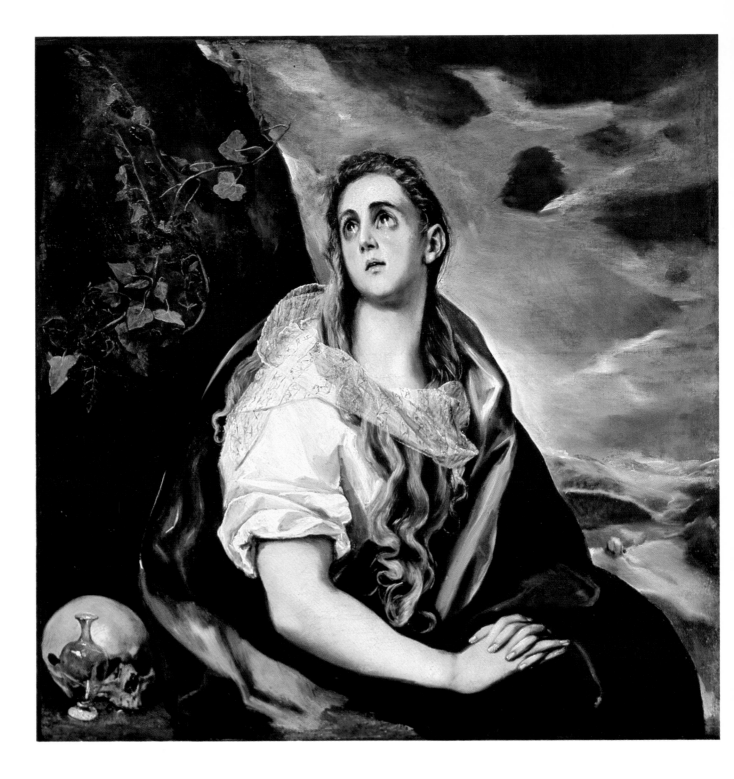

PLATE 34 (cat. no. 9). *Mary Magdalen in Penitence*, 42½ x 39⅞ inches, circa 1577 (Worcester [Massachusetts], Worcester Art Museum)

PLATE 35 (cat. no. 13). *Disrobing of Christ*, 22 x 12½ inches, circa 1577–1579 (New York, Stanley Moss Collection) >

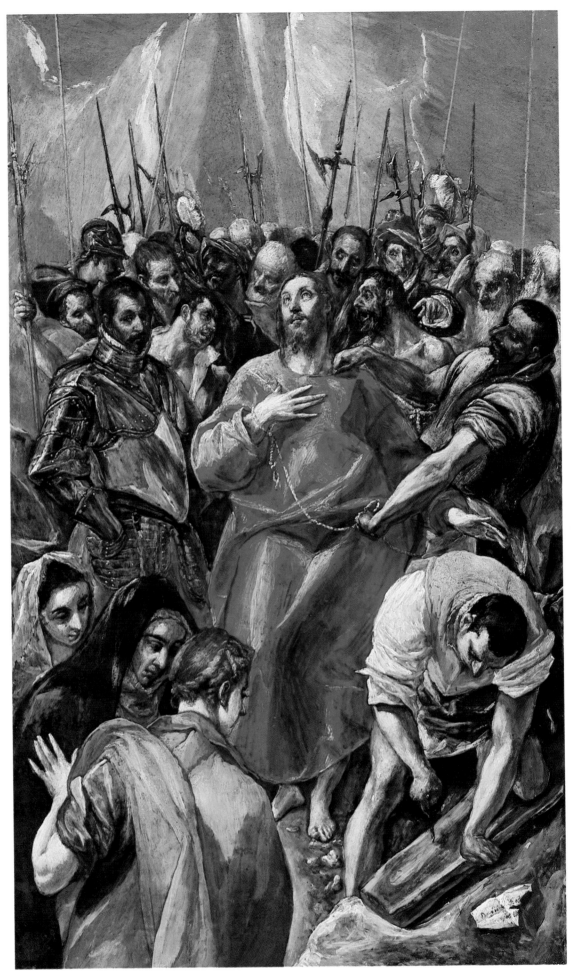

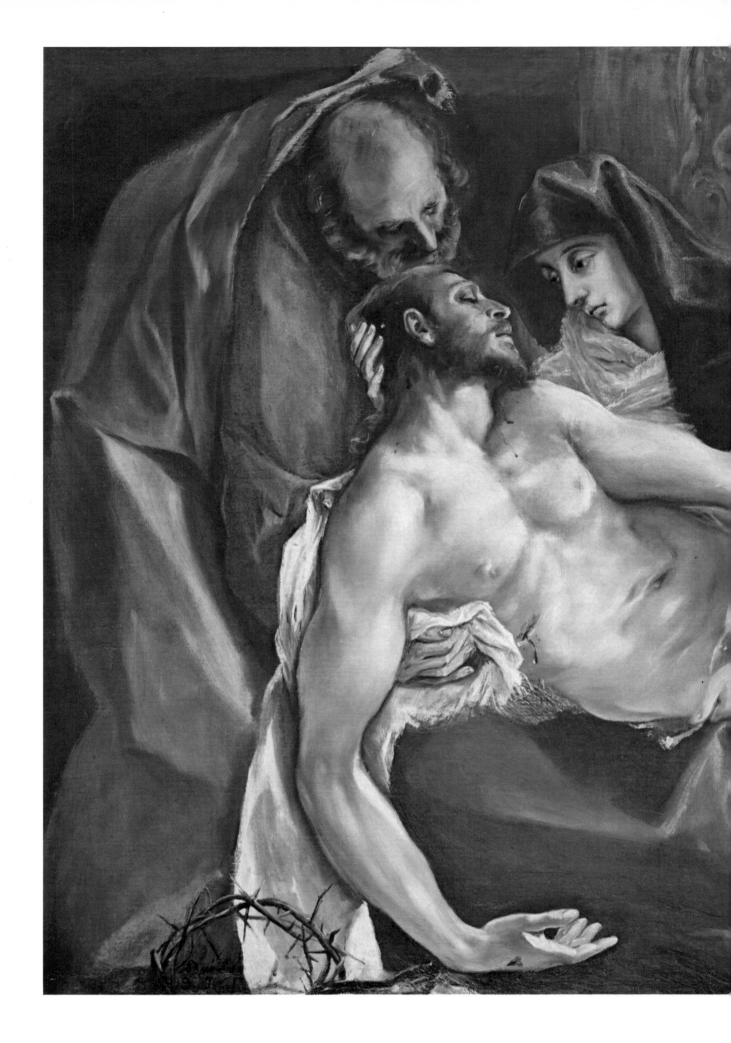

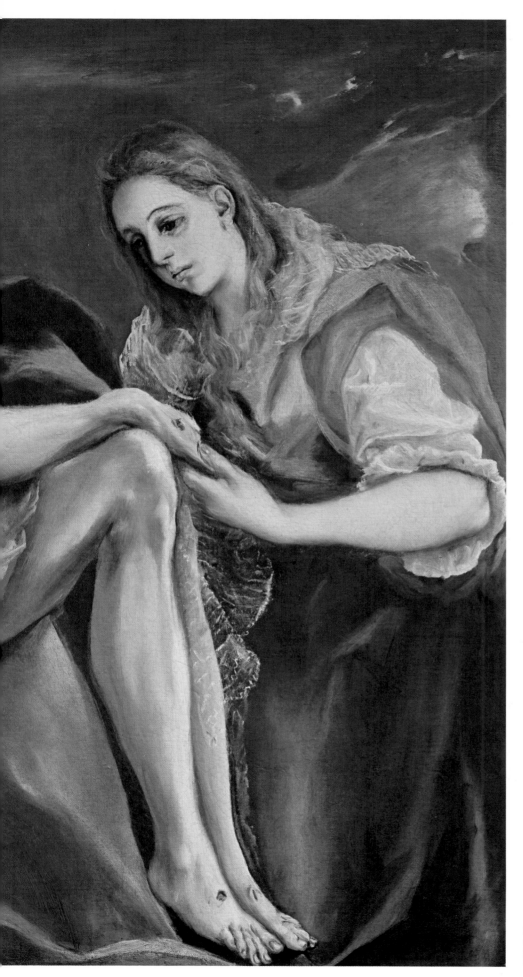

PLATE 36 (cat. no. 17). *Pietà,*
47¼ x 57 inches, circa 1580–1590
(London, Stavros S. Niarchos
Collection)

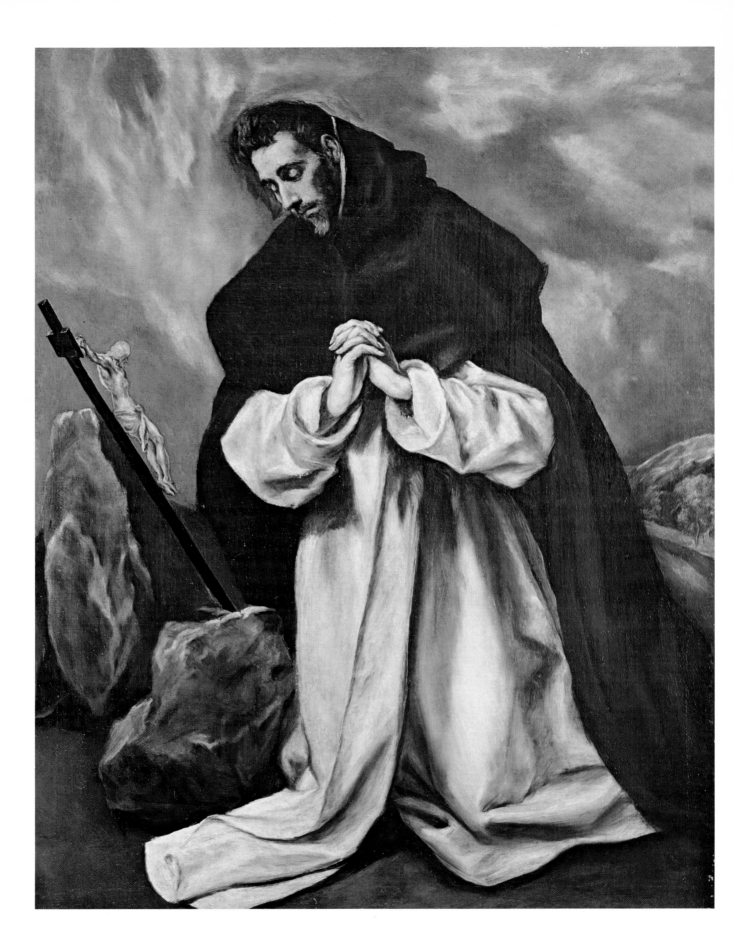

PLATE 37 (cat. no. 18). *Saint Dominic in
Prayer,* 46½ x 33⅞ inches, circa 1585–1590
(Madrid, Plácido Arango Collection)

186

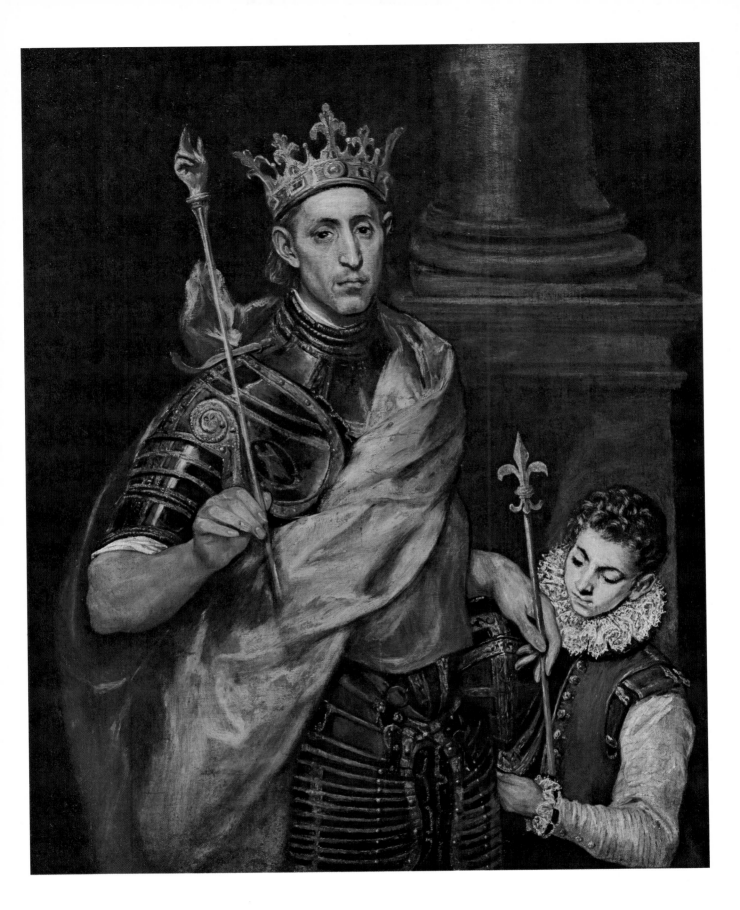

PLATE 38 (cat. no. 19). *Saint Louis of France*,
46⅛ x 37⅜ inches, circa 1585–1590 (Paris,
Musée du Louvre)

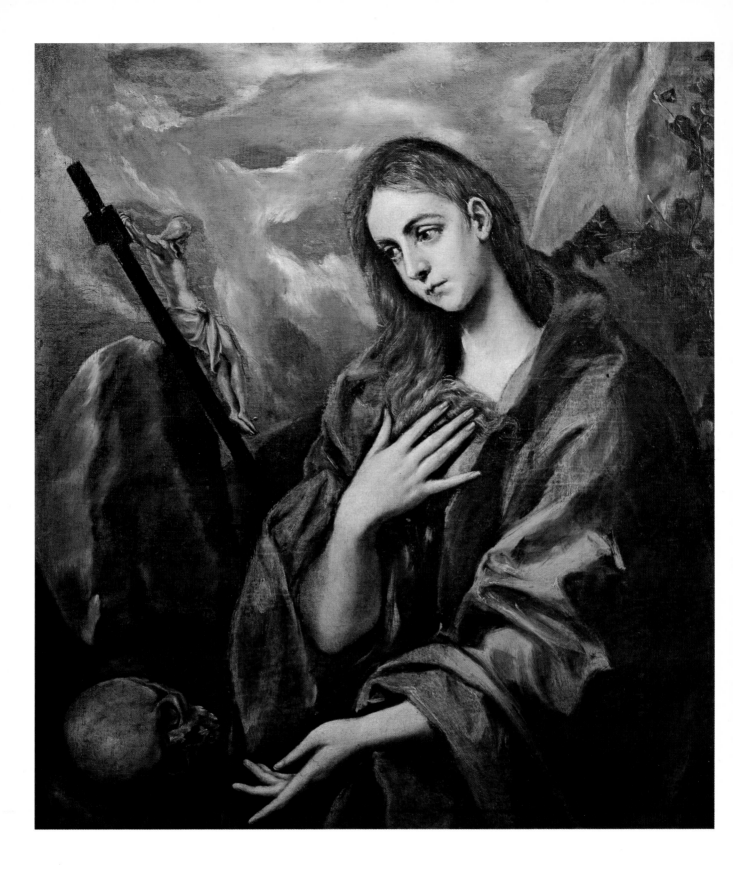

PLATE 39 (cat. no. 20). *Mary Magdalen in Penitence with the Crucifix*, 42⅞ x 37¾ inches, circa 1585–1590 (Sitges, Museo del Cau Ferrat)

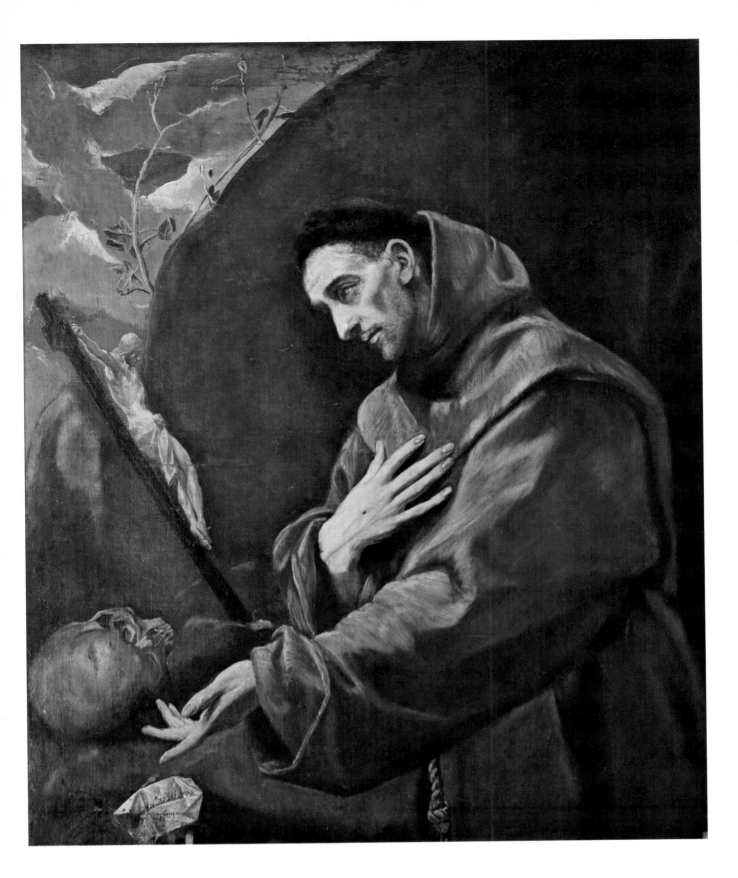

PLATE 40 (cat. no. 21). *Saint Francis in
Meditation*, 40½ x 34¼ inches, circa 1585–
1590 (Barcelona, Torelló Collection)

189

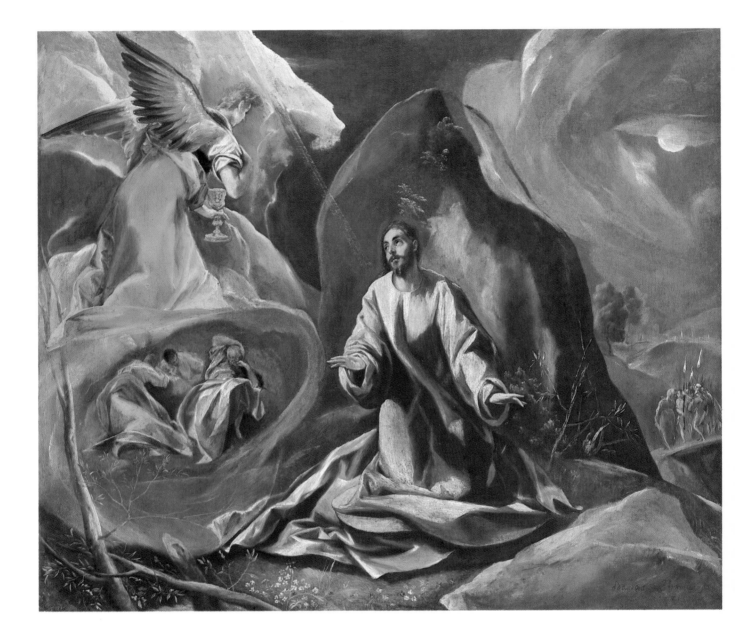

PLATE 41 (cat. no. 22). *Agony in the Garden*,
40¼ x 44¾ inches, circa 1590–1595 (Toledo
[Ohio], The Toledo Museum of Art. Gift of
Edward Drummond Libbey)

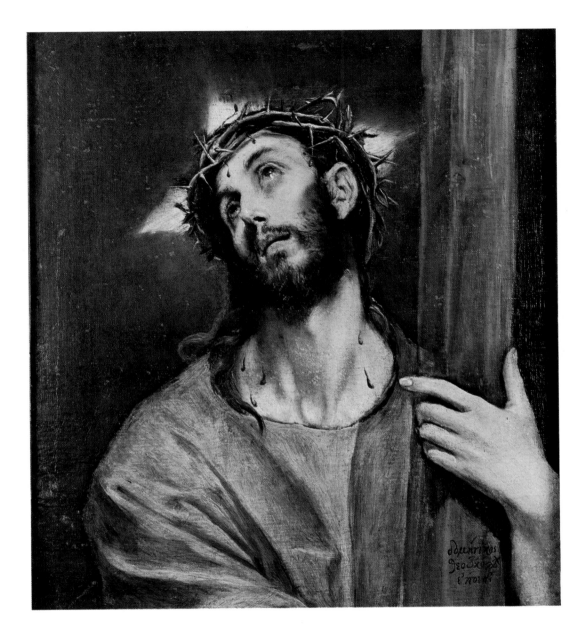

PLATE 42 (cat. no. 23). *Christ Carrying the Cross*, 25¼ x 20¾ inches, circa 1590–1595 (New York, Oscar B. Cintas Foundation. On loan to Cummer Art Gallery, Jacksonville, Florida)

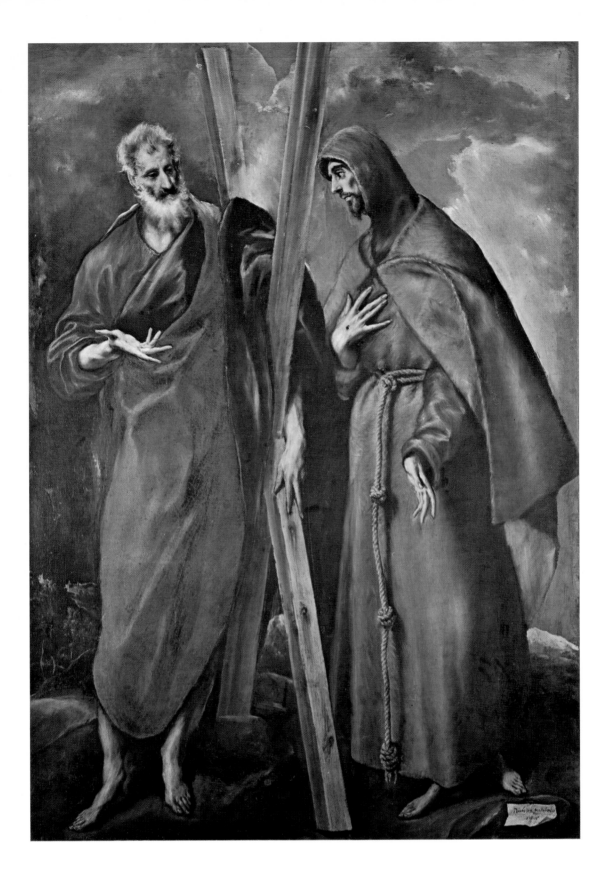

PLATE 43 (cat. no. 24). *Saint Andrew and
Saint Francis*, 65¾ x 44½ inches, circa 1590–
1595 (Madrid, Museo del Prado)

192

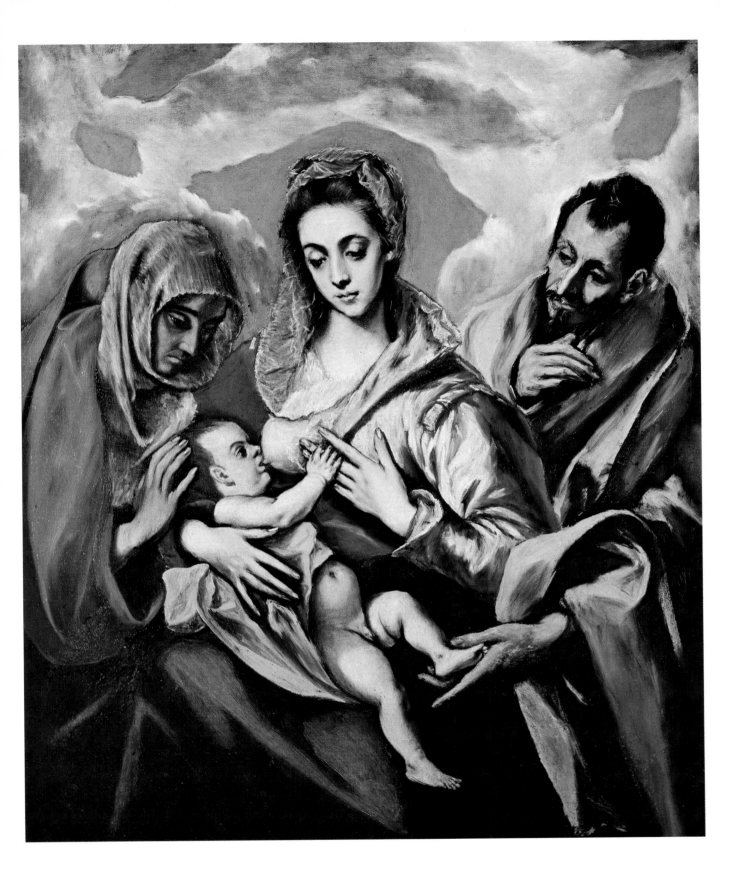

PLATE 44 (cat. no. 25). *Holy Family with
Saint Anne*, 50 x 41³/₄ inches, circa 1590–1595
(Toledo, Hospital of Saint John the Baptist)

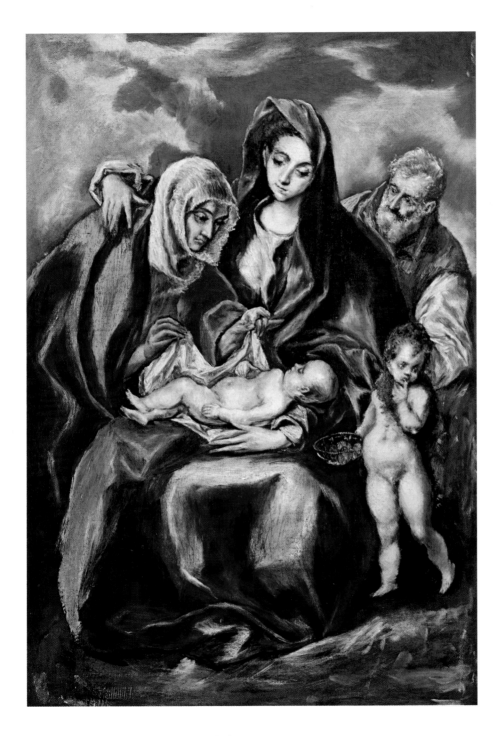

PLATE 45 (cat. no. 26). *Holy Family with the
Sleeping Christ Child and the Infant Baptist,*
20⅞ x 13½ inches, circa 1595–1600 (Wash-
ington, National Gallery of Art. Samuel H.
Kress Collection 1959)

194

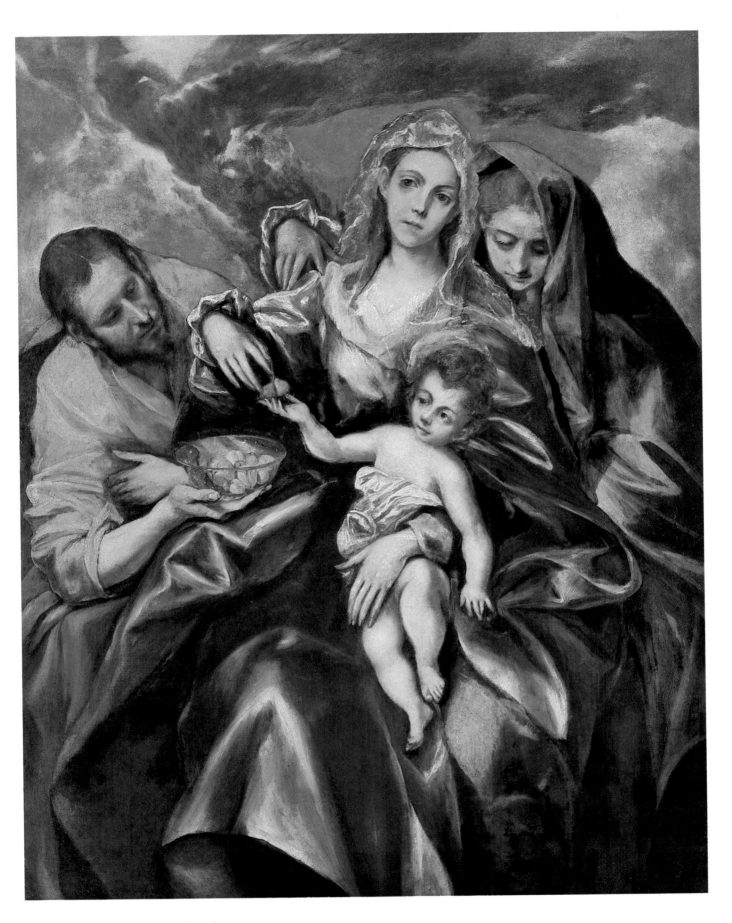

PLATE 46 (cat. no. 27). *Holy Family with Mary Magdalen*, 51⁷/₈ x 39¹/₂ inches, circa 1595–1600 (Cleveland, The Cleveland Museum of Art. Gift of the Friends of the Cleveland Museum of Art, in memory of J. H. Wade)

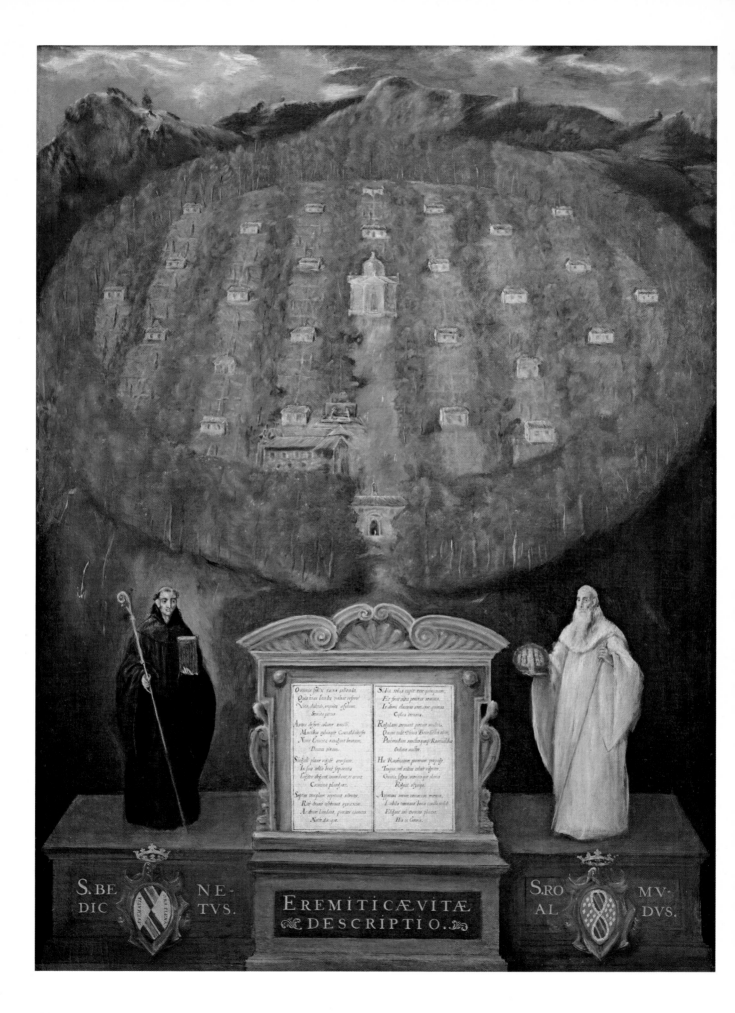

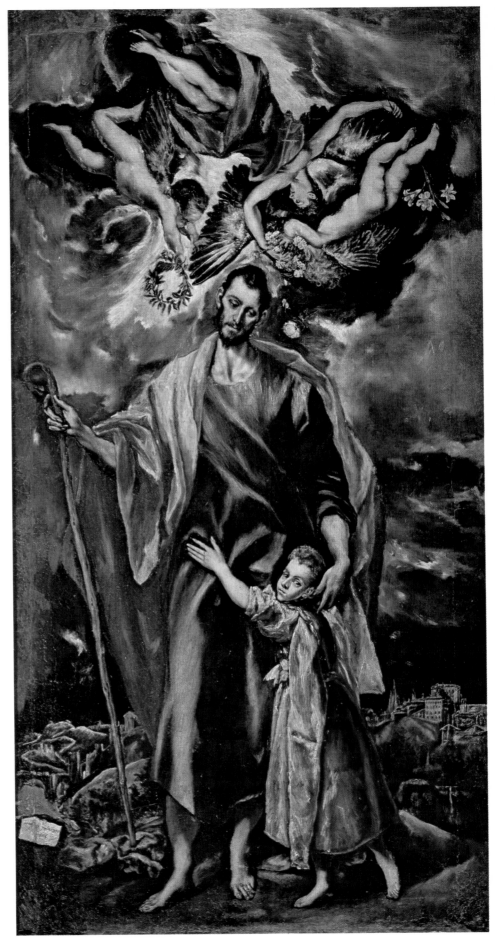

< PLATE 47 (cat. no. 28). *Allegory of the Camaldolite Order*, 48⁷/₈ x 35³/₈ inches, circa 1597 (Madrid, Instituto de Valencia de Don Juan)

PLATE 48 (cat. no. 29). *Saint Joseph and the Christ Child*, 42⁷/₈ x 22 inches, circa 1597–1599 (Toledo Cathedral. On loan to Museo de Santa Cruz, Toledo)

197

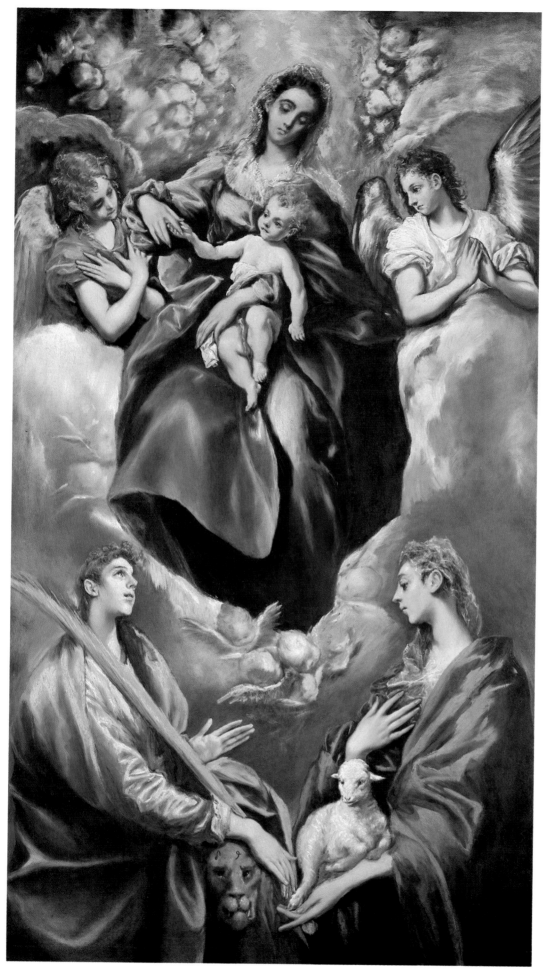

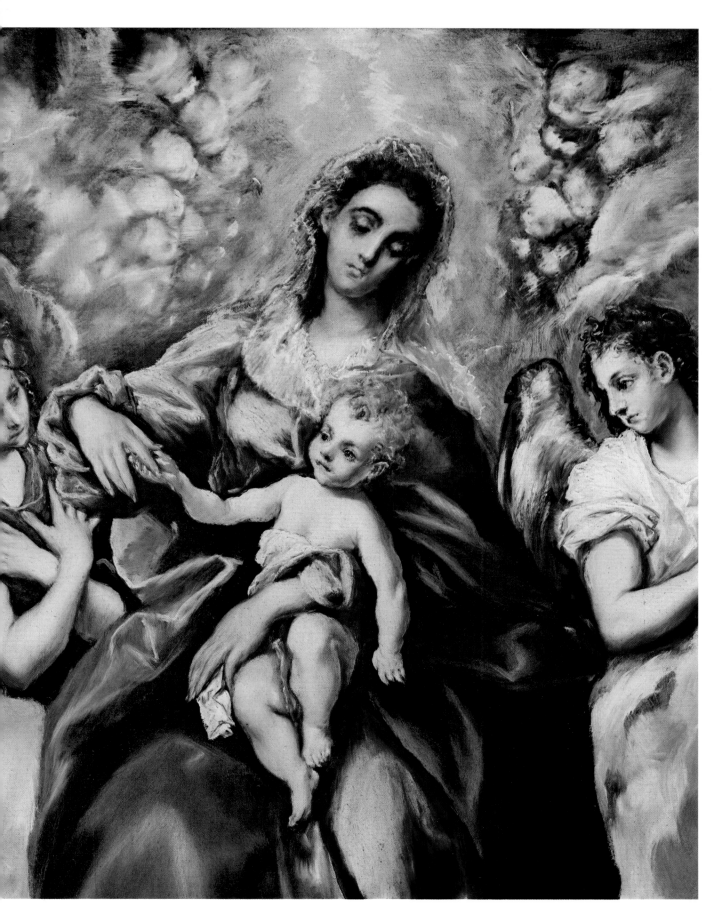

< PLATE 49 (cat. no. 31). *Madonna and Child
with Saint Martina and Saint Agnes*, 76¹/₈ x
40¹/₂ inches, circa 1597–1599 (Washington,
National Gallery of Art. Widener Collection
1942)

PLATE 50. Detail of *Madonna and Child
with Saint Martina and Saint Agnes* (cat. no.
31; pl. 49)

199

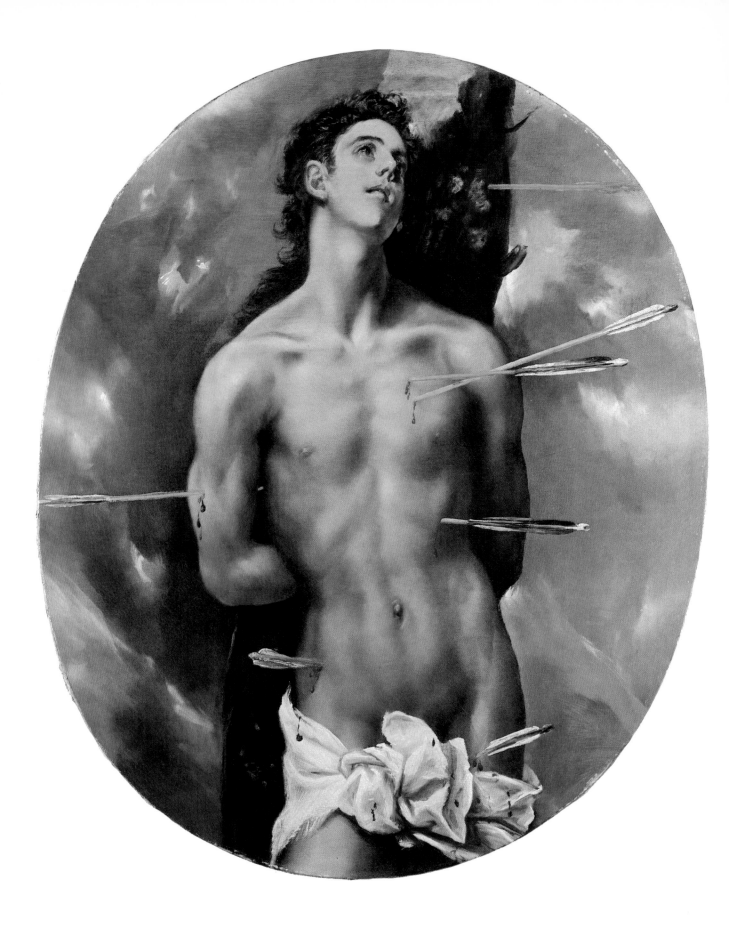

PLATE 51 (cat. no. 36). *Saint Sebastian,*
oval, 35 x 26¾ inches, circa 1600 (private
collection)

PLATE 52 (cat. no. 37). *Saint John the
Baptist,* 43¾ x 26 inches, circa 1600 (San
Francisco, The Fine Arts Museums of San
Francisco. Purchased with Funds from
Various Donors) >

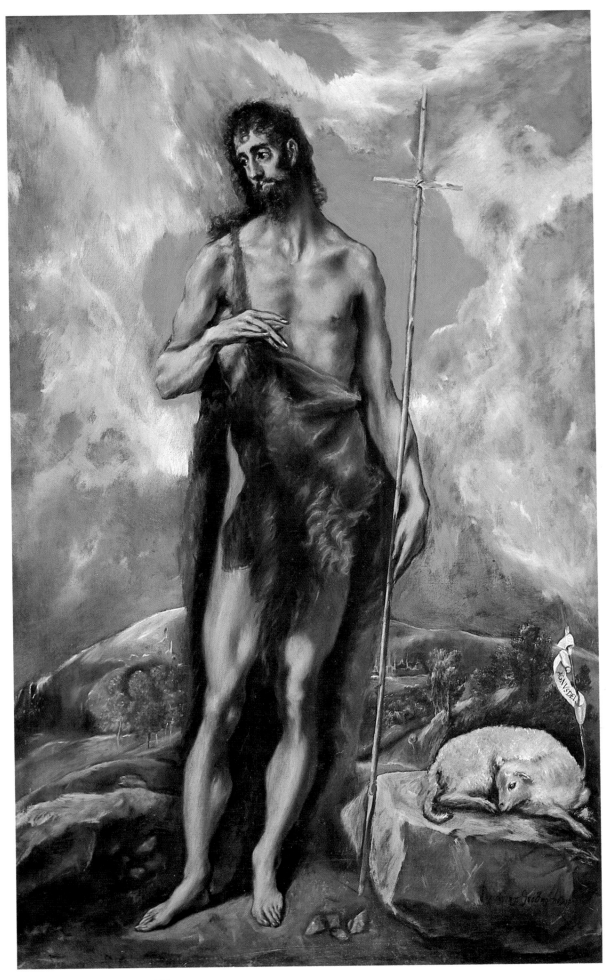

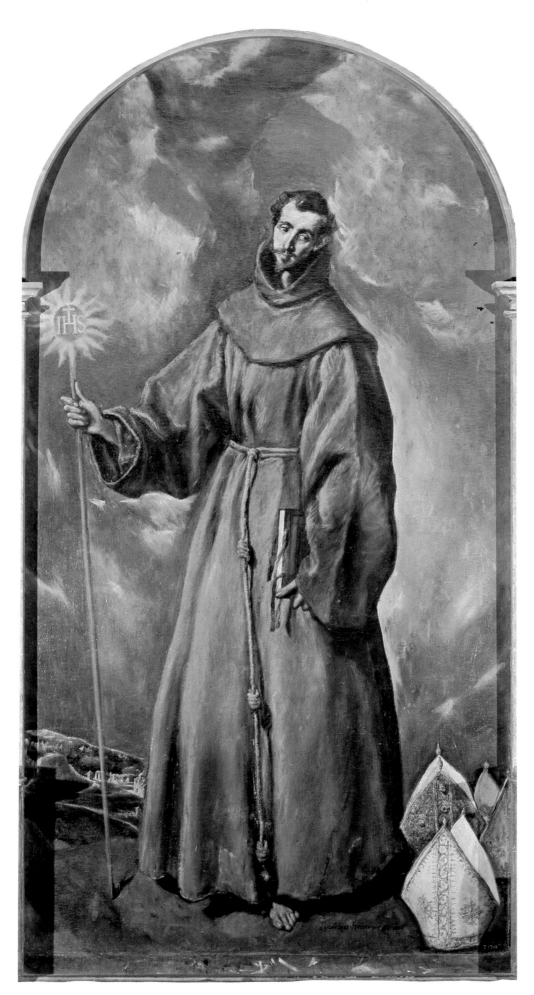

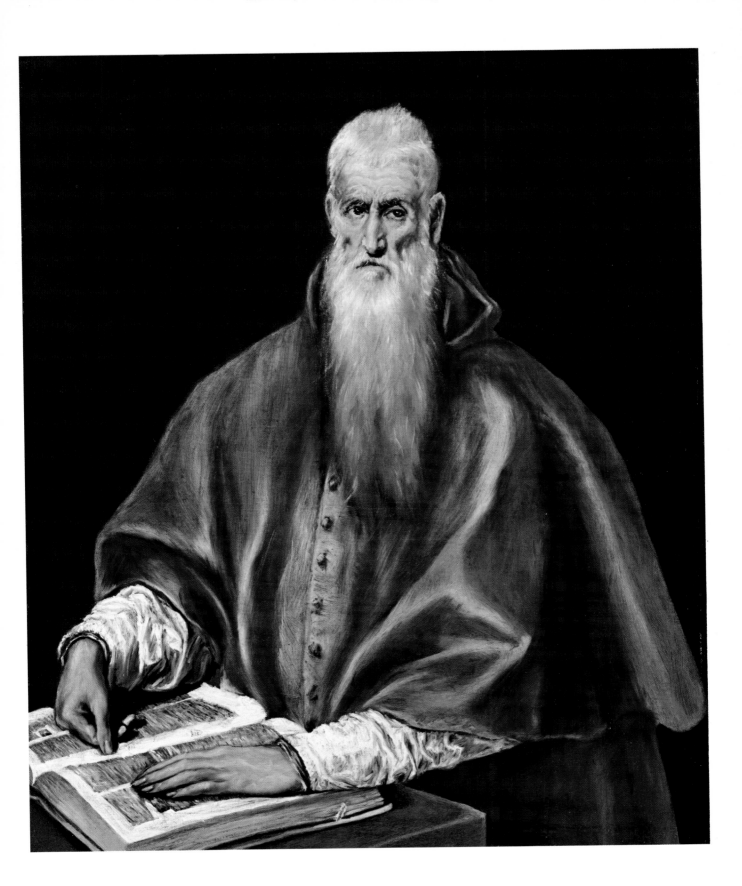

< PLATE 53 (cat. no. 39). *Saint Bernardino*,
105⁷/₈ x 56³/₄ inches, 1603–1604 (Toledo,
Museo del Greco. Fundaciones Vega-Inclán)

PLATE 54 (cat. no. 40). *Saint Jerome as
Cardinal*, 42¹/₂ x 34¹/₄ inches, circa 1600–1610
(New York, The Metropolitan Museum of
Art. Robert Lehman Collection 1975)

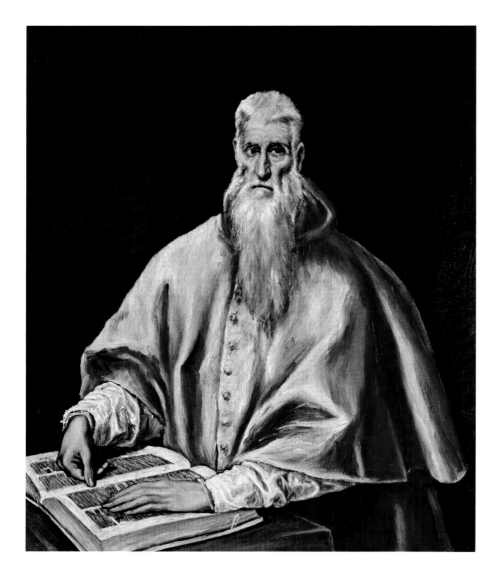

PLATE 55 (cat. no. 41). *Saint Jerome as
Cardinal*, 25¼ x 21¼ inches, circa 1600–1605
(Madrid, Várez-Fisa Collection)

PLATE 56 (cat. no. 43). *Saint Ildefonso*,
44¼ x 25¾ inches, circa 1605–1614 (Washing-
ton, National Gallery of Art. Andrew W.
Mellon Collection 1937) >

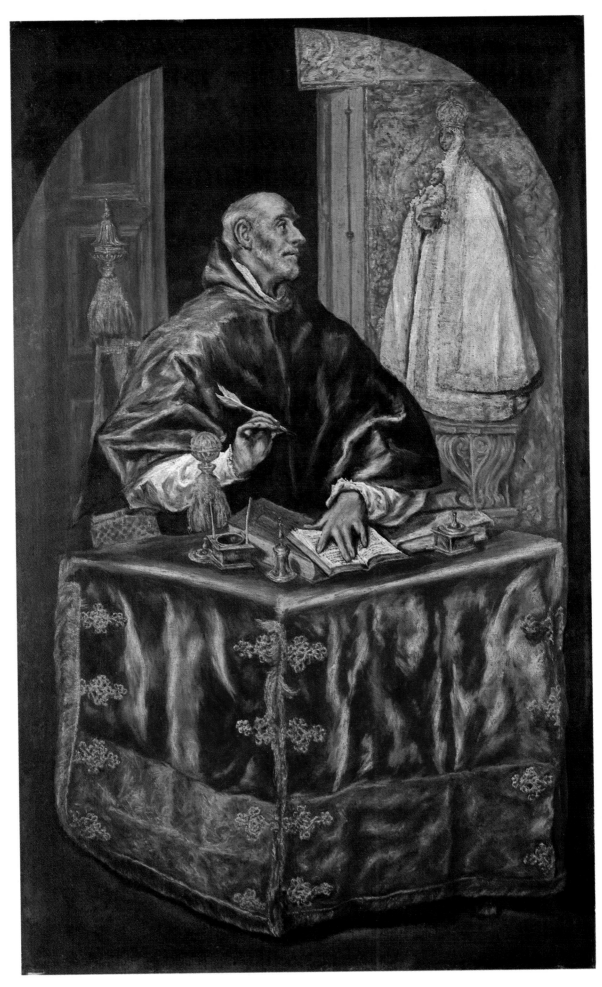

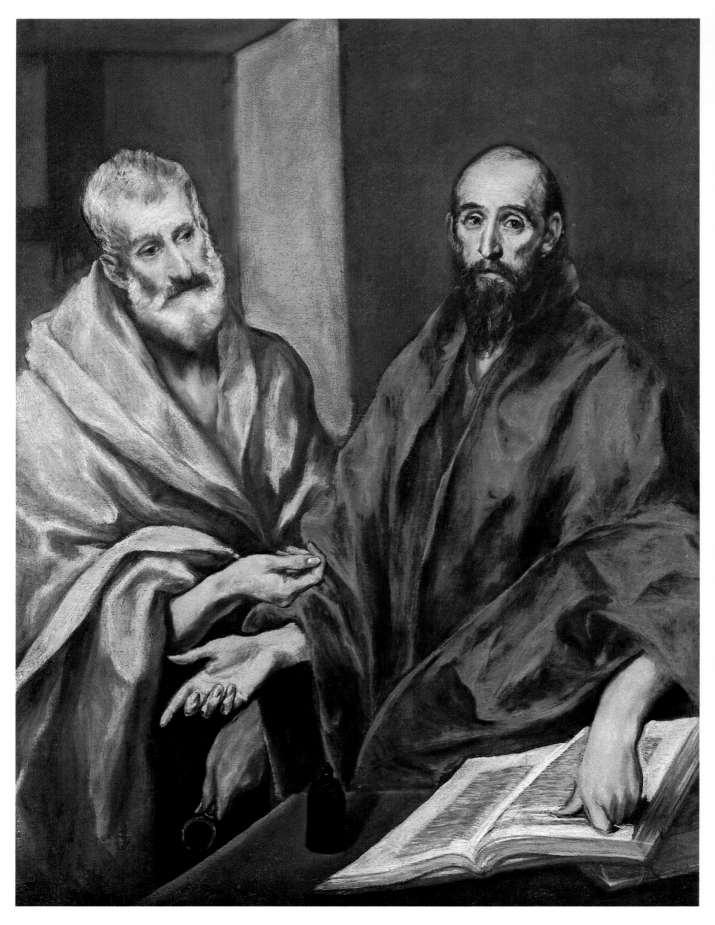

PLATE 57 (cat. no. 44). *Saint Peter and Saint Paul*, 48⅞ x 36⅝ inches, circa 1605–1608 (Stockholm, Nationalmuseum)

PLATE 58 (cat. no. 45). *Christ on the Cross with Landscape*, 74 x 44 inches, circa 1605–1610 (Cleveland, The Cleveland Museum of Art. Gift of the Hanna Fund) >

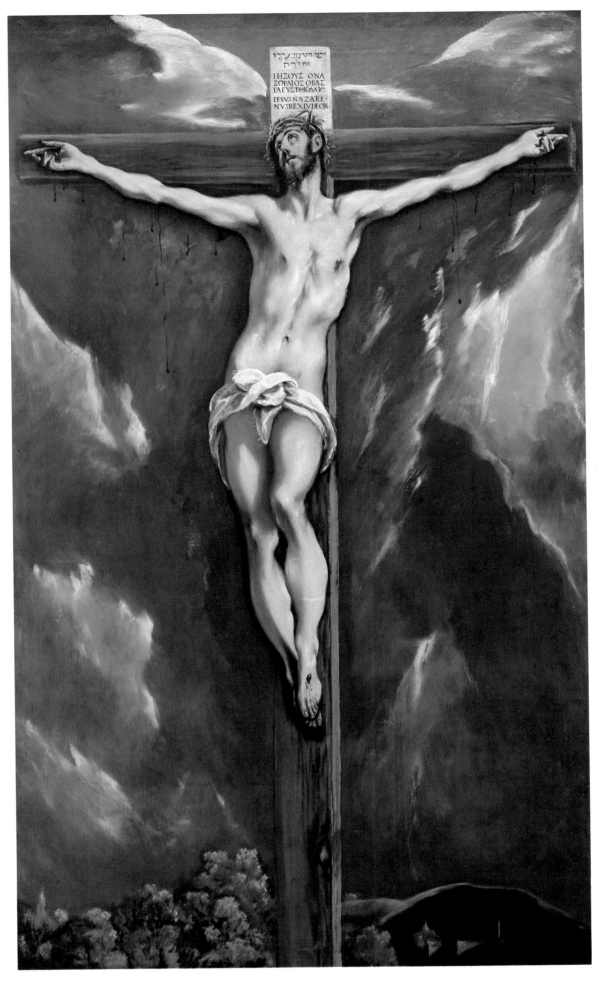

207

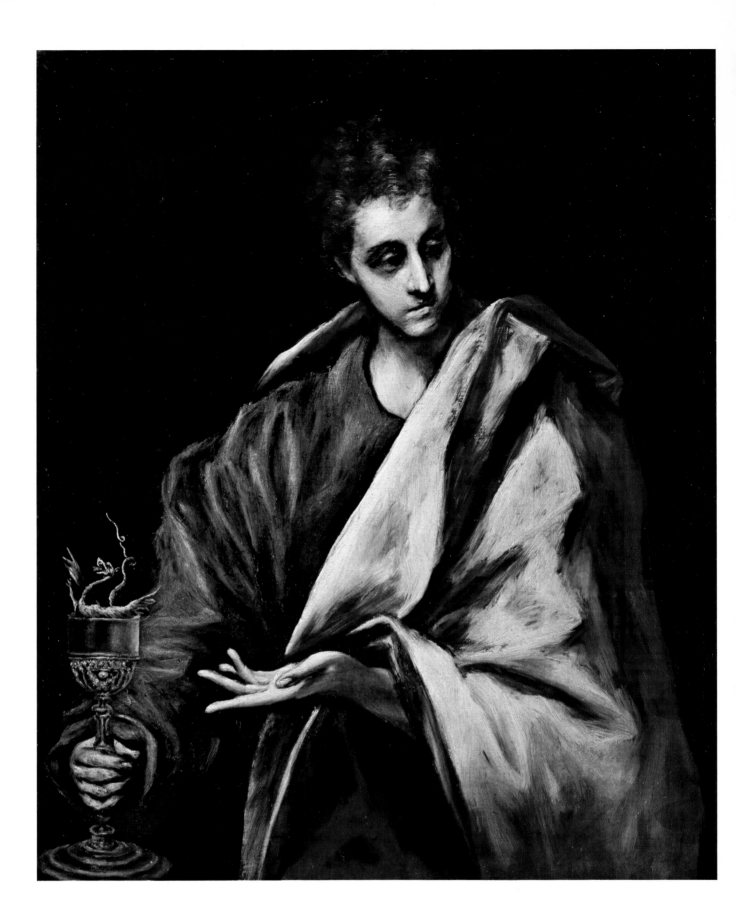

PLATE 59 (cat. no. 46). *Saint John the Evangelist*, 39³/₈ x 29⁷/₈ inches, circa 1605–1610 (Toledo, Cathedral)

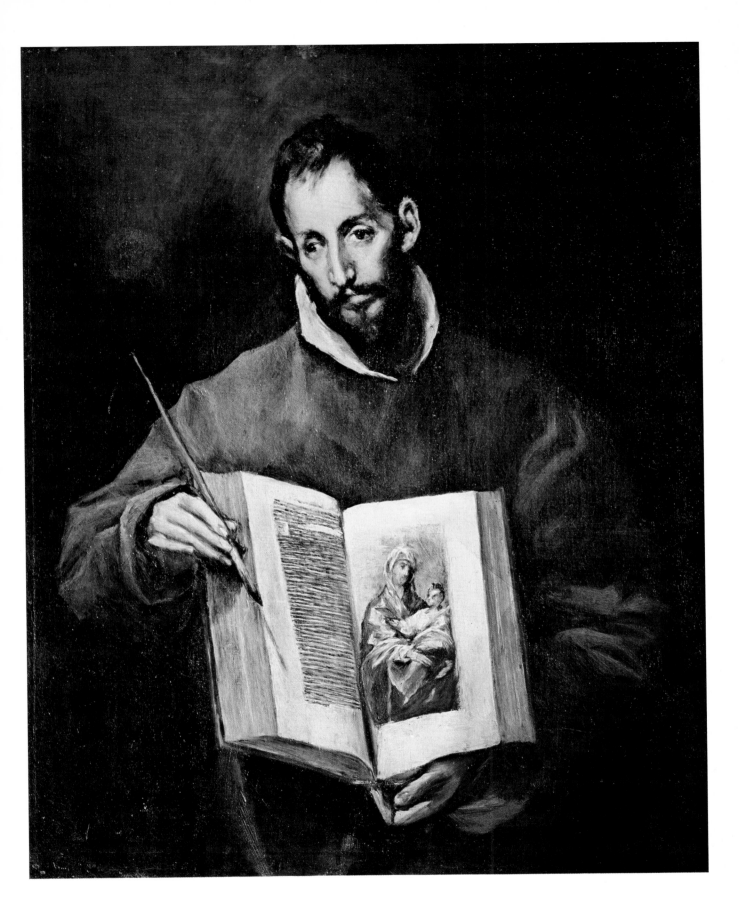

PLATE 60 (cat. no. 47). *Saint Luke,*
39³/₈ x 29⁷/₈ inches, circa 1605–1610
(Toledo, Cathedral)

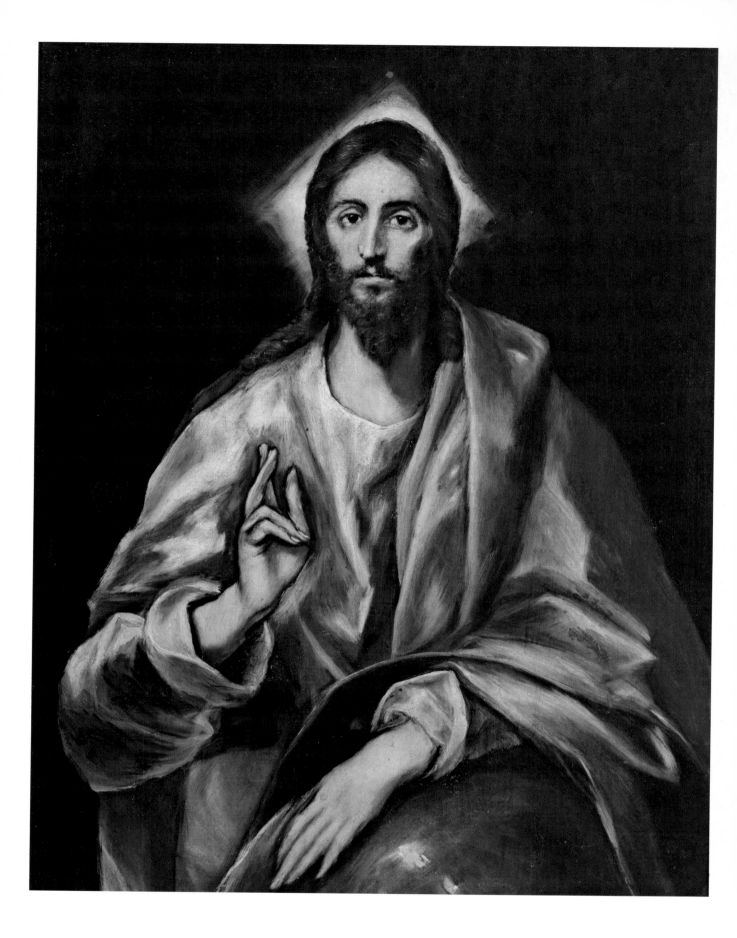

PLATE 61 (cat. no. 48). *Saviour*, 38¼ x 30⅜
inches, circa 1610–1614 (Toledo, Museo
del Greco. Fundaciones Vega-Inclán)

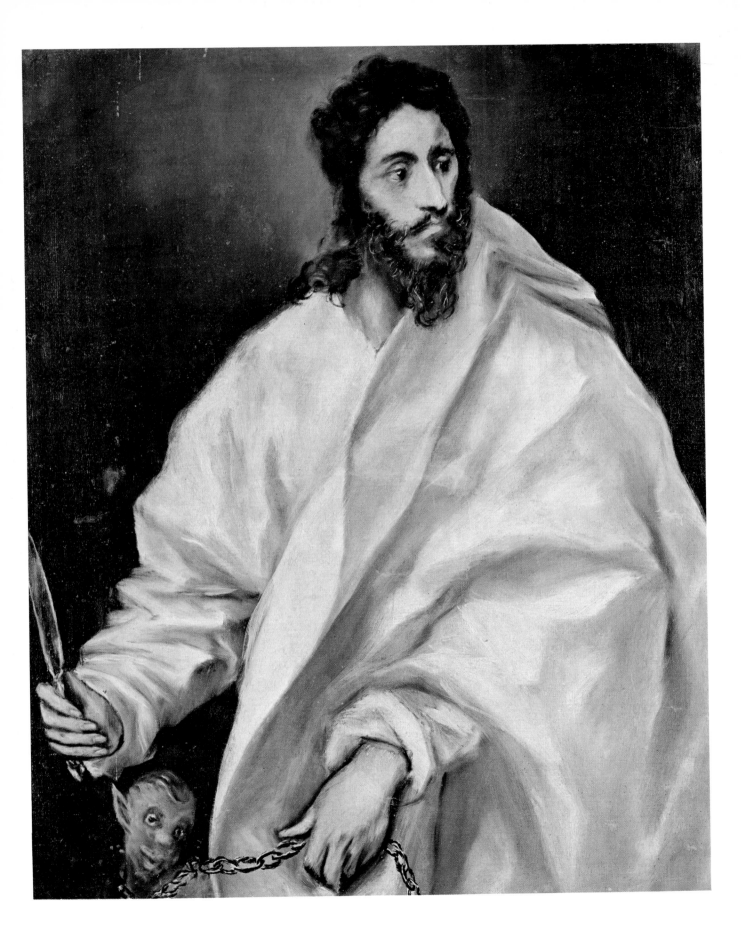

PLATE 62 (cat. no. 49). *Saint Bartholomew,*
38¼ x 30⅜ inches, circa 1610–1614 (Toledo,
Museo del Greco. Fundaciones Vega-Inclán)

211

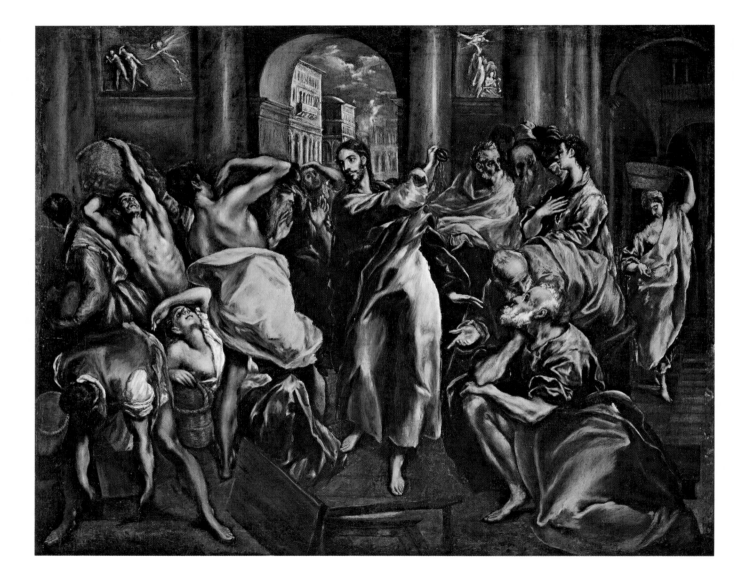

PLATE 63 (cat. no. 50). *Purification of the Temple*, 41⅛ x 48⅞ inches, circa 1610–1614 (Madrid, Várez-Fisa Collection)

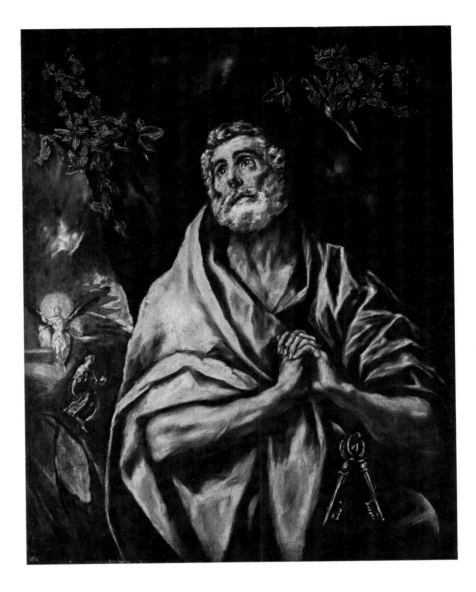

PLATE 64 (cat. no. 51). *Saint Peter in Tears,*
40⅛ x 31¼ inches, circa 1610–1614 (Oslo,
Nasjonalgalleriet)

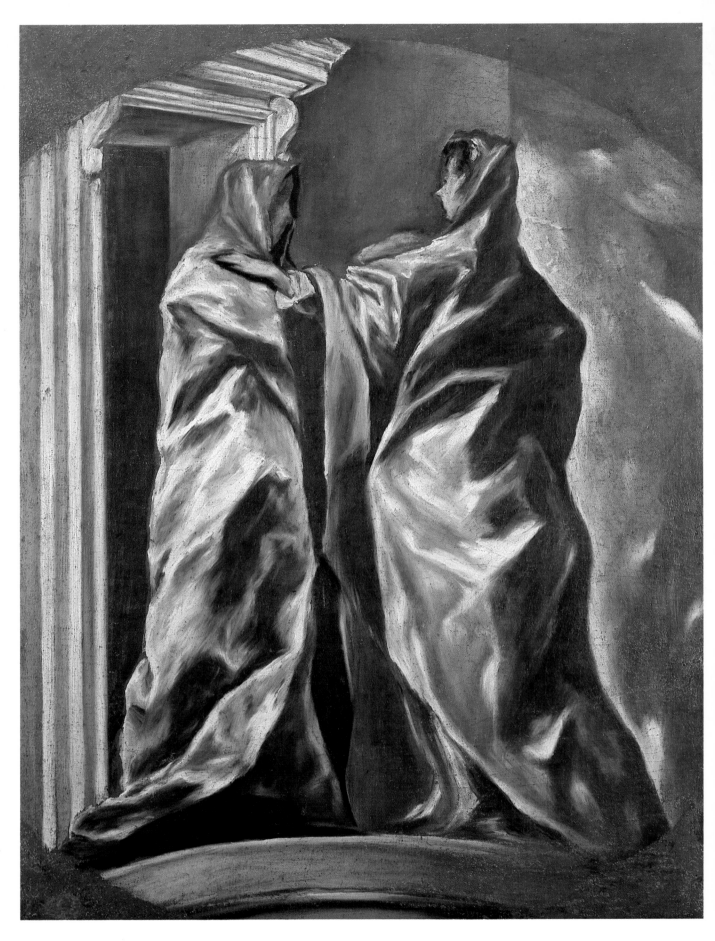

PLATE 65 (cat. no. 52). *Visitation*, 38½ x
28½ inches, circa 1607–1614 (Washington,
Dumbarton Oaks Collection)

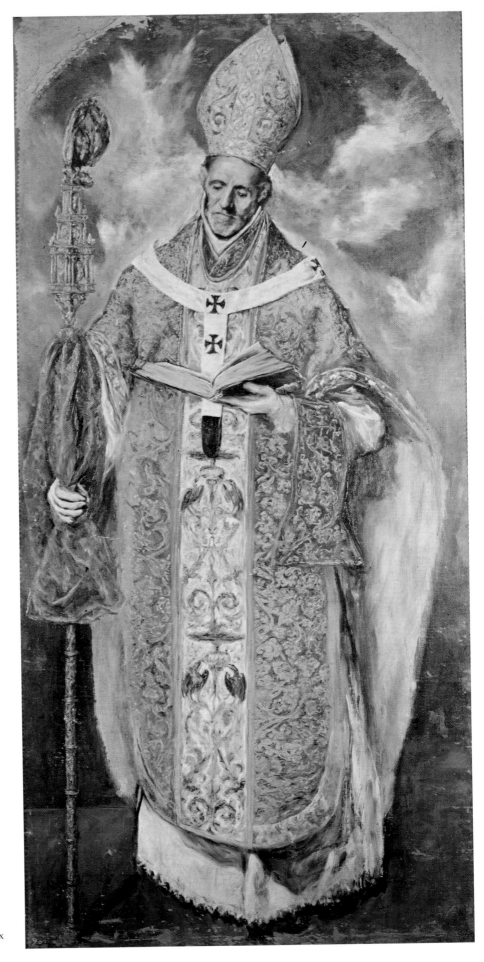

PLATE 66 (cat. no. 53). *Saint Ildefonso*, 87 ³/₈ x
41 ³/₈ inches, circa 1610–1614 (El Escorial)

215

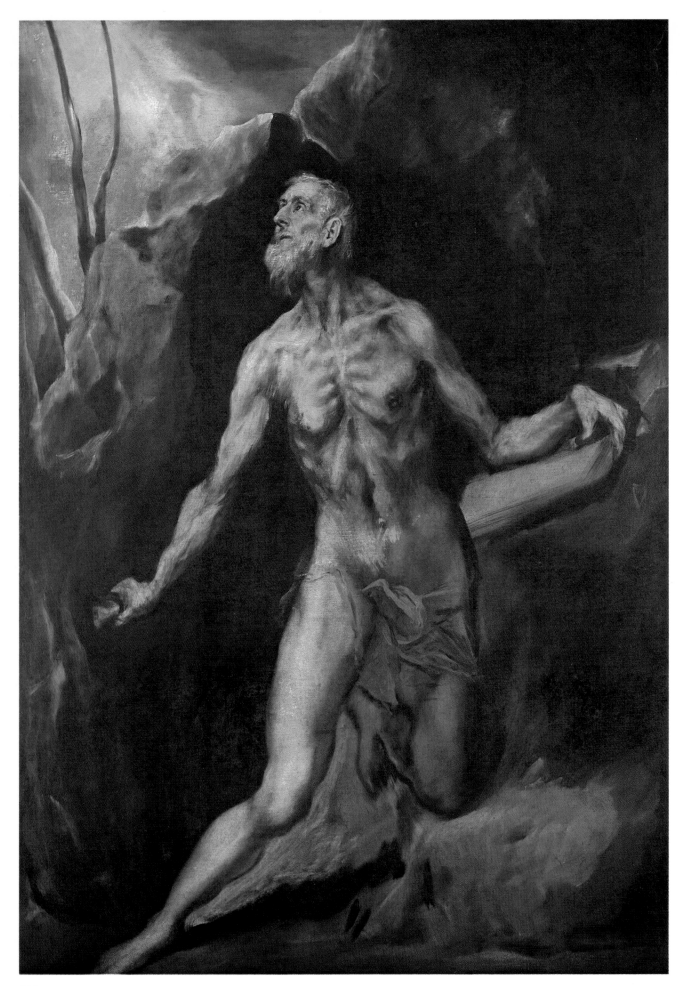

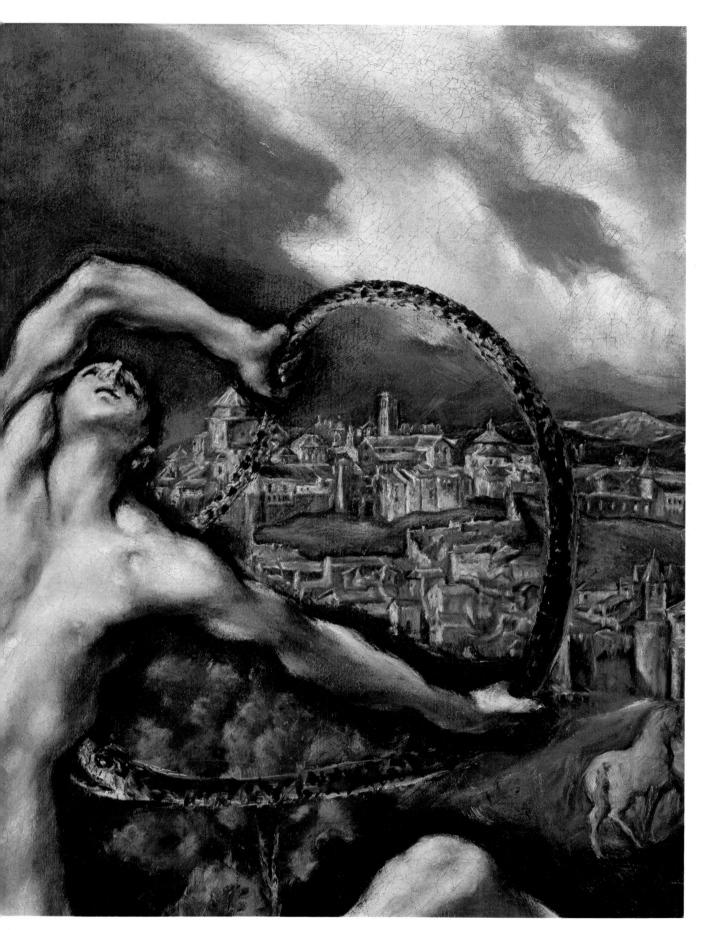

< PLATE 67 (cat. no. 54). *Saint Jerome in*
Penitence, 66¼ x 43½ inches, circa 1610–1614
(Washington, National Gallery of Art. Gift of
Chester Dale 1943)

PLATE 68. Detail of *Laocoön* (cat. no. 56;
pl. 69)

217

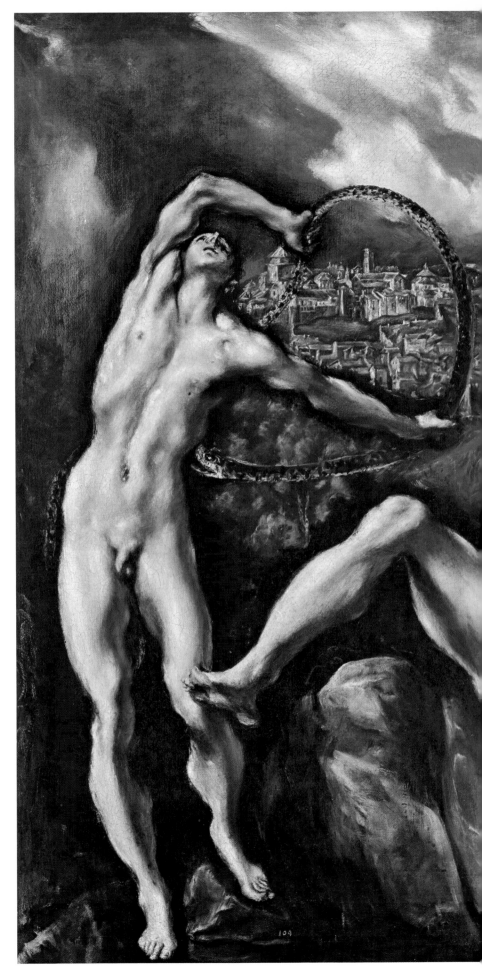

PLATE 69 (cat. no. 56). *Laocoön*, 54 1/8 x 67 7/8
inches, circa 1610–1614 (Washington,
National Gallery of Art. Samuel H. Kress
Collection 1946)

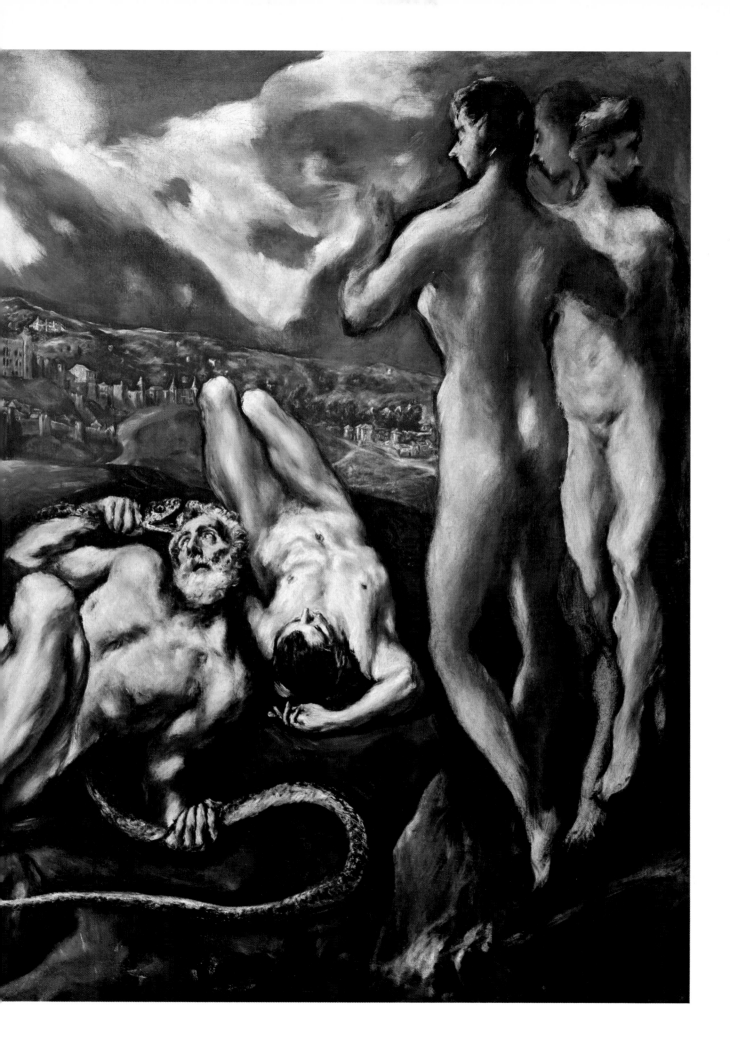

PLATE 70 (cat. no. 58). *Gentleman of the
House of Leiva* [?], 34⅝ x 27⅛ inches, circa
1580–1585 (Montreal, Montreal Museum of
Fine Arts. Adaline Van Horne Bequest 1945)

PLATE 71 (cat. no. 60). *Lady with a Flower in
Her Hair,* 19½ x 16½ inches, circa 1590–1600
(private collection)

221

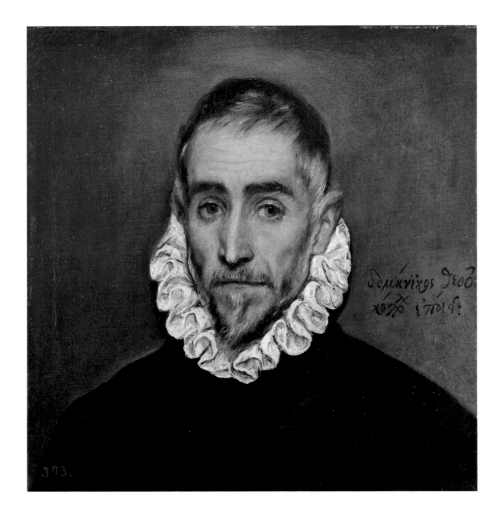

PLATE 72 (cat. no. 59). *Elderly Gentleman,*
17 3/8 x 16 1/2 inches, circa 1585–1595 (Madrid,
Museo del Prado)

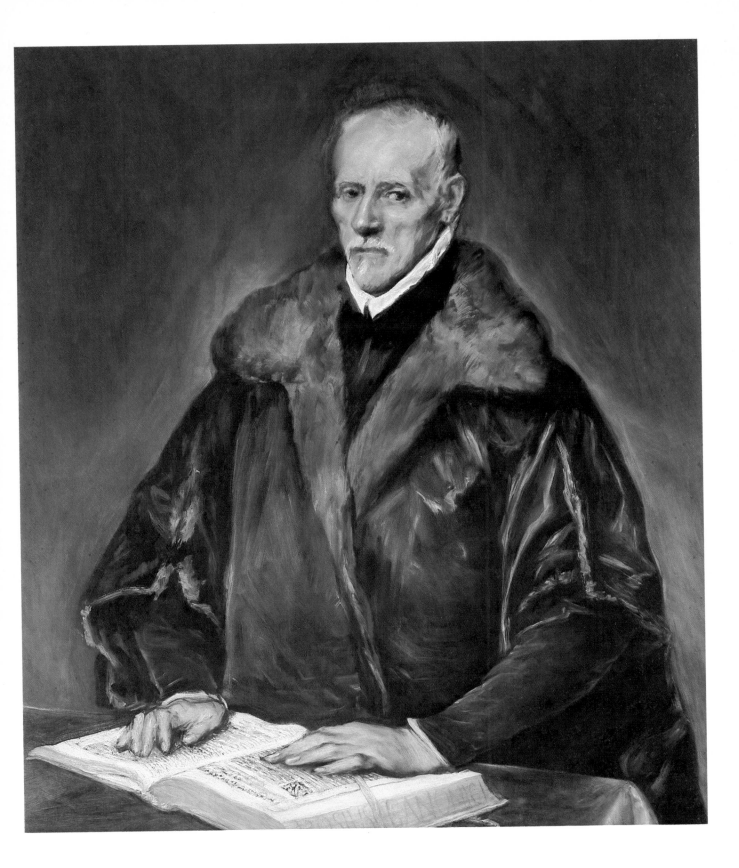

PLATE 73 (cat. no. 66). *Giacomo Bosio*,
45⅝ x 33⅞ inches, circa 1610–1614 (Fort
Worth, Kimbell Art Museum)

Catalogue of the Exhibition

WILLIAM B. JORDAN

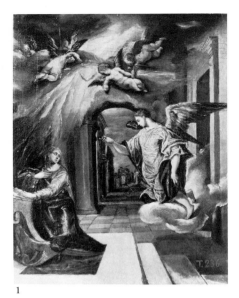

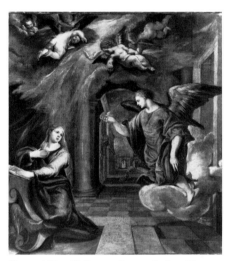

Figure 108. El Greco. *Annunciation*, 42 x 36½ inches, before 1570 (Barcelona, Julio Muñoz Collection)

1 (plate 29)

Annunciation

Tempera on panel, 26 x 20 cm. (10¼ x 7⅞ inches)
Before 1570
Madrid, Museo del Prado

This tiny panel is thoroughly Venetian in style. Its Serlian architectural scenario, used to create a deep space, is similar to those in the *Purification of the Temple* (cat. no. 2; pl. 12) and in the various versions of *Christ Healing the Blind* (figs. 45–47). Such devices were so widely used by painters at the time that any attempt to find a more specific derivation would be pointless. The composition duplicates with fidelity that of a larger painting by El Greco in the Muñoz Collection, Barcelona (fig. 108), and the present painting has been assumed to be a sketch for that work. Whether the Madrid panel and other miniature versions of El Greco's large paintings are simply small paintings or are in fact

sketches or autograph reductions is not totally clear, and the truth may vary from case to case. But the question is crucial to an understanding of El Greco's working method. (I shall return to this subject when considering cat. no. 13, the small version of the *Disrobing of Christ*.) It should be kept in mind that when El Greco was admitted to the Roman Academy of Saint Luke in 1572 it was as a miniature painter, as was true of Giulio Clovio (see chapter 2). Painting on a small scale was probably not just a step on the way to grand scale for El Greco, but was valued in its own right. What was unusual was to work on so small a scale in the broad Venetian manner. Yet he did so, and this seems typical indeed of El Greco's early work.

Provenance: Doña Concepción Parody; purchased from her by the Prado in 1868.
Bibliography: Cossío (1908), p. 559, no. 56; Mayer (1926), p. 3, no. 4; Waterhouse (1930), pp. 72, 85, no. 9; Mâle (1932), chap. 6; Legendre and Hartmann (1937), p. 101; Rodolfo Palluchini, "La periode italienne du Greco," in Bordeaux, Beaux-Arts (1953), p. 20; Soria (1954), p. 220, no. 36; Soehner (1958–1959), p. 176, no. 2; Wethey (1962), vol. 2, p. 32, no. 38; Manzini and Frati (1969), p. 93, no. 15a; Camón Aznar (1970), p. 1337, no. 24; Madrid, Prado (1972), p. 302, no. 827; Cossío (1972), no. 14; Gudiol (1973), pp. 34, 37, 340, no. 18; Alfonso E. Pérez Sánchez, "Presencia de Tiziano en la España del Siglo de Oro," *Goya*, no. 135 (Nov.–Dec. 1976): 149.

2 (plate 12)

Purification of the Temple

Tempera on panel, 65.4 x 83.2 cm. (25¾ x 32¾ inches)
Signed at lower left in Greek capitals:
DOMÉNIKOS THEOTOKÓPOULOS KRÈS
Before 1570
Washington, National Gallery of Art.
Samuel H. Kress Collection 1957

Since the early fourteenth century the Purification of the Temple had only rarely been treated by artists, and even then only as one scene in a sequence of events from the life of Christ. To single it out as the subject for an independent picture was not common even during the Counter-Reformation (although Popes Paul IV, Pius IV, and Gregory XIII chose it for representation on the reverse sides of their commemorative medals). El Greco, however, was preoccupied with the subject throughout his

2

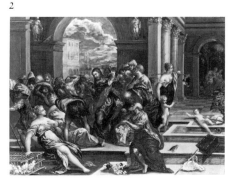

career. From his earliest works to the latest, he repeated the theme, following the same general compositional scheme with subtle variations (see cat. nos. 3, 50; pls. 14, 63). The furious figure of Christ wields a whip as he drives out the money changers, merchants, and revelers who have variously profaned the House of the Lord. El Greco's contemporaries saw this biblical parallel as justification for the Counter-Reformation's own campaign to purge the church of heresy.

This small panel is the earliest authentic El Greco version of the Purification, and it presents striking evidence of his rapid assimilation of Venetian technique and style. The spatial organization is clearly related to the art of Tintoretto, but the art historical literature is filled with speculation about other possible sources of inspiration for the composition and for individual figures. Justi and MacLaren both point to certain drawings of the subject by Michelangelo, as does Jonathan Brown (see chapter 2, page 78); Waterhouse suggests Titian's *Bacchanal;* Harris notes similarities to Raphael's *School of Athens*. In any case, it is clear that El Greco had become quite conversant with the artistic monuments of his time, both Venetian and Roman, and with the antique sources commonly employed by his contemporaries.

The surface of the painting is very labored, like other panels dating from El Greco's Venetian period, and each figure in the complex, overlapping composition seems studied; the whole somehow reveals the effort that went into it. The basic features of the design pleased the artist, for he retained them in later works made after he had developed a greater command of his medium.

Provenance: J. C. Robinson, London; Cook Collection, Doughty House, Richmond (Surrey); Samuel H. Kress Collection.
Bibliography: J. C. Robinson, *Memoranda on Fifty Pictures* (London, 1868), no. 28; Cossío (1908), pp. 76–81, no. 349, fig. 7 bis; Grafton Galleries, *Exhibition of Spanish Old Masters* (London, 1913–1914), no. 116, p. LV; Justi (1914), p. 253; M. W. Brockwell, *Catalogue of the Paintings at Doughty House* (1915), no. 495; Waterhouse (1930), p. 70, no. 5, fig. 4; Mayer (1931), no. 49, pl. III; Legendre and Hartmann (1937), p. 158; Goldscheider (1938), fig. 5; Bourgeoise (1940), pp. 81–82; José Gudiol, "El Greco Works in the Minneapolis Institute of Arts," *Bulletin of the Minneapolis Institute of Arts* 30, no. 23 (7 June 1941): 110; Enriqueta Harris, *El Greco: The "Purification of the Temple" in the National Gallery, London,* The Gallery Books, no. 2 (London, 1943), p. 7, fig. 3; Gómez Moreno (1943), pp. 21, 50; López-Rey (1943), pp. 75–76, fig. 1; Camón Aznar (1950), pp. 62–66, no. 8, fig. 40; MacLaren (1952), p. 13; Lafuente Ferrari (1953), p. 205; Rodolfo Palluchini, "La periode italienne du Greco," in Bordeaux, Beaux-Arts (1953), pp. 21, 23; Wittkower (1957), p. 54, fig. on p. 48; Gaya Nuño (1958), no. 1193; Trapier (1958b), pp. 75–76, 85; Kubler and Soria (1959), p. 211; Washington, National Gallery (1959), p. 268, no. 1482; Wethey (1962), vol. 1, pp. 21–23, 28, 53, 59, figs. 3, 386; ibid., vol. 2, no. 104; Washington, National Gallery (1965), p. 62, no. 1482; Salas (1967a), p. 25; Manzini and Frati (1969), no. 10a; MacLaren (1970), pp. 24–27; Camón Aznar (1970), pp. 80–84, 133, no. 86, fig. 46; Cossío (1972), no. 44; Lafuente Ferrari and Pita Andrade (1972), pp. 22–23,

93; Gudiol (1973), pp. 15, 21–22, no. 30, figs. 9–11; Walker (1974), pp. 234–235, no. 306; Washington, National Gallery (1975), pp. 162–163, no. 1482; Davies (1976), pp. 6, 12, pl. 2.

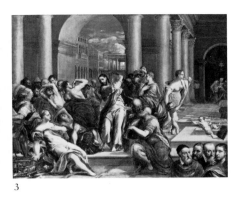

3

3 (plates 14, 15)

Purification of the Temple

Oil on canvas, 118.4 x 150.8 cm. (46⅝ x 59⅜ inches)
Signed on the steps at left center in Greek capitals: DOMÉNIKOS THEOTOKÓPOULOS KRÈS E'POÍEI
Circa 1570–1575
Minneapolis, The Minneapolis Institute of Arts. The William Hood Dunwoody Fund

This version of the Purification of the Temple is the most important work to survive from El Greco's years in Rome. The stiff, posed appearance of the figures in the Washington picture (cat. no. 2; pl. 12) and its labored surface are gone. The sense of space is much more lucid, the result of suppression of architectural details and elimination of still-life elements. The crowd of overlapping figures that seems frozen in the Washington picture is full of movement in the Minneapolis version. The figure of Christ stands out much more prominently as the crowd recoils energetically in the wake of his fury.

It is partly the quality of light that distinguishes this version from the earlier one. The function of light and shade to model individual forms as well as to define pictorial space is vastly more developed in the Minneapolis painting. Also seen here for the first time are certain "refinements" of form (for example, in the seated female figure at the left) that will become the artist's recognizable mannerisms in the future. El Greco's mastery of Venetian brushwork is also evident: note the virtuoso indications of shadow in the draperies and the dry-brushed contours of limbs that resonate with echoes of the creative gesture. Such qualities later characterized his early Spanish masterpieces.

The most striking feature of the Minneapolis Purification is the group of four portrait heads in the right foreground (they are painted on a separate piece of canvas adhered to the larger one). In typical Mannerist fashion, these figures

seem to be standing on a lower level and have no narrative relation to the rest of the composition. The identity of most of them has long been established. At the left is the painter Titian; beside him is Michelangelo; next is Giulio Clovio, looking much as he does in El Greco's portrait of him (cat. no. 57; pl. 13); the identity of the fourth figure has been the subject of much debate and has not been established beyond all doubt. Since the eighteenth century, the figure has been widely thought to be Raphael. Wethey and MacLaren, like Jonathan Brown (in chapter 2), both still believe it is. Around the turn of this century, Justi and Sanpere each called it a self-portrait of El Greco. Justi later abandoned this claim for the earlier identification, but Wind made a full case for identifying the likeness as El Greco. The hair style, however, has led most writers, starting with Cossío, to support a fifteenth-century candidate. Willumsen has been variously reported as identifying the fourth portrait as Marcantonio Raimondi (by Wethey, vol. 2, p. 69), Domenico Ghirlandaio (by Waterhouse [1930], p. 76n), and Giulio Romano (Manzini and Frati, p. 93). Gudiol (1973) mentioned unnamed authors as having suggested Sebastiano del Piombo. And Salas (1967b) puts forward the case for Correggio, noting El Greco's great admiration for that master as revealed in his autograph marginalia in a copy of Vasari's Lives of the Painters.

Whatever the identity of the fourth figure, the presence of this group in El Greco's work is clearly a gesture of homage to the men he considered to be the giants of the Renaissance. It is probably no accident that this gesture occurred in the artist's finest and most mature painting to date.

Provenance: G. Villiers, Duke of Buckingham (1758); Lord Yarborough; Steinmeyer, Lucerne; Henry Reinhardt & Co., New York; purchased by the Minneapolis Institute of Arts in 1924.
Bibliography: A Catalogue of the Curious Collection of G. Villiers, Duke of Buckingham (London, 1758), p. 3; G. F. Waagen, Treasures of Art in Great Britain (London, 1854–1857), vol. 2, p. 87; ibid., vol. 4, p. 70 (misidentified as the work of Veronese); Salvador Sanpere y Miguel, "El Greco," Hispania 71 (30 Jan. 1902): fig. on p. 39; idem, Hispania (1906): 28–29; Cossío (1908), pp. 29–35, 76–81, no. 348, fig. 7; W. B. Brockwell, Spanish Old Masters (London, 1913), p. 118; Justi (1914), pp. 249–253; "An Early El Greco: First Purchase of the Year," Bulletin of the Minneapolis Institute of Arts 13, no. 2 (Feb. 1924): 10–12; J. F. Willumsen, La jeunesse du peintre El Greco (Paris, 1927), vol. 2, pp. 413, 427, pl. LX; Waterhouse (1930), pp. 76–77, no. 14, figs. 15–17; Mayer (1931), no. 50, pl. IV; Legendre and Hartmann (1937), pp. 19, 159; Goldscheider (1938), figs. 7, 8; Edgar Wind, "A Self-Portrait of Greco," Journal of the Warburg and Courtauld Institutes 3 (1939–1940): 141–142; Bourgeoise (1940), p. 84; José Gudiol, Spanish Painting (Toledo Museum of Art, 1941), pp. 61–62, fig. 35; idem, "El Greco Works in the Minneapolis Institute of Arts," Bulletin of the Minneapolis Institute of Arts 30, no. 23 (7 June 1941): 110–115, figs. on pp. 111–113; M. Knoedler & Co., El Greco, Loan Exhibition for the Benefit of the Greek War Relief Association (New York, 1941), no. 1; José López-Rey (1943), pp. 76–77,

fig. 2; Gómez Moreno (1943), pp. 21–22, 50, pl. V; M. H. de Young Memorial Museum, El Greco (San Francisco, 1947), no. 1; Camón Aznar (1950), pp. 113–118, no. 84, figs. 63, 64; MacLaren (1952), p. 13; Rodolfo Palluchini, "La periode italienne du Greco," in Bordeaux, Beaux-Arts (1953), p. 24; Lafuente Ferrari (1953), p. 205; Guinard (1956), pp. 14, 53, ills. on pp. 53–54; Wittkower (1957), p. 54, ill. on p. 49; Soehner (1957), p. 184; Gaya Nuño (1958), no. 1194; Trapier (1958b), pp. 83–85, fig. 11; Soria and Kubler (1959), p. 211; Wethey (1962), vol. 1, pp. 21–22, 25, 28, 53, figs. 11, 30, 387; ibid., vol. 2, no. 105; Rosenthal (1963), pp. 385–387; L. Fehrle-Burger, "Michelangelo in Venedig," Ruperto-Carola 38 (1965): 117–118, fig. 15; Salas (1967a), pp. 25–28; idem (1967b), pp. 179–180; Committee to Rescue Italian Art, The Italian Heritage (Providence, 1967), no. 43; Manzini and Frati (1969), no. 10b; MacLaren (1970), pp. 24–27; Minneapolis Institute of Arts, European Paintings from the Minneapolis Institute of Arts (New York, 1971), no. 268; Cossío (1972), no. 45; Waterhouse (1972), p. 114; Lafuente Ferrari and Pita Andrade (1972), pp. 22–24, 93, fig. 4; Gudiol (1973), pp. 22–27, 333, no. 14, figs. 12–14; Davies (1976), pp. 6, 12, pl. 13; Alfonso E. Pérez Sánchez, "Presencia de Tiziano en la España del Siglo de Oro," Goya, no. 135 (Nov.–Dec. 1976): 149, figs. 6, 7.

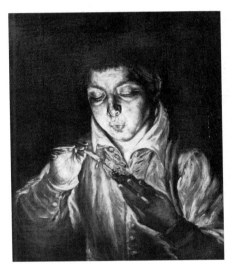

4

4 (plate 30)

Boy Lighting a Candle (Boy Blowing on an Ember)

Oil on canvas, 61.0 x 50.8 cm. (24 x 20 inches)
Signed over the right shoulder in Greek capitals: DOMÉNIKOS THEO [rest is defaced]
Circa 1570–1575
New York, Charles S. Payson Collection

The several versions and copies of this painting are so typically Venetian in style that a number of Italian critics over the years have insisted that the author was Jacopo Bassano rather than El Greco. The fragmentary but perfectly genuine and characteristic signature on the present version, however, as well as documentation that authenticates the Naples version (fig. 37) as the work by El Greco that was in the Farnese Palace in 1662, establishes the fact of his authorship

227

beyond any doubt. Even those writers who have acknowledged El Greco as the painter have traditionally viewed the composition from the standpoint of how its dramatic light effects resemble those pioneered in multifigure compositions by Bassano in Venice. But El Greco himself seems to have been the originator of this single-figure, half-length tour de force of light and shadow. A painterly interest in dramatic light effects, however, does not sufficiently explain the novelty of the painting.

About fifteen years ago, Bialostocki convincingly demonstrated the antique origin of the subject (see *ekphrasis* discussion in chapter 2). The painting is based on a famous lost masterpiece of antiquity—the *Boy Blowing on a Fire* by Antiphilus of Alexandria, a contemporary and rival of Apelles. Pliny the Elder describes the painting (in *Natural History* 35.138): "Antiphilus is praised for his picture of a boy blowing on a fire, and for the reflection cast by the fire on the room, which is in itself beautiful, and on the boy's face." El Greco has extracted the boy from the environment of the room mentioned by Pliny and has thus heightened the visual impact of the glowing ember, the sole source of illumination in the composition. Such an evocation of a lost work of antiquity no doubt gave pleasure to the literati in the sophisticated circle of Fulvio Orsini, librarian in the Farnese Palace, where El Greco lived after his arrival in Rome and where one version of the painting remained for several decades. (See also cat. no. 5; pl. 31.)

Provenance: Private collection, Germany; Dr. A. C. von Frey, Paris and Vienna; G. Caspari, Munich.
Bibliography: Mayer (1926), no. 309; Waterhouse (1930), no. 20; Legendre and Hartmann (1937), p. 471; Camón Aznar (1950), p. 69, no. 681, fig. 43; Gaya Nuño (1958), no. 1187; Wethey (1962), vol. 1, p. 25, fig. 21; ibid., vol. 2, no. 121; Bialostocki (1966); Manzini and Frati (1969), no. 17a; Camón Aznar (1970), pp. 86–87, no. 669, fig. 50; Cossío (1972), no. 397; Gudiol (1973), pp. 35–36, no. 23, fig. 30.

5 (plate 31)
Fable

Oil on canvas, 49.8 x 64.1 cm. (19⅝ x 25¼ inches)
Circa 1570–1575
New York, Stanley Moss Collection

This painting is obviously an elaboration of the *Boy Lighting a Candle* (cat. no. 4; pl. 30), but its exact meaning has eluded complete understanding. A nineteenth-century tradition popularized by Cossío held that the central figure is female rather than male, and that the composition illustrates the Spanish proverb "Man is fire; woman is tow; and the devil blows them into flame." The ape at left was seen as the devil, of course, but the theory overlooked that both the ape and the central figure are blowing on the

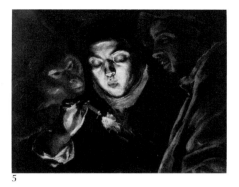

5

ember. Furthermore, judging by its style, this particular version of the composition appears to have been painted in Rome, which would make a purely Spanish iconography unlikely. Now that the true meaning of *Boy Lighting a Candle* is known, it does not seem likely that the artist interpolated the same image into a new context without retaining its meaning. The two additional figures therefore probably expand the antiquarian associations of Antiphilus's lost painting (see chapter 2, page 83). Schulz has pointed out that the ape is a symbol of Vulcan and of fire; he is also the symbol of art according to the dictum *ars simia naturae*. The man at the right is a kind of simpleton gazing in complete fascination at the glowing coal and small candle held by the boy. He, too, no doubt has some more-specific allusion. In any case, El Greco's painting uses an exemplary image of antique naturalism to comment upon art as the ape of nature.

The present painting has been cut down somewhat, especially at the right and top. The artist painted two other versions after moving to Spain. The 1611 inventory of the estate of Juan de Ribera, archbishop of Valencia, included a composition described as "two figures of men and a monkey who are lighting or blowing on a firebrand." Wethey believed that the entry may refer to this painting. The traditional title, *Fable*, derives from an entry in the 1621 inventory of El Greco's estate; it is not certain, however, that the entry refers to the present painting.

Provenance: Anonymous sale, Robinson, Fisher & Harding, London (10 Mar. 1927); Agnew, London; Colnaghi, London; Adolf Pagenstecher, Wiesbaden (1930–1957); V. von Watsdorf, Rio de Janeiro.
Bibliography: August Mayer, "Zu El Greco," *Pantheon*, Feb. 1928, p. 95, no. 49; Waterhouse (1930), pp. 80–81, no. 21; Mayer (1931), fig. 23; Legendre and Hartmann (1937), no. 474 (wrong photograph and dimensions); Camón Aznar (1950), p. 147, no. 673, fig. 83; Robres Lluch, "El Beato Ribera y El Greco," *Archivo Español de Arte*, no. 107 (July–Sept. 1954): 254; Wethey (1962), vol. 1, p. 26; fig. 25; ibid., vol. 2, no. 124; Juergen Schulz, "Letter: Bassano's and El Greco's 'Boy Blowing on a Fire,'" *The Burlington Magazine*, Aug. 1968, p. 466; Wolfgang Stechow, "Letter: Bassano's and El Greco's 'Boy Blowing on a Fire,'" *The Burlington Magazine*, Nov. 1968, p. 633; Manzini and Frati (1969), no. 19a; Camón Aznar (1970), pp. 142–143, 147, no. 673, fig. 83; Gudiol (1973) p. 36, no. 24, fig. 31.

6 (plate 32)
Annunciation

Oil on canvas, 117 x 98 cm. (46⅛ x 38⅝ inches)
Circa 1575–1576
Lugano, Thyssen-Bornemisza Collection

The early Thyssen *Annunciation* represented a major stride for El Greco in the mastery of Venetian pictorial style, an advance comparable to that seen in the Minneapolis *Purification* (cat. no. 3; pls. 14, 15). The use of architecture to create a sense of space has been elegantly simplified to a pattern of subtly colored floor tiles in gray, white, and salmon. A rather indistinct balustrade blocks the eye's recession in the background and focuses attention on the two main figures. The rose-colored drapery behind the Virgin's head and shoulders serves to give extra relief to her form and to thrust it forward in space. This emphasis heightens the effect of her expression of surprise as she turns to face Gabriel, who greets her, languidly floating on a cloud that casts its shadow on the tile floor. The figure of the archangel, with its beautifully classicized drapery and marvelous, heavy wings, looms above the balustrade and is silhouetted against the clouded sky. From a burst of gold at his fingertips and underneath the loosely sketched putti, the white dove of the Holy Spirit descends upon the Annunciate.

Few comparisons could reveal so dramatically El Greco's tremendous growth in the 1570s as that between the *Annunciations* in the Prado (cat. no. 1; pl. 29) and the Muñoz Collection (fig. 108, p. 226), on the one hand, and this later one. The Thyssen picture has sometimes been considered a mere development of the idea in the Prado sketch, but both earlier paintings seem like student works in comparison to the sophistication and maturity of this one.

Provenance: Prince Corsini, Florence; Luigi Grassi, Florence; Sully, London (1927); Trotti

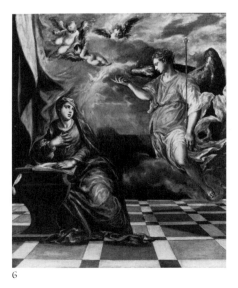

6

et Cie, Paris; Knoedler & Co., New York (1929); Count Alessandro Contini-Bonacossi Collection, Florence.

Bibliography: Mayer (1926), no. 30aa; L. Venturi, "Una nuova annunziazióne del Greco," *L'Arte* 30 (1927): 252–255; Roberto Longhi and August L. Mayer, *The Old Spanish Masters from the Contini-Bonacossi Collection* (Rome, 1930), no. 34, pl. XXV; Wilhelm R. Valentiner, *Das Unbekannte Meisterwerke in Offentlichen und Privaten Sammlungen* (Berlin, 1930), p. 84; Waterhouse (1930), p. 79, no. 18; G. Fiocco, *Enciclopedia italiana* (Milan, 1933), vol. 17, p. 919; Legendre and Hartmann (1937), p. 99; Paris, *Gazette des Beaux-Arts* exhibition (1937), no. 12; Camón Aznar (1950), p. 66, no. 22, fig. 41; Soria (1954), p. 220, no. 56; Wethey (1962), vol. 1, pp. 23–24, fig. 17; ibid., vol. 2, no. 37; Manzini and Frati (1969), fig. 15c; Camón Aznar (1970), pp. 84–86, no. 22, fig. 48; Gudiol (1973), pp. 34–35, no. 19, figs. 26, 27; Allen Rosenbaum, *Old Master Paintings from the Collection of Baron Thyssen-Bornemisza* (Washington, D.C., 1979), pp. 148–149, no. 54, fig. 54; idem, "The Thyssen-Bornemisza Old Masters," *The Connoisseur* 202 (Nov. 1979): 186.

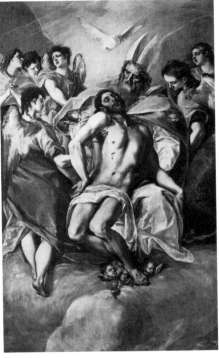

7

7 (plate 23)

Trinity

Oil on canvas, 300 x 178 cm. (118 1/8 x 70 1/8 inches)
1577–1579
Madrid, Museo del Prado

The *Trinity* was the uppermost component of the great altarpiece of Santo Domingo el Antiguo (fig. 74), which had brought El Greco to Toledo in 1577 and which was finished by September of 1579. The church of the Bernardine convent of Santo Domingo was built and decorated according to the will of Doña María de Silva, a former lady-in-waiting to the Empress Isabella, wife of Charles V, who had spent her later years as a nun in the convent. Doña María had appointed as her executor Diego de Castilla, dean of the cathedral chapter, who surely also obtained for El Greco the commission for the *Disrobing of Christ*. (For a more detailed discussion of the altarpiece, see chapters 2 and 3.)

El Greco's composition is similar in the most general way to Dürer's woodcut of 1511 (fig. 57), but his monumental conception of the figure of Christ reveals the profound impact made on him by the works of Michelangelo in Rome. The play of light and shadow on the robust musculature of Christ's body defines its sheer weight as it lies upon the lap of God the Father. The palpable form of the body and the wounds emphasize the humanity of Christ, and the anguished expressions of the angels underscore the pathos of his sacrifice. Thus, the abstract concept of a triune God has been humanized by this emphasis on God Incarnate.

Provenance: High altar, Santo Domingo el Antiguo, Toledo; Valeriano Salvatierra; Ferdinand VII (purchased in 1832).

Bibliography: Cossío (1908), p. 560, no. 57; Mayer (1926), p. 18, no. 108; Legendre and Hartmann (1937), p. 234; Goldscheider (1949), figs. 10, 11; Camón Aznar (1950), pp. 43, 254–266, no. 4, figs. 145–150, 152; Trapier (1958a), pp. 7, 8; Soehner (1958–1959), p. 177, no. 8; Wethey (1962), vol. 1, pp. 35, 54, fig. 50; ibid., vol. 2, no. 2; Manzini and Frati (1969), p. 95, no. 23a; Camón Aznar (1970), pp. 52, 126–127, 279–293, no. 4, figs. 168–175, pl. facing p. 168; Cossío (1972), no. 135; Lafuente Ferrari and Pita Andrade (1972), p. 155, no. 2; Madrid, Prado (1972), no. 824; Gudiol (1973), pp. 68, 342, no. 42.

8 (plate 33)

Veronica's Veil

Oil on panel, oval, 76 x 55 cm. (29 7/8 x 21 5/8 inches)
1577–1579
Madrid, private collection

This image of Veronica's veil painted on a wooden panel was originally part of the main altarpiece of Santo Domingo el Antiguo (fig. 74), occupying the center of the broken pediment over the first story. (See chapters 2 and 3 for discussions of the complete altarpiece.) As Wethey has noted, there is no reference to such an image in the abundant documentation of the commission. Instead, the documents call for an escutcheon to be carved by Juan Bautista Monegro, which Wethey assumed was probably intended to be the coat of arms of Doña María de Silva, patron of the convent. Apparently the change to a painted image of the Holy Face took place during the construction; it was placed in a gilded cartouche held by two youths sculpted by Monegro after designs by El Greco.

As Cossío pointed out, the image of Veronica's veil held by two angels had been used by Dürer in a well-known engraving of 1513. El Greco was surely familiar with this work, though his own version of it is firmly rooted in sixteenth-century Italian decorative style.

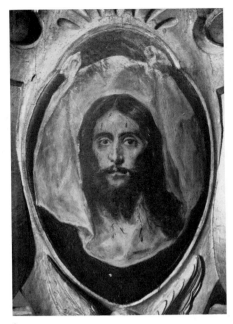

8

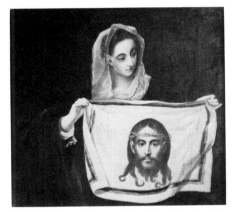

Figure 109. El Greco. *Saint Veronica*, 41 x 43 inches, circa 1577–1578 (Madrid, María Luisa Caturla Collection)

The source of the belief in Veronica's veil is the apocryphal Gospel of Nicodemus. According to the legend, which was often dramatized in medieval mystery plays, the "sudarium" that Veronica used to wipe sweat from the face of Jesus on the way to Calvary miraculously retained his image and was endowed by the Lord with curative power for all those who looked upon it. (In another well-known composition painted around this time, El Greco shows Veronica herself holding the veil [fig. 109].) The placement of the veil in such a prominent place — at the geometric center of the altarpiece — affords it an overriding importance in the overall iconography of the ensemble. If it was an afterthought, it was for the purpose of clarifying the lesson of the whole.

El Greco's highly original and illusionistic treatment of the veil as a real article encased and held by sculpted figures gives it the appearance of a relic. This interaction between the framing device and the image itself somehow sets it apart from the other images in the altar-

piece. Veronica's veil was indeed seen as the archetypal image of Christ. By embedding it as the center of the altarpiece, this presentation underscores the miraculous and symbolic nature of the image of Christ and thus relates the main altar to the two side altars, in which the body of Christ is depicted in the *Adoration of the Shepherds* (the Incarnation) and the *Resurrection.*

Provenance: High altar, Santo Domingo el Antiguo, Toledo; Juan March Servera, Madrid (1964).

Bibliography: Cossío (1908), no. 231; Mayer (1926), no. 68; Camón Aznar (1950), pp. 268, 272, no. 9, fig. 162; Guinard (1956), p. 44; Soehner (1957), p. 132; Trapier (1958a), p. 7, fig. 5; Soehner (1958–1959), no. 11; Wethey (1962), vol. 1, p. 67, fig. 70; ibid., vol. 2, p. 7, no. 6A; Sánchez Cantón (1963), p. 32; Manzini and Frati (1969), no. 23b; Camón Aznar (1970), pp. 295, 299, no. 9, fig. 188; Lafuente Ferrari and Pita Andrade (1972), p. 38, no. 7; Gudiol (1973), p. 77, no. 46, fig. 62.

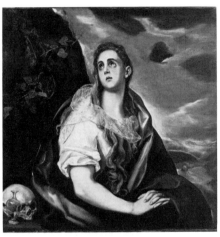

9

9 (plate 34)

Mary Magdalen in Penitence

Oil on canvas, 108.0 x 101.3 cm. (42½ x 39⅞ inches)
Signed at left in Greek capitals:
CHEÏR DOMÉNIKOU
Circa 1577
Worcester (Massachusetts), Worcester Art Museum

The Penitent Magdalen was a subject El Greco returned to again and again, creating, according to Wethey, five different types, the earliest painted very soon after his arrival in Spain, and the latest near the end of his life. The emphasis placed during the Counter-Reformation upon the confession of sin gave special significance to such subjects. The Magdalen, as a repentant prostitute, presented an artist with the challenge of painting a female form that was both voluptuous and expressive of contrition and ardent new faith. Probably no artist ever met that challenge more grandly than the elderly Titian in the enormously moving picture that is now in the Hermitage; it was still in Titian's studio during El Greco's stay at Venice, and a now-lost

version was sent to Philip II in August of 1561. El Greco follows Titian's general compositional formula with the half-length figure posed out-of-doors against a rocky background sprouting with vegetation on one side and an expansive landscape on the other. The jar of oil, the skull, and an open book are the Magdalen's attributes in Titian's painting and are used in different combinations by El Greco. The general similarities stop there, however, for the older artist's naturalism has been replaced by El Greco's mannered elegance.

This painting is clearly the earliest version of the Magdalen by El Greco: it is signed "by the hand of Dominico" in Greek capitals, as are some works from the Italian period. The pose of the figure is the same as in the Kansas City version (cat. no. 14; pl. 20), but this is a more monumental composition. The sharp contour line of the Magdalen's drapery along her left arm and shoulder and the clear silhouette of her head against the light blue sky give the figure a great calm and solidity.

Provenance: Colegio de los Ingleses, Valladolid; R. Langdon Douglas, London; purchased by the Worcester Art Museum in 1922.

Bibliography: Cossío (1908), p. 593, no. 275; "The Magdalene," *Bulletin of the Worcester Art Museum* 13, no. 1 (Apr. 1922): 11–12; Tancred Borenius, "Two El Greco's: . . . 'The Magdalene,'" *The Burlington Magazine* 40, no. 230 (May 1922): 208; F. Ingersoll-Smouse, in *Revue de l'Art* 11 (1922): 232–234; Mayer (1926), p. 47, no. 293a; Legendre and Hartmann (1937), p. 453; Paris, *Gazette des Beaux-Arts* exhibition (1937), no. 18; M. Knoedler & Co., *El Greco,* Loan Exhibition for the Benefit of the Greek War Relief Association (New York, 1941), no. 2; Camón Aznar (1950), p. 399, no. 451, fig. 281; Soehner (1957), p. 154; Wethey (1962), vol. 1, figs. 304, 392; ibid., vol. 2, no. 259; Manzini and Frati (1969), p. 94, no. 20a; Camón Aznar (1970), p. 422, no. 459, fig. 315; Cossío (1972), no. 325; Gudiol (1973), p. 62, no. 33.

10 (plate 25)

Saint Sebastian

Oil on canvas, 191 x 152 cm. (75¼ x 59⅞ inches)
Signed on rock at lower right in Greek capitals: DOMÉNIKOS THEOTOKOPOULOS E'POÏEI
Circa 1577–1578
Palencia, Cathedral Sacristy

This large canvas, one of the best preserved El Grecos in existence, must have been among his earliest works painted in Toledo. According to Wethey, the painting was probably given to the Palencia cathedral by the artist's first Spanish patron, Diego de Castilla, who had been priest, canon, and dean of the cathedral chapter of Palencia early in his career before officially becoming dean of the Toledo cathedral chapter in 1551.

It has often been noted that the composition is extremely similar to the *Saint Sebastian* by Tintoretto in the Scuola di San Rocco in Venice. Tintoretto's painting was not begun until 1576, however,

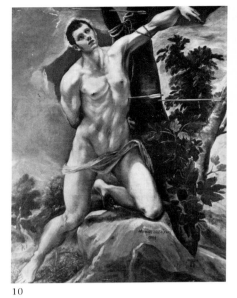

10

when El Greco is believed to have been in Rome. How El Greco could have known the Tintoretto or a study for it has been the subject of speculation. Both pictures, however, apparently owe something to Michelangelo's figure of Adam in the Sistine Chapel. Indeed, the great plasticity of El Greco's figure, its monumentality and heroic scale, owe much to Michelangelo, while the landscape is certainly reminiscent of Veronese and contemporary Venetian painting in general. The considerable elongation of the body in relation to the head of Saint Sebastian is a perfect example of the Mannerist concept of *grazia;* El Greco made special note of a passage on Michelangelo's elongation of figures in his personal copy of Vasari's *Lives of the Painters* (see chapter 2, page 131).

Sebastian was an officer in the army of Emperor Diocletian in the third century; he was also a member of the early Christian community and openly refused to sacrifice to the gods. When the emperor found him out, he had him tied to a stake and shot full of arrows. The Counter-Reformation theologian Johannes Molanus (1533–1585) wrote of Sebastian that "as the sores of every sick person call out for our compassion, so the many wounds and arrows of Sebastian call out to God for mercy on our behalf" (S. and R. Bernen, *Myth and Religion in European Painting: 1270–1700* [New York, 1973], pp. 240–241).

El Greco returned to the subject of Saint Sebastian later in his career. The example catalogued here as number 36 (pl. 51) shows the remarkable transformation of the artist's style by about 1600.

Bibliography: Cossío (1908), no. 158; Mayer (1926), no. 300; Legendre and Hartmann (1937), p. 470; E. Tietze-Conrat, "Decorative Paintings of the Venetian Renaissance Reconstructed from Drawings," *Art Quarterly,* winter 1940, p. 38, no. 17; Gómez Moreno (1943), p. 66, pl. XIII; Goldscheider (1949), fig. 40; Camón Aznar (1950), p. 393, no. 535, figs. 275–277; Bertina Suida Manning, "El Greco y el arte italiano," *Archivo Español de Arte* 24, no. 95 (July–Sept. 1951): 207, pl. VI; Guinard

(1956), pp. 50–51; Soehner (1957), pp. 124, 127; Trapier (1958*a*), p. 15, fig. 20; Soehner (1958–1959), no. 18; Wethey (1962), vol. 1, pp. 35, 38–39, 53, 55, figs. 72, 73, 146, 390; ibid., vol. 2, no. 279; Sánchez Cantón (1963), p. 24, pl. VI; Manzini and Frati (1969), no. 26; Camón Aznar (1970), p. 415, no. 534, figs. 309–311; Cossío (1972), no. 314; Lafuente Ferrari and Pita Andrade (1972), pp. 116–117, no. 11; Gudiol (1973), pp. 48–53, no. 30, fig. 40.

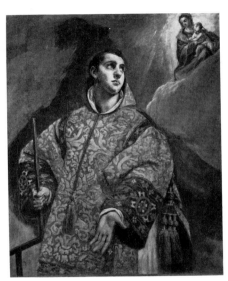

11

11 (plate 8)

Saint Lawrence's Vision of the Virgin

Oil on canvas, 119 x 102 cm. (46⅞ x 40⅛ inches)
Circa 1578–1580
Monforte de Lemos (Lugo), Colegio del Cardinal–Padres Escolapios

This monumental half-length image of Saint Lawrence is similar in style to the *Saint Sebastian* in Palencia (cat. no. 10; pl. 25) and to the paintings of Santo Domingo el Antiguo (for example, cat. no. 7; pl. 23), which means that it was certainly painted before 1580, during El Greco's early years in Toledo. The face and hands have the ruddy flesh-tones reminiscent of Venetian paintings. The golden-and-red-brocade dalmatic, painted with great detail as well as large, simple volumes, combines with the boldly modeled head to give the figure a very sculptural presence. The painting includes one of the first instances of a device that was to become a standard one of El Greco's: the silhouetting of the figure against a patchy sky.

In his right hand Saint Lawrence holds the symbol of his martyrdom, the iron grate upon which he was grilled alive. With his left hand, he seems to gesture toward the unseen foreground at his feet —surely a reference to his martyrdom. He looks upward toward the viewer's right with a supremely peaceful expression. His eyes seem to be concentrating on an inner vision, expressed in visual terms by the small figures of the Virgin and Child on a cloud at the upper right.

Saint Lawrence is the patron saint of the Escorial, the vast enterprise of Philip II that El Greco was still hoping to provide paintings for at this date. According to Wethey, the present work seems to have been acquired early by Rodrigo de Castro, for in 1600 he bequeathed it to the seminary he founded; it has remained there ever since. Castro, who became inquisitor of the Supreme Tribunal in Toledo in 1559, later was bishop of Zamora (1573–1578) and of Cuenca (1578–1581). While bishop of Cuenca, he became acquainted with Luis de Castilla, who was then serving as canon of the Cuenca cathedral; Castilla, who had known El Greco since they spent time together in Rome, was probably the contact who led to Castro's acquiring this painting.

Provenance: Bishop Rodrigo de Castro.
Bibliography: Murguía, *Galicia, España, sus monumentos* (Barcelona, 1868), pp. 1044, 1053; Mayer (1926), p. 46, no. 291; Gómez Moreno (1943), p. 24; Soehner (1957), p. 132; idem (1958–1959), p. 179, no. 17; Wethey (1962), vol. 1, p. 39, fig. 282; ibid., vol. 2, p. 136, no. 255; Manzini and Frati (1969), p. 98, no. 35; Camón Aznar (1970), pp. 260, 1367, no. 520; Cossío (1972), no. 279; Lafuente Ferrari and Pita Andrade (1972), p. 156, no. 12; Gudiol (1973), pp. 59–60, 342, no. 40.

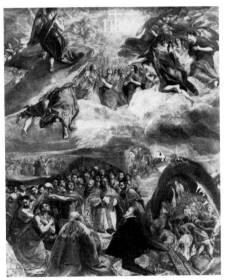

12

12 (plate 11)

Allegory of the Holy League (Adoration of the Holy Name of Jesus)

Oil on canvas, 140 x 110 cm. (55⅛ x 43¼ inches)
Signed on the rock at lower left corner in cursive Greek: *doménikos theotokópoulos krès e'poíei*
1577–1579
El Escorial

Padre Francisco de los Santos, in 1657, was the first to write about this important painting, and he told a good deal about its iconography. Los Santos re-

ferred to the picture as the "*Gloria* of El Greco," thus acknowledging its obvious parallel with Titian's great painting then called *Gloria of Charles V,* which was also at the Escorial. He noted that in the lower part were Hell and Purgatory and the Church Militant, including a likeness of King Philip II; in the upper part he described an Adoration of the Holy Name of Jesus, citing the biblical source as Saint Paul's Letter to the Philippians (2:9–10): "Wherefore God also hath highly exalted him, and given him a name which is above every name: That at the name of Jesus every knee should bow, of things in heaven, and things in earth, and things under the earth."

Anthony Blunt studied the painting in detail in 1939–1940, arriving at the larger interpretation of the picture that is generally held today. In addition to its representing the Adoration of the Holy Name of Jesus, he saw the painting as an allegory of the Holy League (as William Stirling-Maxwell had done before him, according to Blunt). The Holy League was the military alliance between Spain, Venice, and the Vatican that in 1571 resulted in the decisive naval victory over the Turks at the Battle of Lepanto in the Mediterranean. The three principals of this alliance are depicted kneeling in the foreground of the composition—Philip II, dressed in black; Doge Mocenigo of Venice, dressed in an ermine-trimmed robe; and Pope Pius V, wearing red gloves and a blue-lined robe. Blunt, and subsequently others, argued at length the identities of the other figures in the foreground, but most of them are so idealized as to make it impossible to prove one hypothesis or another. Most probably, however, the figure with his hands on a sword is an idealized representation of Philip's half-brother Don John of Austria, commander of the allied fleet at Lepanto, who had died in Flanders in 1578. Blunt proposed that Philip II commissioned the painting as a commemoration of Don John, whose body was brought to the Escorial for burial in 1579. When Padre de los Santos described the picture in 1657, it was hanging in the Escorial's Chapel of the Pantheon of the Kings, the burial place of Spanish royalty, near the vaults of the infantes where Don John is buried.

Blunt's article traces the history of the theme of the Adoration of the Holy Name and studies medieval representations of Hell (a monster with gaping jaws) and Purgatory (a bridge between life and death) in order to locate general and specific sources for El Greco's iconography. The closest visual parallel to El Greco's depiction of Hell and Purgatory, however, was published by Braham in 1966: the *Last Judgment* by Giovanni Battista Fontana, who had been in Venice at the same time as El Greco. Fontana's engraving, which has an almost identical monster and bridge at the lower right, was issued no earlier than 1578, at almost the same time that El

Greco must have been working on his own picture in Spain. The similarity is so great in general and in certain particulars, though, that if El Greco did not know Fontana's image, both artists must have depended on a common source.

The marquis of Lozoya made the novel suggestion that the painting may have been a model for a vast project in the Escorial on the scale of Michelangelo's Vatican frescoes. The overtones of a Last Judgment certainly call to mind Giulio Mancini's 1614 report of El Greco's outspoken criticism of Michelangelo's fresco and of his willingness to repaint it. There are no grounds for taking Lozoya's suggestion seriously, however. Indeed, nothing certain is known about the origin of this painting. It is not known if it was commissioned by Philip II or presented to him; nor is it known if it was painted in Toledo or during a stopover in Madrid on the way to Toledo, as has been proposed by Lafuente (1972). It was El Greco's first opportunity to impress the king—and that had been one of his prime objectives in coming to Spain. The king was evidently not displeased, for he shortly afterward commissioned the artist to paint the *Martyrdom of Saint Maurice* (pl. 2).

Most of the literature has dealt with the meaning or with the compositional sources of the painting. As a picture, it is a dense and marvelous work that transcends the few awkwardnesses it contains. The Leviathan fairly shrieks as he lurches from his fiery sea to engorge the sinners falling from the bridge. In the lower left quadrant, a long shadow (according to Blunt, the "Shadow of the Almighty" or the "Shadow of Death") passes across the huddled mass awaiting Judgment, separating those in the foreground from those in the background. Among the latter, the rose-clad figure with upstretched arms—which Wethey observed anticipates the main figure in El Greco's late work the *Fifth Seal of the Apocalypse* (pl. 28)—can be seen as the dramatic fulcrum of the entire composition. His gesture of striving for salvation unites the upper and lower parts of the picture, and his small scale helps to establish the enormity of the space and the operatic dimensions of the event.

Bibliography: Francisco de los Santos, "Descripción breve del monasterio de S. Lorenzo el Real del Escorial" (Madrid, 1657), in Sánchez Cantón (1933), vol. 2, pp. 287–288; Palomino (1715–1724; ed. 1947), p. 841; Ponz (1772–1794), vol. 2, *carta* II, 77; Ceán Bermúdez (1800), vol. 5, p. 12; D. Vicente Poleró y Toledo, *Catálogo de los cuadros del real monasterio de San Lorenzo* (Madrid, 1857), p. 39; Carl Justi, "El Greco in Toledo," *Estudios de Arte Español* 2 (1914): 274–275; Cossío (1908), no. 45; Beruete (1914), pp. 24–25; Mélida (1915), p. 102, fig. following p. 102; Byron and Rice (1930), pp. 191–192, pl. 73; D. Sánchez de Rivera, "Nuestra visión de los Grecos de El Escorial," *Arte Español* 10 (1930–1931): 45–46; Mayer (1931), no. 123, pls. XIII, XIV; Legendre and Hartmann (1937), p. 93; Zervos (1939), pp. 61–62, figs. on pp. 63–68; Blunt (1939–1940); Bourgeoise (1940), pp. 88–89; August L. Mayer, "Notas sobre la iconografía sagrada en las obras del Greco," *Archivo Español de Arte* 14 (1940–1941), p. 166; Gómez Moreno (1943), pp. 24, 68, 70, pls. XIV, XV; Martin S. Soria, "Some Flemish Sources of Baroque Painting in Spain," *Art Bulletin* 30, no. 4 (Dec. 1948): 251; Goldscheider (1949), pls. 41–43; Camón Aznar (1950), pp. 219–236, no. 262, figs. 122–134; Lafuente Ferrari (1953), pp. 204, 206, fig. 123; Guinard (1956), pp. 21, 44, 93, 95, figs. on pp. 17, 92; Soehner (1957), pp. 122, 124, 126–127, 130, 132, fig. 1; Trapier (1958a), pp. 20–26, fig. 28; Soehner (1958–1959), no. 7; Kubler and Soria (1959), p. 213; Wethey (1962), vol. 1, pp. 10, 37–38, 52, 93 (notes 135, 136), figs. 65, 66; ibid., vol. 2, no. 117; Rosenthal (1963), p. 386; Caturla (1963–1967): 132; Marqués de Lozoya, "El Greco en el Escorial," *Reales Sitios* 1 (July 1964): 27, figs. on pp. 26, 27; Allan Braham (1966); Manzini and Frati (1969), no. 37; Camón Aznar (1970), pp. 242, 245, 248, 251, no. 274, figs. 141–153, pls. between pp. 248, 249; MacLaren (1970), pp. 27–34; Cossío (1972), no. 389; Lafuente Ferrari and Pita Andrade (1972), pp. 42–44, 95, 117, no. 13, fig. 25; Gudiol (1973), no. 29, figs. 37–39; Davies (1976), p. 13, pl. 5.

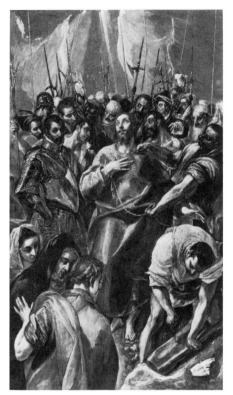

13

13 (plate 35)
Disrobing of Christ
Oil on panel, 55.9 x 31.8 cm. (22 x 12½ inches)
Signed on the torn paper at lower right in cursive Greek, in two lines: *doménikos theoto/krès e'p*
Circa 1577–1579
New York, Stanley Moss Collection

El Greco's large painting of the Disrobing of Christ (*El Espolio*) in the sacristy of the cathedral of Toledo (pl. 16), a work completed in 1579, is one of the finest and most important paintings of his career; it is also one of the great masterpieces of European painting. At the moment of its creation, at the very beginning of his career in Spain, El Greco showed himself to be the equal of any living painter in Italy. Surrounded by controversy at the time of its completion, the painting surely established the artist's reputation as a master immediately. (See chapter 2 for a fuller discussion of the Toledo canvas.) The picture's fame resulted in numerous requests from private individuals for replicas, some of which were painted by El Greco himself and others by his studio assistants.

The Disrobing of Christ was rarely represented by artists after the Middle Ages. Azcárate has shown that El Greco's representation of the subject is deeply rooted in orthodox medieval traditions. Saint Bonaventure's *Meditations on the Passion of Jesus Christ* is the apparent source for the painter's inclusion of the Three Marys at the lower left. In the Gospel these women were not present at the Disrobing, and by incorporating them El Greco gave the cathedral canons a premise by which they tried to reduce his payment for the Toledo commission. Although he promised to remove the figures to satisfy the canons, he never did, which suggests that in time he was able to persuade them to his view, or that after the price was settled, they did not care enough to press the matter further. Saint Bonaventure also seems to have been the source for the rope tied to Christ's wrist: he relates that when Christ became too exhausted to carry the Cross any farther, it was given to someone else to carry, and He was pulled along by a rope, as a thief would have been.

El Greco has depicted the moment when Christ, surrounded by an angry mob of revilers, is about to be stripped naked. The canons objected that certain heads in the mob were on a higher level than the head of Christ—another aspect of the painting grounded in traditional medieval representations. Wethey has suggested that the armor-clad figure at the viewer's left is Saint Longinus, the good centurion who was converted to Christianity at the moment he pierced Christ's side with his lance.

There are two small versions of the *Disrobing of Christ* that all writers on the subject have agreed are by El Greco himself—the present one, formerly in the Contini-Bonacossi Collection, and the one in the collection of Viscount Bearsted at Upton House (National Trust). Both are painted on pine panels (of almost identical size) and both have undergone cleaning and technical examinations recently. Wethey suggested tentatively that the medium of both panels is tempera, but it now seems certain that both are painted in oils, with no tempera involved.

The crucial question about these small versions of the *Disrobing of Christ* is whether either of them is a preliminary study for the large painting in the cathedral. The preponderance of the documentary evidence suggests that if such a study indeed existed, it was never pre-

sented to the cathedral chapter, for if it had been, the canons would have had no grounds for their later objections about the composition. Traditionally, the belief that El Greco made finished oil sketches as preparation for his larger paintings is based on Francisco Pacheco's statement that when he visited the artist in Toledo in 1611, he was shown "the originals of everything he had painted in his life, painted in oil on smaller canvases" (Pacheco [1649; 1956 ed.], vol. 2, pp. 8–9); this statement occurs in a chapter entitled "On Sketches, Drawings, and Cartoons, and on the Various Ways of Using Them." It is possible, however, that many of the small paintings Pacheco saw were reduced replicas by the artist kept as records and models for use by his assistants and by himself in making copies and repetitions at a later date. Such models must have existed, for certain compositions, including this one, were repeated at wide intervals throughout El Greco's career. The prominent underdrawing visible with both natural and infrared light in the Upton House *Espolio* traces the main features of the composition in a rather offhand way and thus supports the view that it could not have been a preliminary study for the painting in the Cathedral of Toledo.

Of the two small versions, the present one is the more labored-over painting. Included at the far right is a head (looking away from the viewer) that does not appear in any other version of the composition. There are also visible pentimenti around the outstretched forearm of the man behind the armored figure at the left. This is the only version in which the rope tied to Christ's wrist is slack rather than taut. In general, compared to the Upton House version the paint here is more thickly applied and the naturalism closer to the Italian works of the mid-1570s. The recent cleaning disproved Wethey's observation that the colors might have darkened chemically. The colors are, however, richer and more saturated than those of the Upton House version, which is blonder and more thinly brushed.

The present *Disrobing* is clearly the earlier of the two small panels. It may have been executed early in the course of planning the picture in the cathedral; if any painting has a claim to being a preliminary study for the Toledo version, it is this one. In any case, its style places it very early in the artist's Spanish career. The Upton House painting, along with the small version of the *Allegory of the Holy League* now in the National Gallery in London, was in the collection of Gaspar Méndez de Haro, the marquis of Eliche, before 1687. The present version, as Wethey has speculated, may have been that recorded in 1653 in the collection of the duke of Benavente in Madrid.

Provenance: Duke of Benavente, Madrid (1653) [?]; Infante don Sebastian Gabriel de Borbón; Infanta María Christina de Borbón (Dowager Queen of Spain), Madrid; Principe del Drago, Rome; Count Alessandro Contini-Bonacossi, Florence (from the 1920s).

Bibliography: Cossío (1908), pp. 189, 611, no. 355, pl. 29; Mayer (1926), p. 14, no. 72, pl. XXIII; Waterhouse (1930), pp. 61–88, no. 12; Roberto Longhi and August L. Mayer, *The Old Spanish Masters from the Contini-Bonacossi Collection* (Rome, 1930), p. 26, no. 36; Paris, *Gazette des Beaux-Arts* exhibition (1937), no. 23; Legendre and Hartmann (1937), p. 198; Blunt (1939–1940); Camón Aznar (1950), pp. 137, 306, no. 148, fig. 82; Soria (1954), no. 70; J. M. de Azcárate, "La iconografía de 'El Espolio' del Greco," *Archivo Español de Arte* 28 (1955): 189–197; Wethey (1962), vol. 1, fig. 59; ibid., vol. 2, no. 81; Halldor Soehner, *Gemäldekataloge: Spanische Meister* (Alte Pinakothek, Munich, 1963), p. 82; Manzini and Frati (1969), no. 24b; Camón Aznar (1970), pp. 162–164, 336, no. 151, fig. 102; Cossío (1972), no. 76; Gudiol (1973), pp. 91, 343, no. 53, figs. 75, 76; Jacques Lassaigne, *El Greco*, translated by Jane Breton (London, 1973), p. 38, fig. 19.

14 (plate 20)
Mary Magdalen in Penitence

Oil on canvas, 104.6 x 84.3 cm. (41¼ x 33¼ inches)
Circa 1580–1585
Kansas City (Missouri), Nelson Gallery–Atkins Museum. Nelson Fund

Superficially the Kansas City version of the Penitent Magdalen is similar to the version in Worcester painted in about 1577 (cat. no. 9; pl. 34), but in fact the artist's style evolved a great deal in the intervening years. The same pose of the figure is employed, but the modeling is much subtler. By shifting the rocky mass, the skull, and jar of oil to the right side of the composition, the painter has exchanged the overall balance and repose of the earlier work for a sense of movement. Similarly, the large planes of drapery in the Magdalen's white sleeve and her diaphanous veil have been broken up into many tiny, nervous planes. Her hair is blonder and seems curlier, and the calm sky is now ablaze with moonlight shining through the billowing cloud mass. What began as a rather quiet

14

conception has been charged with great feeling.

Provenance: Martínez Lechón, Seville (1929); Gutiérrez, Seville; R. Ruiz, Madrid; purchased by William Rockhill Nelson Gallery in 1930.

Bibliography: Cossío (1908), no. 391; Legendre and Hartmann (1937), no. 449; Paris, *Gazette des Beaux-Arts* exhibition (1937), no. 19; Goldscheider (1949), figs. 48, 49; Camón Aznar (1950), p. 407, no. 454, figs. 282, 283; Wethey (1962), vol. 1, fig. 305; ibid., vol. 2, no. 260; "Noticias de Arte," *Goya*, no. 54 (1963): 240; Manzini and Frati (1969), p. 94, no. 20b; Camón Aznar (1970), pp. 423–425, 429, no. 463; Cossío (1972), no. 331; Marilyn Stokstad, "Spanish Art from the Middle Ages to the Nineteenth Century," *Apollo* 96, no. 130 (Dec. 1972): 499–503; Gudiol (1973), pp. 107, 343, no. 60.

15

15 (plate 19)
Saint Peter in Tears

Oil on canvas, 108 x 89.6 cm. (42½ x 35¼ inches)
Signed at right in cursive Greek:
doménikos theotokópolis [sic] *e'poíei*
Circa 1580–1585
Barnard Castle (County Durham, England), The Bowes Museum

There were no pictures of Saint Peter Repentant before El Greco's time, yet he painted no fewer than five versions throughout his career (see also cat. no. 51; pl. 64). That he was one of the first artists to represent this subject and that he did so during the Counter-Reformation is perfectly consistent with all that we know about the artist's work and his time. Emile Mâle was the first to associate the theme with Counter-Reformation theology, and José López-Rey (1947) developed the interpretation of El Greco's treatment of it that has been followed by most subsequent scholars.

Although El Greco's several versions of this subject reflect the evolution of his style over a period of more than thirty years, the essential features of the composition are the same in all versions. He depicted the saint at the opening of a cave (a place of retreat and solitude), clad in robes reminiscent of early Chris-

tian times. His hands are clasped over his heart in a tense gesture of despair, as he looks upward, his eyes glazed, and begins to weep. The moment is just after the second crowing of the cock, when Peter realizes that he has unwittingly fulfilled Jesus' prophecy: "Before the cock crow twice, thou shalt deny me thrice." With his gesture and his facial expression, the Apostle acknowledges to himself and confesses to his God his lapse of faith and implores forgiveness for his sin.

For Protestants at this time, as López-Rey has pointed out, Peter was not a symbol of the papacy, but simply the Apostle who denied Christ; for Roman Catholics, Saint Peter was the first pope, and the tears shed after his repentance became a symbol of the sacrament of Confession. Saint Peter had set for Catholics the example of repentance and made forever clear to them that even the meanest sinner could earn God's forgiveness.

The scene in the background at the left side of the picture has also been explained by López-Rey: an angel sits on the empty sepulcher of Christ, while Mary Magdalen, carrying a jar of spices she has brought to anoint the body of the Messiah, hurries away in astonishment to tell Peter of Christ's Resurrection. Mary Magdalen is the clearest example of a repentant sinner, and her presence in the picture thus reinforces the message embodied by Saint Peter in Counter-Reformation theology that the forgiveness of sin follows from the sacrament of Confession. The empty sepulcher, moreover, suggests the idea of the Resurrection as the foundation for faith and hope.

The Bowes Museum version of *Saint Peter in Tears* is the earliest of the several authentic paintings of this subject. In point of execution, it is not far from the Kansas City *Mary Magdalen in Penitence* (cat. no. 14; pl. 20). Wethey, though, dated it circa 1585–1590, or about five years later. Gudiol disagreed, suggesting a date of 1579–1586; Camón and Soehner inclined toward a later dating of about 1590. The earlier dating seems more plausible.

Provenance: Count of Quinto; Countess of Quinto (sale Paris, 1862, no. 62).
Bibliography: Mayer (1926), no. 212, pl. XLVII; Mâle (1932), pp. 66–67; Legendre and Hartmann (1937), p. 295; Bowes Museum, *Handbook* (Barnard Castle, Darlington, 1939), no. 642; José López-Rey, "Spanish Baroque: A Baroque Vision of Repentance in El Greco's 'St. Peter,'" *Art in America* 35 (1947): 313–318; Camón Aznar (1950), p. 602, no. 433, fig. 459; Soehner (1957), pp. 142–143, 151; Trapier (1958a), p. 28, fig. 37; Gaya Nuño (1958), no. 1242; Wethey (1962), vol. 1, p. 45, fig. 310; ibid., vol. 2, no. 269; Bowes Museum, *Four Centuries of Spanish Painting* (Barnard Castle, County Durham, 1967), pp. 25–26, no. 24; Manzini and Frati (1969), no. 64a; Camón Aznar (1970), p. 618, no. 442, fig. 501; Eric Young, *The Bowes Museum, Barnard Castle, County Durham: Catalogue of the Spanish and Italian Paintings* (1970), pp. 38–40, no. 642, pl. 10; Cossío (1972), no. 304; Gudiol (1973), p. 111, no. 70, fig. 96; Davies (1976), p.

13, no. 11; Allan Braham, *El Greco to Goya* (National Gallery, London, 1981), no. 5, pl. on p. 15, fig. 57.

16

Madonna and Sleeping Christ Child with Saint Anne and the Infant Baptist

Oil on canvas, 178 x 105 cm. (70⅛ x 41⅜ inches)
Signed on the paper at lower right in cursive Greek: *doménikos theotokópoulos e'poíei*
Circa 1580–1585
Toledo, Church of Saint Leocadia. On loan to Museo de Santa Cruz, Toledo

16

This large painting is similar in composition to the well-known and somewhat smaller *Holy Family* in the Prado and to the small painting of the same subject in the National Gallery of Art in Washington (cat. no. 26; pl. 45). Its style is earlier than either of them, however, and there is one other major difference: the figure of Saint Joseph, originally included at the right in all three paintings, has been eliminated here. At the right in this version, over the Virgin's left shoulder, a shadowy figure of Saint Joseph can be discerned beneath the blue paint of the sky. Responding to a suggestion by Ellis K. Waterhouse that the figure of Saint Joseph was painted over, Wethey insisted that El Greco must

have done it himself, since he used the same group without Saint Joseph (or the Infant Baptist) in another painting (Hartford, Wadsworth Atheneum). Other scholars have contended that the overpainting is a modern addition rather than a pentimento. The cleaning of the painting, which will have been completed by the time this catalogue is published, will resolve the matter. There are some indications at this writing, though, that the alteration was made by El Greco himself. The obscured head of Saint Joseph seems quite erect here, as opposed to its inclined position in both the Madrid and Washington versions. His open collar is also depicted much more frontally here. These differences suggest that this painting was not at one time just a larger version of the Washington and Madrid pictures, but rather an earlier stage of the composition.

Wethey commented on the iconographic importance of the Infant Jesus' sleep as a symbol of His future sacrifice and death, and also suggested that the veil held by Saint Anne prefigures the Holy Shroud. More recently, Enriqueta Harris called attention to a drawing of the Holy Family by Michelangelo in which the Infant John the Baptist, wearing a wolfskin, holds his finger to his lips (like the Infant Baptist here) to admonish silence before the mystery of Christ's future sacrifice. This figure is based on Harpocrates, the Greek god of silence. According to Harris, El Greco's Infant Baptist resembles even more closely the woodcut image of Harpocrates from Vincenzo Cartari's *Le Imagini de i dei degli antichi* (Venice, 1571), in which the god holds in his outstretched hand a peach branch — his attribute because its leaves resemble the human tongue. Cartari's figure was based in turn on the many Roman statues of Harpocrates as a naked boy with his finger to his lips and with a cornucopia in his other hand. This latter model is the closest of all to El Greco's Infant Saint John, who holds a bowl of fruit, with peaches.

As laborious as it is today to reconstruct the background and symbolism of this image of Silence, it was surely once familiar to the learned viewer and served to underscore the awesome mystery of Christ's sacrifice, which is so palpably reflected in the faces of the Virgin and Saint Anne.

The fine modeling of the Virgin's face and the figure of the Infant John the Baptist, as well as the relatively smooth blending of color in the drapery, relates this work chronologically to the *Burial of the Count of Orgaz* (pl. 3) — that is, the mid-1580s.

Provenance: Hospitalillo de Santa Ana, Toledo; Museo de San Vicente, Toledo.
Bibliography: Cossío (1908), p. 585, no. 227; Mayer (1926), p. 8, no. 32; Goldscheider (1949), fig. 82; Camón Aznar (1950), p. 581, no. 235, fig. 436; Soehner (1957), p. 151; idem (1958–1959), p. 184, no. 34; Wethey (1962), vol. 1, p. 45, fig. 99; ibid., vol. 2, no. 93; Camón

Aznar (1970), pp. 581–582, no. 251, fig. 472; Cossío (1972), no. 34; Lafuente Ferrari and Pita Andrade (1972), p. 156; Gudiol (1973), pp. 197, 349, no. 148; Harris (1974), p. 104.

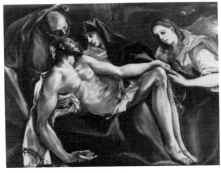

17

17 (plate 36)
Pietà

Oil on canvas, 120 x 144.7 cm. (47¼ x 57 inches)
Signed within the crown of thorns at lower left in cursive Greek: *doménikos theotokópolis* [sic]
Circa 1580–1590
London, Stavros S. Niarchos Collection

Few comparisons reveal more dramatically the phenomenal transformation that occurred in El Greco's style after his arrival in Spain than that between the early Italian-period *Pietà* now in the Hispanic Society (fig. 44) and this *Pietà* executed about ten years later in Toledo. The earlier painting, inspired by the sculptures of Michelangelo (see fig. 58), is itself very sculptural in its design, with forms interlocking like the pieces of a puzzle to create one gigantic triangular mass in the center of the painting in front of a rather expansive view of Golgotha. By the very nature of its design, it is not a very intimate conception of the subject. It is primarily in this respect that it differs from the Niarchos *Pietà*.

In the Niarchos painting (which, as far as is known, was never duplicated by El Greco or his studio) almost the entire picture space is filled by the four participants in the sorrowful scene. The figures are placed at the foot of the Cross, which is visible just behind the central group of the Virgin and the dead Christ. At the viewer's right, the kneeling Magdalen holds the wounded hand of Jesus and contemplates it. At left, Joseph of Arimethea, stooping to support the weighty trunk of Christ's body, closes the composition. His bent form is compressed by the top edge of the picture, a structuring that charges the image with a certain tension. The focus of every gesture and gaze is the body of Christ, upon which the strong light creates a flickering pattern of shadow that seems to move in a semicircle down his sinuous right arm and up along his legs. This active play of light endows the figure

with a visual heartbeat, a supernatural rhythm that distinguishes it from the other figures and intensifies the sense of pathos that pervades the entire composition.

There is no agreement as to the date of the painting, but it would seem to fall somewhere within the decade of the 1580s.

Provenance: Evariste Fouret (sale Paris, 12 June 1863, no. 77 [*La mise au tombeau*] was possibly this picture); Yves Perdoux, Paris; Countess de la Béraudière, Paris; Wildenstein & Co.; purchased by Niarchos from Wildenstein in 1955.
Bibliography: Mayer (1926), p. 17, no. 102, pl. XXV; Paris, *Gazette des Beaux-Arts* exhibition (1937), no. 20; Legendre and Hartmann (1937), pls. IX, X; Goldscheider (1949), pls. 73, 74; Camón Aznar (1950), pp. 503–506, no. 203, figs. 368–370; Soehner (1957), p. 140; Wethey (1962), vol. 1, pp. 39–40, 53–54, figs. 95, 395; ibid., vol. 2, no. 103; Manzini and Frati (1969), pp. 98–99, no. 41, fig. 41; Camón Aznar (1970), pp. 513–514, no. 215, figs. 399–401; Cossío (1972), no. 130; Gudiol (1973), pp. 141–142, 345, no. 83, figs. 117, 118.

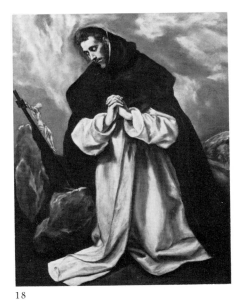

18

18 (plate 37)
Saint Dominic in Prayer

Oil on canvas, 118 x 86 cm. (46½ x 33⅞ inches)
Signed on the rock at lower left in cursive Greek: *doménikos theotokópo* [defaced] *e'poíei*
Circa 1585–1590
Madrid, Plácido Arango Collection

As Wethey has pointed out, *Saint Dominic in Prayer* is one of El Greco's major iconographical inventions. The Spanish saint was born into the noble family of Guzmán at Calaruega in Castile in 1170 and was educated at the University of Palencia. In 1216, with papal sanction, he founded the Order of Preachers, and his black-and-white-robed friars quickly penetrated into even the remotest corners of Europe. Dominic himself traveled and preached widely. He died in Bologna in 1221.

235

El Greco created three different compositional types of *Saint Dominic in Prayer*. The type considered here is known in at least three authentic versions and in several copies from his workshop or by later artists. The present example is the earliest of these and one of the loveliest of El Greco's images of single saints. The point of view, which is rather low, silhouettes the massive black cloak and Dominic's sensitive, aristocratic face against the light sky, accentuating the saint's solitude. This representation is the perfect image of a man alone with his God, and it is no wonder that in the religious climate of the time there was much demand that the composition be repeated.

Provenance: A. Sanz Bremón, Valencia; Marquis of Amurrio, Madrid (purchased from Sanz Bremón, 28 May 1924); Jaime Urquijo Chacón, Madrid (bequeathed to him by his father, the marquis of Amurrio).

Bibliography: Viniegra (1902), no. 37; Cossío (1908), no. 273; Mayer (1926), no. 223; Legendre and Hartmann (1937), pp. 355–356 (reproduced twice); Paris, *Gazette des Beaux-Arts* exhibition (1937), no. 24 (misidentified as·Contini-Bonacossi *St. Dominic*); Camón Aznar (1950), p. 624, nos. 483 (misidentified as in Contini-Bonacossi Collection), 492 (misidentified as Santo Domingo de Silos), fig. 472 (identified as in the Sanz Bremón Collection); Wethey (1962), vol. 1, fig. 247; ibid., vol. 2, no. 203; Manzini and Frati (1969), no. 70a; Camón Aznar (1970), no. 494, fig. 514; Cossío (1972), no. 200; Lafuente Ferrari and Pita Andrade (1972), pp. 58, 60, no. 47, fig. 68; Gudiol (1973), p. 152, no. 95, fig. 126.

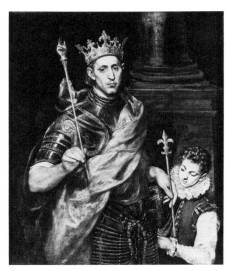

19

19 (plate 38)
Saint Louis of France

Oil on canvas, 117 x 95 cm. (46⅛ x 37⅜ inches)
Circa 1585–1590
Paris, Musée du Louvre

This well-preserved painting is one of El Greco's most unusual and arresting images of saints. Cossío was the first to identify the subject correctly as Saint Louis of France (whose mother was Blanche of Castile), as opposed to the previous traditional identification as Saint Ferdinand the Catholic. The fleur-de-lis motif of the crown and the scepter proves the French identity of the subject. Saint Louis's appeal as a devotional subject in contemporary Toledo is further demonstrated by the painting *Saint Louis Giving Alms* (Paris, Musée du Louvre), executed by El Greco's pupil Luis Tristán in 1620. As Trapier, Wethey, and Camón have observed, the artist has transformed the medieval saint into the portraitlike image of a sixteenth-century king by giving contemporary features to the painting: the black-and-gold armor of Philip II's reign, the sharp characterization of Louis's face, and the costume of the young page. The youth's resemblance to the figure of the artist's son Jorge Manuel in the lower left corner of the *Burial of the Count of Orgaz* (pl. 3) has also been noted. Only the gold crown, with its clear Gothic style, seems to evoke medieval times. Contemporary writers — such as François de Sales, in his *Introduction to the Devout Life* (1608) — repeatedly praised the pious virtues of the saintly King Louis, whose acts of charity included visiting the sick in hospitals. Surely the obvious parallel with contemporary ideals of Christian monarchy was intentional.

Provenance: Count of Quinto; Countess of Quinto (sale Paris, 1862, no. 67 [as *Saint Ferdinand*]); Château de Chenonceaux (sale Paris, 3 June 1889, no. 2 [as *Charles VII*]); M. Glanzer, Paris; acquired by the Louvre in 1903.

Bibliography: Cossío (1908), no. 292; Marcel Nicolle, *La peinture au Musée du Louvre*, vol. 6, *Ecole Espagnole* (Paris, 1920), p. 4; Trapier (1925), pp. 92–93; Mayer (1926), no. 292; Legendre and Hartmann (1937), pls. I, II; Gómez Moreno (1943), p. 33; Goldscheider (1949), p. 19, pl. 66; Camón Aznar (1950), pp. 674, 678, no. 520, figs. 519, 520; Soehner (1957), pp. 155–156; Gaya Nuño (1958), no. 1303; Wethey (1962), vol. 1, p. 45, fig. 302; ibid., vol. 2, no. 256; Sánchez Cantón (1963), pls. XXV, XXVI; Jeannine Baticle, *Trésors de la peinture espagnole* (Musée des Arts Decoratifs, Paris, 1963), p. 145; Manzini and Frati (1969), no. 63; Camón Aznar (1970), pp. 684, 689, no. 521, figs. 566, 567, fig. facing p. 682; Cossío (1972), no. 280; Gudiol (1973), p. 132, no. 80, fig. 113.

20 (plate 39)
Mary Magdalen in Penitence with the Crucifix

Oil on canvas, 109 x 96 cm. (42⅞ x 37¾ inches)
Signed below the skull at lower left in cursive Greek: *doménikos theotokópoulos e'poíei*
Circa 1585–1590
Sitges, Museo del Cau Ferrat

The Sitges Magdalen presents a conception of the saint completely different from that of the earlier versions (see cat. nos. 9, 14; pls. 34, 20). Gone are the sumptuous garments and the emphasis on vanity expressed by her long golden tresses in the earlier works; indeed, the jar of oil, the utmost symbol of her vanity, is omitted from this work. Instead, the figure is clothed in the timeless garb of a saint — a simple red robe gloriously painted in broad, facile brushstrokes. Instead of tautly clasping her hands on her lap as in the earlier versions, here she gently gestures with her left hand toward the skull that symbolizes human mortality and with her right hand toward herself, while her gaze is directed toward the crucifix at the viewer's left, a symbol of man's salvation through Christ.

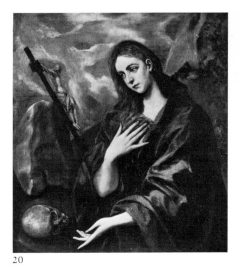

20

Provenance: Art market, Paris (1894); Santiago Rusiñol, Sitges.

Bibliography: Cossío (1908), no. 183; Mayer (1926), no. 295, pl. LVI; Legendre and Hartmann (1937), p. 456; Museo del Cau Ferrat, *Catálogo de pintura y dibujo del Cau Ferrat* (Barcelona, 1942), p. 11; Camón Aznar (1950), p. 414, no. 453, fig. 289; Soehner (1957), p. 167; idem (1958–1959), p. 191, no. 62; Wethey (1962), vol. 1, pp. 44–45, fig. 303; ibid., vol. 2, no. 263; Camón Aznar (1970), p. 428, no. 461, fig. 323; Cossío (1972), no. 327; Gudiol (1973), p. 347; "La Galerie Espagnole...," *Connaissance des Arts* 328 (June 1979): 94.

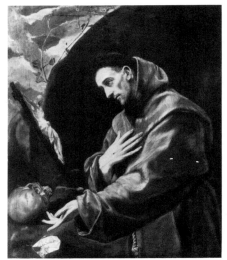

21

21 (plate 40)

Saint Francis in Meditation

Oil on canvas, 103 x 87 cm. (40½ x 34¼ inches)
Signed on the paper at lower left in cursive Greek: *doménikos theotokópolos* [sic] *e'poíei*
Circa 1585–1590
Barcelona, Torelló Collection

El Greco's contemporaries felt a particular affinity for Saint Francis of Assisi— a fact demonstrated by the three Franciscan monasteries and the seven such convents that were in Toledo at the time. Throughout his career in Spain, El Greco was the preeminent artistic interpreter of the life of the gentle saint; he created a number of different compositions, each of which is known in several autograph versions as well as in copies. (Wethey entitled the present painting *Saint Francis Standing in Meditation* in order to distinguish it from compositions in which the saint is shown kneeling—for example, cat. no. 38; pl. 21.)

El Greco's paintings of Saint Francis by their nature have an austere coloration. In this example, the saint is dressed in his rough, brownish gray habit, meditating in some dark corner of the wild. The composition is very similar to that of *Mary Magdalen in Penitence with the Crucifix* in the Museo del Cau Ferrat in Sitges (cat. no. 20; pl. 39). In both paintings the saints refer to symbols of human mortality (the skull) and of man's eternal salvation through Christ (the crucifix). Wethey considers three versions of this composition, including this one, to be authentic. The Torelló version seems to me by far to be the finest. There is little agreement among scholars as to its date, but a date close to the Magdalen in Sitges, or about 1585–1590, seems logical.

Provenance: Count of Adanero, Madrid; Marquis of Castro Serna, Madrid (1907); Count of Campo Giro, Madrid (1927).
Bibliography: Viniegra (1902), no. 53; Cossío (1908), no. 97; Mayer (1926), no. 259; Legendre and Hartmann (1937), p. 366; Camón Aznar (1950), p. 342, no. 558, fig. 233; Soehner (1957), p. 140; idem (1958–1959), no. 29; Wethey (1962), vol. 1, fig. 274; ibid., vol. 2, pp. 115–116, no. 223; José Gudiol, "Iconography and Chronology in El Greco's Paintings of St. Francis," *Art Bulletin* 44, no. 3 (Sept. 1962): 201, fig. 10; Manzini and Frati (1969), no. 51b; Camón Aznar (1970), p. 373, no. 564, fig. 267; Cossío (1972), no. 214; Gudiol (1973), p. 151, no. 89, fig. 122.

22 (plate 41)

Agony in the Garden

Oil on canvas, 102.2 x 113.7 cm. (40¼ x 44¾ inches)
Signed at lower right in cursive Greek: *doménikos theotokópoulos krès e'poíei*
Circa 1590–1595
Toledo (Ohio), The Toledo Museum of Art. Gift of Edward Drummond Libbey

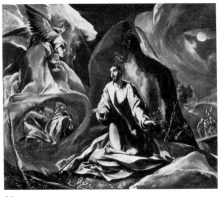

22

This famous composition is one of El Greco's most unusual and original creations. Although the subject of Christ at Gethsemane had been treated by Titian and other artists known to El Greco, none had ever done so quite like this. No single text from any of the Gospels can account for all of the features of the composition. Instead, the artist drew from all four Gospels in order to piece together his own version of the event. Christ, kneeling in prayer in front of a great rock, faces the angel who gives him strength (Luke 22:41, 43). The golden cup held by the angel symbolizes the Passion and refers to Christ's words, "O my Father, if this cup may not pass away from me, except I drink it, thy will be done" (Matt. 26:42). Beneath the angel, seemingly encased in the mist or cloud on which the heavenly messenger kneels, are the sleeping figures of the disciples Peter, James Major, and John (Matt. 26:37; Mark 14:33). At the right, in the distance, Judas approaches, leading the guards of the chief priests who will take Christ captive (John 18:3).

The artist has taken some simply astonishing risks in this painting. The most daring is the sense of discontinuous space created by the apparent enclosure of the sleeping disciples within the cloud underneath the angel: the viewer looks through a sort of whirlwind on which the angel is poised and sees Christ's followers "a stone's cast" away (Luke 22:41). The swirling oval of mist, which insulates the disciples from the supernatural event that is transpiring, is balanced at the upper right by a fog that is passing over the edge of the rock. The glaring divine light that emanates from above the angel creates an unusually brilliant effect on the red robe of Christ; the robe's sharply faceted planes range in hue from almost white, on his right shoulder, to deepest crimson, in the shadows about his left leg.

Precisely because of the risks inherent in this composition, it becomes a travesty in hands other than El Greco's. Wethey was perhaps charitable when he ascribed to "El Greco and workshop" the copy in the National Gallery of London, a version in which the spatial ambiguities are hardened into absurdities. The version in the Valdés Collection in Bilbao has been cut down on all sides and appears to be no match for the brilliance of the Toledo picture. El Greco also created a totally different compositional type of *Agony in the Garden*, vertical in format, of which there are several known versions.

Provenance: Cacho Collection, Madrid (until circa 1919); Lionel Harris, London; Durlacher Bros., New York; Arthur Sachs, New York (by 1928); acquired by the Toledo Museum of Art in 1946.
Bibliography: Mayer (1916), p. 30, pl. 59; idem (1926), p. 11, no. 55; idem (1931), p. 120, fig. 11; Legendre and Hartmann (1937), pp. 176, 503; Goldscheider (1949), fig. 72; Camón Aznar (1950), p. 821, no. 109, fig. 634; MacLaren (1952), pp. 15–17; Soehner (1957), p. 151; Wethey (1962), vol. 1, p. 47, fig. 162; ibid., vol. 2, no. 29; "Spanish Art," *Toledo Museum News*, Summer 1967, pp. 34, 39; Otto Wittmann, "Director's Choice," *Apollo* 86, no. 70 (Dec. 1967): 509; Manzini and Frati (1969), p. 107, no. 90a; MacLaren (1970), pp. 37–39; Camón Aznar (1970), p. 833, no. 112, figs. 696–698; Cossío (1972), no. 66; Lafuente Ferrari and Pita Andrade (1972), p. 157, no. 48; Gudiol (1973), p. 351, no. 169; Davies (1976), pp. 13–14, pl. 17; Toledo Museum of Art, *The Toledo Museum of Art: European Paintings* (University Park, Penn., 1976), pp. 68, 71–72.

23 (plate 42)

Christ Carrying the Cross

Oil on canvas, 64.1 x 52.7 cm. (25¼ x 20¾ inches)
Signed on the Cross, below the hand, in cursive Greek: *doménikos theotokópoli* [sic] *e'poíei*
Circa 1590–1595
New York, Oscar B. Cintas Foundation. On loan to Cummer Art Gallery, Jacksonville, Florida

The subject of *Christ Carrying the Cross* must have been one of El Greco's most successful with his public (Wethey catalogues eleven genuine versions). Around the middle of the 1580s the artist first transformed into a devotional image the traditional narrative image of Christ struggling with the Cross on the way to Calvary (as recounted in the Gospel of Saint John). One of the earliest and most beautiful of El Greco's versions is the extraordinary canvas in the Lehman Collection, Metropolitan Museum of Art (fig. 110). Christ, clad in regal blue-and-red robes and crowned with thorns, carries the heavy Cross, with seemingly little effort, on his left shoulder. His elegant hands embrace it lightly, enhancing its symbolic function. Drops of blood appear on his brow and his smooth, white neck. In acceptance of his destiny and in spiritual communion with his Father, he is presented not as the pathetic victim, but as Christ the King.

In the canvas belonging to the Oscar B. Cintas Foundation, El Greco has created a quite different type of *Christ Carrying the Cross*. Although several copies are known, the Cintas picture is the only one that is certainly by El Greco's own hand. Christ, shown bust-length, wears only the red robe, without

237

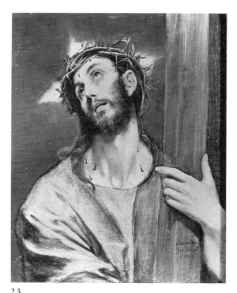

23

24 (plate 43)

Saint Andrew and Saint Francis

Oil on canvas, 167 x 113 cm. (65¾ x 44½ inches)
Signed on the paper at lower right in cursive Greek: *doménikos theotokópolis* [sic] *e'poíei*
Circa 1590–1595
Madrid, Museo del Prado

This very fine and unique canvas was unknown until the Spanish Civil War, when it was found in the Convent of the Incarnation in Madrid. The provenance was traced to the daughter of the duke of Abrantes, Mother Ana Agustina del Niño Jesús, who donated the work to the convent on October 3, 1676. After its discovery, it was exhibited briefly at the Prado in 1939 and then purchased by the museum in January of 1942.

The pairing of two saints in a single painting was an old tradition in Spain, and it occurred frequently in paintings done during the 1580s for Philip II at the Escorial. The iconography of the pairing of these two saints in particular, however, has not been sufficiently investigated. Lafuente (1945) suggested that Saints Andrew and Francis were selected by a patron and arbitrarily united, as on a Byzantine icon. In his 1977 article, Wethey agreed that the provenance does not explain the iconography and suggested that the picture must have been

Figure 110. El Greco. *Christ Carrying the Cross*, 41⅜ x 31 inches, circa 1585–1590 (New York, The Metropolitan Museum of Art. Robert Lehman Collection 1975)

the blue mantle. Only the vertical member of the Cross is visible, and only his left hand is seen holding it. His head is inclined toward the viewer's left, and his gaze is directed dramatically upward. The figure, full of torsion, lacks the noble calm of the Lehman version and has instead a pathos and emotionalism not wholly unrelated to the approach taken by Luis de Morales, who also depicted Christ Carrying the Cross as a devotional, bust-length image, though with more bizarre and anguished results. El Greco's Christ, although suffering, is full of refinement and grace.

Provenance: Pereire Collection (sale Paris, 30 Jan. 1868, no. 33); Etienne Arago (sale Paris, 8 Feb. 1872, no. 34); Féral (anonymous sale Paris, 26 Jan. 1878, no. 15); Tomás Harris, London; Seligmann & Rey, New York; Oscar B. Cintas Collection, Havana.
Bibliography: Legendre and Hartmann (1937), pl. V; Tomás Harris, *Greco to Goya* (London,

1938), p. 20; Camón Aznar (1950), p. 340, no. 115, fig. 221; Soehner (1957), p. 158; Wethey (1962), vol. 1, fig. 180; ibid., vol. 2, no. 59; Axel von Saldern, "Spanish Paintings from the Cintas Collection," *The Brooklyn Museum Annual* 4 (1962–1963): 59–60, no. 2, fig. on p. 54; Manzini and Frati (1969), no. 80a; Camón Aznar (1970), p. 365, no. 120, fig. 254; Lafuente Ferrari and Pita Andrade (1972), p. 157, no. 35; Gudiol (1973), p. 347, no. 111.

intended for private devotion. While there is no known replica of this composition, the figure of Saint Andrew appears alone in a painting by El Greco in the Metropolitan Museum of Art, and the figure of Saint Francis appears juxtaposed with Saint John the Evangelist in a paired-saint picture recently acquired by the Uffizi.

Although mysterious, this is El Greco's greatest painting of paired saints standing in a landscape. The two saints—of totally different times, one from the early Christian era and one from the thirteenth century—stand together gesturing and conversing in the Toledan countryside. The color harmony of the work is beautiful, with the greens and blues of Saint Andrew's robes and the gray of Saint Francis's reflected throughout the landscape and the turbulent sky. The great X-shaped cross of Saint Andrew serves both coloristically and compositionally as the powerful nexus of the image.

Provenance: Duke of Abrantes, whose daughter, Mother Ana Agustina del Niño Jesús, gave it to her convent in 1676; Convent of the Incarnation, Madrid (1676–1942); purchased by the Prado in 1942.
Bibliography: F. J. Sánchez Cantón, *De Barnaba da Modena a Francisco de Goya* (Madrid, 1939), p. 14; Enrique Lafuente Ferrari, "El Greco: Some Recent Discoveries," *The Burlington Magazine* 87, no. 513 (Dec. 1945): 293; Goldscheider (1949), pl. 165; Camón Aznar (1950), p. 591, no. 423, figs. 447–449, pl. facing p. 592; Guinard (1956), p. 78; Soehner (1957), p. 167; idem (1958–1959), no. 64; Wethey (1962), vol. 1, p. 45, figs. 111, 401; ibid., vol. 2, no. 197; Sánchez Cantón (1963), p. 31, pl. XV; Manzini and Frati (1969), no. 84; Camón Aznar (1970), pp. 594, 598, no. 432, figs. 484–486; Madrid, Prado (1972), no. 2819; Cossío (1972), no. 316; Lafuente Ferrari and Pita Andrade (1972), p. 122, no. 41, pl. L; Gudiol (1973), p. 153, no. 100, figs. 131, 132; Harold Wethey, "El Greco's 'St. John the Evangelist with St. Francis' at the Uffizi," *Pantheon* 35 (1977): 205 ff., fig. 1.

24

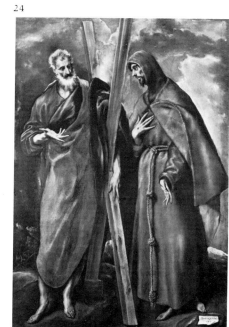

25 (plate 44)

Holy Family with Saint Anne

Oil on canvas, 127 x 106 cm. (50 x 41¾ inches)
Circa 1590–1595
Toledo, Hospital of Saint John the Baptist (Hospital de Afuera)

Taking as his point of departure an earlier composition, the *Holy Family* in the Hispanic Society of America, El Greco has created in this work a painting justly renowned for its surpassing beauty. He has added the figure of Saint Anne at the left and has altered the Virgin's drapery in a way that serves to unify the composition. The most extraordinary and daring feature is the interplay of hands about the figure of the Holy Infant. This lends a vibrancy to the design at the focus of attention and enhances the loving and knowing gazes of the three adults. The face of the Virgin is one of the loveliest images of idealized feminine beauty in all of El Greco's oeuvre.

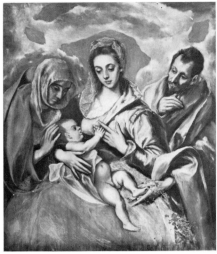

25

Like many of the painter's works that have never left Spanish collections and have not been subjected to harsh relining techniques, the surface of this painting is, on the whole, exquisitely well preserved and a testimony to the artist's virtuosity.

Provenance: Gift to the hospital from Teresa de Aguilera, widow of Alonso Capoche (before 1631).
Bibliography: Cossío (1908), p. 589, no. 246; Mayer (1926), p. 7, no. 26; San Román (1927), p. 339; Legendre and Hartmann (1937), p. 148; Camón Aznar (1950), pp. 573, 581, no. 236, figs. 432, 433, pl. facing p. 572; Soehner (1957), p. 167; idem (1958–1959), p. 190, no. 59; Wethey (1962), vol. 1, p. 46, figs. 98, 104; ibid., vol. 2, p. 23, no. 85; Camón Aznar (1970), p. 580, no. 250, figs. 461, 462; Cossío (1972), no. 37; Lafuente Ferrari and Pita Andrade (1972), p. 157, no. 25; Gudiol (1973), pp. 132, 134–135, 141, no. 250.

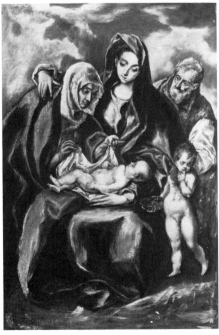

26

26 (plate 45)

Holy Family with the Sleeping Christ Child and the Infant Baptist

Oil on canvas, 53.0 x 34.3 cm. (20⅞ x 13½ inches)
Circa 1595–1600
Washington, National Gallery of Art. Samuel H. Kress Collection 1959

This brilliant little painting repeats the composition of the medium-sized version of the Holy Family in the Prado and the large version on loan to the Museo de Santa Cruz (see cat. no. 16, where the iconography is discussed). Like the former, it seems to date somewhat later than the large version, as is suggested by the looser brushwork and the more dramatic contrast of light and dark. This broader handling is typical of paintings documented to the late 1590s, such as those for the altarpiece of the College of Doña María de Aragón (for example, cat. nos. 32, 33; pls. 1, 27).

Most critics have assumed that this painting is a sketch. If so, it cannot be a sketch for the Santa Cruz composition, because that work exhibits a manifestly earlier style. This version is more likely one of the small *originales*, or models, that Francisco Pacheco mentioned having seen for all of El Greco's compositions (Pacheco [1649; 1956 ed.], vol. 2, pp. 8–9). Many of these were probably not sketches or studies in the usual sense, but rather small replicas, made by the artist, that could be used by studio assistants or by himself in meeting the demands of his clientele for repetitions of successful compositions.

Even allowing for the breadth of its technique, there is something unfinished about this picture. The entire bottom and right margins are unresolved, painted in a way unlike that of El Greco's finished works. The fluid drawing with the brush along the hemline of the Virgin's skirt and about the legs and feet of the Infant Baptist is an interesting indication of how El Greco went about painting. The edge of the light blue mantle at the Virgin's feet has not received the glazes that it probably would have ultimately been given in a finished work, and it looks rather raw over the brownish priming of the canvas. The scumblings of white and gray along the bottom and at the right edge contribute to the scintillating effect of the whole for the modern eye, but they are simply jottings that remain to be filled in. As Wethey noted, a painting of this subject and approximate size was listed in the 1621 inventory of El Greco's paintings still in the possession of his son, Jorge Manuel. A similar entry in the 1614 inventory, made immediately after El Greco's death, was described as unfinished.

The Saint Joseph shown in this work is decidedly older than he is in any of the other depictions of the Holy Family by El Greco. Such variation reflects the contemporary debate over the age of the saint at the time of his marriage to Mary. Spaniards tended to favor a younger Saint Joseph, though this view was by no means a unanimous one.

Provenance: Carlos de Beistegui, Paris; Michael Dreicer, New York (on loan to the Metropolitan Museum of Art, New York, 1921–1933); Paul Drey, New York; French & Co., New York.
Bibliography: Mayer (1926), p. 8, no. 31; Camón Aznar (1950), p. 581, nos. 242, 245; Washington, National Gallery (1959), p. 270, no. 1527; Wethey (1962), vol. 1, p. 46, fig. 102; ibid., vol. 2, pp. 59–60, no. 88; Washington, National Gallery (1965), p. 63, no. 1527; Camón Aznar (1970), p. 588, no. 254, fig. 477; Cossío (1972), no. 30; Lafuente Ferrari and Pita Andrade (1972), p. 156, no. 26; Gudiol (1973), pp. 194–197, 349, no. 147; Harris (1974), pp. 103–111, fig. 69; Walker (1974), p. 237, fig. 311; Washington, National Gallery (1975), pp. 164–165, no. 1527.

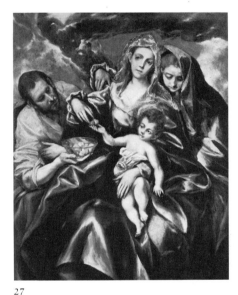

27

27 (plate 46)

Holy Family with Mary Magdalen

Oil on canvas, 131.8 x 100.3 cm. (51⅞ x 39½ inches)
Circa 1595–1600
Cleveland, The Cleveland Museum of Art. Gift of the Friends of the Cleveland Museum of Art, in memory of J. H. Wade

The Cleveland *Holy Family* represents a compositional type completely different from other versions of the subject created by El Greco; it is known in at least six copies of inferior quality executed by his workshop and later imitators. The painting from Cleveland is the artist's original and, although not in good condition, is a very grand conception. The Christ Child here is playful and squirms in his mother's lap as she hands him a piece of fruit from the bowl held by Saint Joseph, at the left. The bowl is similar to that offered by the Infant Saint John in the Santa Cruz and Washington paintings (cat. nos. 16, 26; pl. 45). In a very unusual switch, the artist has substituted Saint Mary Magdalen, at the

right, for Saint Anne. The saint embraces the Virgin and places her own face, foreshortened and looking downward, close to that of the Madonna. This establishes a contrast that Gudiol has pointed to as a key aspect of the picture's meaning: the pensive, complex, and tormented face of the repentant Magdalen serves to emphasize the radiant serenity of the Virgin as the Mother of God.

Provenance: Convento de Esquivias, Torrejón de Velasco (Toledo); Juan Gutiérrez, Torrejón de Velasco; Varga Machuca, Madrid; M. Albarrán, Madrid; Stanislas O'Rossen, Paris (1908); Marczell von Nemes, Budapest (sale Paris, Galerie Manzi, Joyant, 17–18 June 1913, no. 31); Gentile di Giuseppe, Paris; M. Knoedler & Co., New York; acquired by the Cleveland Museum of Art in 1926.

Bibliography: Cossío (1908), p. 601, no. 310; Mayer (1926), pp. 24, 59, pl. 42; William M. Milliken, "The 'Holy Family' by El Greco," *Cleveland Museum Bulletin* 14 (Jan. 1927): 3–6, fig. on p. 1; "The Friends of the Cleveland Museum of Art," *Cleveland Museum Bulletin* 17 (Mar. 1930): 50, fig. on p. 51; Paris, *Gazette des Beaux-Arts* exhibition (1937), no. 25; Goldscheider (1949), fig. 4; Camón Aznar (1950), p. 570, no. 241, figs. 427, 428; Soehner (1957), p. 167; Wethey (1962), vol. 1, p. 46, fig. 105; ibid., vol. 2, pp. 58–59, no. 86; Joseph Alsop, "Treasures of the Cleveland Museum of Art," *Art in America* 54 (May–June 1966): 66; Manzini and Frati (1969), pp. 106–107, no. 91a; Camón Aznar (1970), pp. 574–576, no. 247, figs. 463, 464; Cossío (1972), no. 35; Lafuente Ferrari and Pita Andrade (1972), p. 157, no. 29; Gudiol (1973), pp. 142, 345, no. 85.

28 (plate 47)
Allegory of the Camaldolite Order

Oil on canvas, 124 x 90 cm. (48⅞ x 35⅜ inches)
Circa 1597
Madrid, Instituto de Valencia de Don Juan

The strange, emblematic appearance of this painting is related to an unusual circumstance that surely attended its creation: the unsuccessful campaign waged from 1597 by Fray Juan de Castañiza to establish the Italian monastic order of the Camaldolesi in Spain. The Camaldolite order was founded in the year 975 by the Benedictine monk Saint Romuald, with the intent of combining the characteristics of monastic and hermitic life. Establishing his community near Arezzo on mountainous land provided by the count of Maldolus, Romuald built a series of small hermitages, or individual cells, where the monks would spend the majority of their time alone, subsisting on a diet of bread and water. At the center of the group of hermitages was a simple chapel, which was the only meeting place for the order. An early print of Camaldoli, as the place was called, was published by Byron and Rice. It shows the arrangement of the cells in rows, much as in El Greco's painting.

The painting shows a large plinth in the foreground, with a sort of tabernacle in its center. Inscribed on the white

28

panels of the tabernacle is a Latin poem praising Saint Romuald. The principal Latin inscription below translates as "Description of the Hermitical Life." To the left of the tabernacle stands the figure of Saint Benedict, clad in a black habit. To the right is the figure of Saint Romuald, clad in white and carrying an orb with a reduced version of the same landscape on it that is painted above. The coats of arms below the saints are those of the probable sponsors of the campaign to establish the order in Spain—the counts of los Arcos y Añover (on the left) and perhaps of some branch of the Mendoza family (on the right). In the upper half of the painting is the tree-ringed circular landscape of the site of Camaldoli; it is emblematically superimposed on a mountainous terrain suggesting the rugged heights that Padre Yepes in his *Crónica general de la Orden de San Benito* (1615) said must be traversed in order to reach the retreat (Sánchez Cantón, p. 178).

A somewhat larger version of this composition in the Colegio del Patriarca in Valencia varies slightly from this one. Wethey and Soehner (1957) regard both paintings as joint efforts of the artist and his studio.

Provenance: Guillermo de Osma, Madrid (1908).

Bibliography: Cossío (1908), no. 118; F. J. Sánchez Cantón, *Catálogo de las pinturas del Instituto de Valencia de Don Juan* (Madrid, 1923), pp. 177–179; Byron and Rice (1930), pls. 88, 89; Camón Aznar (1950), pp. 859–860, no. 673, figs. 668–670; Soehner (1957), p. 167; idem (1958–1959), no. 65; Wethey (1962), vol. 1, fig. 147; ibid., vol. 2, no. 119; Manzini and Frati (1969), no. 112b; Camón Aznar (1970), pp. 868–872, no. 660, figs. 732, 733; Cossío (1972), no. 386; Gudiol (1973), p. 203, no. 166, fig. 184.

29 (plate 48)
Saint Joseph and the Christ Child

Oil on canvas, 109 x 56 cm. (42⅞ x 22 inches)
Fragments of a signature on the paper at left in tiny cursive Greek letters: *doménikos theotokópoulos e'poíei*
Circa 1597–1599
Toledo, Cathedral. On loan to Museo de Santa Cruz, Toledo

This painting is related to the large canvas of the same subject that is still in situ in the main altarpiece of the Chapel of Saint Joseph in Toledo. Cossío (1908) regarded the present work as an autograph replica of the original; both Wethey and Lafuente thought it to be the artist's preliminary sketch. It roughly corresponds in size to the version of the subject listed as number 32 in the 1621 inventory of paintings in the possession of El Greco's son Jorge Manuel. (See chapters 2 and 3 for a full discussion of the iconography of the Chapel of Saint Joseph.)

The composition shows the figure of Saint Joseph protectively shepherding the boy Jesus. The two figures are silhouetted against a dramatic sky and tower monumentally over the landscape of Toledo, which is shown much as it appears in El Greco's *View of Toledo* in New York's Metropolitan Museum (cat. no. 35; pl. 4). Angels hovering above Saint Joseph and the Christ Child celebrate their passage with flowers and wreaths.

29

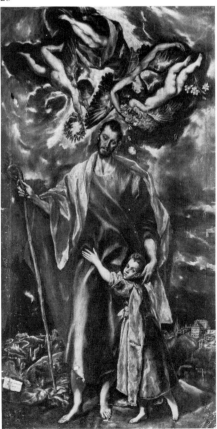

Mayer (1940–1941), writing of the large canvas in the chapel, was the first to comment on the novel iconographic treatment of Saint Joseph that El Greco employed in this composition. He observed that El Greco was one of the first artists to glorify Saint Joseph in accordance with the new cult devoted to him that arose after the Council of Trent. Saint Theresa, the most active propagator of the cult, made the saint patron of all of her newly founded convents. Mayer also cited the influence in Spain of Johannes Molanus's *De historia sacrarum imaginum* (1571); in this work Molanus spoke of Saint Joseph as a young, strong man, of almost equal importance to the Christ Child as the Virgin. This concept of the saint was gaining currency in Spain at the time the altarpiece for the chapel was commissioned; Father Gracián de la Madre de Dios elaborated on such ideas in his *Grandeza y excelencias del glorioso San José*, which was published in 1597, the year the contract with El Greco was signed.

Provenance: Church of La Magdalena, Toledo (gift of Fernando Elejalde, circa 1781–1805).
Bibliography: Cossío (1908), no. 252; Ramírez de Arellano (1920), p. 298; Mayer (1926), no. 37; Legendre and Hartmann (1937), p. 131; Mayer (1940–1941), pp. 164-165; Gómez Moreno (1943), p. XLVI; Goldscheider (1949), pp. 112–113; Camón Aznar (1950), pp. 689–692, no. 269, figs. 523–526; Bronstein (1950), pp. 58, 60, figs. on pp. 59, 61; Soehner (1958–1959), no. 155; Wethey (1962), vol. 2, no. 254; Sánchez Cantón (1963), pp. 38, 44; M. Revuelta, *Museo de Santa Cruz, Guía* (Madrid, 1966), no. 879; Manzini and Frati (1969), no. 105b; Camón Aznar (1970), p. 701, no. 281, figs. 575–579; idem, "San José en el arte español," *Goya*, no. 107 (Mar.–Apr. 1972): 308; Cossío (1972), no. 270; Lafuente Ferrari and Pita Andrade (1972), no. 56, pl. XXI; Gudiol (1973), p. 175, no. 132, figs. 157–158.

30 (plate 17)

Saint Martin and the Beggar

Oil on canvas, 193.4 x 102.9 cm. (76⅛ x 40½ inches)
Signed at lower right in cursive Greek:
doménikos theotokópoulos e'poíei
Circa 1597–1599
Washington, National Gallery of Art.
Widener Collection 1942

Saint Martin and the Beggar is one of El Greco's most unforgettable images, and the five roughly contemporary copies that survive attest to its instant popularity. As one of the lateral altars (the north) of the Chapel of Saint Joseph in Toledo, it formed part of one of the artist's most beautiful and original ensembles. (The chapel and its paintings are discussed in detail in chapters 2 and 3.)

Saint Martin was the patron saint of the chapel's founder, Martín Ramírez. Soehner (1961) pointed out that the theme of this painting—the charity of a rich man who shares his possessions with the poor—no doubt had great per-

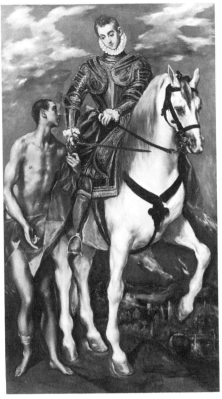

30

sonal significance to Ramírez, whose tomb bears an inscription referring to his own works of charity.

The saint was born in what is today Hungary, during the reign of the fourth-century Roman emperor Constantine the Great. He was converted to Christianity as a child and wanted to join a monastery, but was forced by his father to enter the military. Having joined the imperial cavalry, he was stationed in France, near Amiens, when, on a cold winter day, he came upon a beggar dressed in rags and suffering from exposure. In an act of charity that has become legendary, Martin divided his cloak in two with his sword and gave half of it to the beggar. That night Christ appeared to Martin and said, "What thou hast done for that poor man, thou hast done for me." Later in his life, Saint Martin served as bishop of Tours for thirty years.

El Greco has represented the saint as a refined young nobleman of the painter's own day, clad in gold-damascened armor, astride a splendid white Arabian horse. The very low vantage point makes the figures appear monumental and heightens the significance of the act of charity. In the distance, beyond the horse's beautifully drawn and modeled forelegs, the familiar landscape by the River Tagus near the Alcántara Bridge reminds the viewer that Christian virtue is timeless and that the act of Saint Martin is an eternal example.

Provenance: North lateral altar, Chapel of Saint Joseph, Toledo; Widener Collection, Philadelphia (1906).
Bibliography: Cossío (1908), no. 242; Mayer (1926), no. 297; Legendre and Hartmann

(1937), p. 459; Cook (1945), pp. 69–73; Goldscheider (1949), p. 15, pl. 111; Bronstein (1950), pp. 66, 68, figs. on pp. 67, 69; Guinard (1956), p. 26; Soehner (1957), p. 167, pl. 39; Gaya Nuño (1958), no. 1337; National Gallery of Art, *Paintings and Sculpture from the Widener Collection* (Washington, 1959), p. 30, no. 621; Soehner (1961), pp. 29–30; Wethey (1962), vol. 1, pp. 47, 64, figs. 116–118; ibid., vol. 2, no. 18; Sánchez Cantón (1963), p. 38, pl. XVII; Washington, National Gallery (1965), p. 62, no. 621; Manzini and Frati (1969), no. 105c; Camón Aznar (1970), pp. 708–711, no. 523, figs. 587–589; Cossío (1972), no. 282; Lafuente Ferrari and Pita Andrade (1972), no. 58, fig. 75; Gudiol (1973), p. 176, no. 135, fig. 162; Walker (1974), pp. 236–237, no. 310; Washington, National Gallery (1975), pp. 162–163, no. 621; Davies (1976), no. 22.

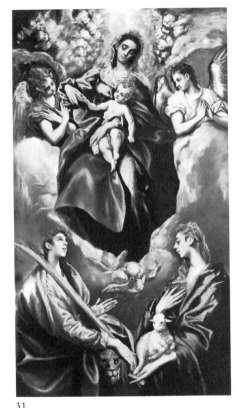

31

31 (plates 49, 50)

Madonna and Child with Saint Martina and Saint Agnes

Oil on canvas, 193.4 x 102.9 cm. (76⅛ x 40½ inches)
Initialed on lion's head in cursive Greek: *d t*
Circa 1597–1599
Washington, National Gallery of Art.
Widener Collection 1942

The lateral altar on the south side in the Chapel of Saint Joseph was occupied by this radiant and well-preserved canvas. The Madonna and Child are enthroned in heaven, surrounded by angels and seraphim. The figures of the Madonna and Child, except for their heads, are very similar to those in the *Holy Family with Mary Magdalen* from the Cleveland Museum (cat. no. 27; pl. 46). The saints below are seen in three-quarter length.

Saint Agnes, at right, is easily recognized by her symbol, the lamb. The saint at left stands beside a lion, on whose head El Greco has inscribed his initials in Greek characters. This figure used to be identified as Saint Thecla, the first martyr of the Greek Church, but the identification was proved wrong on the basis of two inventories made of El Greco's paintings after his death. In the 1614 inventory, one version of the theme represented here is clearly identified; in the 1621 inventory, two versions are listed, and one of them is described in detail: "An image of Heaven with the Child and some angels and seraphim, and below Saint Inez [Agnes] and Saint Martina." Saint Martina's presence here is appropriate: she is the nominative counterpart of Saint Martin, who was the patron saint of the chapel's founder and the subject of the painting originally in the lateral altar on the north side of the chapel (moreover, both the founder and his nephew, who commissioned the altarpiece, were named Martín Ramírez). Saints Agnes and Martina are early Christian "virgin martyrs," and Soehner (1961) was surely right when he observed that the Virgin Mary is presented here as the Queen of Virgins. The versions of the subject listed in the early El Greco inventories are now lost, and the original painting (the present work) is thus unique.

Provenance: South lateral altar, Chapel of Saint Joseph, Toledo; Widener Collection, Philadelphia (1906).

Bibliography: Paul Lafond, "La Chapelle San José de Tolède et ses peintures du Greco," *Gazette des Beaux-Arts*, 3d series, vol. 36, no. 593 (Nov. 1906): 383, 388; Cossío (1908), p. 588, no. 241; Mayer (1926), p. 8, no. 35; Cook (1945), pp. 65–69; Goldscheider (1949), pl. 110; Camón Aznar (1950), pp. 692–697, no. 227, figs. 530, 531; Halldor Soehner, "Ein Hauptwerk Grecos die Kapelle San José in Toledo," *Zeitschrift für Kunstwissenschaft* 10, no. 3–4 (1956): 215–222; idem (1957), p. 167; National Gallery of Art, *Paintings and Sculpture from the Widener Collection* (Washington, 1959), p. 31, no. 622; Soehner (1961), pp. 30–32; Wethey (1962), vol. 1, fig. 115; ibid., vol. 2, no. 17; Washington, National Gallery (1965), p. 62, no. 622; Manzini and Frati (1969), p. 109, no. 105d; Camón Aznar (1970), pp. 703–708, no. 236, figs. 582–585; Cossío (1972), no. 152; Lafuente Ferrari and Pita Andrade (1972), p. 158, no. 57; Gudiol (1973), pp. 175–176, 178–179, 348, no. 134; Walker (1974), pp. 238–239, no. 312; Washington, National Gallery (1975), pp. 162–163, no. 622.

32 (plate 1)

Annunciation

Oil on canvas, 315 x 174 cm. (124 x 68½ inches)
Signed on the step, below the basket, in cursive Greek: *doménikos theotokópoulos e'poíei*
1596–1600
Madrid, Museo del Prado. On loan to Museo Balaguer, Villanueva y Geltrú

This very large painting is one of El Greco's masterpieces. All scholars agree

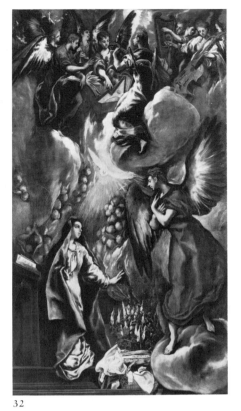

32

that it constituted the center of the high altar of an Augustinian seminary in Madrid—the College of Our Lady of the Incarnation, better known by the name of its founder as the College of Doña María de Aragón. El Greco worked on this important commission between 1596 and 1600. The building was partially destroyed in the nineteenth century, the altarpiece dismantled, and its contents dispersed. There is no clear documentation of the original appearance of the whole. Wethey critically reviews the history of speculation on the subject, and Pérez Sánchez addresses it anew in chapter 3 of this catalogue.

Comparison of this monumental work with the early Thyssen-Bornemisza *Annunciation* (cat. no. 6; pl. 32) reveals what must be one of the truly phenomenal transformations in the history of art. The rational space and classical proportions of the Italianate work have totally disappeared in the later painting. The entire pictorial space now seems suffused with the import of the archangel Gabriel's message. Instead of a few golden rays emanating from the dove of the Holy Spirit, the heavens themselves open up and spill to the earth with a brilliance that has no parallel. The Divine Light shining forth from the dove illuminates the myriad tiny seraphim heads; these seem to magnify the wonder of the Light as it passes through the narrow passageway in the clouds and strikes the astonished figure of the Virgin. The burning bush just above the Virgin's sewing basket is an unusual feature in an *Annunciation* and is surely a reference to the bush that burned but was not consumed when

the Lord appeared to Moses; similarly, the Virgin received the Divine Light at the moment of conception but remained Immaculate (as Rosenbaum reasoned in a recent publication). The angelic choir provides the appropriate accompaniment for this momentous event and terminates the great upward sweep of the composition.

Two small versions of the present work survive. One of them (110 x 65 centimeters), in the Museo de Bellas Artes in Bilbao, is generally considered to be a workshop replica. The other small version (114 x 67 centimeters), in the Thyssen-Bornemisza Collection, is universally held to be by El Greco's hand and is considered by many to be a preliminary study for the large canvas. It seems more probable to me that it is a fine replica by the artist, as it duplicates in such detail all features of the large composition.

Provenance: High altar, College of Doña María de Aragón, Madrid; Museo Nacional de la Trinidad, Madrid.

Bibliography: Madoz (1848), p. 234; Cossío (1908), p. 593, no. 276; Mayer (1926), p. 4, no. 11; Legendre and Hartmann (1937), p. 111; Goldscheider (1949), pls. 104, 105; Camón Aznar (1950), pp. 74–76, no. 25, figs. 572, 574–576; Soehner (1957), p. 167; idem (1958–1959), p. 189, no. 55; Wethey (1962), vol. 1, figs. 126, 127, 129, 398; ibid., vol. 2, no. 13; Manzini and Frati (1969), pp. 110–111, no. 107b; Camón Aznar (1970), pp. 758–764, 766–767, 774, no. 25, figs. 629–632, pls. facing p. 764 and between pp. 772–773; Cossío (1972), no. 2; Lafuente Ferrari and Pita Andrade (1972), pp. 157–158, no. 50; Gudiol (1973), pp. 181–185, 349, no. 138; Pérez Sánchez in London, Royal Academy (1976), pp. 30–31, no. 5; Robert Harbison, "The Golden Age of Spanish Painting," *The Connoisseur* 191, no. 768 (Feb. 1976): 153; Adeline C. de Bissy, "La peinture espagnole au Siècle d'Or," *Goya*, no. 251 (June 1976): 13, 15; Allen Rosenbaum, *Old Master Paintings from the Collection of Baron Thyssen-Bornemisza* (Washington, D.C., 1979), p. 150.

33 (plate 27)

Baptism of Christ

Oil on canvas, 350 x 144 cm. (137¾ x 56¾ inches)
Signed on the paper at lower left in cursive Greek: *doménikos theotokópoulos e'poíei*
1596–1600
Madrid, Museo del Prado

The records of Madrid's Museo Nacional de la Trinidad indicate that in the nineteenth century the great canvas of the Baptism of Christ was brought to the museum from the church of the defunct College of Doña María de Aragón in that city. The painting is the only one besides the *Annunciation* in Villanueva y Geltrú (cat. no. 32; pl. 1) that can be associated on the basis of some document or reliable published account with the Aragón altarpiece, one of El Greco's most important. The *Pentecost* (cat. no. 34; pl. 26) possibly may have been part of this altarpiece also. (See chapter 3 for a discussion of the entire retable.)

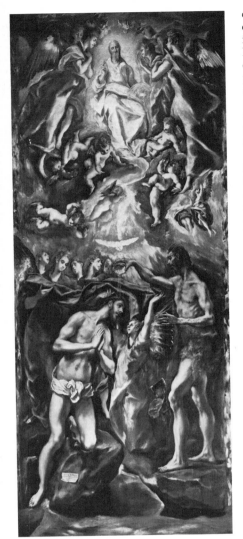

33

The extraordinary blending together of the heavenly and earthly realms in the composition has been often noted. Only the rocks on which Christ kneels and the Baptist stands suggest the earth. As in the *Annunciation*, all other hint of locale has been wiped out by the overflowing of light and celestial beings into the space where the sacramental event occurs. All of these visual fireworks are employed for a single purpose: to underscore the significance of the moment when the drops of water from the Baptist's shell fall onto Christ's head. The Baptism is presented not just as an event in the narrative flow of Christ's life, nor as a mere symbolic event. It is shown as the actual miraculous moment when man is redeemed by the grace of God, and, despite all of the operatic flamboyance of the composition, this central theological message could not be clearer. It was the artist's genius for cutting right to the core of such subtle doctrinal matters and giving vivid, forceful expression to essential truths that made him the preferred painter of the intellectual elite of Toledo.

Much has been written about the scintillating surface and the flamelike quality of this painting. It is certainly the

culmination of the major stylistic trends of El Greco's career up to this point and it opens the way to the final phase of his art. The viewer is struck by the curious vertical bands on both sides of the painting — the strips in which hundreds of varied brushstrokes create a sparkling pattern. These are places where the artist cleaned his brush of excess paint; the bands were covered by the original framework of the altarpiece.

A small workshop replica (111 x 47 centimeters) is preserved in the National Gallery in Rome. It forms a pair with an *Adoration of the Shepherds* of identical dimensions in the same museum, a version that is a replica of the large *Adoration* in the Rumanian National Museum in Bucharest (fig. 50). The Bucharest canvas, whose dimensions match those of the present painting, is generally agreed to have been part of the altarpiece of the College of Doña María de Aragón also. When El Greco died in 1614, he left unfinished an even larger version of the *Baptism*; it was completed by his son, Jorge Manuel, and delivered to the client, the Hospital of Saint John the Baptist, where it remains (see fig. 105).

Provenance: High altar, College of Doña María de Aragón, Madrid; Museo Nacional de la Trinidad, Madrid, no. T1140.

Bibliography: Museo del Prado catalogue (Madrid, 1889); Cossío (1908), pp. 293–295, no. 59, fig. 38; Mélida (1915), pp. 101–102; Byron (1929); idem and Rice (1930), p. 13, pl. 26; Mayer (1931), no. 38, pl. XXVII; Legendre and Hartmann (1937), p. 153; Zervos (1939), pp. 125–126, figs. on pp. 127–132; Gómez Moreno (1943), pp. 34–35, 38, 128, pl. XLIV; Goldscheider (1949), figs. 114–116; Camón Aznar (1950), pp. 713–721, no. 69, figs. 544–549; Guinard (1956), pp. 26, 44, fig. on p. 24; Wittkower (1957), p. 49, fig. on p. 46; Soehner (1957), pp. 158–162, 167, 185; idem (1958–1959), no. 54; Kubler and Soria (1959), p. 217; Soehner (1960), pp. 202–203; Wethey (1962), vol. 1, pp. 45, 48, 52, figs. 131, 132, 155, 399; ibid., vol. 2, no. 14; Manzini and Frati (1969), no. 197c, pls. XLI, XLII; Camón Aznar (1970), pp. 725–731, no. 70, figs. 598–603, pl. facing p. 724; Madrid, Prado (1972), no. 821; Cossío (1972), no. 38; Lafuente Ferrari and Pita Andrade (1972), pp. 63, 64, 66, 79, no. 54, fig. 76; Gudiol (1973), pp. 176, 182–187, no. 140, figs. 168, 169; Davies (1976), pp. 13–14, pl. 23.

34 (plate 26)

Pentecost

Oil on canvas, 275 x 127 cm. (108¼ x 50 inches)
Restored signature at lower center in tiny cursive Greek letters: *doménikos theotokópoulos e'poíei*
Circa 1600 [?]
Madrid, Museo del Prado

The history of this canvas is not clearly documented, and scholars have differed greatly about its date and its origin. In 1931 Mayer suggested that it was grouped with five other large canvases as part of the decoration of the Church of the College of Doña María de Aragón in Madrid. In 1943 Gómez Moreno adopted Mayer's idea, proposing further

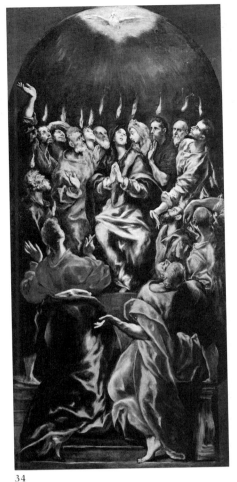

34

that the paintings were arranged in two stories on the high altar with three paintings in each story. Wethey methodically disputed this hypothetical reconstruction of the altarpiece on several grounds, including his belief that the *Pentecost* is manifestly later in style. Other writers, among them Gudiol and the authors of the 1972 Prado catalogue, were certain at least that the *Pentecost* and the *Resurrection* in the Prado (fig. 73), which are exactly the same size and have arched tops, had both originally been from the same, unknown altarpiece. (Wethey also had disagreed with that.) In chapter 3 of this book, Pérez Sánchez revives Gómez Moreno's theory and proposes an arrangement of the Doña María de Aragón altarpiece that includes this painting. This would date the picture no later than 1600, an earlier date than has usually been assigned it.

The Pentecost, or the Descent of the Holy Spirit, is a fairly common theme in sixteenth- and early-seventeenth-century altarpieces in Castile. On the Feast of Pentecost following Christ's Ascension, a large gathering of his followers formed. While they were together, "suddenly there came a sound from heaven as of a rushing mighty wind, and it filled all the house where they were sitting. And there appeared unto them cloven tongues like as of fire, and it sat upon each of them. And they were all filled with the Holy Ghost, and began

to speak with other tongues, as the Spirit gave them utterance" (Acts 2:2–4).

Provenance: High altar, College of Doña María de Aragón, Madrid [?]; Museo Nacional de la Trinidad, Madrid, no. T1138; Sabadell Museum (1884–1902).

Bibliography: Cossío (1908), p. 288, no. 67; Mayer (1926), p. 19, no. 109; Mayer (1931), pp. 105–106; Legendre and Hartmann (1937), p. 235; Gómez Moreno (1943), pp. 34–35; Goldscheider (1949), fig. 192; Camón Aznar (1950), pp. 958–967, no. 208, figs. 745–750; Soehner (1957), p. 194; idem (1958–1959), p. 204, no. 126; Wethey (1962), vol. 1, p. 50, fig. 195; ibid., vol. 2, pp. 9–10, 71, no. 100; Manzini and Frati (1969), p. 119, no. 146a; Camón Aznar (1970), pp. 27, 31, 33, 958–968, no. 220, figs. 813–818, pls. between pp. 964–965; Cossío (1972), no. 137; Lafuente Ferrari and Pita Andrade (1972), p. 160, no. 108; Madrid, Prado (1972), no. 828; Gudiol (1973), pp. 230–235, 238–239, 353, no. 191.

35

35 (plate 4)
View of Toledo

Oil on canvas, 121.3 x 108.6 cm. (47 3/4 x 42 3/4 inches)
Signed at lower right in cursive Greek:
doménikos theotokópoulos e'poíei
Circa 1600
New York, The Metropolitan Museum of Art. Bequest of Mrs. H. O. Havemeyer 1929, H. O. Havemeyer Collection

Since its publication by Cossío in 1908, this painting has become one of El Greco's most famous works and has come to stand for the special relationship that existed between the artist and his adopted city. In discussing the picture, most writers have touched on the tempestuous or moonlit sky, the liberties El Greco took in the placement of the city's prominent landmarks, and what these distortions may mean within the context of his time.

Wethey suggested that the northern tradition of the panoramic landscape, as represented by Pieter Brueghel's works and those of Dutch and Flemish artists working in Rome around 1570, had an impact on El Greco. More recently, Brown (1981) has related the painting to the tradition of the emblematic city view, which was a way of broadcasting the fame or greatness of a city or town; he interprets the painting as an expression of the resurgent civic pride that manifested itself in late-sixteenth-century Toledo. This local patriotism was based on a renewed consciousness of past glories and a determination to maintain Toledo's preeminent place among Spanish cities. Brown also contrasts the painting with another view of Toledo (fig. 4); this view was made in 1563 for cartographic purposes by the Flemish artist Anton van den Wyngaerde, who made a large number of drawings of Spanish cities and towns for Philip II.

Comparison of these two views of Toledo demonstrates the vast divergence in the purposes of the two artists. El Greco shows only the easternmost part of the city. Dominating its hill, whose steepness is exaggerated, is the *alcázar*, or royal palace (see fig. 2); the artist has depicted its northern facade, which was designed by Alonso de Covarrubias, architect for Emperor Charles V and father of Antonio and Diego de Covarrubias y Leiva, whom El Greco portrayed around 1600 (cat. nos. 61, 62). Displaced to the left of the *alcázar* is the belltower of the cathedral, which would actually be far to the right and outside the scope of the picture. At the bottom of the hill, spanning the river, is the Alcántara Bridge, built by the Romans and in continuous use ever since. (The river itself has been portrayed to the right of its actual location.) Above and to the left of the bridge is the Castle of San Servando. Beneath the castle, near the left margin of the picture, is a mysterious group of buildings resting on a patch of white. These buildings, resembling a convent or monastery, relate to no known structures and seem to be an invention of the artist. Although he subsequently rejected the idea, Wethey at one point speculated that the patch of white on which these buildings rest is intended to be a cloud similar to the one in the *View and Plan of Toledo* (cat. no. 55; pl. 9) on which El Greco placed the model of the Hospital of Saint John the Baptist. Brown and Kagan (1982) agree that the patch is intended as a cloud and suggest that the structures may represent the Agaliense monastery where Saint Ildefonso, patron saint of Toledo, went on retreat. According to Pedro Salazar de Mendoza's biography of the saint, this monastery was located on the north side of the city, near the river, and specifically on a "flat clearing [*llano*] on the side of a hill" (Salazar [1618], pp. 30–32). In its arbitrary regrouping of historic monuments both past and present, El Greco's painting clearly falls more within the tradition of the emblematic city view than within that represented by the objective panorama of van den Wyngaerde.

The enormously evocative mood of the painting has inspired many attempts to explain it. Davies, who calls the picture a "hymn to the forces of nature," relates it to contemporary spiritual literature, especially to Fray Luis de León's *Vida retirada*. The mood of the painting, it should be emphasized, is not at all unlike that of the landscapes that appear in El Greco's religious compositions from the late 1590s on. The background of *Saint Joseph and the Christ Child* (fig. 94; see also cat. no. 29; pl. 48), for example, is virtually identical to this one except for the interval created by the insertion of the figures in the foreground; and the *Virgin of the Immaculate Conception* from the Oballe Chapel (pl. 24) makes use of elements from the present painting's left side. In terms of its brooding quality, the *View of Toledo* resembles many other El Greco paintings of this period. (It has even been unconvincingly proposed that the scene is a fragment of a large *Crucifixion*.) It does not seem warranted, therefore, to attach a special significance to the mood of this picture that would not apply to the artist's style in general at this date.

When the artist died in 1614 there were three landscapes of Toledo listed among the paintings in his studio. When his son Jorge Manuel's possessions were inventoried in 1621, two of those landscapes ("*Dos paises de Toledo, de bara y terzia en quadrado*") were listed again; their size corresponds closely to the present canvas. This painting is also probably the one described in the 1629 inventory of the possessions of El Greco's friend and patron Pedro Salazar de Mendoza as "*un pais de Toledo acia la puente de Alcantara*" ("a landscape of Toledo looking toward the Alcántara Bridge"). Salazar, an avid collector of maps and city views, was the owner of El Greco's *View and Plan of Toledo*.

Provenance: Pedro Salazar de Mendoza, Toledo (1629) [?]; Countess of Añover y Castañeda, Madrid; Mrs. H. O. Havemeyer, New York.

Bibliography: Ceán Bermúdez (1800), vol. 5, p. 12; Cossío (1908), pp. 451–456, nos. 83, 403, fig. 137; Trapier (1925), pp. 129 f., 156; San Román (1927), p. 300, nos. 137, 138; J. F. Willumsen, *La jeunesse du peintre El Greco* (Paris, 1927), vol. 2, pp. 669 f., pl. CII; Frank Jewett Mather, Jr., "The Havemeyer Pictures," *The Arts* 16 (Sept. 1929–May 1930): 459–462, fig. on p. 60; Mayer (1931), pp. xxxii, no. 315, pl. LXVIII; Legendre and Hartmann (1937), pl. XVI; Harry B. Wehle, *A Catalogue of Italian, Spanish and Byzantine Paintings* (The Metropolitan Museum of Art, New York, 1940), pp. 231, 232, no. 29.100.6, fig. on p. 232; Enriqueta Harris, *El Greco: The "Purification of the Temple" in the National Gallery, London,* The Gallery Books, no. 2 (London, 1943), fig. 2; Gómez Moreno (1943), p. 37; Goldscheider (1949), fig. 179; Bronstein (1950), p. 110, fig. on p. 111; Camón Aznar (1950), pp. 967–972, no. 699, fig. 753; Lafuente Ferrari (1953), p. 215, fig. 134; Marañón (1956b), fig. 75; Soehner (1957), pp. 158–159, 163–164, 167, 170; Gaya Nuño (1958), no. 1412; Kubler and Soria (1959), p. 218, pl. 111A; Wethey (1962), vol. 1, pp. 58, 63–64, figs. 141, 142; ibid., vol. 2, no. 129; Manzini and Frati (1969), no. 121, pl. XXI; Camón Aznar (1970), pp. 968–973, no. 686, figs. 822, 823; Lafuente Ferrari and Pita Andrade (1972), pp. 75–76, 133, no. 123, pls. I, II; Cossío (1972), no. 384; Gudiol (1973), p. 188, no. 143, figs. 172, 173; Davies

(1976), p. 15, pl. 39; Jonathan Brown, "El Greco's 'View of Toledo,'" *Portfolio* 3 (Jan.– Feb. 1981): 34–38; idem and Richard L. Kagan, "El Greco's 'View of Toledo,'" in Brown (1982).

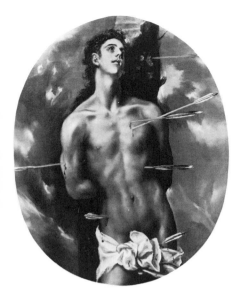

36

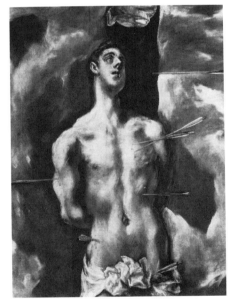

Figure 111. El Greco. *Saint Sebastian,* 45 x 33 inches, circa 1610–1614 (Madrid, Museo del Prado)

36 (plate 51)

Saint Sebastian

Oil on canvas, oval, 88.9 x 67.9 cm.
(35 x 26¾ inches)
Circa 1600
Private collection

After the monumental Italianate *Saint Sebastian* of Palencia (cat. no. 10; pl. 25), it was two decades before El Greco returned to the subject, so far as can be determined from surviving paintings. There are two late versions of the subject: the present one—formerly in the royal collection in Bucharest—which must have been executed around 1600, and a very late work in the Prado (fig.

111). Whereas both may originally have been full-length paintings of the saint standing in a landscape, they have been greatly reduced in size and altered in shape: the Bucharest version has been truncated just below the saint's loins and cut into an oval; the Prado version has also been cut just below the loin cloth. What may be the bottom part of one of the canvases, showing just the legs and feet and the landscape, has been discovered in a private collection in Madrid; Gudiol published a photographic reconstruction based on this fragment and the Prado torso that is convincing. With the figure of Sebastian thrust upward against the sky and a scene on the banks of the Tagus beyond his feet, the reconstruction is typical of the full-length compositions of saints in a Toledan landscape executed from around 1600 onward (for example, cat. no. 37; pl. 52).

Judging by the two surviving torso fragments, the Bucharest and the Prado compositions must have been very similar originally. In the Bucharest version, the axis of the torso is slightly more diagonal in relation to the vertical tree trunk to which it is tied. It also has a somewhat "prettier" and more refined face. The position of the arrows in the two compositions is virtually identical. The surface of the Bucharest version has been somewhat flattened in an old relining, and, as noted by Waterhouse (according to Wethey), it has lost its glazes. The Prado torso is in excellent condition. I do not concur with Wethey that its looseness of technique suggests workshop participation; it would appear to be a wholly genuine work of the final years.

Provenance: Royal Palace, Bucharest.

Bibliography: L. Bachelin, *Tableaux anciens de la Galerie Charles 1er, roi de Roumanie* (Paris, 1898), p. 222, no. 169; Cossío (1908), no. 367, fig. 91 bis; Mayer (1926), no. 301; A. Busuioceanu, "Les tableaux du Greco de la collection royale de Roumanie," *Gazette des Beaux-Arts,* 6th series, vol. 11 (May 1934): 298–299, fig. 10; idem, *Les tableaux du Greco de la collection royale de Roumanie* (Brussels, 1937), pp. 18–19, pls. XIII, XIV; Paris, *Gazette des Beaux-Arts* exhibition (1937), no. 5; Legendre and Hartmann (1937), p. 468; Gómez Moreno (1943), p. 33; Camón Aznar (1950), p. 910, no. 536, figs. 710, 711; Soehner (1957), pp. 159, 167; Gaya Nuño (1958), no. 135B; Wethey (1962), vol. 2, no. 280; Manzini and Frati (1969), no. 122; Camón Aznar (1970), p. 913, no. 536, fig. 773; Cossío (1972), no. 313; Gudiol (1973), p. 236, no. 194, fig. 218.

37 (plate 52)

Saint John the Baptist

Oil on canvas, 111.1 x 66.0 cm. (43¾ x 26 inches)
Signed on the rock at lower right in cursive Greek: *doménikos theotokópolis* [sic] *e'poíei*
Circa 1600
San Francisco, The Fine Arts Museums of San Francisco. Purchased with Funds from Various Donors

Saint John the Baptist was the last of the prophets of Christ and the first of the New Testament saints. He prepared the way for Christ's coming by preaching baptism for the remission of sins. At an early age Saint John left his parents and went to dwell in the wilderness, where, according to Saint Mark, he clothed himself in animal skins and camel's hair. El Greco and his workshop made several versions of this composition, which shows the figure of the Baptist standing alone. (The artist also incorporated the same figure into a paired-saint composition with John the Evangelist now in San Ildefonso, Toledo.) The present work, however, is by far his finest picture of the Baptist. Wethey notes the "nacreous flesh tints" and brilliancy of color, qualities that in part derive from the painting's good state of preservation.

The extraordinary elongation of the body of the saint—which is matched by the mannered elegance of the fingers of his right hand—represents the ultimate development in El Greco's search for *grazia* (a concept discussed in chapter 2). Using a low horizon line, the painter has made the figure appear to tower above the landscape. The landscape, indeed, is Castilian, and the building just to the right of Saint John strongly resembles the Escorial; thus, in keeping with his usual practice, El Greco monumentalized what Soehner called the "Christian heroes" in the familiar ambiance of his own land.

Provenance: Carmelitas Descalzas, Malagón (Ciudad Real; until 1929); Félix Schlayer, Madrid; Rudolph Heinemann, Lugano;

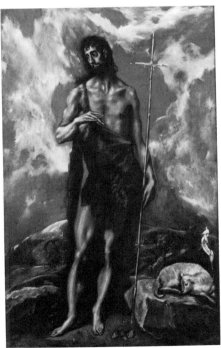

37

bought by the M. H. de Young Memorial Museum, San Francisco, in 1946.

Bibliography: Legendre and Hartmann (1937), p. 289 (misidentified as in B. Koehler Collection); Camón Aznar (1950), p. 910, nos. 409, 410, 413, figs. 703 (misidentified as in B. Koehler Collection), 705; Soehner (1957), pp. 159, 167; Gaya Nuño (1958), no. 1304; Wethey (1962), vol. 1, p. 48, figs. 294–296; ibid., vol. 2, no. 250; M. H. de Young Memorial Museum, *European Works of Art in the M. H. de Young Memorial Museum* (San Francisco, 1966), p. 95; Manzini and Frati (1969), no. 118a; Camón Aznar (1970), p. 911, no. 416, figs. 765, 767–769; Cossío (1972), no. 273; Lafuente Ferrari and Pita Andrade (1972), no. 91, fig. 77; Gudiol (1973), p. 197, no. 151, fig. 178.

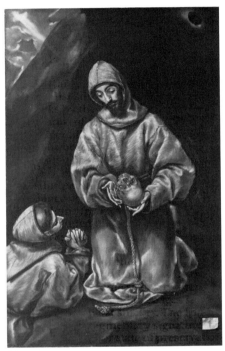

38

38 (plate 21)

Saint Francis and Brother Leo Meditating on Death

Oil on canvas, 168.5 x 102.9 cm. (66³/₈ x 40¹/₂ inches)
Signed on the paper at lower right in cursive Greek: *doménikos theotokópoulos e'poíei*
Circa 1600–1605
Ottawa, National Gallery of Canada/ Galerie Nationale du Canada

The most famous of El Greco's images of Saint Francis is this one, which exists in virtually countless versions, some of them no doubt spawned by an engraving made by Diego de Astor in 1606. Of all the many versions, the finest and the best preserved is the painting in the National Gallery of Canada. In this work Saint Francis and Brother Leo, dressed in the coarse, hairy habits of the Franciscan order, are shown in the dark opening of a grotto. Saint Francis is kneeling and holding in his hands a human skull. He is balancing it so lightly with his dainty fingers, and the play of light and shadow on his hands is so intense, that a vibrant rhythm is set up — a rhythm that is echoed by the folds of his habit and that seems to charge the figure with life. This sense of eddying life surrounding the death's head at the center of the composition is the most remarkable feature of the painting — an aspect that has not survived in many of the other versions, most of which have been subjected to abrasive cleanings. The figure of Brother Leo is kneeling on a lower level, clasping his hands in a prayerful gesture. The light falls hard upon him also, and his staring at the skull held by Saint Francis refocuses the viewer's attention on the picture's center. This original and daring work of art, which eschews all "prettiness" in the spirit of the saint it depicts, shows the artist's genius for creating a design that is inseparable from its meaning and in which a symbol becomes a kernel of the whole and not merely a theological stage prop.

Meditation on the brevity of life and the certainty of death was fundamental to Counter-Reformation teaching, a legacy from the Middle Ages. Saint Ignatius Loyola in his *Spiritual Exercises* had recommended using the human skull as an object of meditation, and, under the immense influence of his book and the teachings of the Jesuits, the skull as a symbol was treated with a certain sense of drama in paintings of the late sixteenth and early seventeenth centuries. This was not just a Spanish phenomenon, of course; Cossío (1908) was the first to remark in print on the resemblance between El Greco's composition showing Saint Francis with a skull and Shakespeare's literary image of Hamlet with Yorick's.

Provenance: Parish church, Nambroca (Toledo; until 1927); Linares (dealer), Madrid; Tomás Harris, London; purchased by the National Gallery of Canada in 1936.
Bibliography: Mayer (1931), no. 83; Legendre and Hartmann (1937), pp. 399–401, 421; Camón Aznar (1950), p. 534, no. 632, figs. 405, 406 (also no. 554, fig. 227, misidentified as belonging to the National Gallery of Canada); R. H. Hubbard, *European Paintings in Canadian Collections* (Toronto, 1956), pp. 38, 148, pl. XIX; idem, *Catalog of Painting and Sculpture* (National Gallery of Canada, Toronto, 1957), vol. 1, p. 48, no. 4267; Soehner (1957), pp. 135, 179; José Gudiol, "Iconography and Chronology in El Greco's Paintings of St. Francis," *Art Bulletin* 44, no. 3 (Sept. 1962): 200–201; Wethey (1962), vol. 1, p. 49, fig. 275; ibid., vol. 2, p. 116, no. 225; Manzini and Frati (1969), no. 132a; Camón Aznar (1970), p. 561, no. 609, fig. 443; Myron Laskin, Jr., *St. Francis and Brother Leo Meditating on Death* (Ottawa, 1971); Lafuente Ferrari and Pita Andrade (1972), no. 68, fig. 71; Gudiol (1973), p. 198, no. 154, fig. 180; Davies (1976), p. 14.

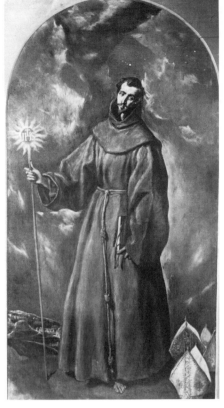

39

39 (plate 53)

Saint Bernardino

Oil on canvas, 269 x 144 cm. (105⁷/₈ x 56³/₄ inches)
Signed at lower right in large cursive Greek letters: *doménikos theotokópoulos e'poíei*
1603–1604
Toledo, Museo del Greco. Fundaciones Vega-Inclán

In 1603 the Franciscan College of Saint Bernardino commissioned El Greco to design an altar and execute a painting of Saint Bernardino. Although the contract has been lost, a receipt of payment dated February 3, 1603, informs us that the total price agreed upon was 3,000 reales (about 275 ducats). The final payment was made on September 10, 1604, indicating that the work had been completed by that time.

Saint Bernardino was born into a patrician family in the city-state of Siena in 1380. He spent a devout youth and studied law there. During an outbreak of the plague in 1400, he spent months ministering to the sick, and afterward he decided to join the Order of Saint Francis. Ordained a priest, he traveled widely throughout Italy and became extremely well known and influential in religious and public affairs. He was offered the bishoprics of Siena, Ferrara, and Urbino, all of which he refused in order to continue his work as a missionary. In his preaching he made use of a tablet inscribed with the Greek letters IHS, symbolizing the name of Jesus. For

this he was accused of heresy by Pope Martin V, but he was acquitted at his trial in Rome, and he became known as the founder of the cult of the Holy Name of Jesus. Bernardino died in 1444.

El Greco has depicted the saint in the simple habit of the Franciscan order, standing barefoot and towering over a Toledan landscape with his elongated form silhouetted against a stormy sky. He carries in his right hand a staff topped with a radiant sun and the golden letters IHS. At his feet are three miters representing the three bishoprics that he declined in his great humility.

No copies or other versions of this composition have survived. The inventory of El Greco paintings taken in 1621 listed number 128 as a small painting of the subject; Camón Aznar pointed out that it did not correspond to the size of the seminary's altarpiece, and Wethey speculated that it must have been a study or a replica that is now lost.

El Greco also designed the painting's frame, which has Ionic-Doric columns. When the College of Saint Bernardino was dissolved in 1846, the painting was separated from its frame. The two were reunited again in 1962, when the Museo del Greco acquired the frame from the convent, where it had been deposited for more than a hundred years.

Provenance: College of Saint Bernardino, Toledo; Instituto de Segunda Enseñanza, Toledo; Museo del Prado, Madrid (on loan 1902–1912).

Bibliography: Viniegra (1902), no. 61; Cossío (1908), no. 68; San Román (1910), pp. 43–47, 217–221; Ramírez de Arellano (1920), p. 294; F. J. Sánchez Cantón, *La nueva sala del Museo del Greco* (Madrid, 1921); Mayer (1926), no. 221, pl. LXI; Legendre and Hartmann (1937), p. 351; Manuel Gómez Moreno (1943), p. 36; Goldscheider (1949), pl. 162; Camón Aznar (1950), pp. 799, 801, no. 475, figs. 616–618; Guinard (1956), p. 78; Soehner (1957), pp. 168, 171, 179; idem (1958–1959), no. 81; Wethey (1962), vol. 1, pp. 48, 106, fig. 297; ibid., vol. 2, p. 16, no. 200; Sánchez Cantón (1963), pp. 42–44, pl. XXIV; María Elena Gómez Moreno (1968), pp. 29–30; Manzini and Frati (1969), no. 124; Camón Aznar (1970), pp. 808, 811, no. 482, figs. 675–677; Cossío (1972), no. 196; Lafuente Ferrari and Pita Andrade (1972), pp. 66, 128, no. 90, fig. 78; Gudiol (1973), p. 219, no. 180, fig. 197; Davies (1976), no. 29.

40 (plate 54)

Saint Jerome as Cardinal

Oil on canvas, 108.0 x 87.0 cm. (42½ x 34¼ inches)
Circa 1600–1610
New York, The Metropolitan Museum of Art. Robert Lehman Collection 1975

Saint Jerome (circa 342–420), one of the four "Doctors of the Church," made his great contribution to Christianity by translating the Bible into Latin (the version known as the Vulgate). Ordained a priest in Rome, Jerome traveled widely, living for a while in the Syrian desert before returning to Rome to serve as secretary to Pope Damasus I. In 386 he

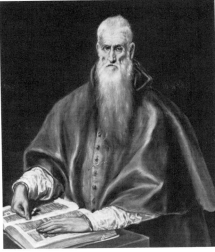

40

left Rome again and retired to a monastery in Bethlehem, where he spent the rest of his life working on his monumental Bible and leading an existence largely devoted to contemplation and study. Although the College of Cardinals did not exist in the fourth century, the early priests of Rome had functions that later fell to the cardinals, which is why Saint Jerome is often depicted wearing the crimson robes of that office. Most representations of Saint Jerome as a cardinal, though, show him in his study accompanied by the lion that became his constant companion after he removed a thorn from its paw. El Greco's startlingly portraitlike image of Saint Jerome shows the saint at a simple green-draped table. He is looking to his left, as if he has just been distracted from his reading; with his left hand he marks his place in his book, while with his right thumb he keeps track of the notes, which are placed in the margin as was common in scholarly books of El Greco's time.

The portraitlike quality of the composition led in the past to attempts to identify the image as a portrait of Cardinal Gaspar de Quiroga (1513–1594), who was archbishop of Toledo from 1577 until his death (see fig. 19). Cossío disproved that identification in 1908 by comparing the work to a known portrait of Quiroga that resembles this head in no way. A smaller workshop version of the *Saint Jerome as Cardinal* in the National Gallery in London bore, prior to its cleaning in 1952, an apocryphal inscription with the name "L. Cornaro," which led in the nineteenth century to the belief that the work was a portrait of Luigi Cornaro (1467?–1566), Venetian author of *Discorsi della Vita Sobria* (1558). Comparison with a portrait of Cornaro by Tintoretto in the Pitti Palace, however, put that theory to rest. These false identifications are cited simply as testimony to the artist's success in creating a convincing imaginary portrait of the early Christian saint.

There are five versions of this picture attributed to El Greco and his workshop (including cat. no. 41; pl. 55). The two largest and most important are the one in the Frick Collection, New York, and the present one, in the Lehman Collection. The Frick version is generally thought to be the earlier of the two. In the Lehman version, the cape of Saint Jerome is a much deeper crimson, the shadows are stronger, and the folds a bit more nervously drawn. These qualities would suggest a somewhat later date— sometime in the first decade of the seventeenth century. Either painting could have been the larger of the two depictions of this subject listed among El Greco's possessions in 1614 and in 1621; as the Lehman picture is the later of the two, it is more likely to have been the one listed.

The format of El Greco's painting of Saint Jerome is very similar to that of several of his portraits of ecclesiastics of his time. For example, both the posthumous portrait of Cardinal Juan de Tavera (cat. no. 65) and the portrait of Giacomo Bosio (cat. no. 66; pl. 73) make use of a table and include books to suggest the scholarly pursuits of the sitters. Beyond that, Saint Jerome is presented here as the essence of spiritual discipline and strength of character. Toledo, more than most places, was filled with men who may have patterned their lives after such a scholarly cleric and who might have seen in this noble effigy the paradigm of themselves. Indeed, *Saint Jerome as Cardinal* is one of El Greco's most extraordinary and original creations, one of those rare masterpieces that can stand for a whole age.

Provenance: Marquis del Arco, Madrid; purchased by Philip Lehman between 1908 and 1915.

Bibliography: Cossío (1908), p. 565, no. 85; Walter W. S. Cook, "Spanish and French Paintings in the Lehman Collection," *Art Bulletin* 7, no. 2 (Dec. 1924): 51–54; Mayer (1926), no. 277, pl. LXV; Walter W. S. Cook, *The Philip Lehman Collection* (New York, 1928), pl. CI; Wilhelm R. Valentiner, *Das Unbekannte Meisterwerke in Offentlichen und Privaten Sammlungen* (Berlin, 1930), pl. 86; Legendre and Hartmann (1937), p. 444; Camón Aznar (1950), p. 881, no. 502, fig. 687; Wethey (1962), vol. 1, fig. 288; ibid., vol. 2, no. 241; Manzini and Frati (1969), no. 98b; Camón Aznar (1970), pp. 587, 892–893, no. 506, fig. 749; Cossío (1972), no. 262; Gudiol (1973), pp. 153–154; Baetjer (1981), pp. 35–37.

41 (plate 55)

Saint Jerome as Cardinal

Oil on canvas, 64 x 54 cm. (25¼ x 21¼ inches)
Circa 1600–1605
Madrid, Várez-Fisa Collection

It appears that until now no one writing on El Greco's work has actually seen this painting since Cossío in 1908. Its presence in the exhibition, therefore, affords specialists the opportunity to assess its relationship with other versions of the

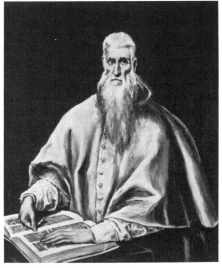

41

subject (among them, cat. no. 40; pl. 54). Wethey lists five versions in the category of works by the artist himself and his workshop (of these, three are small canvases, including the present one), and he lists four others as copies by other artists. Solely on the basis of photographs of the work, Wethey tentatively attributed this painting to El Greco with the assistance of his workshop. Soehner, also judging from photographs alone, had concluded that it was entirely by the workshop.

This *Saint Jerome as Cardinal* and the reduced version of the subject in the National Gallery in London were originally about the same size; the latter has been trimmed around the edges so that it is now somewhat smaller. The London version has a fragmentary signature, but the painting's poor state of preservation makes it difficult to determine if it is anything more than a workshop copy. The Adanero version, as the present work has been known, is much better preserved and is an impressive painting. The subject's head is strongly executed and full of character.

The inventory of El Greco's studio drawn up in 1614 listed *"Un S. Jeronimo cardenal pequeño."* Number 162 in the 1621 inventory of El Greco paintings still in his son Jorge Manuel's possession was a *Saint Jerome as Cardinal* almost exactly this size—³/₄ by ²/₃ varas (about 62 x 55 cm.). While it could have been either the London canvas or the present picture, it could also have been the very small painting in the Musée Bonnat in Bayonne, a version that shows only the subject's head and shoulders. Wethey thought this work an oil sketch, intact; MacLaren, more plausibly, believed it to be a fragment, in which case it would also have originally measured about ³/₄ by ²/₃ varas. Even though it is dirty and somewhat abraded, the Musée Bonnat painting, with its brilliant and spontaneous brushwork, is generally agreed to be the finest of the small versions.

Provenance: Count of Adanero, Madrid (nineteenth century); Marquis of Castro Serna, Madrid.
Bibliography: Viniegra (1902), no. 55; Cossío (1908), no. 96; Legendre and Hartmann (1937), p. 446; Camón Aznar (1950), p. 881, no. 507, figs. 685, 686; MacLaren (1952), p. 19; Soehner (1958–1959), no. 104; Wethey (1962), vol. 2, no. 242; Manzini and Frati (1969), no. 98d; Camón Aznar (1970), p. 893, no. 510, fig. 748; Cossío (1972), no. 263; Gudiol (1973), no. 103.

42 (plate 18)
Nativity

Oil on canvas, circular, 128 cm. (50³/₈ inches) in diameter
Signed in the center, below the Infant Christ, in small cursive Greek letters: *doménikos theotokópoulos e'poíei*
1603–1605
Illescas, Hospital of Charity

The problems that El Greco had with his clients over payment for the work he did for the Hospital of Charity at Illescas were the worst and most humiliating of his entire career. (See chapters 2 and 3 for discussions of the lawsuits and of the paintings and altarpieces involved.) The litigation, though, provides some documentation about the original appearance of the ensemble, which is no longer arranged as it was at first. In 1938 Enriqueta Harris published an excellent article on El Greco's overall design concept for the chapel. Originally, the oval canvas *Coronation of the Virgin* (fig. 100) occupied the center of the vault over the main altar. In roundels on either side of the *Coronation* were the *Annunciation* (fig. 101) and the *Nativity.* Thematically, all of these paintings glorify the Virgin as the unblemished recipient of God's grace.

The *Nativity* is the only instance of this particular subject in El Greco's oeuvre: the Adoration of the Shepherds is a theme he frequently treated (see, for example, figs. 50, 55), but no other scene of the Holy Manger depicts only the Virgin and Saint Joseph adoring the Infant Christ. The head of an ass is visible in the shadows to the left of the Virgin; and the head of an ox, quite fore-

42

shortened, looks up into the composition from below—an indication of the painting's high placement in the original setting. Both of these animals are derived from a passage in the first chapter of Isaiah: "The ox knoweth his owner, and the ass his master's crib" (Isa. 1:3).

In the original contract for the commission, signed in 1603, the painters are listed as Domingo Griego (El Greco) and Jorge Manuel, his son, which indicates that Jorge Manuel was by then a full-fledged partner in El Greco's studio and that the clients expected him to participate in the work. It is generally agreed that he assisted his father on the *Nativity.*

Bibliography: Cossío (1908), no. 51; Mayer (1926), Appendix, no. 20a; Legendre and Hartmann (1937), p. 124; Harris (1938); Gómez Moreno (1943), pp. 36–37; Camón Aznar (1950), pp. 794–798, no. 16, figs. 614, 615; Guinard (1956), p. 83; Soehner (1957), p. 179; idem (1958–1959), no. 87; Wethey (1962), vol. 1, fig. 135; ibid., vol. 2, pp. 13–15, no. 22; Sánchez Cantón (1963), p. 42; Manzini and Frati (1969), no. 125d; Camón Aznar (1970), pp. 804–807, no. 16, figs. 673, 674; Cossío (1972), no. 18; Lafuente Ferrari and Pita Andrade (1972), pp. 129, 130, no. 99, fig. 91; Gudiol (1973), pp. 221–222, no. 183, figs. 201, 202.

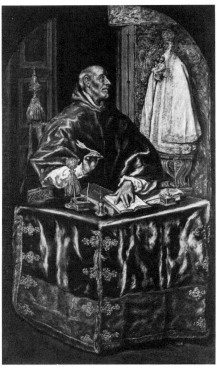

43

43 (plate 56)
Saint Ildefonso

Oil on canvas, 112.4 x 65.4 cm. (44¹/₄ x 25³/₄ inches)
Circa 1605–1614
Washington, National Gallery of Art. Andrew W. Mellon Collection 1937

Saint Ildefonso was a seventh-century archbishop of Toledo and is the patron saint of the city. This canvas is a replica

of a larger and more important one (fig. 103) made for—and still in—the Hospital of Charity in the small town of Illescas, on the road from Madrid to Toledo. Writing of the larger painting, Cossío (1908; pp. 312–313) was the first to comment on this unusual depiction of the saint, who is normally represented receiving the chasuble from the Virgin. Cossío conjectured that El Greco's painting portrays the Toledan saint in the act of writing his book on the virginity of Mary. According to Cossío, the abbot Juan Tritemio wrote that as soon as Saint Ildefonso finished the book, the Virgin appeared to him with his book in her hand to affirm her pleasure with it. El Greco, however, chose to represent Ildefonso before he encountered the apparition of the Virgin; the artist shows the saint still in the act of writing, glancing up at the image of the Madonna in search of inspiration. Cossío also noted that the image of the Virgin in El Greco's composition duplicates the actual wooden "miraculous" image in the church at Illescas. Harris (1938), who concurred with Cossío's interpretation, added that, according to tradition, Ildefonso had this wooden image of the Virgin in his oratory and later presented it to the convent at Illescas, which he founded.

As was his custom, El Greco has represented the saint in sixteenth-century dress, and all of the furnishings and objects shown, including the statue of the Virgin, are consistent with the style of the artist's own day. As Pérez Sánchez notes in chapter 3, this kind of image of the Church Father at his desk, pausing for inspiration in the act of writing, became popular in the early decades of the seventeenth century. As Soehner (1957) pointed out, El Greco more and more during the course of his career concentrated on portraitlike images of saints, inventing a new iconography and a new spirit of psychological absorption.

Since the painting of Saint Ildefonso was not mentioned in any of the lengthy documents connected with the lawsuits over the Illescas commission (these disputes are discussed in chapters 2 and 3), it seems likely, as Wethey has proposed, that the hospital's picture was painted before those commissioned in 1603 for the altarpiece and perhaps played a part in El Greco's obtaining the commission. The smaller version catalogued here is considered by Wethey to be a replica by El Greco's workshop. Cossío (1908), who thought it genuine, considered it a work from the last decade of the artist's life. The exaggerated, flashing highlights on the gray cape and the crimson table cover certainly suggest a later date than the larger version, and the modeling is a bit harder than that in the Illescas painting.

Provenance: Count of Quinto; Countess of Quinto (sale Paris, 1862, no. 64); Alphonse Oudry (sale Paris, 16–17 Apr. 1869, no. 139); J. F. Millet (sale Paris, 25 Apr. 1894, no. 261); Edgar Degas (sale Paris, 1918, no. 2); Knoedler & Co., London; Mellon Collection (donated to the National Gallery, Washington).
Bibliography: Cossío (1908), no. 299; Mayer (1926), no. 287; Legendre and Hartmann (1937), p. 433; Cook (1945), pp. 73–75; Goldscheider (1949), p. 187; National Gallery of Art, *Paintings and Sculpture from the Mellon Collection* (Washington, 1949), p. 42, no. 83; Camón Aznar (1950), p. 871, no. 495, fig. 676; Wethey (1962), vol. 1, fig. 133; ibid., vol. 2, p. 19, no. X-361; Washington, National Gallery (1965), p. 62, no. 83; Manzini and Frati (1969), no. 125Ee; Camón Aznar (1970), p. 880, no. 500, fig. 740; Cossío (1972), no. 255; Walker (1974), p. 236, fig. 308; Washington, National Gallery (1975), pp. 162–163, no. 83.

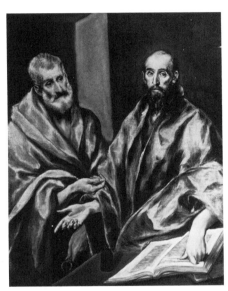

44

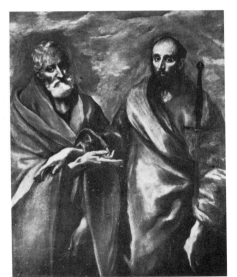

Figure 112. El Greco. *Saint Peter and Saint Paul*, 47¼ x 36¼ inches, circa 1595–1600 (Barcelona, Museo de Arte de Cataluña)

44 (plate 57)
Saint Peter and Saint Paul

Oil on canvas, 124 x 93 cm. (48⅞ x 36⅝ inches)
Circa 1605–1608
Stockholm, Nationalmuseum

Among Christ's disciples, Saint Peter and Saint Paul were considered the true founders of the Christian church. Toward the end of his career, El Greco painted several versions of a composition that portrayed the two saints together. The first of these (fig. 112), done around 1595–1600, is in the Museo de Arte de Cataluña in Barcelona. There he shows the two saints in three-quarter length, standing side by side. Saint Peter, on the left, holds the symbolic keys of heaven in his left hand. Saint Paul, on the right, holds an enormous sword, symbolic of his alleged martyrdom. The most striking aspect of the composition, however, is that the right wrists of the saints are interlaced in an eloquent gesture that perhaps suggests a linking of their individual characteristics to symbolize the essential strength of Christian faith.

In two later versions of this subject—one in Leningrad, and the present one from Stockholm—El Greco developed this concept further, and its importance is attested to by the fact that the composition was engraved by Diego de Astor (in 1608). The Stockholm version must be the latest of the three El Grecos, because the drapery here is a blaze of fiery lights and shadows. Saint Paul, rather than holding the sword, points to a passage in a book (the book, a reference to his epistles, is also his symbol). Instead of linking their wrists, the two saints gesture as though engaged in a theological dialogue. The rather hieratic presentation of the earlier work has thus been humanized and given more dramatic force. This is a truly noble image and a spectacular example of the artist's virtuosity.

Provenance: Viscountess of San Javier, Madrid; Marquis of Perinat, Madrid.
Bibliography: Viniegra (1902), no. 1; Cossío (1908), no. 120; Mayer (1926), no. 199, pl. XLVIII; Axel Gauffin, "El Grecos 'S. Petrus och S. Paulus' i National museum," *Nationalmusei arsbok* 5 (1935): 20–23; Legendre and Hartmann (1937), p. 345; Gómez Moreno (1943), p. 33; Goldscheider (1949), pl. 95; Camón Aznar (1950), p. 520, nos. 426, 427, fig. 381; Soehner (1957), p. 179 (identified as a second version); Wethey (1962), vol. 1, p. 49, fig. 320; ibid., vol. 2, p. 157, no. 277; Manzini and Frati (1969), no. 136a; Camón Aznar (1970), p. 528, no. 435, fig. 411; Cossío (1972), no. 321; Lafuente Ferrari and Pita Andrade (1972), pp. 61, 132, no. 114, fig. 100; Gudiol (1973), p. 245, no. 207, fig. 225.

45 (plate 58)
Christ on the Cross with Landscape

Oil on canvas, 188.0 x 111.8 cm. (74 x 44 inches)
Circa 1605–1610
Cleveland, The Cleveland Museum of Art. Gift of the Hanna Fund

Wethey distinguishes between the themes Christ on the Cross (showing Christ alone) and the Crucifixion (show-

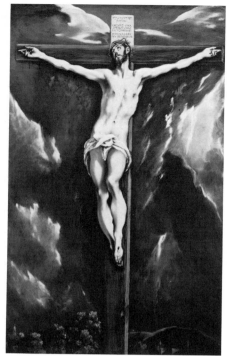

45

in the Cleveland composition, and at the foot of the Cross are the tops of some trees, at the left, and a domed structure nestled at the foot of a hill, at the right. Wethey was positive that at some point several inches were cut off the bottom of this painting, thus eliminating a portion of the original composition that is common to all other versions: skulls and bones at the very foot of the Cross and a diagonal road extending into the distance at the right with several horsemen galloping along it (see fig. 113). Waterhouse (1964), evidently on the basis of information provided by the

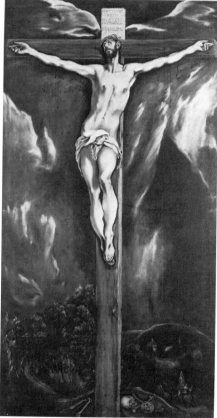

Figure 113. Workshop of El Greco. *Christ on the Cross in a Landscape,* 81⅞ x 40¼ inches, circa 1605–1610 (Philadelphia, Philadelphia Museum of Art. Wilstach Collection)

museum, wrote that the unpainted tacking edge along the bottom of the Cleveland picture negated this possibility. Further examination by the museum in 1977 reinforced the position of officials there that the painting has not been cut down. Wethey's surmise was certainly a reasonable one, however, for the composition is exactly like the other versions in most respects, and it seems odd that the artist would have eliminated the bottom part of his design, or, if he had, that no other version of this frequently copied subject reflects such an alteration. In any event, the composition makes perfect sense in its present form. Its deliberate character as a devotional image could not be made clearer than

by comparing it with the *Crucifixion* in the Prado (fig. 72), in which the Virgin, Saint John, Mary Magdalen, and three angels contribute to the narrative detail of the scene on Golgotha.

Provenance: Salesas Nuevas, Madrid; Tomás Harris, London (1952).
Bibliography: Paseo por Madrid (Madrid, 1815), p. 41; Cossío (1908), no. 81; Maurice Serullaz, *Cristo in croce* (Paris, 1947), unpaged; Camón Aznar (1950), no. 178, fig. 491; Henry S. Francis, "A 'Crucifixion' by El Greco," *The Bulletin of the Cleveland Museum of Art* 40, no. 1 (Jan. 1953): 4–7; Wethey (1962), vol. 1, fig. 186; ibid., vol. 2, no. 68; Ellis K. Waterhouse, review of Wethey (1962) in *The Burlington Magazine,* p. 106, no. 730 (May 1964): 238; Manzini and Frati (1969), no. 61c; Camón Aznar (1970), p. 655, no. 185, fig. 532; Cossío (1972), no. 109; Lafuente Ferrari and Pita Andrade (1972), p. 128, no. 94, fig. 79; Gudiol (1973), p. 162, no. 117, fig. 140.

46

46 (plate 59)
Saint John the Evangelist

Oil on canvas, about 100 x 76 cm. (39⅜ x 27⅞ inches)
Circa 1605–1610
Toledo, Cathedral

During the last decade of his career, El Greco played a major role in popularizing a new kind of pictorial ensemble—what the Spanish call the *Apostolado,* or "Apostle series." Such groups usually consist of thirteen pictures, twelve representing the Apostles and one representing the Saviour. There are several such series, or fragments of them, clearly associated with El Greco's studio, and they seem to have been in considerable demand from his workshop. Only two complete Apostle series showing the hand of the artist himself are intact today, however. One of these is in the sacristy of the Cathedral of Toledo, where it was recorded by Palomino in 1724; according to Kagan (chapter 1, p. 69) and Brown, it may have been bequeathed to the cathedral by Cardinal Bernardo de Sandoval y Rojas in the

ing Christ with donors or saints). Early in his career in Spain, El Greco created a monumental *Crucifixion with Two Donors* (fig. 70), a painting now in the Louvre, in which the crucified Christ, his beautifully modeled and languidly posed body affixed to the Cross with little evidence of pain, is silhouetted against a turbulent night sky. Still alive, Christ raises his eyes toward his Heavenly Father. By omitting the landscape and including the anachronism of two contemporary donors, the artist has eschewed narrative quality, instead presenting the subject as a devotional image reflecting the central mystery of Christianity. Precisely because of the juxtaposition of the naturalistic portraits and the idealized beauty of Christ's figure, the force of this mystery is magnified. Donor portraits had been a common feature in Crucifixion scenes since the Middle Ages, but their role had usually been supernumerary—an anachronism to be overlooked. In El Greco's painting, the crucified Christ functions not only as a Christian symbol, but also as a visual expression of the donors' faith, and it is that faith, a live and tangible thing, that may also be considered the theme of the picture.

The subject of *Christ on the Cross* was one that was repeated frequently by El Greco's studio, but few unquestionably autograph versions have survived. The finest of these is the large canvas in the Cleveland Museum of Art. In it, the basic pose of the Christ figure matches the earlier painting in the Louvre, but, in keeping with its later date, the figure is somewhat more elongated and its undulating contours more exaggerated by the blazing light that flickers across the musculature. The donors are absent

early seventeenth century. Soehner (1958–1959) and Wethey saw ample workshop collaboration in the Toledo series, even though it is one of the best of the *Apostolados*. The other complete *Apostolado* is now in the Museo del Greco in Toledo; left unfinished at the artist's death, this series was first placed in the Hospital of Saint James in Toledo, where it remained until about 1848. The selection of works from the two intact Apostle series exhibited here (cat. nos. 46–49; pls. 59–62) is made up of pictures that scholars generally accept as wholly by El Greco's own hand.

In each of the two complete sets, six of the saints face toward the right and six face toward the left, which suggests that each set was meant to be hung along the two lateral walls of a long room with the image of the Saviour placed at one end. Iconographically, the grouped paintings obviously represent the early Church in its most primitive form. The grouping of the Apostles and the Saviour was certainly not unknown as a subject in art; it was a theme incorporated into the sculptural or mural decoration of churches of both the Eastern and the Roman rites. But the conception of the subject as a series of portraitlike easel paintings was novel, and it reflected the new emphasis on the personality of the individual Apostles that characterized the Counter-Reformation. The symbology employed by El Greco follows traditional lines, but, as Soehner observed, the artist seems to have been striving to portray the individual temperament of each Apostle. During the Baroque period, artists such as Jusepe de Ribera carried this effort to individualize the Apostles to great lengths, achieving highly naturalistic images.

This painting of the Evangelist, the youngest of the Apostles, is one of the most beautiful works from the Toledo Cathedral *Apostolado*, all of which are three-quarter-length figures. Saint John is shown wearing a green tunic and a rose-colored mantle — the colors he is usually associated with — and holding a golden chalice from which a serpent emerges. This symbol of the saint refers to the legend that the emperor Domitian attempted to kill him by ordering him to drink poisoned wine; when he raised the chalice to obey, the poison departed in the form of a serpent.

Bibliography: Palomino (1715–1724), p. 840; Ponz (1772–1794), vol. 1, letter 2, par. 50; Ceán Bermúdez (1800), vol. 5, p. 9; Parro (1857), p. 545; Cossío (1908), no. 216; Mayer (1926), no. 153; Legendre and Hartmann (1937), p. 273; Alberto de Aguilar, "El 'Apostolado' de la Catedral Primada," *Boletín de la Sociedad Española de Excursiones* 45 (1941): 119–127; Camón Aznar (1950), p. 990, no. 277, fig. 771; Soehner (1958–1959), no. 73; Wethey (1962), vol. 1, fig. 211; ibid., vol. 2, no. 164; Manzini and Frati (1969), no. 131f; Camón Aznar (1970), p. 997, no. 289, fig. 843; Cossío (1972), no. 153; Lafuente Ferrari and Pita Andrade (1972), no. 81; Gudiol (1973), no. 271, fig. 281.

47

47 (plate 60)
Saint Luke

Oil on canvas, about 100 x 76 cm. (39³/₈ x 29⁷/₈ inches)
Circa 1605–1610
Toledo, Cathedral

Although Saint Luke was not one of the original twelve Apostles, El Greco included him in several of his "Apostle series" (see cat. no. 46 discussion). The Toledo Cathedral version (Luke does not appear in the Museo del Greco series) is by far the artist's most beautiful and sensitive image of the saint and one of the finest paintings of the group.

Saint Luke was a physician, but, according to popular belief, he was also known as a painter who did several portraits of the Virgin Mary and of Jesus. For this reason he is the patron saint of artists. From the late Middle Ages, it was common for painters to depict themselves as Saint Luke in the act of painting the Virgin's portrait. Eisler traces the history of the subject and repeats the suggestion often made that El Greco's *Saint Luke* is a self-portrait. Camón doubted this, and others, including both Lafuente and Pérez Sánchez (1976), rightly pointed out that the theory would seem to be contradicted by the apparent age of the saint, who is portrayed as substantially younger than El Greco's sixty-five or so years at the time he executed this painting.

Bibliography: Palomino (1715–1724), p. 840; Ponz (1772–1794), vol. 1, letter 2, par. 50; Ceán Bermúdez (1800), vol. 5, p. 9; Parro (1857), p. 545; Cossío (1908), no. 215 (misidentified as *Santiago* [*Saint James*]); Mayer (1926), no. 155 (misidentified as *Saint Bartholomew*); Legendre and Hartmann (1937), p. 275; Alberto de Aguilar, "El 'Apostolado' de la Catedral Primada," *Boletín de la Sociedad Española de Excursiones* 45 (1941): 119–127; Goldscheider (1949), pl. 149; Camón Aznar (1950), p. 1021, no. 279, figs. 796, 797; Guinard (1956), p. 80; Soehner (1958–1959), no. 75; Colin Eisler, "Portrait of the Artist as St. Luke," *Art News*, Summer 1960, pp. 32–42; Wethey (1962), vol. 1, fig. 214; ibid., vol. 2, no. 166; Sánchez Cantón (1963), pl. XXXI; Manzini and Frati (1969), no. 131h; Camón Aznar

(1970), pp. 1025–1027, figs. 874, 875, no. 291; Cossío (1972), no. 153; Lafuente Ferrari and Pita Andrade (1972), no. 78, fig. 83; Gudiol (1973), no. 274, fig. 298; Pérez Sánchez in London, Royal Academy (1976), p. 32, no. 8.

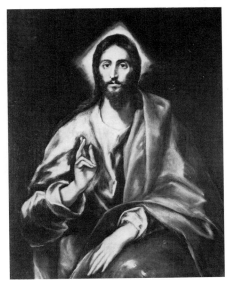

48

48 (plate 61)
Saviour

Oil on canvas, about 97 x 77 cm. (38¹/₄ x 30³/₈ inches)
Circa 1610–1614
Toledo, Museo del Greco. Fundaciones Vega-Inclán

The *Saviour* from the *Apostolado* in the Museo del Greco (see cat. no. 46 discussion) is the most majestic version of this subject to have survived and, according to Wethey, is perhaps the only entirely finished work in this late series (which also includes cat. no. 49; pl. 62).

Scholars have frequently commented that El Greco was perpetuating the Byzantine Christ Pantocrator tradition in this composition, but the more immediate parallel is the Salvator Mundi that had wide currency in the West during the fifteenth and sixteenth centuries. Camón noted the similarity between El Greco's composition and the type created by Titian, which was surely known to the artist. In the Titian version painted circa 1570 (now in the Hermitage), Christ is blessing with his right hand and holding a crystal orb surmounted by a cross in his left hand; in El Greco's painting, Christ is resting his left hand on a larger orb beneath his sleeve.

Provenance: Hospital of Saint James, Toledo (until circa 1848); San Pedro Mártir, Toledo; San Juan de los Reyes, Toledo (until 1908).
Bibliography: Cossío (1908), no. 204; Mayer (1926), no. 161; Byron and Rice (1930), p. 192; Legendre and Hartmann (1937), p. 243; Bronstein (1950), p. 104, fig. on p. 105; Camón Aznar (1950), p. 985, no. 294, fig. 761; Guinard (1956), p. 44; Soehner (1957), p. 179; idem (1958–1959), no. 107; Wethey (1962), vol. 1, fig. 218; ibid., vol. 2, no. 173; Gómez Moreno (1968), pp. 20–21, no. 1; Manzini and Frati (1969), no. 164a; Camón Aznar (1970), p. 990,

251

no. 307, fig. 831; Cossío (1972), no. 154; Lafuente Ferrari and Pita Andrade (1972), p. 134, no. 127, fig. 120; Gudiol (1973), no. 283, fig. 276.

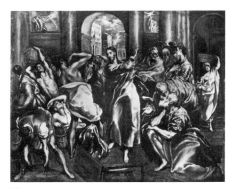

50

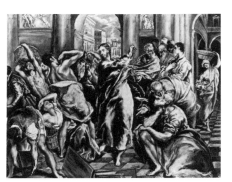

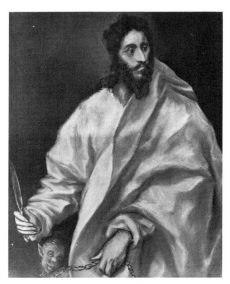

49

Figure 114. El Greco. *Purification of the Temple*, 16½ x 20⅝ inches, after 1600 (New York, copyright The Frick Collection)

49 (plate 62)
Saint Bartholomew

Oil on canvas, about 97 x 77 cm. (38¼ x 30⅜ inches)
Circa 1610–1614
Toledo, Museo del Greco. Fundaciones Vega-Inclán

This figure is unique among all the *Apostolados* (see cat. no. 46 discussion); no clearly recognizable Bartholomew appears in any of the other cycles. Although Bartholomew was one of the original twelve Apostles, El Greco seems to have substituted Saint Luke, who was not one of them, in all the other series (see, for example, cat. no. 47; pl. 60). Bartholomew's usual symbols are those shown here—the small demon on a chain and the knife, which is a reference to the saint's being flayed alive. Wethey points out that the Golden Legend refers to the white robes of this saint. Indeed, the painting of these white robes is one of the most beautiful passages in all of El Greco's Apostle paintings.

Provenance: Hospital of Saint James, Toledo (until circa 1848); San Pedro Mártir, Toledo; San Juan de los Reyes, Toledo (until 1908).

Bibliography: Cossío (1908), no. 202; Mayer (1926), no. 170; Legendre and Hartmann (1937), p. 249; Goldscheider (1949), fig. 155; Camón Aznar (1950), pp. 1063, 1072, no. 303, figs. 840, 841; "Un Greco vendido en Nueve York," *Goya*, no. 8 (Sept.–Oct. 1955): 147; Guinard (1956), p. 80; Marañón (1956b), pp. 232–233, fig. 63; Soehner (1958–1959), no. 114; Wethey (1962), vol. 1, fig. 227; ibid., vol. 2, no. 175; Sánchez Cantón (1963), pl. XLII; Gómez Moreno (1968), p. 26, no. 10; Manzini and Frati (1969), no. 164c; Camón Aznar (1970), pp. 1066, 1070, 1074, fig. 923, no. 316; Cossío (1972), no. 154; Lafuente Ferrari and Pita Andrade (1972), p. 134, no. 139, pl. XXXII; Gudiol (1973), no. 289, figs. 310, 311.

50 (plate 63)
Purification of the Temple

Oil on canvas, 107 x 124 cm. (42⅛ x 48⅞ inches)
Circa 1610–1614
Madrid, Várez-Fisa Collection

More than two decades after painting the great Minneapolis *Purification of the Temple* (cat. no. 3; pls. 14, 15) during his Roman period, El Greco returned to the subject, revamping the composition somewhat and painting several versions after 1600. At the time of his death, four versions of the *Purification* were recorded in his studio. One of these was smaller than the others and was most likely the excellent small canvas today in the Frick Collection in New York (fig. 114), which probably served as the studio's model of the composition. El Greco has somewhat simplified the architectural setting in the Frick version and has greatly clarified the pictorial space by eliminating the complicated arrangement of steps in the foreground of the earlier composition. The figures, which have grown considerably in size relative to the overall composition, are thrust forward in space toward the viewer. The whole composition in the later work is much more agitated, and the light, which in the Roman picture had contributed to a fairly lucid impression of space, here rages like a fire and suggests swift movement.

One of the main differences between the late versions and the early ones is the addition of the two bas-reliefs on the

rear wall flanking the arch. The themes of these reliefs are the Expulsion from Paradise and the Sacrifice of Isaac. There has been a good deal of varied discussion in the literature as to the ways in which these reliefs amplify the meaning of the principal theme. To be sure, the Expulsion from Paradise, as an expression of divine anger, prefigures Christ's Purification of the Temple. The Sacrifice of Isaac has been seen as a prefiguration of the Crucifixion, or of the redemptive value of Christ's sacrifice. Wittkower (1957, p. 54), noting the increasingly doctrinal impulse in the artist's work, interpreted the two sides of this composition as representing the expelled, on the left, and the redeemed, on the right. Davies (1976, pp. 14–15), who agreed that the themes of damnation and redemption are key to the iconography, suggested that the female figure at the far right represents a repentant sinner who has been saved.

The best-known large version of this subject is the canvas in the National Gallery of London. The Várez-Fisa version, although it had been known and cited in the literature since early in this century, was not exhibited publicly until 1976, when it was shown in London. It follows very closely the composition of the London and Frick versions. Both Wethey and Pérez Sánchez described the execution of the figures as closer to the version in the Church of San Ginés, Madrid, however, which places the painting quite late—about 1610–1614. Soehner believed that parts of the present version are the work of El Greco's studio, but he called the painting autograph and related its technique and color to the *Fifth Seal of the Apocalypse* in New York (pl. 28). Wethey also classified the painting as by El Greco and workshop, but noted its excellent quality. The recent cleaning and restoration, as reported by Pérez Sánchez in his thorough catalogue entry on the painting for the London exhibition, supports Wethey's assessment of its high quality.

Provenance: Doña Dolores Alonso, San Sebastián (1908); Don Luciano Abrisqueta, San Sebastián (1962); Várez-Fisa, Madrid (1974).

Bibliography: Cossío (1908), p. 93, no. 163; Camón Aznar (1950), p. 844, no. 91; MacLaren (1952), p. 13; Soehner (1958–1959), no. 125; Wethey (1962), vol. 2, p. 67, no. 109; Manzini and Frati (1969), no. 95f; MacLaren (1970), pp. 25, 27 (n. 19); Camón Aznar (1970), p. 855, no. 94; Cossío (1972), no. 47; Gudiol (1973), p. 211, no. 171, figs. 188, 189; Pérez Sánchez in London, Royal Academy (1976), no. 6, fig. on p. 33.

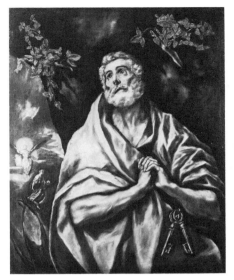

51

51 (plate 64)
Saint Peter in Tears

Oil on canvas, 102.0 x 79.5 cm. (40⅛ x
31¼ inches)
Signed on the rock below the Magdalen
in cursive Greek: *doménikos
theotokópoulos* [?] *e'poíei*
Circa 1610–1614
Oslo, Nasjonalgalleriet

See catalogue number 15 for a discussion of the iconography of this subject,
which El Greco treated at various times
throughout his career. In the present
version he has painted two keys hanging
from Peter's waist—symbols of Peter's
pastoral power for the remission of sins
and for excommunication. The Oslo
Saint Peter in Tears is his latest representation of the theme; it was definitely
painted toward the end of the artist's
life. Although the basic elements of the
composition remain the same as in the
earlier versions, the surface has become
much elaborated by an intense contrast
of light and dark and by a very active
brush.

Provenance: Marchioness of Guad-el-Jelú,
Madrid [?]; Cabot y Rovira, Barcelona; Marquis of Villatoya, Madrid; Julius Böhler,
Munich; Christian Langaard, who donated it
to the Nasjonalgalleriet in 1923.
Bibliography: Cossío (1908), no. 371; Jens
Thiis, "Spansk Malerkunst: Studier og
betragtninger i anledning av billederne i den
Langaardske samling," *Kunst og Kultur*
(1922), p. 141; Mayer (1926), no. 206; idem
(1931), no. 53; Jens Thiis, "Den 'Angrende
Petrus' i Nasjonalgalleriet," in *Fra Nielen til
Seinen* (Oslo, 1936), pp. 135–140; Legendre
and Hartmann (1937), p. 302; Paris, *Gazette
des Beaux-Arts* exhibition (1937), no. 27;
Goldscheider (1949), pl. 137; Camón Aznar
(1950), p. 602, no. 445, fig. 461; Soehner
(1957), p. 179; Wethey (1962), vol. 1, fig. 313;
ibid., vol. 2, no. 272; Manzini and Frati (1969),
no. 64f; Camón Aznar (1970), p. 618, no. 453,
fig. 503; Cossío (1972), no. 308; Lafuente
Ferrari and Pita Andrade (1972), p. 61; Gudiol
(1973), p. 245, no. 204, fig. 224.

52 (plate 65)
Visitation

Oil on canvas, oval, 97.8 x 72.4 cm. (38½
x 28½ inches)
Circa 1607–1614
Washington, Dumbarton Oaks
Collection

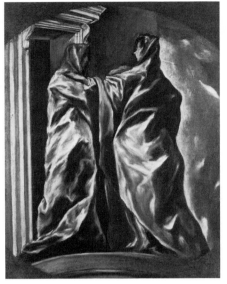

52

At the time of El Greco's death, this bold
composition was left unfinished, as is
evident primarily in the sketchy faces
and hands of the figures. According to
documents published by San Román,
the *Visitation* was originally intended
for the ceiling of the Oballe Chapel in
the Church of San Vicente in Toledo.
The contract for the commission, which
was signed on December 11, 1607, specified that there was to be "in the ceiling a
story of the Visitation of Saint Elizabeth
[Isabel], because that is the name of the
founder, which is to be placed in a circle
adorned with a cornice like that in
Illescas" (Wethey's translation); the circular *Nativity* catalogued here as number 42 (pl. 18), which was executed
between 1603 and 1605, is one of those
incorporated into the ceiling of the
Hospital of Charity at Illescas.

For some unknown reason, the *Visitation* was never installed in the Oballe
Chapel. Had it been, it would have accompanied the *Virgin of the Immaculate
Conception* now in the Museo de Santa
Cruz in Toledo (pl. 24; fig. 69), one of
El Greco's most important and beautiful
late works. The large paintings of *Saint
Peter* (fig. 115) and *Saint Ildefonso* (cat.
no. 53; pl. 66), both now at the Escorial,
were also probably once in the same
chapel but were apparently not delivered until some time after the artist's
death.

Wethey, whose catalogue entry for
this painting is especially sensitive,
notes the similarity of its style to that of
the *Fifth Seal of the Apocalypse* (pl. 28)
in New York's Metropolitan Museum of

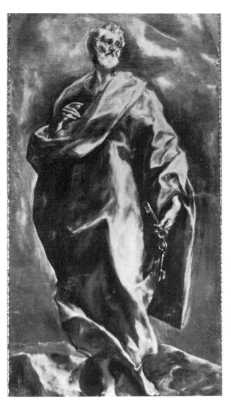

Figure 115. El Greco. *Saint Peter*, 81½ x 41⅓
inches, circa 1610–1614 (El Escorial)

Art; the figure of Mary at the right in
the *Visitation* especially recalls that
painting's monumental figure of Saint
John the Evangelist, with its jagged profile against the sky and the flashing
white highlights on the blue drapery.

Provenance: Church of Santa Clara, Daimiel
(Ciudad Real); Arthur Byne, Madrid.
Bibliography: San Román (1927), doc. XXX;
Legendre and Hartmann (1937), p. 116; Gómez
Moreno (1943), p. 39; *The Dumbarton Oaks
Research Library and Collection* (Washington,
1946), unpaged; Goldscheider (1949), pl. 214;
Camón Aznar (1950), pp. 938–941, no. 47, fig.
732; Soehner (1957), p. 193; Wethey (1962),
vol. 1, fig. 202; ibid., vol. 2, no. 115; Manzini
and Frati (1969), pp. 121–122, no. 160b; Camón
Aznar (1970), pp. 938–941, no. 45; Cossío
(1972), no. 17; Lafuente Ferrari and Pita
Andrade (1972), pp. 135, 162, no. 142; Gudiol
(1973), pp. 252, 255, 258, 355, no. 221.

53 (plate 66)
Saint Ildefonso

Oil on canvas, 222 x 105 cm. (87⅜ x 41⅜
inches)
Circa 1610–1614
El Escorial

According to documents first published
by Ramírez de Arellano (1921), it appears
that this painting and its pendant, the
full-length *Saint Peter* in the Escorial
(fig. 115), were originally part of the
decoration of the Oballe Chapel in the
Church of San Vicente in Toledo.
These two works were not mentioned,
however, in the contract of 1607 for the
chapel, in which El Greco agreed to

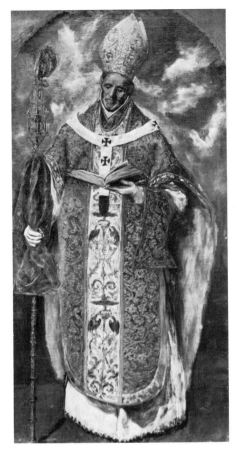

paint the *Virgin of the Immaculate Conception* (pl. 24; fig. 69) and the *Visitation* (cat. no. 52; pl. 65). If indeed the paintings of the saints were intended for the Oballe Chapel, they were not delivered to San Vicente until long after El Greco's death in 1614, because they were both described in detail among the paintings inventoried in the possession of El Greco's son, Jorge Manuel, in 1621.

The first literary reference to this painting, in Francisco de los Santos's description of the Escorial (1698), identifies the subject as Saint Eugene, the first archbishop of Toledo, whose relics had been transferred from France to the Cathedral of Toledo on November 18, 1565. The logic of this identification was never challenged, surely because, taken out of context, the pairing with Saint Peter, the first bishop of Rome, seemed to make such sense. It was not until 1926 that Mayer showed that in the 1621 inventory the pair were called *Saint Peter Standing* and *Saint Ildefonso*. Subsequently all scholars have accepted this identification, based on the assumption that those closest to the artist knew what he intended. Considered in the context of the Oballe Chapel, moreover, the identification of the figure as Saint Ildefonso seems reasonable (see cat. no. 43 for more information on this saint). As archbishop and patron saint of Toledo, he is appropriately paired with Saint Peter; and an image of Ildefonso, the eloquent defender of the Virgin's purity, would have enhanced the impact of the glorious representation of the

Immaculate Conception that hung over the main altar.

Stylistically, *Saint Ildefonso* and *Saint Peter* are extremely close to that great painting of the Immaculate Conception, which is now in the Museo de Santa Cruz in Toledo. The brushwork in all three is free and fluid—thin in places, thick in others, but never labored; frequently the ground is allowed to show as a middle value in the modeling of forms. The dazzling virtuosity evident in the present painting—Saint Ildefonso's richly detailed chasuble and miter, the brilliant whites of his alb and gloves, the indications of El Greco's totally absorbed and transcended experience of Venetian art—all of this must have amazed the young Velázquez, who surely learned much from a painting such as this.

Provenance: Oballe Chapel, Church of San Vicente, Toledo.

Bibliography: Francisco de los Santos, "Descripción del real monasterio de San Lorenzo del Escorial" (Madrid, 1698), in Sánchez Cantón (1933), pp. 309, 312; D. Vicente Poleró y Toledo, *Catálogo de los cuadros del real monasterio de San Lorenzo* (Madrid, 1857), no. 96; Cossío (1908), no. 42; Ramírez de Arellano (1920), pp. 300–301; idem (1921), p. 287; Mayer (1926), no. 288; Legendre and Hartmann (1937), p. 435; Goldscheider (1949), fig. 109; Camón Aznar (1950), pp. 871–875, no. 496, figs. 678, 679; Guinard (1956), p. 79; Soehner (1957), p. 193; Wethey (1962), vol. 1, fig. 315; ibid., vol. 2, no. 275; Manzini and Frati (1969), no. 144; Camón Aznar (1970), pp. 880–883, no. 501, figs. 742, 743; Cossío (1972), no. 254; Lafuente Ferrari and Pita Andrade (1972), no. 117, fig. 102; Gudiol (1973), p. 236, no. 193, fig. 217; Davies (1976), no. 47.

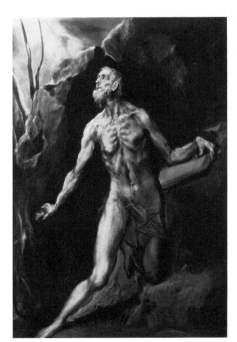

54

54 (plate 67)

Saint Jerome in Penitence

Oil on canvas, 168.3 x 110.5 cm. (66¼ x 43½ inches)
Circa 1610–1614
Washington, National Gallery of Art.
Gift of Chester Dale 1943

The austere and penitential nature of Saint Jerome's life (see cat. no. 40 discussion) was a particularly important devotional example in the sixteenth century. The Spanish monarchs were especially devoted to the Hieronymite order: Charles V retired to the Hieronymite monastery of Yuste in western Spain, and Philip II founded the Escorial upon the monastic rock of Saint Jerome. El Greco created two types of compositions depicting this saint as a penitent. The first—examples are in Edinburgh, in a private collection in Madrid (fig. 116), and elsewhere—shows the old saint naked in half-length, surrounded by symbols such as a Bible, an hourglass, a skull, and a cardinal's hat; he holds a crucifix in his left hand and

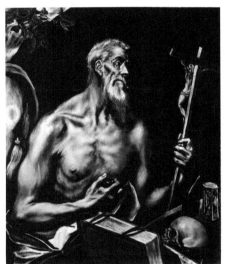

Figure 116. El Greco. *Saint Jerome in Penitence*, 41½ x 35²⁄₅ inches, circa 1600–1605 (Madrid; private collection. Formerly Marquis of Santa María de Silvela y de Castañar Collection)

beats his breast with a stone he is clutching in his right hand. El Greco toward the very end of his life began to create a second type of *Saint Jerome in Penitence*, and the unfinished canvas in the National Gallery of Art in Washington, which is known in no other version or copy, is the very moving result. Probably no other painting tells so much about the way El Greco painted.

In this tall, full-length composition, the saint, shown at the opening of a cave, is kneeling on his left knee; the pose is reminiscent of those of Saint Sebastian in the painting from Palencia (cat. 10; pl. 25) and of Christ in the *Baptism* from the College of Doña María de Aragón (cat. no. 33; pl. 27). Jerome's left arm supports his Bible, and his right arm is

stiff as he clenches a stone in his fist and prepares to beat his breast. As a strong, supernatural light enters from the upper left, Saint Jerome stares upward, transfixed in his devotion.

Wethey considered the head and torso and the landscape at the upper left to be finished. Certainly the lower right quadrant of the painting—including the book and the saint's left forearm and hand—is only sketched. The various stages of creation are apparent. The figure was first sketched with long, fluid strokes upon the reddish brown ground. The rock forms were suggested by rough patches of lights and darks. The figure was underpainted in a warm grayish tone that establishes the shadowed areas of musculature. The subtler contours of the anatomy were then modeled in a lighter flesh tone that was applied on top of the underpaint, as seen in the brushstrokes pulled across the figure's abdomen. There is a constant push-pull between lighter and darker values until the final form emerges fully rounded; comparison of the left and right legs of Saint Jerome provides the perfect before-and-after example. In the final stage of creating a given form—the head of the saint, for example—the artist added the flickering touches of the brush that suggest the hair and highlights on the skin; these strokes disguise the labor and the many steps involved, striking the viewer with the painter's mastery of his medium.

This painting is surely the unfinished one listed as number 145 (*"un San Jerónimo desnudo"*) in the 1621 inventory of El Greco's estate. Fortunately, no one tried to finish it, as happened with some of the commissioned works. In the state in which El Greco left it, this work ranks as one of his most affecting images of saints.

Provenance: Felipe de la Rica, Madrid; Doña María Montejo, Madrid; Marquis of Castro Leruna, Madrid; Chester Dale, New York.

Bibliography: Viniegra (1902), no. 43 (misidentified as *Saint Francis*); Cossío (1908), p. 571, no. 113, pl. 71; Mayer (1926), p. 45, no. 281; Legendre and Hartmann (1937), p. 437; Cook (1945), pp. 75–76, fig. on p. 77; Camón Aznar (1950), p. 897, no. 516, fig. 698; Soehner (1957), p. 194; Wethey (1962), vol. 1, figs. 291, 293; ibid., vol. 2, no. 249; National Gallery of Art, *Paintings Other than French in the Chester Dale Collection* (Washington, 1965), p. 11, no. 743; Washington, National Gallery (1965), p. 62, no. 743; Manzini and Frati (1969), no. 170, pl. LXIII; Camón Aznar (1970), pp. 893–900, no. 518, figs. 759, 760; Cossío (1972), no. 264; Lafuente Ferrari and Pita Andrade (1972), p. 162, no. 146; Gudiol (1973), pp. 196–198, 350, no. 153, fig. 179; Walker (1974), p. 237, no. 309; Washington, National Gallery (1975), p. 163, fig. 743.

55 (plate 9)

View and Plan of Toledo

Oil on canvas, 132 x 228 cm. (52 x 89¾ inches)
Circa 1610–1614
Toledo, Museo del Greco. Fundaciones Vega-Inclán

55

Figure 117. Jacopo de' Barbari. Detail of *View of Venice*, 1500 (London, British Museum. Courtesy of the Trustees)

El Greco's *View and Plan of Toledo*, about twice as wide as his more famous *View of Toledo* in New York's Metropolitan Museum of Art (cat. no. 35; pl. 4), is one of his most important late works. Cossío (1908) related the panoramic scope of the landscape to fifteenth-century views of Venice, and Brown and Kagan (1982) specifically refer to one of the most famous of such views, Jacopo de' Barbari's monumental woodcut *View of Venice*, published in 1500 (fig. 117). As noted by Cossío, Pita, and others, the displacement of architectural monuments that is so much a part of the New York *View of Toledo* is not a feature of the present work, in which the topographic accuracy is underscored by the prominent display of a map of the city held up by the youth at the right. The map is carefully labeled and keyed to the principal buildings of the city. Following Italian precedent, El Greco has

included at the lower left a golden-colored youth with a bounty of fruits and an overturned jar symbolizing the Tagus River, which surrounds two-thirds of the city.

In the foreground near the center of the composition the artist has depicted a cloud with a building on it. An inscription on the map explains that the building is the Hospital of Saint John the Baptist (also called the Hospital of Cardinal Tavera) and that the artist has found it necessary to show the hospital thus because if it had been represented in its actual position, it would have obscured the view of the Bisagra Gate and its cupola would have partially covered the view of the city. Having decided to show the building as a model on a cloud, El Greco goes on to say, he then decided to reorient it so that the facade faced the viewer. Wilkenson, in her doctoral dissertation on the Hospital of Cardinal

255

Tavera, notes the extraordinary veracity of the artist's representation of the building (see fig. 15), which, she maintains, is depicted still under construction.

The inscription on the map also explains the apparition in the sky above the city—a vision of the Virgin accompanied by angels bringing the chasuble to Saint Ildefonso, which was the principal event in the life of the city's patron saint. "In order to justify making the figures large," the inscription says, "I made use of the fact that they were in a certain way like celestial bodies and treated them like lights that, when seen from afar, appear to be large no matter how small they may really be." Modern writers have sought to use these words to explain the artist's general style. S. Sanpere and R. Domenech tried to draw upon them to explain El Greco's elongation of form (see Cossío [1908], p. 456, n. 1), but Cossío disagreed, insisting that the painter simply meant what he said in making an ingenuous excuse for the large size of the figures in the sky relative to the buildings in the landscape. López-Rey saw both the cityscape and the figures as imbued with a life distinct from natural appearances and viewed the inscription as an illustration of the antinaturalistic inclinations of the artist in his Baroque years. Wethey and Pita both called the inscription a significant statement of principles. Villar interpreted it in metaphysical terms as an assertion that images of supernatural or divine beings are not bound by the limitations of naturalistic representation. Davies pursued a Neoplatonic interpretation and also suggested that the ideas about light expressed in El Greco's statement probably derive from John Pecham's treatise on optics, the *Perspectiva Communis*: "Firelight . . . appears larger from afar, since the distance makes it impossible to distinguish between the flame and the intense light near the flame, and so they are perceived by the eye undividedly as though a single great light" (as quoted in Davies, p. 15, from D. C. Lindberg, *John Pecham and the Science of Optics* [London, 1970], p. 87).

It is possible that the painting was never entirely finished. It is painted very thinly, as are parts of the *Laocoön* (cat. no. 56; pls. 68, 69), with the reddish brown underpainting allowed to show in many parts. Camón Aznar suggests that Jorge Manuel Theotokopoulos, El Greco's son, executed the inscription and the plan; María Elena Gómez Moreno agrees that he must have done at least the plan, and Martín Cleto, who transcribed the plan and published it with a short essay on the picture, maintains that the handwriting of the inscription seems to be Jorge Manuel's.

It is almost certain that this painting was commissioned by Pedro Salazar de Mendoza, administrator of the Hospital of Saint John the Baptist, who had engaged El Greco's services since at least

1596. From 1608 until his death in 1614, the artist was engaged on the high altar for the chapel of the hospital, a project Jorge Manuel undertook to finish after his father died. Salazar de Mendoza had a special interest in maps and city views, as indicated by the very large collection of them listed among his possessions following his death in 1629. Among those pictures was one described as a *"quadro de la ciudad de Toledo con su planta,"* which must be the present work. He seems also to have owned the *View of Toledo* now in the Metropolitan Museum of Art.

Provenance: Pedro Salazar de Mendoza, Toledo (1629); Archiepiscopal Palace, Toledo; Hospital de Santiago, Toledo; San Pedro Mártir, Toledo; San Juan de los Reyes, Toledo.
Bibliography: Ponz (1772–1794), vol. 1, *carta* V, p. 20; Ceán Bermúdez (1800), vol. 5, p. 10; Cruz y Bahamonde (1812), vol. 11, p. 524; Cossío (1908), no. 205; Toledo, Museo del Greco (1912), pp. 13–14, no. 1, fig. on p. 15; San Román (1914), p. 115; E. del Villar, *Estudios hispánicos, El Greco en España* (1928), p. 156; Mayer (1931), no. 314, pl. XLVII; Legendre and Hartmann (1937), pp. 479–480; López-Rey (1943), pp. 82–83, fig. 5; Manuel Gómez Moreno (1943), pp. 23, 37, 68, 158, pl. LIX; Goldscheider (1949), pls. 181, 182; Camón Aznar (1950), pp. 972–979, no. 700, figs. 755–758; Bronstein (1950), p. 108, fig. 109; Lafuente Ferrari (1953), p. 215; Guinard (1956), pp. 106, 108–109, fig. on p. 28; Marañón (1956b), pp. 273–277, figs. 55, 79; Soehner (1957), pp. 188, 194; idem (1958–1959), no. 136; Wethey (1962), vol. 1, pp. 15, 50–51, 64, fig. 143; ibid., vol. 2, no. 128; J. P. Martín Cleto, *"Plano de Toledo" por Dominíco Theotocópuli* (Toledo, 1967); María Elena Gómez Moreno (1968), pp. 28–29; Catherine Wilkenson, "The Hospital of Cardinal Tavera" (Ph.D. diss., Yale University, 1968); Manzini and Frati (1969), no. 163, pls. LX–LXII; Camón Aznar (1970), pp. 973–979, no. 687, figs. 825–828; Lafuente Ferrari and Pita Andrade (1972), pp. 76, 129–130, no. 106, fig. 48, pls. III–VI; Cossío (1972), no. 383; Gudiol (1973), pp. 271–272, no. 228, figs. 252–254; Davies (1976), pp. 5, 15–16, pl. 40; Jonathan Brown, "El Greco's 'View of Toledo,'" *Portfolio* 3 (Jan.–Feb. 1981): 34–38; idem and Richard L. Kagan, "El Greco's 'View of Toledo,'" in Brown (1982).

56 (plates 68, 69)

Laocoön

Oil on canvas, 137.5 x 172.4 cm. (54⅛ x 67⅞ inches)
Circa 1610–1614
Washington, National Gallery of Art. Samuel H. Kress Collection 1946

After El Greco's death in 1614, three paintings of this subject were recorded in his studio; two are apparently lost, and the other was probably the present canvas, which the artist did not finish. The only mythological subject El Greco is known to have painted, the *Laocoön* has inspired several attempts to interpret it as something other than a straightforward portrayal of an ancient tale (which, in the end, it may simply be). Understanding is made difficult, however, by the unfinished right side, where the artist seems to have been in the midst of major adjustments in the two

standing figures when his work on the picture ceased.

Interest in the story of Laocoön, a priest of Apollo at Troy, became widespread in the sixteenth century after the unearthing in Rome, in 1506, of the monumental Hellenistic marble group representing Laocoön and his sons. Cossío suggested in 1908 that El Greco based his representation on the oldest literary account of the legend, that of Arctinus of Miletus, rather than on the better-known account of Virgil. According to the legend, Laocoön had incurred the wrath of Apollo by desecrating his temple and by violating a prohibition against marriage and fathering children. During the last year of the Trojan War, he was chosen by the Trojans to offer a sacrifice to propitiate the god Poseidon. While Laocoön was making the offering, a great wooden horse was discovered on the beach before Troy; Laocoön hurled his spear into its side and urged the Trojans, who believed the horse to be a gift from the goddess Athena, not to take it inside the walls of the city. He maintained that it was a trap and declared, "Fools, trust not the Greeks, even when bearing gifts." As the Trojans hesitated, two great serpents sent by Apollo to punish Laocoön for his offenses came out of the sea and attacked him and his two sons, killing them. (According to Arctinus's version, Laocoön and only one of his sons were killed by the serpents; the other son escaped death.) Upon witnessing Laocoön's terrible demise, the Trojans concluded that he had been punished for doubting the worthiness of Athena's gift and for casting his spear into its flank. They resolved to take the horse inside the walls of the city—the act that admitted the Greeks and led to their victory over the Trojans.

In this, his most spectacular gesture to his adopted city, El Greco has unfolded the tale not before the walls of an imagined Troy, but at the very gates of Toledo itself. This choice of background led Waterhouse to speculate that the picture represents a veiled allusion to some conflict between conservative and reformist churchmen in Toledo. Davies took Waterhouse's idea one step further and attempted to show that the painting alludes to the persecution of the reformist archbishop of Toledo Bartolomé de Carranza y Miranda, who died in 1576 following seventeen years of imprisonment by the Inquisition for his Erasmian tendencies. Crombie found these arguments unconvincing because fifty years had elapsed between Carranza's imprisonment and the execution of the picture. Intriguing, however, is Davies's suggestion that El Greco's choice of subject may have been inspired by an old tradition that Toledo was founded by two descendants of the Trojans, Telemon and Brutus (Davies [p. 16, n. 41] cites Agapito Rey, *Sumas de historia Troyana* [Madrid, 1932], p. 15). It is perfectly plausible that the artist had simply de-

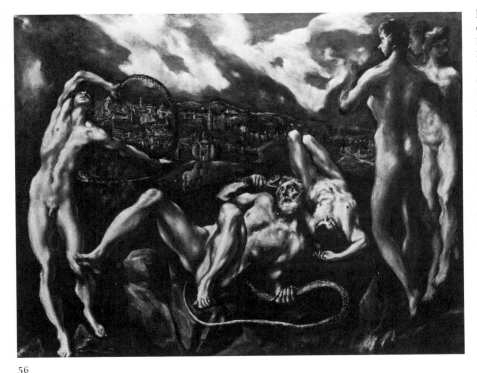

56

cided to tell the story of Laocoön and was merely setting it before the familiar backdrop of Toledo, as he did with Christian themes (for example, cat. nos. 30, 39; pls. 17, 53)—although the "historical" connection between Troy and Toledo makes the setting especially appropriate. More-specific allusions may not have been intended by El Greco; like other artists of his stature, he may have been content with the universality of a great story, which permits endless permutations.

El Greco was probably familiar with numerous antique renditions of the story of Laocoön, as well as with those drawn or engraved by his contemporaries. Scholars from Cossío onward have tried to illustrate this familiarity, but, by and large, El Greco's overall composition appears to be original. In creating the individual figures, however, he borrowed liberally from other artists and from his own work. The body of Laocoön was derived from the *Wounded Gaul* now in the Museo Archeologico, Venice (as Saxl pointed out). The head of Laocoön, however, is very close to that of the Oslo *Saint Peter in Tears* (cat. no. 51; pl. 64), as Bourgeoise first noted. Davies suggested that the figure of the dead son is based on the *Fallen Giant* in the Museo Nazionale, Naples, which, like the *Wounded Gaul*, came originally from the small altar at Pergamum. The same figure, studied from the reverse side, was used by the artist in the *Resurrections* at Santo Domingo el Antiguo (fig. 56) and the Prado (fig. 73), as Cook observed. And as Pita pointed out, the standing son at the left is almost identical to the striving figure at the far right in the *Fifth Seal of the Apocalypse* (pl. 28), which may have been painted later.

The figures at the far right have caused much confusion, partly because El Greco never finished them. When the picture was cleaned during 1955 and 1956, overpainting added after El Greco's death was removed, revealing, among other things, a third head and an extra leg. As Pita (p. 137) suggested, these may indicate the original position of the left male figure—which has a similar profile—and are probably not related to a third figure. Cossío (1908) first identified the two figures at right as Apollo, who admonishes Laocoön, and Artemis, who turns away. Camón Aznar suggested that the two represent Poseidon, to whom Laocoön was sacrificing when he was attacked by the serpents, and King Priam's daughter Cassandra, who foresaw the attack. Sánchez Cantón called the figures Epimetheus and Pandora. Palm (1969) argued that they are Adam and Eve; according to his view, a perplexed Adam is gazing at an apple in his hand (the artist seems to have purposely begun to overpaint with sky the male figure's left hand, which holds a small round object, as if to eliminate or change it somehow), while Eve turns away in shame as Laocoön is punished for breaking his vow of chastity. Palm (ibid.) discussed the iconographical relation between Adam and Eve and Epimetheus and Pandora, a further combination of pagan and Christian meanings. Vetter countered Palm's interpretation, saying that the two figures represent Helen and Paris, who is holding the apple that initiated the Trojan War.

It may be impossible to resolve this painting's mystery definitively, because essential clues are missing as the result of accidental incompletion rather than intentional poetic omission. The specu-

lation will continue, surely, but this fact does not diminish the enormous magnetism of the *Laocoön*. In his only foray into mythology, El Greco produced in his old age an ironic masterpiece that stands out as one of the singular achievements in the history of art.

Provenance: Alcázar, Madrid (inventory of 1666, no. 520; inventory of 1686); Charles III, La Granja (inventory of 1791); Duke of Montpensier, Palacio de San Telmo, Seville; Infante Don Antonio de Orleans, Sanlúcar de Barrameda; Alte Pinakothek, Munich (on loan 1910–1913); E. Fischer, Charlottenburg, Germany; Prince Paul of Yugoslavia; Kress Collection, New York.

Bibliography: R. Forster, "Laocoön in Mittelalter und in der Renaissance," *Jahrbuch der Preussischen Kunstsammlungen* 27 (1906): 174, fig. 17; Cossío (1908), pp. 357–364, no. 162, ill. 67; F. Saxl, *Kritische Berichte zur Kunstgeschichtlichen Literatur,* 2 vols. (Leipzig, 1927–1929), p. 96; Mayer (1931), no. 311, pl. LXVI; Legendre and Hartmann (1937), p. 482; Bourgeoise (1940), pp. 99–101; Walter W. S. Cook, "El Greco's 'Laocoön' in the National Gallery," *Gazette des Beaux-Arts,* 6th series, vol. 26 (1941): 261–272; Gómez Moreno (1943), pp. 37, 160, pl. LX; Goldscheider (1949), p. 17, fig. 200; Bronstein (1950), fig. on p. 121; Camón Aznar (1950), pp. 914–921, no. 696, figs. 714–717; Lafuente Ferrari (1953), p. 215, fig. 133; Guinard (1956), pp. 103–104, 106, figs. on pp. 102 (before cleaning), 103; Marañón (1956b), pp. 73, 79, figs. 18, 53; Soehner (1957), pp. 181, 185, 193–194, fig. 59; Gaya Nuño (1958), no. 1424; Trapier (1958a), pp. 2, 25, fig. 33; Washington, National Gallery (1959), p. 269, no. 885; Wethey (1962), vol. 1, pp. 24, 50–51, 61, 63, figs. 144, 145, 161; ibid., vol. 2, no. 127; Sánchez Cantón (1963), pp. 43–44, pl. XLIV; Washington, National Gallery (1965), p. 62, no. 885; Margarete Bieber, *"Laocoön": The Influence of the Group Since Its Rediscovery* (Detroit, 1967), pp. 18–19; Manzini and Frati (1969), no. 166, pls. XLVII–LI; Erwin Walter Palm, "El Greco's 'Laokoon,'" *Pantheon* 27, no. 2 (Mar.–Apr. 1969): 129–135; Ewald M. Vetter, "El Greco's 'Laokoon' Reconsidered," *Pantheon* 27, no. 4 (July–Aug. 1969): 295–298; Erwin Walter Palm, "Zu zwei späten Bildern von El Greco," *Pantheon* 28, no. 4 (July–Aug. 1970): 298–299; Camón Aznar (1970), pp. 918–924, no. 684, figs. 780–783, 785, 786; Waterhouse (1972), p. 114; Cossío (1972), no. 385; Lafuente Ferrari and Pita Andrade (1972), pp. 73–75, 114, 136–137, no. 145, pls. VII–IX; Gudiol (1973), pp. 268–271, no. 227, figs. 250, 251; Walker (1974), pp. 240–241, no. 313; Washington, National Gallery (1975), pp. 162–163, no. 885; Davies (1976), pp. 10, 16, pls. 38, 41–43; T. Crombie, review of Davies (1976) in *Apollo* 106 (1977): 321; H. W. van Helsdingen, "Laocoön in the Seventeenth Century," *Simiolus* 10, nos. 3–4 (1978–1979): 127.

The Portraits

Few great, or even very good, portraitists emerged in Spain in the sixteenth century. Philip II shared his father's taste for foreign painters, and the portraits that Titian painted for him, like those he had done for Emperor Charles, are among the most exalted examples of the art. Philip brought to Spain for a short while in the 1550s the most distinguished northern portraitist of his day, the Dutchman Anthonis Mor (circa 1519–1576), who continued to paint for the king after he left Spain, sending numerous portraits back to Madrid from other capitals. Italian portraitists besides Titian also served the king. The most prominent of them to come to Spain was a woman, the eminent painter Sofonisba Anguissola (1535?–1625), who was called to the court in 1559, and who remained until 1580, just when El Greco was establishing himself in Toledo. (Few of her portraits are known today, however.)

Out of the mix of styles imported to Spain, one truly great portrait artist besides El Greco did emerge: Alonso Sánchez Coello (1531?–1588), who epitomizes the international court portrait style at its best (see fig. 118). Sánchez Coello was able to achieve subtle portrayals of character while still entertaining the eye with the lavish detail of court costumes, but his elegant works never lose themselves in the topography of opulence. Some of our deepest and most valuable understanding of the court of Philip II comes to us through the faces of his sitters. For two generations, portrait painters at the court imitated his style, although none achieved his greatness until Velázquez put an end to all comparisons.

Even before El Greco came to Spain from Rome in 1577, he was already an accomplished portraitist, as demonstrated by his masterly likeness of Giulio Clovio (cat. no. 57; pl. 13). His style at that time (circa 1570) was closest to the bold naturalism of Tintoretto and had nothing to do with the refined subtleties of Sánchez Coello and the Spanish court. His approach to portraiture, formed in Italy, evolved into something completely new in Toledo, a manner still totally apart from the established court tradition. The evolution of his portrait style parallels that of his style in general and can be traced from his earliest days in Spain until his death.

The famous portrait in the Prado traditionally entitled *Gentleman with His Hand on His Breast* (fig. 119, which Wethey called *Knight Taking an Oath*) is stylistically very close to the donor portraits in the *Crucifixion with Two Donors* in the Louvre (fig. 70) and like that work must have been painted within the first two years or so in Toledo (also, the gesture of the hand on the breast is similar to that of the donor on

Figure 118. Alonso Sánchez Coello. *Unknown Gentleman*, circa 1570s (Barcelona, private collection)

the right side of the Louvre picture). A still somewhat Venetian warmth and sensuousness suffuses the Prado canvas, especially in comparison to the relatively cool refinement of Sánchez Coello's portraits. An important feature of this portrait and most of the rest by El Greco is the degree to which the manners of the noble and intellectual class of Toledo have molded the sitter and informed the artist's predisposition toward the subject before brush was ever put to canvas. The hauteur and refinement of this segment of Toledan society was remarkable even within a broader European social context, and El Greco's sitters look confidently back at the world from this lofty vantage point. This, as much as the way they are painted, distinguishes El Greco's Spanish portraits from those of his Italian period.

The portraits catalogued here include some of El Greco's finest works and fairly trace the development of his style. If Spain had failed to excel in the art of portraiture before his time, these paintings bear witness to the historic redress of that situation. Although El Greco was preoccupied with style and virtuosity, his portraits testify cogently to the profound humanistic vision that also guided him.

57 (plate 13)
Giulio Clovio

Oil on canvas, 58 x 86 cm. (22⅞ x 33⅞ inches)
Signed at left in Greek capitals:
DOMÉNIKOS THEOTOKÓPOULOS KRÈS E'POÍEI
Circa 1570
Naples, Museo e Gallerie Nazionale di Capodimonte

Probably El Greco's earliest surviving portrait, this likeness of Giulio Clovio, his friend and mentor in Rome, reveals his personal mastery of Venetian portrait style. Parallels have been drawn with Tintoretto and Bassano, and, indeed, the sure, vibrant naturalism of this portrait clearly derives from the tradition represented by their works.

Giulio Clovio (1498–1578) was one of the most renowned artists of Rome in the sixteenth century ("this small and new Michelangelo," Vasari called him). He was the last of the great manuscript illuminators in an age when printing was already rendering such books obsolete, and his fame has faded somewhat in modern times for want of a familiar category in which to place him. El Greco has portrayed him holding a small book in his left hand and pointing to it with his right. The book was first identified by Justi as Clovio's masterpiece *The Farnese Hours*, written for Cardinal Alessandro Farnese, which he finished in 1546 after working on it for some twenty years. (The book is shown open to folio 59v, "God the Father Creating Heaven and Earth," and folio 60, "The Holy Family.") A breathtaking example of Maniera style, the tiny manuscript (today in the Pierpont Morgan Library, New York) was one of the most celebrated contemporary works of art in Rome. It could be examined with relative ease by artists at the Farnese Palace during the years that El Greco was living there in the circle of Fulvio Orsini, the cardinal's librarian, who owned this portrait of Giulio Clovio. (See chapter 2 for a discussion of the orbit of Orsini and Clovio.)

57

El Greco portrayed Clovio in the company of Titian, Michelangelo, and a figure who is possibly Raphael in the right foreground of his Roman *Purification of the Temple*, now in Minneapolis (cat. no. 3; pl. 14). The clear implication of this gesture of homage was to single out these artists as the giants of the Renaissance. Clovio's fame as a miniaturist and as a consummate practitioner of Maniera style would have made this grouping seem quite logical in the 1570s.

Provenance: Fulvio Orsini, Farnese Palace, Rome (inventory of 1600); sent to Farnese Collection, Palazzo del Giardino, Parma

(1662; mentioned in inventory of 1680); brought from Parma to the Museo di Capodimonte in 1758.

Bibliography: G. Campori, *Raccolta di cataloghi* (Modena, 1870), p. 231; Nolhac (1884), p. 433; John Bradley, *Life and Works of Giorgio Giulio Clovio* (London, 1891), p. 186; Cossío (1908), no. 357; Aldo de Rinaldis, *Pinacoteca del Museo Nazionale di Napoli, Catalogo* (Naples, 1911), pp. 178–179, no. 98; Justi (1914), pp. 244–246; Beruete y Moret (1914), p. 13; Waterhouse (1930), no. 16; Mayer (1931), pp. xxi–xxii, 51, no. 323, fig. 69; Paris, *Gazette des Beaux-Arts* exhibition (1937), no. 14; Legendre and Hartmann (1937), p. 51; Gómez Moreno (1943), pp. 22, 56, pl. VIII; Goldscheider (1949), pls. 5, 6; Camón Aznar (1950), p. 125, no. 709, figs. 72, 73; Rodolfo Palluchini, "La periode italienne du Greco," in Bordeaux, Beaux-Arts (1953), p. 23; Guinard (1956), pp. 14, 49, 124, fig. on p. 151; Bruno Molajoli, *Notizie su Capodimonte* (Naples, 1958), no. 191, fig. 46; Trapier (1958), p. 76; Gaya Nuño (1958), no. 1182; Bruno Molajoli, *Retratti a Capodimonte* (Torino, 1959), pp. 86–87, pl. XVI; M. G. de la Coste-Mésseliere, "Don Giulio," *L'Oeil* 52 (Apr. 1959): fig. on p. 5; Wethey (1962), vol. 1, pp. 8, 20–21, 27, 89 (n. 105), fig. 29; ibid., vol. 2, no. 134; Rosenthal (1963), pp. 385–388; Manzini and Frati (1969), no. 13; Camón Aznar (1970), pp. 149–150, no. 701, figs. 87–90; Cossío (1972), no. 337; Lafuente Ferrari and Pita Andrade (1972), pp. 23–24, 93–94, 120, fig. 5; Gudiol (1973), pp. 36, 45, no. 25, figs. 32, 33.

been completely removed. Any attempt to identify the sitter more specifically, therefore, such as Sambricio's proposal that he is Alonso Martínez de Leiva, is problematical. The painting as a whole has suffered in its general condition, but it is clearly a work of quality. As Wethey noted, it was probably originally somewhat larger—as is suggested by the fact that the sitter's left hand is now cut at the bottom edge of the canvas.

The sitter is obviously from the aristocracy-intelligentsia of Toledo. In his manner of dress, he resembles the gentlemen witnesses in the *Burial of the Count of Orgaz* (pl. 3; fig. 68). As far as can be discerned from the work in its present condition, the painting's style is also close to that of the *Burial*. The greater naturalism of the earlier Spanish works—such as the paintings from the Santo Domingo el Antiguo altarpiece (for example, cat. no. 7; pls. 22, 23), the *Crucifixion with Two Donors* in the Louvre (fig. 70), or the *Gentleman with His Hand on His Breast* (fig. 119)—has been modified somewhat in favor of a rather suave and elegant modeling of form.

Paintings (Montreal Museum of Fine Arts, Montreal, 1960), pp. 71–72, no. 885; Wethey (1962), vol. 1, fig. 325; ibid., vol. 2, no. 150; José López-Rey, review of Wethey (1962) in *Art News* 61 (Oct. 1962): 589; *El Greco to Goya* (John Herron Museum of Art, Indianapolis, and Museum of Art, Rhode Island School of Design, Providence, 1963), no. 18; Manzini and Frati (1969), no. 43; Camón Aznar (1970), pp. 369, 483, 1092–1093, no. 717, fig. 936; Cossío (1972), no. 345; Gudiol (1973), p. 112, no. 71, fig. 97.

59

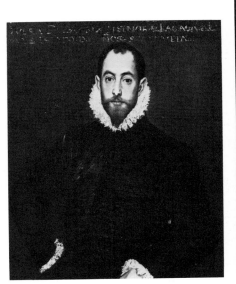

58

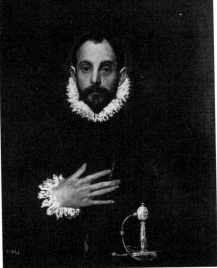

Figure 119. El Greco. *Gentleman with His Hand on His Breast*, 36 x 32 inches, circa 1577–1579 (Madrid, Museo del Prado)

58 (plate 70)
Gentleman of the House of Leiva [?]

Oil on canvas, 88 x 69 cm. (34⅝ x 27⅛ inches)
Circa 1580–1585
Montreal, Montreal Museum of Fine Arts. Adaline Van Horne Bequest 1945

The traditional title of this picture derives from the fragmentary inscription across the top—probably added at a later date—which successive cleanings have made all but illegible. There was at one time a cross of Santiago painted on the sitter's chest, which may also have been a later addition and which has

Provenance: Cathedral of Valladolid; Dealer Parés, Madrid (1904); Bouderiat, Paris; Trotti, Paris; M. Knoedler & Co., New York (1905); T. J. Blakeslee, New York (1906); Sir William Van Horne, Montreal (1906); bequeathed by Miss Adaline Van Horne to the Art Association of Montreal (1945).
Bibliography: Forma (Barcelona, 1904), p. 196; Cossío (1908), pp. 401–402, no. 9, fig. 110 bis; Mayer (1931), no. 341; Legendre and Hartmann (1937), p. 36; Valentín Sambricio, "El Appiano Alejandrino de Venecia (1551)," *Archivo Español de Arte* 14 (1940–1941): 239; Camón Aznar (1950), p. 1093, no. 724, fig. 854; Marañón (1956b), p. 247, fig. 69-3; R. H. Hubbard, *European Paintings in Canadian Collections* (Toronto, 1956), p. 34, pl. 17; Soehner (1957), p. 141; Gaya Nuño (1958), no. 1231; J. H. Steegman, *Catalogue of*

59 (plate 72)
Elderly Gentleman

Oil on canvas, 44 x 42 cm. (17⅜ x 16½ inches)
Signed at right in cursive Greek:
doménikos theotokópoli [sic] *e'poíei*
Circa 1585–1595
Madrid, Museo del Prado

Scholars have not agreed and some have vacillated concerning the date of this portrait, but virtually all regard it as one of the artist's most captivating works. Soehner admired the variety of textures, from thin passages revealing the blue-gray underpaint and the texture of the canvas to the strong and vigorous impasto of the ruff. Cossío (1908), who called the portrait one of the artist's very finest, noted the light tone, open brushwork, and the carmine color showing through in the flesh tones for the first time. The extraordinarily expressive and sensitive face of the sitter, with its clear, kind eyes, has inspired many attempts to characterize it verbally.

Provenance: Alcázar, Madrid (inventory of 1666, no. 147; inventory of 1686).
Bibliography: Cossío (1908), no. 74, fig. 111; Mayer (1931), no. 344, pl. LXXXVI; Legendre and Hartmann (1937), p. 61; Zervos (1939), fig. on p. 210; Gómez Moreno (1943), p. 100, pl. XXX; Goldscheider (1949), fig. 90; Bronstein (1950), p. 76, fig. on p. 77; Camón Aznar (1950), pp. 1114, 1117, no. 738, fig. 872; Soehner (1957), p. 153, 158; Trapier (1958a), p. 32, fig. 42; Soehner (1958–1959), no. 48; Wethey (1962), vol. 1, p. 62, fig. 328; ibid., vol. 2, no. 139; Manzini and Frati (1969), no. 53; Camón Aznar (1970), pp. 1116–1119, no. 730, fig. 956; Madrid, Prado (1972), no. 806; Cossío (1972), no. 346; Lafuente Ferrari and Pita Andrade (1972), p. 68, no. 22; Gudiol (1973), p. 166, no. 127, fig. 150.

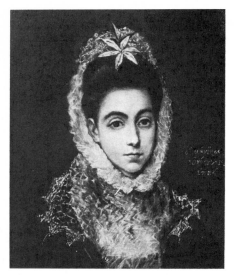

60

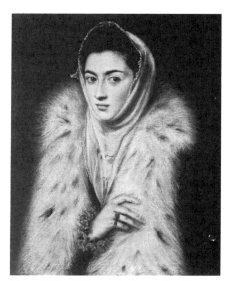

Figure 120. El Greco. *Lady in a Fur Wrap*, 24½ x 19½ inches, circa 1577–1578 (Glasgow, Pollock House)

60 (plate 71)

Lady with a Flower in Her Hair

Oil on canvas, 49.5 x 41.9 cm. (19½ x 16½ inches)
Signed at upper right in cursive Greek: *doménikos theotokópolis* [sic] *e'poíei*
Circa 1590–1600
Private collection

Several unconvincing attempts to identify the sitter of this portrait have been made. Sánchez Cantón thought that the young woman was a member of the artist's family and suggested that she might be Alfonsa de los Morales, the first wife of El Greco's son, Jorge Manuel. Goldscheider thought that, whoever she was, she may have posed for the *Madonna of Charity* in Illescas (fig. 63). Lafuente, who reiterated this observation, thought the face resembles several of the artist's Virgins. Beruete believed that the sitter was a modest, simple woman, certainly not a court figure. Vázquez-Campo, on the other hand,

claimed that she was the Infanta Catalina Micaela, daughter of Philip II. In fact, there is no evidence at all as to her identity.

It is instructive to compare this portrait to the *Lady in a Fur Wrap* from the artist's first years in Toledo (fig. 120) in order to appreciate the considerable development of his style. The subtle modeling of the face and the illusionistic treatment of the fur in the earlier painting are replaced here by a much broader indication of forms. The crumbly white brushstrokes suggesting the lace guimpe are similar to those that describe the diaphanous veil of Saint Agnes in the *Madonna and Child with Saint Martina and Saint Agnes* (cat. no. 31; pl. 49). In both portraits, the sitters wear necklaces. In the present example, the depiction of the necklace through the overlaid lace is a tour de force that reveals the artist's fresh response to visual stimuli.

Provenance: General Meade; Stirling-Maxwell, Keir, Scotland; Viscount Rothermere, London (acquired in 1957).

Bibliography: Cossío (1908), no. 339; Beruete (1914), pp. 20–21; Mélida (1915), fig. following p. 98; Mayer (1931), no. 352; Legendre and Hartmann (1937), p. 77; F. J. Sánchez Cantón, "La mujer en los cuadros del Greco," *Escorial, Revista de Cultura y Letras* 1 (1942): 28; Gómez Moreno (1943), p. 106, pl. XXXIII; Goldscheider (1949), pl. 88; Camón Aznar (1950), pp. 1080–1084, no. 717, fig. 847; Ellis [K.] Waterhouse, *Spanish Paintings* (Edinburgh, 1951), no. 13; Guinard (1956), p. 66; Marañón (1956b), pp. 53, 57, fig. 8; Soehner (1957), pp. 153, 167; Gaya Nuño (1958), no. 1316; Wethey (1962), vol. 1, fig. 322; ibid., vol. 2, no. 147; Manzini and Frati (1969), no. 81; Camón Aznar (1970), pp. 1082–1083, no. 709, fig. 929; Lafuente Ferrari and Pita Andrade (1972), pp. 69–70, 88 (n. 90); Cossío (1972), no. 356; Gudiol (1973), p. 251, no. 216, fig. 232; Antonio Vázquez-Campo, *El Divino Greco* (Madrid, 1974), p. 243.

61 (plate 5)

Antonio de Covarrubias

Oil on canvas, 65 x 52 cm. (25⅝ x 20½ inches)
Signed above the sitter's left shoulder in cursive Greek: *doménikos theotokópoulos e'poíei*
Circa 1600
Paris, Musée du Louvre

There has been much discussion in the literature concerning the date of this portrait and the work's relationship to El Greco's painting of the same sitter in Toledo's Museo del Greco. The consensus of recent opinion—including the views of Wethey, María Elena Gómez Moreno, Lafuente, and Gudiol—dates the present work around 1600 and holds that the Toledo version is a somewhat later replica. The Louvre version is definitely the finer painting and is well preserved.

Antonio de Covarrubias y Leiva (1524–1602) and his older brother Diego (cat. no. 62; pl. 6) were the sons of Alonso de Covarrubias, the "master of works" at

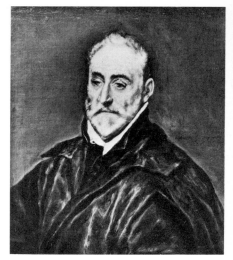

61

the Toledo Cathedral who also served as architect to Emperor Charles V. (Alonso designed the principal facade of the *alcázar* [royal palace] of Toledo and was one of the guiding lights of the Renaissance in Spain.) Antonio, educated at the University of Salamanca, distinguished himself as jurist, antiquarian, philosopher, humanist, and Hellenist. As *maestrescuela* of the cathedral in Toledo, he controlled the city's university. With his brother Diego, Antonio was a member of the Spanish delegation to the Council of Trent, and he was subsequently appointed canon of the cathedral chapter. Widely esteemed as a moral and intellectual force in Spain, Antonio Covarrubias was called upon by Philip II to articulate the Spanish monarch's right to the crown of Portugal; he responded with a work entitled *Derecho que el Señor Rey Felipe II tuvo á la Corona de Portugal.*

Covarrubias, who became totally deaf in his old age, died on December 21, 1602. If El Greco's portrait was indeed painted about 1600, as its style seems to indicate, then the sitter would have been in his mid-seventies. Knowing of Covarrubias's deafness, the viewer can almost sense it in the painting. Covarrubias was a close friend of El Greco's (see chapter 2), and the artist had portrayed him about fifteen years earlier as one of the witnesses in the *Burial of the Count of Orgaz* (pl. 3; he is seen there toward the right in profile).

The impasto in this portrait is fairly thick, and the work provides an illustration on a small scale of what Francisco Pacheco meant when he noted that El Greco returned to his canvases time and again, retouching them in order to leave the colors distinct and unblended (Pacheco [1649; 1956 ed.], vol. 2, p. 79). Upon close examination, the viewer can see the tiny strokes of black that have been added throughout the black cloak on top of the white highlights and black shadows in order to enliven the surface. Similar strokes occur in the face. In an overcleaned picture, such details are often abraded away.

Provenance: Archiepiscopal Palace, Toledo; Museo Provincial, Toledo; Museo del Greco, Toledo (until 1941); given to the Louvre, in exchange, by the Spanish government.
Bibliography: Cruz y Bahamonde (1812), vol. 11, p. 524; Cossío (1908), pp. 437–438, no. 207, fig. 116; Madrid, Real Academia (1909), no. 3; Toledo, Museo del Greco (1912), pp. 21–22, no. 4, fig. following p. 22; Mayer (1931), no. 324; Legendre and Hartmann (1937), p. 46; G. Bazin, "Les Echanges Franco-Espagnoles," *Revue des Beaux-Arts de France* 2 (Dec. 1942–Jan. 1943): 74–75; Manuel Gómez Moreno (1943), p. 33; Camón Aznar (1950), pp. 1147–1152, no. 757, fig. 894 (misidentified as Toledo version); Guinard (1956), pp. 70, 125 (biog.); Soehner (1957), pp. 181, 194; Gaya Nuño (1958), no. 1369; Soehner (1958–1959), p. 204 (discussed in entry on Toledo version); M. de Maeyer, "De Portretten van Don Antonio de Covarrubias Door Greco," *Bulletin Musées Royaux des Beaux-Arts* (Brussels) 7, no. 3 (Sept. 1959): 139–148; Wethey (1962), vol. 1, p. 13, fig. 327; ibid., vol. 2, no. 135; idem, "Portraits du Greco in France," *Revue du Louvre* 12, no. 6 (1962): 280, fig. 6; María Elena Gómez Moreno (1968), p. 31; Manzini and Frati (1969), no. 113; Camón Aznar (1970), pp. 1080, 1139–1143, 1146, 1149, no. 749, fig. 973; Cossío (1972), no. 367; Lafuente Ferrari and Pita Andrade (1972), pp. 68, 127, no. 74, fig. 86; Gudiol (1973), p. 212, no. 176, fig. 194.

62

62 (plate 6)
Diego de Covarrubias

Oil on canvas, 67 x 55 cm. (26 3/8 x 21 5/8 inches)
Faint remnants of a signature over the sitter's left shoulder
Circa 1600–1605
Toledo, Museo del Greco. Fundaciones Vega-Inclán

This portrait of Diego de Covarrubias y Leiva (1512–1577) is the pendant to the one of his brother Antonio in the same museum. Both were probably painted for El Greco's friend and patron Pedro Salazar de Mendoza, in whose collection they were inventoried in 1629. The consensus of recent criticism places the date of this pair as somewhat later than that of the portrait of Antonio de Covarrubias in the Louvre (cat. no. 61; pl. 5),

which was probably painted just before the sitter's death. Both of the paintings done for Salazar de Mendoza, therefore, were posthumous likenesses, since Diego had been dead for many years. El Greco used as his model a likeness painted in the style of Alonso Sánchez Coello in 1574, when the sitter was sixty-one or sixty-two years old (fig. 121).

Diego de Covarrubias was the most brilliant member of his illustrious family (which is discussed in chapter 2

Figure 121. Style of Alonso Sánchez Coello. *Diego de Covarrubias,* 1574 (Toledo, Museo del Greco)

and at cat. no. 61). After beginning his career as a professor of canon law at the University of Salamanca, he was appointed or elected to several important ecclesiastical positions. In 1560 Philip II ordered him to return to Salamanca to supervise the reform of the curriculum at the university, and in 1563 he attended the final session of the Council of Trent with his brother Antonio. Together with Ugo de Buoncompagni (who later became Pope Gregory XIII), he was charged with writing the decrees of reform that were the culminating document of the Counter-Reformation. In 1565 he became bishop of Segovia, a seat he occupied until his death, and in 1572 he succeeded to the presidency of the Royal Council of Castile, the kingdom's most powerful secular office.

Although Covarrubias died the year El Greco arrived in Toledo and the two men probably never met, the artist has painted a face so full of life and intelligence that it can hang alongside his most insightful portrayals of living sitters. Starting from a dry and lifeless model, probably itself a copy, he has created an image that stands as a paradigm of the intellectual churchman of his age.

Provenance: Pedro Salazar de Mendoza, Toledo (1629); Biblioteca Provincial, Toledo.
Bibliography: Cossío (1908), no. 190; Madrid, Real Academia (1909), illustrated (unpaged);
Toledo, Museo del Greco (1912), pp. 18–20, no. 3, fig. following p. 18; Mayer (1931), no. 326, pl. LXXXII; Legendre and Hartmann (1937), p. 64; Manuel Gómez Moreno (1943), p. 33; Goldscheider (1949), fig. 142; Camón Aznar (1950), pp. 1152, 1155, no. 758, fig. 895; G. Martín-Mery in Bordeaux, Beaux-Arts (1953), no. 49; Marañón (1956b), p. 113, fig. 32-2; Guinard (1956), pp. 70, 125; Soehner (1957), pp. 181, 189, 194; idem (1958–1959), no. 122; Wethey (1962), vol. 2, no. 137; María Elena Gómez Moreno (1968), pp. 32–33; Manzini and Frati (1969), no. 114; Camón Aznar (1970), pp. 1143–1146, no. 750, fig. 976; Lafuente Ferrari and Pita Andrade (1972), p. 127, no, 76; Cossío (1972), no. 374; Gudiol (1973), p. 212, no. 174, fig. 192.

63

63 (frontispiece)
Fray Hortensio Félix Paravicino

Oil on canvas, 113.0 x 86.0 cm. (44 1/2 x 33 7/8 inches)
Signed at the right edge near the book in small cursive Greek letters: *doménikos theotokópoulos e'poíei*
Circa 1609
Boston, Museum of Fine Arts. Isaac Sweetser Fund 1904

El Greco's portrait of the Trinitarian friar Hortensio Félix Paravicino y Arteaga (1580–1633) is one of the greatest works of his career and one of the great portraits in the history of art. Paravicino's family was of Milanese origin, but he was a native of Madrid. A prodigy, he was already a professor of rhetoric at the University of Salamanca by the time he was twenty-one. He became the most eloquent and famous orator of his time and in 1616 was appointed preacher to King Philip III. Admired and praised by Lope de Vega and Quevedo, Paravicino was a prolific poet in the highly literate *culterano* style of his friend Luis de Góngora y Argote (fig. 28). Among his poems published in 1641 under the title *Obras postumas, divinas y humanas* were four sonnets dedicated to El Greco. In one of them addressed to "Divino Griego," he wrote of a portrait the artist

painted of him when he was twenty-nine years old. Most critics have assumed that the present portrait is the one alluded to and that it must therefore have been painted in or before 1609.

Paravicino is shown wearing the black-and-white habit of the Trinitarian order with its blue-and-red cross. He sits in a high-backed chair, with his left hand propping up a large tome against the arm of the chair and his finger marking his place in a small volume, as though he has just paused while studying. He gazes toward the viewer but seems to be absorbed in his thoughts. His pale, sensitive face and expressive hands suggest his benign character.

As he was increasingly wont to do in his late works, El Greco has taken full advantage of the reddish brown ground as a key pictorial element. It defines the shadowed areas of the white drapery throughout and lends a prevailing warmth to the background. The brushwork is free and spontaneous in all parts of the picture, and the artist has built up a rather thick impasto along certain contours. The bold, unblended strokes of black and gray — especially along the left side of the white hood, against the chair's backrest — enhance a vibrancy, initiated in the sketchy passages of white, that invigorates the entire image. Addressing himself to this vital quality of the portrait, Paravicino wrote in his sonnet that, looking at the portrait, he could not tell which of the two bodies (the painted one or his own) his soul was to inhabit.

Provenance: Duke del Arco, Madrid (1724); Fray Javier de Muguiro, Madrid; Isaac Sweetser Foundation, Boston (1904).
Bibliography: Palomino (1715–1724; 1947 ed.), p. 842; Salvador Sanpere y Miguel, "Exposiciones Rosales y El Greco," *Album Salon* 115 (1 June 1902); *Museum of Fine Arts Bulletin* (Boston), vol. 2 (May 1904): 9–10; Cossío (1908), no. 278; Beruete (1914), p. 19; Malcolm Vaughn, "Portraits by El Greco in America," *International Studio* 86 (Mar. 1927): 30, fig. on p. 22; Mayer (1931), no. 335a, pl. LXXXIV; Legendre and Hartmann (1937), p. 35; José Gudiol, *Spanish Painting* (Toledo Museum of Art, 1941), fig. 49; Gómez Moreno (1943), pp. 37, 154, pl. LVII; López-Rey (1943), pp. 86–88; Goldscheider (1949), pl. 199; Bronstein (1950), pp. 86–91, figs. on pp. 87, 89, 91; Camón Aznar (1950), pp. 1136–1142, no. 751, fig. 887; Marañón (1956b), pp. 106, 109, fig. 30-2; Guinard (1956), pp. 70, 127–128; Soehner (1957), pp. 171, 180; Gaya Nuño (1958), no. 1421; Soehner (1958–1959), no. 97, p. 199; Wethey (1962), vol. 1, pp. 13, 20, 62–63, figs. 333, 336; ibid., vol. 2, no. 153; Manzini and Frati (1969), no. 156a, pl. XXXI; Camón Aznar (1970), pp. 1128–1135, no. 743, figs. 967, 968; Cossío (1972), no. 371; Lafuente Ferrari and Pita Andrade (1972), pp. 70, 120, 132, no. 121, fig. 109; Gudiol (1973), pp. 283, 295, no. 243, fig. 269; Davies (1976), pp. 9, 15, pl. 33.

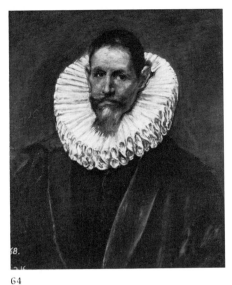

64

64 (plate 7)

Jerónimo de Cevallos

Oil on canvas, 65 x 55 cm. (25⅝ x 21⅝ inches)
Circa 1605–1610
Madrid, Museo del Prado

The sitter in this superb late portrait was identified by Allende Salazar and Sánchez Cantón in 1919 on the basis of an engraving (fig. 18) executed in 1613 by Pedro Angel; the identification was supported by a document in the Cevallos family archive that mentions a portrait of Jerónimo by El Greco (the document gives a date of 1618 for the El Greco portrait — after the death of the artist — but the authors claim it should read 1608). Subsequent writers, including the authors of the 1972 Prado catalogue, have also maintained that the sitter is Cevallos. Recently, however, Roteta, in an essay on Pedro Angel's engraved portraits, presented an argument against the usual identification. In any case, this very well preserved painting ranks as one of the artist's finest late portraits.

Jerónimo de Cevallos (1562–after 1623) was a native of the town of Escalona, near Toledo. A student of law at Salamanca, he came to Toledo around 1600 to practice and eventually became a member of the city council and a prominent citizen known to frequent the literary academy in the house of the count of Mora, Francisco Rojas y Guzmán. (For more on Cevallos, see chapter 1.)

The surface texture of this painting is especially well preserved; as it catches the light the essential pictorial relationship between the reddish ground and the brushstrokes is clearly revealed.

Provenance: Duke del Arco (1794).
Bibliography: Cossío (1908), pp. 429–430, no. 79, fig. 124; Allende Salazar and Sánchez Cantón (1919), pp. 175–178; Mayer (1931), no. 322, pl. LXXXVII; Legendre and Hartmann (1937), p. 45; Goldscheider (1938), fig. 199; Zervos (1939), fig. on p. 101; Bronstein (1950), p. 100, fig. on p. 101; Camón Aznar (1950), pp. 1117, 1122, no. 741, fig. 874; Guinard (1956), pp. 70, 124 (biog.), fig. on p. 71; Soehner (1957), pp. 170–171, 180, fig. 52; idem (1960), no. 100;

Wethey (1962), vol. 1, pp. 28, 62, fig. 340; ibid., vol. 2, no. 133; Gómez Menor (1966b), pp. 81–84; Manzini and Frati (1969), no. 158, pl. XXXV; Camón Aznar (1970), pp. 208, 209, 1119, no. 733, fig. 957; Madrid, Prado (1972), no. 812; Cossío (1972), no. 361; Lafuente Ferrari and Pita Andrade (1972), pp. 68, 132, no. 120, fig. 85; Gudiol (1973), p. 283, no. 242, fig. 268; Ana María Roteta, "El retrato-grabado español en Pedro Angel," *Goya*, no. 130 (Jan.–Feb. 1976): 226–227, fig. on p. 227.

65

Cardinal Juan de Tavera

Oil on canvas, 103 x 82 cm. (40½ x 32¼ inches)
Originally signed at lower right in cursive Greek: *doménikos theotokópoulos e'poíei*
Circa 1608–1614
Toledo, Hospital of Saint John the Baptist (Hospital de Afuera)

Four years after he founded the Hospital of Saint John the Baptist in 1541 (fig. 15), the great cardinal Juan de Tavera died at the age of seventy-three. This posthumous portrait is generally dated after 1608, the year that El Greco was commissioned by Pedro Salazar de Mendoza, administrator of the hospital, to create the altarpieces for its chapel. Cossío (1908) made the credible suggestion that the likeness was probably based on the death mask (still extant) of the cardinal made by Alonso Berrugeute. In its design, the canvas is similar to the portraitlike *Saint Jerome as Cardinal* (cat. nos. 40, 41; pls. 54, 55).

Cardinal Tavera — humanist, diplomat, administrator, and patron of the arts — was one of the most distinguished men in all of Spain during the reign of Emperor Charles V. He was bishop of Burgo de Osma and archbishop of Santiago de Compostela before becoming archbishop of Toledo and primate of Spain in 1534. He also served as inquisitor general and president of the Royal Council of Castile. A portrait of Cardinal Tavera was listed among the possessions of Salazar de Mendoza at his death in 1629; according to Wethey, such a portrait was listed in the hospital inventories of 1628 and 1630.

In 1936 the painting was badly slashed and the signature was lost (see the photograph in Falkner von Sonnenburg). The canvas was restored in 1940, but its condition is far from satisfactory.

Provenance: Pedro Salazar de Mendoza, Toledo (1629).
Bibliography: Cossío (1908), pp. 446–450, no. 247, fig. 135; San Román (1914), 115; Mayer (1931), no. 339, pl. LXXXVIII; Legendre and Hartmann (1937), p. 37; Goldscheider (1949), fig. 140; Camón Aznar (1950), pp. 1166, 1169, no. 763, fig. 905; Bronstein (1950), p. 102, fig. on p. 103; Guinard (1956), pp. 66, 129; Marañón (1956b), p. 137, fig. 42-1; Soehner (1957), pp. 169, 180; idem (1958–1959), no. 105; H. Falkner von Sonnenburg, "Zur Maltechnik Grecos," *Münchner Jahrbuch der bildenden Kunst* 9–10 (1958–1959): fig. 3; Wethey (1962), vol. 1, fig. 338; ibid., vol. 2, no. 157; Manzini and Frati (1969), no. 162; Camón Aznar (1970), pp. 1155–1157, no. 755, fig. 986;

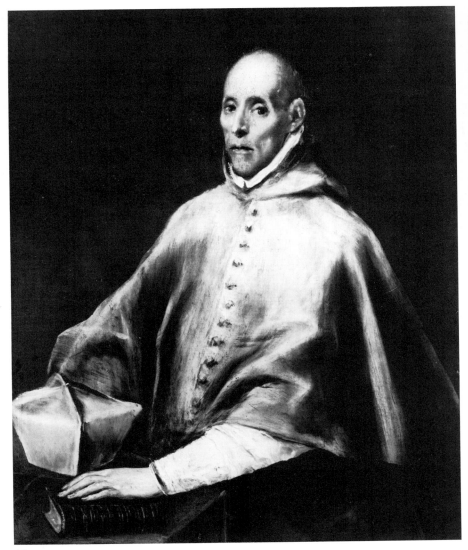

65

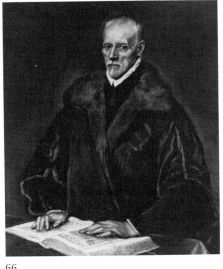

66

Lafuente Ferrari and Pita Andrade (1972), pp. 70, 88 (n. 91), 161, no. 122, fig. 110; Cossío (1972), no. 377; Gudiol (1973), p. 283, no. 244, fig. 270.

66 (plate 73)

Giacomo Bosio

Oil on canvas, 115.9 x 86.0 cm. (45⅝ x 33⅞ inches)
Circa 1610–1614
Fort Worth, Kimbell Art Museum

This great portrait left Spain for Paris in the mid-nineteenth century with an important collection of pictures formed by the count of Quinto that included other El Grecos (among them cat. nos. 15, 19, 43; pls. 19, 38, 56). The painting was eventually acquired by King Carol I of Rumania, who had a special fondness for the works of El Greco and bought quite a number of them. Except for its inclusion in the 1937 Paris exhibition of the artist's work, the portrait was not seen publicly in this century until its acquisition by the Kimbell Art Museum in 1977.

Until shortly before the 1937 exhibition, the sitter was thought to be Diego de Covarrubias (see cat. no. 62; pl. 6) — an unconvincing identification based on a suggested resemblance to El Greco's portrait. The cleaning of the picture around that time uncovered the first word of the two-word inscription on the edge of the book; only the second word had been visible previously. The inscription reads "BOSIUS CANONICI." Sometimes wrongly translated as "Canon Bosio," the actual English equivalent of the Latin is "Canons of Bosius." Camón Aznar identified this Bosius as Giacomo Bosio (1544–1627), Italian cleric and historian who was the agent of the Order of Malta at the court of Pope Gregory XIII. In addition to writing a history of the Knights of Malta, Bosio was the author of other books about the order, including *Gli privilegi della sacra religione di San Giovanni Gerosolimitano* and *Gli statuti della sacra religione di San Giovanni Gerosolimitano*, both published in Rome in 1589. The volume in the painting might represent one of the above works. Harold Wethey, who has graciously shared his information on Bosio with the author, has thus far been unsuccessful in his attempts to determine through archival research whether Bosio made a trip to Spain. Bosio would have been roughly seventy years old in 1614, the year El Greco died; the man portrayed here could be that old, or even older. It is possible, of course, that the inscription on the book, despite its apparent authenticity, is misleading.

Stylistically, this portrait is surely one of the artist's latest. The relatively thin paint film and its brilliant application is consistent with such very late works as those in the Apostle series from the Museo del Greco (see cat. nos. 48, 49; pls. 61, 62). The red ground is allowed to show in parts, especially in the beautifully painted beaver collar and lining of the coat. A quite visible pentimento exists around the top and left side of the head. The exquisitely painted hands, with flickering touches of crimson in the grayish flesh tone, and the book, with its pink binding spread out on a green cloth, call to mind *Saint Jerome as Cardinal* (cat. no. 40; pl. 54).

Provenance: Count of Quinto; Countess of Quinto (sale Paris, 1862, no. 66 [identified as Diego de Covarrubias]); Alphonse Oudry (sale Paris, 16–17 Apr. 1869, no. 138); Félix Bamberg, Messina (1869–1879); King Carol I of Rumania, Royal Palace, Sinaia; King Carol II of Rumania; heirs of Carol II; acquired by the Kimbell Art Museum in 1977.

Bibliography: Cossío (1908), pp. 444–446, no. 359, fig. 134 bis; Valerian von Loga, "Die Spanischen Bilder des Königs Carol von Rumänien," *Zeitschrift für bildende Kunst* (1912): 28, fig. 1; Mayer (1931), p. 133, no. 347a; A. Busuionceanu, "Les tableaux du Greco de la collection royale de Roumanie," *Gazette des Beaux-Arts*, 6th series, vol. 11 (May 1934): 302–304, fig. 6; Paris, *Gazette des Beaux-Arts* exhibition (1937), no. 8; Legendre and Hartmann (1937), p. 65; Gómez Moreno (1943), p. 37; Goldscheider (1949), fig. 141; Camón Aznar (1950), p. 1157, no. 760, fig. 898; Soehner (1957), p. 194; Gaya Nuño (1958), no. 1395; Wethey (1962), vol. 2, no. 132; Manzini and Frati (1969), no. 139; Camón Aznar (1970), pp. 1147–1149, no. 752, fig. 979; Cossío (1972), no. 376; Gudiol (1973), p. 284, no. 247, fig. 273; "Paintings on the Move," *Apollo* 106, no. 188 (Aug. 1977): 162, fig. 2; Kimbell Art Museum, *Handbook of the Collection* (Fort Worth, 1981), pp. 150, 153.

Bibliography Suggestions for Further Reading

El Greco

Brown, Jonathan, ed. *Figures of Thought: El Greco as Interpreter of History, Tradition, and Ideas.* Washington, D.C.: National Gallery of Art, 1982.
A collection of detailed studies by various authors on some of El Greco's most important commissions and individual works.

Davies, David. *El Greco.* Oxford: Phaidon Books, and New York: E. P. Dutton, 1976.
A short, thoughtful text accompanied by numerous color illustrations.

Guinard, Paul. *El Greco: A Biographical and Critical Study.* Barcelona, and New York: Skira Art Books, 1956.
An excellent biography, although now somewhat out-of-date.

Wethey, Harold E. *El Greco and His School.* 2 vols. Princeton: Princeton University Press, 1962.
The authoritative monograph and catalogue of the artist's works.

The Spanish Background

Alpért, Michael, ed. and trans. *Two Spanish Picaresque Novels.* Harmondsworth, England: Penguin Books, 1969.
These stories by contemporary authors provide a satiric view of Spanish life. The city of Toledo figures prominently in Lazarillo de Tormes, an anonymous work first published in 1554. The Swindler (1626), by Francisco Gómez de Quevedo y Villegas, introduces the turbulent world of Spain's universities, its prisons, and the royal court.

Defourneaux, Marcelin. *Daily Life in Spain in the Golden Age.* New York: Praeger Publishers, 1971, and Stanford: Stanford University Press, 1978 (paperback).
Based primarily on literary sources, this work offers a glimpse into the world of ordinary Spaniards.

Elliott, J. H. *Imperial Spain 1469–1716.* London: Saint Martin's Press, 1963, and New York: Meridian, 1977 (paperback).
A comprehensive and readable survey of Spain's history during this period.

Kubler, George, and Soria, Martin. *Art and Architecture in Spain and Portugal and Their American Dominions, 1500–1880.* The Pelican History of Art. Baltimore: Penguin Books, 1959.
A useful general survey.

Parker, Geoffrey. *Philip II.* Library of World Biography. Boston: Little, Brown, 1978.
A lucid biography of the king whose patronage El Greco sought.

Works Cited

Alarcos, Emilio. "Los sermones de Paravicino." *Revista de Filología Española* 24 (1937): 162–197, 249–319.

Alcocer, Pedro de. *Historia o descripción de la imperial ciudad de Toledo.* Toledo, 1554. Reprint ed., Toledo, 1973.

Aliaga Girbes, José. "Relación del viaje del embajador veneciano Sigismundo di Cavelli a España (1567)." *Anthológica Annua* 16 (1968): 409–478.

Allende Salazar, Juan, and Sánchez Cantón, F. J. *Retratos del Museo del Prado, identificación y rectificaciones.* Madrid, 1919.

Amezcua, Agustín G. de. *Epistolario de Lope de Vega.* 4 vols. Madrid, 1940–1943.

Andrés, Gregorio de. "Historia de un fondo griego de la Biblioteca Nacional de Madrid: Colecciones Cardenal Mendoza y García de Loaysa." *Revista de Archivos, Bibliotecas y Museos* 77 (1974): 5–65.

——. "Viaje del humanista Alvar Gómez de Castro a Plasencia en busca de códices de obras de San Isidro para Felipe II (1572)." In *Fondo para la Investigación Económica y Social de la Confederación Española de Cajas de Ahorros, Homenaje a don Agustín Millares Carlo,* vol. 1, pp. 607–621. Las Palmas, 1975.

Angulo Iñiguez, Diego, and Pérez Sánchez, Alfonso E. *Historia de la pintura española: Escuela madrileña del primer tercio del siglo XVII.* Madrid, 1969.

——. *Historia de la pintura española: Escuela toledana de la primera mitad del siglo XVII.* Madrid, 1972.

——. *Corpus of Spanish Drawing,* vol. 1. London, 1975.

Azcárate, José M. de. "La iconografía de 'El Espolio' del Greco." *Archivo Español de Arte* 28 (1955): 189–197.

Baetjer, Katharine. *El Greco.* (*The Metropolitan Museum of Art Bulletin,* New York, Summer 1981.)

Barrès, Maurice. *Le Greco ou le secret de Tolède.* Paris, 1911. Reprint ed., Paris, 1966.

Beltrán de Heredia, Vicente. "La facultad de teología en la universidad de Toledo." *Revista Española de Teología* 3 (1943): 201–247.

Beritens, Germán. *Aberraciones del Greco científicamente consideradas.* Madrid, 1913.

Beruete y Moret, Aureliano de. *El Greco, pintor de retratos.* Toledo, 1914.

Bettini, Sergio. "Maistro Menegos Theotokopulos Sgurafos." *Arte Veneta* 32 (1978): 238–252.

Bialostocki, Jan. "Puer Sufflans Ingues." In *Arte in Europa: Scritti di storia dell'arte in onore di Edoardo Arslan,* pp. 591–595. Milan, 1966.

Blunt, Anthony. "El Greco's 'Dream of Philip II': An Allegory of the Holy League." *Journal of the Warburg and Courtauld Institutes* 3 (1939–1940): 58–69.

——. *Artistic Theory in Italy, 1450–1600.* Oxford, 1940.

Bordeaux, Galerie des Beaux-Arts. *Domenico Theotocopuli dit Le Greco, 1541–1614: De la Crète à Tolède par Venise.* Bordeaux, 1953.

Bourgeoise, S. "El Greco." In *Byrdecliffe Afternoons.* Woodstock, N.Y., 1940.

Boyd, Maurice. *Cardinal Quiroga, Inquisitor General of Spain.* Dubuque, Iowa, 1954.

Braham, Allan. "Two Notes on El Greco and Michelangelo." *The Burlington Magazine* 108, no. 759 (June 1966): 307–308.

Bronstein, Leo. *El Greco.* New York, 1950.

Brown, Jonathan. *Images and Ideas in Seventeenth-Century Spanish Painting.* Princeton, 1978.

——, ed. *Figures of Thought: El Greco as Interpreter of History, Tradition, and Ideas.* Washington, D.C., 1982.

Bustamante García, Agustín. "El colegio de doña María de Aragón, en Madrid." *Boletín del Seminario de Arte y Arqueología* 38 (1972): 427–438.

Byron, Robert. "Greco: The Epilogue to Byzantine Culture." *The Burlington Magazine* 55, no. 319 (Oct. 1929): 160–176.

——, and Rice, David Talbot. *The Birth of Western Painting.* London, 1930.

Cacho Viu, Vicente. *La Institución Libre de Enseñanza.* Vol. 1, *Origenes y etapa universitaria (1860–1881).* Madrid, 1962.

Calendar of State Papers and Manuscripts Relating to English Affairs Existing in the Archives of Venice, and in Other Libraries of Northern Italy. Edited by Horatio F. Brown et al. London, 1864.

Camón Aznar, José. *Dominico Greco.* Madrid, 1950. 2d ed. (2 vols.), Madrid, 1970.

Canons and Decrees of the Council of Trent. . . . Translated by Henry J. Schroeder. St. Louis and London, 1950.

Carter, James E. "President Carter on Art: 'If I Had to Pick a Favorite Artist It Would Be El Greco.'" *Art News* 79, no. 4 (Apr. 1980): 62–63.

Caturla, María Luisa. "Una carta de El Greco a Felipe II?" *Arte Español* 25 (1963–1967): 129–133.

Ceán Bermúdez, Juan Agustín. *Diccionario histórico de los más ilustres profesores de las bellas artes en España.* 6 vols. Madrid, 1800. Reprint ed. (6 vols.), Madrid, 1965.

Cedillo, Conde de. *Toledo en el siglo XVI.* Madrid, 1901.

Cervantes, Miguel de. *Novelas ejemplares.* Edited by Harry Sieber. 2 vols. Madrid, 1980.

Chatzidakis, Manolis. *Etudes sur la peinture postbyzantine.* London, 1976.

——. *Icônes de Saint-Georges des Grecs et de la collection de l'Institut.* Venice, n.d.

Christian, William A., Jr. *Local Religion in Sixteenth-Century Spain.* Princeton, 1981.

Coffin, David R. "Pirro Ligorio on the Nobility of the Arts." *Journal of the Warburg and Courtauld Institutes* 27 (1964): 191–210.

Colección de documentos inéditos para la historia de España (CODOIN). 112 vols. Madrid, 1842–1915.

Constantoudaki, Marie. "Dominicos Théotocopoulos (El Greco) de Candie à Venise: Documents inédits (1566–1568)." *Thesaurimata* 12 (1975): 292–308.

Constituciones sinodales del arzobispado de Toledo. Toledo, 1601.

Constituciones sinodales hechas por el . . . Sr. don Gaspar de Quiroga. Madrid, 1583.

Cook, Walter W. S. "Spanish Painting in the National Gallery of Art: I. El Greco to Goya." *Gazette des Beaux-Arts,* 6th series, vol. 28 (Aug. 1945): 65–86.

Cope, Maurice E. *The Venetian Chapel of the Sacrament in the Sixteenth Century.* New York and London, 1979.

Cossío, Manuel B. "La pintura española." In *Enciclopedia popular ilustrada de ciencias y artes.* Madrid, 1886.

——. *El Greco.* Madrid, 1908.

——. *Dominico Theotocopuli El Greco.* Revised by Natalia Cossío de Jiménez. Barcelona, 1972.

Cruz y Bahamonde, Nicolás de la. *Viaje de España, Francia e Italia.* 11 vols. Cádiz, 1812.

Davies, David. "The Influence of Philosophical and Theological Ideas on the Art of El Greco in Spain." In *Actas del XXIII Congreso Internacional de Historia de Arte,* vol. 2., pp. 242–249. Granada, 1973.

——. *El Greco.* Oxford and New York, 1976.

Denucé, Jean. *Correspondence de Christophe Plantin.* 9 vols. Antwerp and The Hague, 1915–1918.

Domínguez Bordona, Jesús. "Federico Zuccaro en España." *Archivo Español de Arte y Arqueología* 3 (1927): 77–89.

Domínguez Ortiz, Antonio. *La sociedad española en el siglo XVII.* Madrid, 1963.

Dvořák, Max. "Ueber Greco und der Manierismus." In Dvořák's *Kunstgeschichte als Geistesgeschichte.* Munich, 1928. Translated by John Coolidge in *Magazine of Art* 46 (1953): 14–23.

Enggass, Robert, and Brown, Jonathan. *Sources and Documents in the History of Art: Italy and Spain, 1600–1750.* Englewood Cliffs, N.J., 1970.

Foradada y Castan, José. "Datos biográficos desconocidos, o mal apreciados, acerca del célebre pintor Dominico Theotocópoli." *Revista de Archivos, Bibliotecas y Museos* 6 (1876): 137ff.

Freedberg, S. J. *Painting in Italy 1500 to 1600.* The Pelican History of Art. Harmondsworth, England, 1971.

Fry, Roger. *Vision and Design.* New York, 1920.

Gállego, Julián. *El pintor de artesano a artista.* Granada, 1976.

García Caraffa, Alberto and Arturo. *Enciclopedia heráldica y genealógica hispanoamericano.* 88 vols. Madrid, 1952–1963.

García Chico, Esteban. *Documentos para el estudio del arte en Castilla,* vol. 3. Valladolid, 1946.

García Mercadal, José. *Viajes de extranjeros por España y Portugal.* 3 vols. Madrid, 1952–1962.

García Rey, Verardo. "El deán don Diego de Castilla y la reconstrucción de Santo Domingo el Antiguo de Toledo." *Boletín de la Real Academia de Bellas Artes y Ciencias Históricas de Toledo* 4–5 (1923): 28–109, 129–189.

——. "Recuerdos de antaño: El Greco y la entrada de los restos de Santa Leocadia en Toledo." *Arte Español* 8 (1926): 125–129.

——. "Artistas madrileños al servicio del arzobispado de Toledo." *Revista de la Biblioteca, Archivo y Museo* (Ayuntamiento de Madrid) 8 (1931): 76–87.

——. "Juan Bautista Monegro, escultor y arquitecto: Segunda parte. Datos relativos a sus obra." *Boletín de la Sociedad Española de Excursiones* 40 (1932): 22–38.

Gautier, Théophile. *Voyage en Espagne.* Paris, 1845. Reprint ed., Paris, 1878.

Gaya Nuño, J. A. *La pintura española fuera de España.* Madrid, 1958.

Gilio da Fabriano, G. A. *Due dialogi.* Camerino, Italy, 1564.

Glen, Thomas L. *Rubens and the Counter-Reformation: Studies in His Religious Paintings between 1609 and 1620.* New York and London, 1977.

Goldscheider, Ludwig. *El Greco.* Oxford and New York, 1938. 2d ed., New York, 1949.

Gómez Menor, José C. "En torno a figura de Jerónima de las Cuevas." *Arte Español* 25–26 (1963–1966): 96–103.

——. "El pintor Blas de Prado." *Boletín del Arte Toledano* 1 (1966a): 60–74, 96–100, 109–117.

——. "En torno a algunos retratos del Greco." *Boletín del Arte Toledano* 1 (1966b): 78–88.

Gómez Moreno, Manuel. *El Greco (Domenico Theotocópuli).* Barcelona, 1943.

Gómez Moreno, María Elena. *Catálogo de las pinturas del Museo del Greco en Toledo.* Madrid, 1968.

Gudiol, José. *Doménikos Theotokopoulos: El Greco, 1541–1614.* New York, 1973.

Guinard, Paul. "Le retable du Greco à Talavera la Vieja." *Revue de l'Art* (1926): 175–177.

——. *El Greco: A Biographical and Critical Study.* Barcelona and New York, 1956.

Harris, Enriqueta [Enriqueta Harris Frankfort]. "A Decorative Scheme by El Greco." *The Burlington Magazine* 72 (1938): 154–164.

——. "El Greco's 'Holy Family with the Sleeping Christ Child and the Infant Baptist': An Image of Silence and Mystery." In *Hortus Imaginum: Essays in Western Art,* edited by Robert Enggass and Marilyn Stokstad, pp. 103–111. Lawrence, Kans., 1974.

Hatzfeld, Helmut. "Textos teresianos aplicados a la interpretación del Greco." In *Estudios literarios sobre mística española,* edited by Hatzfeld, pp. 243–276. Madrid, 1955.

Hernández, Miguel. *Vida, martyrio y translación de la gloriosa virgen y martyr Santa Leocadia.* Toledo, 1591.

Higuera, Gerónimo Román de la. "Historia eclesiástica de Toledo. . . ." Biblioteca Nacional (Madrid): Mss. 1285–1293.

Horozco y Covarrubias, Sebastián de. *Cancionero.* Madrid, 1874.

Jammes, Robert. *Etudes sur l'oeuvre poétique de don Luis de Góngora y Argote.* Bordeaux, 1967.

Jiménez-Landi, Antonio. *Don Francisco Giner de los Ríos y la Institución Libre de Enseñanza.* New York, 1959.

Justi, Carl. "Die Anfäng des Greco." In Justi's *Miscellaneen aus drei Jahrhunderten Spanischen Kunstlebens.* Berlin, 1908.

——. "Los comienzos de El Greco." *Estudios de Arte Español* 2 (1914).

Kandinsky, Wassily, and Marc, Franz, eds. *The Blaue Reiter Almanac.* Edited by Klaus Lankheit. London, 1974.

Kubler, George, and Soria, Martin. *Art and Architecture in Spain and Portugal and Their American Dominions, 1500–1880.* The Pelican History of Art. Baltimore, 1959.

Lafond, Paul. "Domenikos Theotokopuli dit Le Greco." *Les Arts,* no. 58 (Oct. 1906), pp. 1–32.

Lafuente Ferrari, Enrique. *La vida y el arte de Ignacio Zuloaga.* San Sebastián, 1950.

——. *Breve historia de la pintura española,* 4th ed. Madrid, 1953.

——, and Pita Andrade, José Manuel. *El Greco di Toledo e il suo espressionismo estremo.* Milan, 1969. U.S. ed., *El Greco: The Expressionism of the Final Years.* New York, 1972.

Laín Entralgo, Pedro. *La generación de noventa y ocho.* Madrid, 1955.

Laínez Alcalá, Rafael. *Don Bernardo de Sandoval y Rojas, protector de Cervantes.* Salamanca, 1958.

Lefort, Paul. "Le Greco." In *Histoire des peintres de toutes les écoles,* edited by Charles Blanc. Vol. 4, *Ecole espagnole.* Paris, 1869.

Legendre, M., and Hartmann, A. *Domenico Theotokopoulos Called El Greco.* Paris, 1937.

Leiris, Alain de. "Manet and El Greco: 'The Opera Ball.'" *Arts Magazine* 55, no. 1 (Sept. 1980), pp. 95–99.

"Libros para Felipe II: Epitafios para el Emperador Carlos V" (by L.P.B.). *Archivo Español de Arte* 21 (1948): 58–61.

Lipschutz, Ilse H. *Spanish Painting and the French Romantics.* Cambridge, Mass., 1972.

Llaguno y Amirola, Eugenio. *Noticias de los arquitectos y arquitectura de España desde su restauración.* 4 vols. Madrid, 1829.

Llamas Martínez, Enrique. *Santa Teresa de Jesús y la inquisición española.* Madrid, 1972.

Lomazzo, Giovanni P. *Trattato dell'arte de la pittura.* Milan, 1584.

London, Royal Academy of the Arts. *The Golden Age of Spanish Painting.* London, 1976.

López-Rey, José. "El Greco's Baroque Light and Form." *Gazette des Beaux-Arts,* 6th series, 24 (1943): 73–88.

——. "Spanish Baroque: A Baroque Vision of Repentance in El Greco's 'St. Peter.'" *Art in America* 35 (1947): 313–318.

MacLaren, Neil. *National Gallery Catalogues: The Spanish School.* London, 1952. 2d ed., revised by Allan Braham, 1970.

Madoz, Pascual. *Diccionario geográfico-estadístico-histórico.* Madrid, 1848.

Madrid, Museo del Prado. *Catálogo de los cuadros.* Madrid, 1972.

Madrid, Real Academia de San Fernando. *Catálogo de la exposición de cuadros del Greco.* Madrid, 1909.

Mâle, Emile. *L'art religieux après le Concile de Trente: Etude sur l'iconographie de la fin du XVIᵉ siècle, du XVIIᵉ du XVIIIᵉ siècle. Italie-France-Espagne-Flandres.* Paris, 1932.

Mancini, Giulio. *Considerazioni sulla pittura* (1614). Edited by Adrianna Marucchi and Luigi Salerno. 2 vols. Rome, 1956.

Mansilla, Demetrio. "La reorganización eclesiástica española del siglo XVI." *Anthológica Annua* 5 (1957): 9–259.

Manzini, Gianni, and Frati, Tiziana. *L'opera completa del Greco.* Milan, 1969.

Marañón, Gregorio. "Las academias toledanas en tiempo de El Greco." *Papeles de Son Armadans* 1 (1956a): 13–30.

——. *El Greco y Toledo.* Madrid, 1956b. Later ed., Madrid, 1973.

Marías, Fernando. "Luis de Carvajal en la Concepción Franciscana de Toledo." *Archivo Español de Arte* 48 (1975): 276–278.

——. "La arquitectura del renacimiento en Toledo (1541–1631)." Doctoral thesis, Universidad Complutense de Madrid, Fac. de Filosofía y Letras (Sección de Arte), 6 vols., 1978.

——. "De nuevo, el colegio madrileño de doña María de Aragón." *Boletín del Seminario de Estudios de Arte y Arqueología* 45 (1979): 449–451.

——, and Bustamante, Agustín. *Las ideas artísticas de El Greco: Comentarios a un texto inédito.* Madrid, 1981.

Martin, John R. "Immagini della Virtù: The Paintings of the Camerino Farnese." *Art Bulletin* 38 (1956): 91–112.

Martínez, Jusepe. "Discursos practicables del nobilísimo arte de la pintura" [1675?]. In *Fuentes literarias para la historia del arte español,* edited by F. J. Sánchez Cantón, vol. 3. Madrid, 1934.

Martínez de lá Peña, Domingo. "El Greco, en la Academia de San Lucás: El primer documento cierto sobre la estancia del Greco en Italia." *Archivo Español de Arte* 45 (1967): 97–105.

Martín Gamero, Antonio. *Los cigarrales de Toledo.* Toledo, 1857.

——. *Historia de la ciudad de Toledo.* Toledo, 1862.

Martín González, Juan J. "El Greco, arquitecto." *Goya,* no. 26 (1958), pp. 86–88.

Martz, Linda M. "Poverty and Welfare in Habsburg Spain: The Example of Toledo." Ph.D. dissertation, King's College, University of London, 1974. Cambridge University Press, forthcoming.

——, and Porres, Julio. *Toledo y los toledanos en 1561.* Toledo, 1974.

Mayer, August L. *El Greco.* Munich, 1916. Revised eds., Munich, 1926; Berlin, 1931.

——. "El Greco—An Oriental Artist." *Art Bulletin* 11 (1929): 146–152.

——. "Notas sobre la iconografía sagrada en las obras del Greco." *Archivo Español de Arte* 14 (1940–1941): 164–168.

Medina, Miguel de. *Exercicio de la verdadera y cristiana humilidad.* Toledo, 1570.

Meier-Graefe, Julius. *Spanische Reise.* Berlin, 1910. U.S. ed. (translated by J. Holroyd-Reece), New York, 1926.

Mélida, José Ramón. "El arte antiguo y El Greco." *Boletín de la Sociedad Española de Excursiones* 23 (June 1915): 89–103.

——. *Catálogo monumental de España: Provincia de Cáceres.* Madrid, 1924.

Mertzios, C. D. "Domenicos Theotocopoulos: Nouveaux éléments biographiques." *Arte Veneta* 15 (1961): 217–219.

Millé y Giménez, Juan. "La epístola de Lope de Vega al doctor Gregorio de Angulo." *Bulletin Hispanique* 37 (1935): 159–188.

Moffett, Kenworth. *Meier-Graefe as Art Critic.* Munich, 1973.

Morales, Ambrosio de. *Las antigüedades de las ciudades de España.* Alcalá de Henares, 1575.

Navenne, Ferdinand de. *Les palais Farnèse et les Farnèse*. Paris, n.d.

Nolhac, Pierre de. "Une galerie de peinture au XVI^e siècle: Les collections de Fulvio Orsini." *Gazette des Beaux-Arts*, 2d series, vol. 29 (1884): 427–436.

——. *La bibliothèque de Fulvio Orsini*. Paris, 1887.

Pacheco, Francisco. "El arte de la pintura" (Seville, 1649). In *Fuentes literarias para la historia del arte español*, edited by F. J. Sánchez Cantón, vol. 2. Madrid, 1933. Also *Arte de la pintura*, edited by F. J. Sánchez Cantón. Madrid, 1956.

Palomino de Castro y Velasco, Antonio. *El museo pictórico y escala óptica*. 3 vols. Madrid, 1715–1724. Reprint ed. (1 vol.), Madrid, 1947.

Paris, *Gazette des Beaux-Arts. Domenico Theotocopuli, El Greco: Exposition organisée par la 'Gazette des Beaux-Arts.'* Paris, 1937.

Parro, Sixto Roman. *Toledo en la mano*. Toledo, 1857. Reprint ed., Toledo, 1978.

Partridge, Loren. "The Sala d'Ercole in the Villa Farnese at Caprarola." *Art Bulletin* 53 (1971): 467–486 (part 1); 54 (1972): 50–62 (part 2).

Pastor, Ludwig, Freiherr von. *The History of the Popes from the Close of the Middle Ages*. 40 vols. London, 1891–1953.

Peers, E. Allison. *Handbook to the Life and Times of St. Teresa de Avila and St. John of the Cross*. London, 1952.

Pérez Martín, María J. *Margarita de Austria, reina de España*. Madrid, 1961.

Pérez Pastor, Cristóbal. *Noticias y documentos relativos a la historia y literatura española*. Memorias de la Real Academia Española, vol. 10. Madrid, 1910.

——. *Colección de documentos inéditos para la historia de las bellas artes en España*. Memorias de la Real Academia Española, vol. 11. Madrid, 1914.

Pijoán, Joseph. "El Greco—A Spaniard." *Art Bulletin* 12 (1930): 13–18.

Pisa, Francisco de. *Descripción de la imperial ciudad de Toledo*. Toledo, 1605. Reprint ed., Toledo, 1974.

——. *Apuntamientos para la II parte de la "Descripción de la imperial ciudad de Toledo."* Toledo, 1976.

Pita Andrade, José Manuel. *See under* Lafuente Ferrari, Enrique.

Ponz, Antonio. *Viaje de España*. 18 vols. Madrid, 1772–1794. Reprint ed., Madrid, 1947.

Porreño, Baltasar. "Historia episcopal y real de los arzobispos de Toledo y cosas de España" (circa 1605). Biblioteca Capitular de Toledo: Ms. 27, 21–22.

Ramírez de Arellano, Rafael. *Catálogo de artífices que trabajaron en Toledo*. Toledo, 1920.

——. *Las parroquias de Toledo*. Toledo, 1921.

Rekers, B. *Benito Arias Montano (1527–1598)*. London and Leiden, 1972.

Relaciones de las fiestas que la imperial ciudad de Toledo hizo al nacimiento del príncipe N. S. Felipe IIII de este nombre. Madrid, 1605.

Ringrose, David. "The Impact of a New Capital City: Madrid, Toledo, and New Castile, 1560–1606." *Journal of Economic History* 33 (Dec. 1973): 761–790.

Ronchini, Amadeo. "Giulio Clovio." *Atti e memorie delle RR. Deputazione di Storia Patria per le provincie modenesi e parmesi* 3 (1865): 259–270.

Rosenthal, Earl. Review of Wethey (1962) in *Art Bulletin* 45, no. 4 (Dec. 1963): 385–388.

Roskill, Mark. *Dolce's "Aretino" and Venetian Art Theory of the Cinquecento*. New York, 1968.

Saínz Rodríguez, Pedro. "La historia literaria en los antiguos bibliógrafos españoles." In Fondo para la Investigación Económica y Social de la Confederación Española de Cajas de Ahorros, *Homenaje a don Agustín Millares Carlo*, vol. 1, pp. 447–464. Las Palmas, 1975.

Salas, Xavier de. "Una academia toledana del tiempo de Felipe III." *Archivo Español de Arte y Arqueología* 7 (1931): 178–181.

——. "La valoración del Greco por los románticos españoles y franceses." *Archivo Español de Arte* 14 (1940–1941): 397–406.

——. "Más valoraciones románticas del Greco." *Clavileño* 5 (1954): 19–31.

——. *Cuatro obras maestras: Vicente Macip, El Greco, Van Dyck, Goya*. Madrid, 1966.

——. *Miguel Angel y El Greco*. Madrid, 1967a.

——. "Un exemplaire des *Vies* de Vasari annoté par Le Greco." *Gazette des Beaux-Arts*, 6th series, vol. 69 (1967b): 177–180.

Salazar de Mendoza, Pedro. *Chrónica del Cardinal Don Juan Tavera*. Toledo, 1603.

——. *El Glorioso Doctor San Ildefonso*. Toledo, 1618.

——. *Vida y sucesos prósperos y adversos de Bartolomé de Carranza y Miranda*. Madrid, 1784.

Sánchez, Pedro. *Arbol de la consideración y varia doctrina*. Toledo, 1584.

——. *Historia moral y philosóphica*. Toledo, 1590.

——. *Libro del reyno de Dios*. Madrid, 1594.

Sánchez Cantón, F. J., ed. *Fuentes literarias para la historia del arte español*. 5 vols. Madrid, 1923–1941.

——. *El Greco*. London, 1963.

Sandoval, Bernardino de. *Tratado del oficio eclesiástico canónico*. Toledo, 1568.

San Román y Fernández, Francisco de Borja de. *El Greco en Toledo ó nuevas investigaciones acerca de la vida y obras de Dominico Theotocopuli*. Madrid, 1910.

——. "Discurso . . . en commeración del tercer centenario . . . el Greco" ("Los retablos del Hospital de Afuera"). *Boletín de la Real Academia de Bellas Artes de San Fernando* 8 (1914): 112–122.

——. "De la vida del Greco." *Archivo Español de Arte y Arqueología* 3 (1927): 139 ff., and offprint.

——. "Documentos del Greco, referentes a los cuadros de Santo Domingo el Antiguo." *Archivo Español de Arte y Arqueología* 10 (1934): 1–13.

——. "Dos libros de la biblioteca del Greco." *Archivo Español de Arte y Arqueología* 14 (1940–1941): 235–238.

Santa María, Juan de. *República y política christiana*. Madrid, 1615.

Santos Díez, José Luis. "Política conciliar postridentina en España." *Anthológica Annua* 15 (1967), 309–461.

Schiller, Gertrud. *Iconography of Christian Art*, translated by Janet Seligman. Vol. 2, *The Passion of Jesus Christ*. Greenwich, Conn., 1972.

Shaw, Donald L. *The Generation of 1898 in Spain*. London and New York, 1975.

Shearman, John. *Mannerism*. Harmondsworth, England, 1967.

Sigüenza, José de. "Historia de la Orden de San Jerónimo" [Madrid, 1600–1605]. In *Fuentes literarias para la historia del arte español*, edited by F. J. Sánchez Cantón, vol. 1. Madrid, 1923.

Soehner, Halldor. "Der Stand der Greco-Forschung." *Zeitschrift für Kunstgeschichte* 19 (1956): 47–75.

——. "Greco in Spanien." *Münchner Jahrbuch der bildenden Kunst*, 3d series, vol. 8 (1957): 122–194 (part 1); 9–10 (1958–1959): 147–242 (parts 2–3); 11 (1960): 173–217 (part 4).

——. *Una obra maestra de El Greco: La Capilla de San José de Toledo*. Madrid, 1961.

Soria, Martin. "Greco's Italian Period." *Arte Veneta* 8 (1954): 213–221.

Steinbart, Kurt. "Greco und die Spanische Mystik." *Repertorium für Kunstwissenschaft* 36 (1913): 121–134.

Stirling-Maxwell, William. *Annals of the Artists of Spain*. London, 1848. Reprint ed. (4 vols.), London, 1891.

Summers, David. "Maniera and Movement: The 'Figura Serpentinata.'" *Art Quarterly* 35 (1972): 269–301.

——. "Contrapposto: Style and Meaning in Renaissance Art." *Art Bulletin* 59 (1977): 336–361.

——. *Michelangelo and the Language of Art*. Princeton, 1981.

Tellechea Idigoras, José Ignacio. *El Arzobispo Carranza y su tiempo*. 2 vols. Madrid, 1968.

Teresa de Avila, Saint. *Obras completas*. Madrid, 1951.

Toledo, Museo del Greco. *Catálogo del Museo del Greco de Toledo*. Madrid, 1912.

Tolnay, Charles de. *Michelangelo: The Final Period*. Princeton, 1960.

Trapier, Elizabeth Du Gué. *El Greco*. Hispanic Notes and Monographs. New York, 1925.

——. *El Greco: The Early Years at Toledo, 1576–1586*. New York, 1958a.

——. "El Greco in the Farnese Palace, Rome." *Gazette des Beaux-Arts*, 6th series, vol. 51 (Feb. 1958b): 73–90.

Unamuno, Miguel de. "En torno al casticismo." *La España Moderna* 7 (May 1895): 27–40. Reprinted in *Obras completas*, edited by Manuel García Blanco, vol. 1. Madrid, 1966.

Vasari, Giorgio. *Lives of Seventy of the Most Eminent Painters, Sculptors and Architects*. Translated by E. H. and E. W. Blashfield and A. A. Hopkins. 4 vols. New York, 1896.

Vega, Diego de la. *Paraíso de la gloria de los santos*. Toledo, 1602. Later ed., Medina del Campo, 1604.

Vegüe y Goldoni, Angel. "En torno a la figura del Greco." *Arte Español* 8 (1926–1927): 70–79.

Viardot, Louis. *Les Musées d'Espagne: Guide et memento de l'artiste et du voyageur*. Paris, 1855.

Vilar, Jean. "Intellectuels et noblesse: Le doctor Eugenio de Narbona." *Etudes Iberiques* 3 (1968): 7–28.

Villegas, Alonso de. *Flos Sanctorum*. 4 vols. Toledo, 1578–1589. Also later eds.

Viñas y Mey, Carmelo, and Paz, Ramon. *Relaciones histórico-geográfico-estadísticas de los pueblos de España hechas por iniciativa de Felipe II (reino de Toledo)*, vol. 3. Madrid, 1963.

Viniegra, Salvador. *Catálogo ilustrado de la exposición de las obras de Domenico Theotocópuli, llamado El Greco*. Madrid, 1902.

Walker, John. *National Gallery of Art, Washington, D.C.* New York, 1974.

Washington, National Gallery of Art. *Paintings and Sculpture from the Samuel H. Kress Collection*. Washington, 1959.

——. *Summary Catalogue of European Paintings and Sculpture*. Washington, 1965.

——. *European Paintings: An Illustrated Summary Catalogue*. Washington, 1975.

Waterhouse, Ellis K. "El Greco's Italian Period." *Art Studies* 7 (1930): 61–88.

——. "Some Painters and the Counter-Reformation before 1600." *Transactions of the Royal Historical Society* 22 (1972): 103–118.

Wethey, Harold E. *El Greco and His School.* 2 vols. Princeton, 1962.

Wittkower, Rudolf. "El Greco's Language of Gestures." *Art News* 56 (Mar. 1957): 45/ff.

Xiráu, Joaquin. *Manuel B. Cossío y la educación en España.* Mexico City, 1944.

Zarco Cuevas, Julián. *Pintores españoles en San Lorenzo el Real de El Escorial (1566–1613)* Madrid, 1931.

Zarco del Valle, Manuel R. "Documentos inéditos para la historia de las bellas artes en España." In *Colección de documentos inéditos para la historia de España,* vol. 45. Madrid, 1870.

——. Datos documentales para la historia del arte español. Vol. 2, *Documentos de la Catedral de Toledo.* Madrid, 1916.

Zayas, Alonso de. *Vida y virtudes del venerable . . . Doctor Martín Ramírez de Zayas.* Madrid, 1662.

Zervos, Christian. *Les oeuvres du Greco en Espagne.* Paris, 1939.

Index

Photograph Credits

Color transparencies of works from collections in Spain were provided by Juan Antonio Oroñoz, Madrid, with the exception of pls. 37, 40, and 63, which were provided by David Manso, Madrid. Color transparencies of works from collections outside of Spain were generally supplied by the owner of the painting. Other sources included: Documentation Photographique de la Réunion des Musées Nationaux, Paris — pls. 5, 38; Foto Brunel, Lugano — pl. 32; and Pedicini, Naples — pl. 13.

Black-and-white photographs in most cases were provided by the owner of the work. Other sources included: Anderson/Alinari, Florence — figs. 42, 49; Brogi, Rome — fig. 59; Documentation Photographique de la Réunion des Musées Nationaux, Paris — fig. 70, and cat. nos. 19, 61; Foto Arte San José, Toledo — fig. 19; Foto Brunel, Lugano — cat. no. 6; FOTO Mas, Barcelona — figs. 12, 29, 52, 55, 56, 62–64, 93, 100–103, 105, 106 (*Annunciation*), 108, 109, 112, and cat. nos. 10, 11, 32, 55, 62; Foto Rodríguez, Toledo — figs. 16, 20, 68; Instituto Centràle per il catálogo e la documentazione, Rome — figs. 38, 39; Instituto Diego Velásquez, Madrid — figs. 6, 15, 24, 26; Laboratòrio Fotografico, Soprintendènza ai Beni artistici e stòrici, Naples — fig. 37; Library of Congress, Washington, D. C. — fig. 1; Museo del Prado, Madrid — figs. 25, 27; National Gallery, London — fig. 35; Pedicini, Naples — cat. no. 57; Juan Antonio Oroñoz, Madrid — figs. 76–80 (all but *Saint Bernard* and *Assumption of the Virgin* on p. 151), 84–86, 87 (*Annunciation*), and cat. nos. 1, 7, 8, 20, 21, 24, 25, 28, 33, 34, 39, 41, 46–50, 53, 59; Pandó, Madrid — figs. 61, 74, 98, 104, 116.

Copyedited by Michael Brandon
Designed by Carl Zahn
Composition in Comenius by Arrow Composition, West Boylston, Massachusetts
Manufactured by Kunstbuch Berlin Verlagsgesellschaft m.b.H., Berlin

Library of Congress Cataloging in Publication Data

Greco, 1541?–1614.
 El Greco of Toledo.

 Bibliography: p.
 Includes index.
 1. Greco, 1541?–1614 — Exhibitions. I. Brown,
Jonathan. II. Toledo Museum of Art. III. Title.
ND813.T4A4 1982 759.6 82-2310
ISBN 0-8212-1501-9 AACR2
ISBN 0-8212-1506-X (pbk.)